DREAMING IN BLACK AND WHITE

One dreams in black and white—

or I do, with a little color occasionally as emphasis.

Julien Levy, 1979

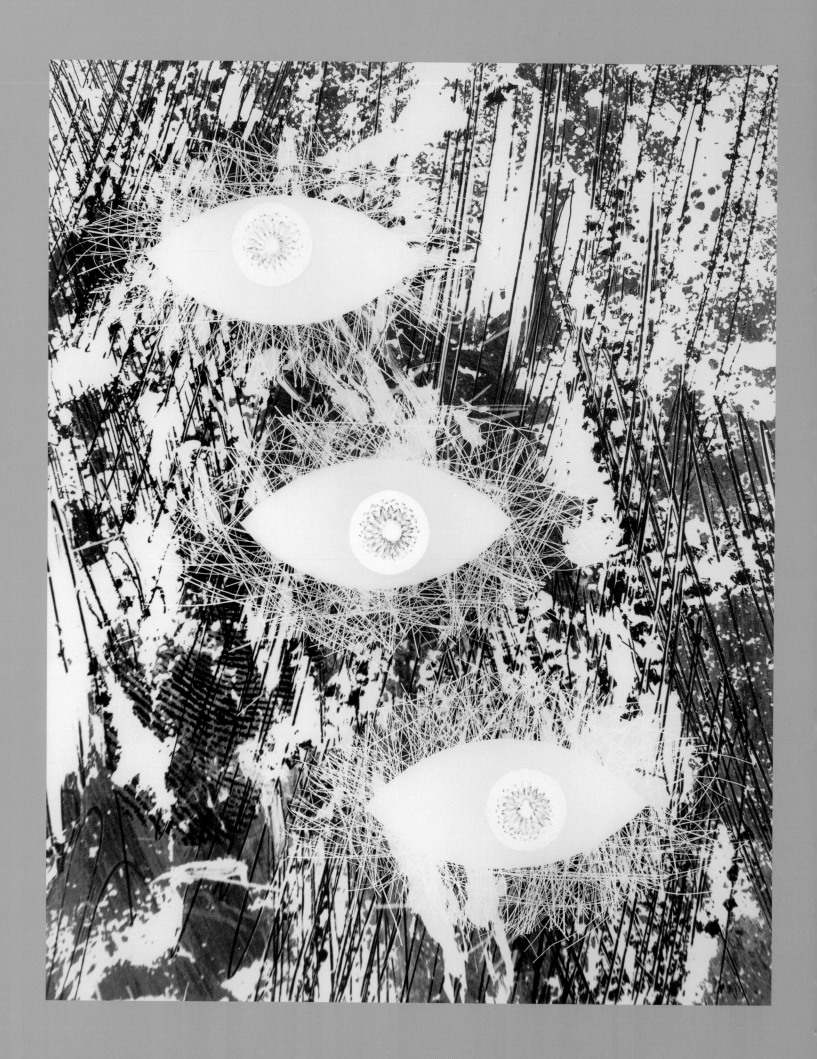

DREAMING IN BLACK AND WHITE
PHOTOGRAPHY AT THE JULIEN LEVY GALLERY

KATHERINE WARE AND PETER BARBERIE

PHILADELPHIA MUSEUM OF ART

IN ASSOCIATION WITH

YALE UNIVERSITY PRESS

This book was published on the occasion of the exhibition
Dreaming in Black and White
Photography at the Julien Levy Gallery
at the Philadelphia Museum of Art, June 17–September 17, 2006.

The exhibition and book were made possible by The Horace W. Goldsmith Foundation with additional support from Furthermore: a program of the J. M. Kaplan Fund. The catalogue was also supported by an endowment for scholarly publications established at the Philadelphia Museum of Art in 2002 by The Andrew W. Mellon Foundation and matched by generous donors.

Front cover: **Lee Miller, *Mrs. Donald Friede,*** c. 1930–32 (see pl. 235)
Back cover: **Manuel Álvarez Bravo, *The Obstacles (Los obstáculos),*** 1929 (see pl. 248)
Frontispiece: **Emilio Amero** (American, born Mexico, 1901–1976). ***S Cloud Photogram / Eyes in the Sky,*** c. 1932–34. Gelatin silver print, 9⅝ x 7¾ inches (24.4 x 19.7 cm). Philadelphia Museum of Art. The Lynne and Harold Honickman Gift of the Julien Levy Collection, 2001-62-39
Endpapers: **Berenice Abbott, Photograph design for a wastebasket,** 1931 (see pl. 280)

Produced by the Publishing Department
Philadelphia Museum of Art
2525 Pennsylvania Avenue
Philadelphia, PA 19130
www.philamuseum.org

Published by the Philadelphia Museum of Art
in association with Yale University Press
P. O. Box 209040
302 Temple Street
New Haven, CT 06520
www.yalebooks.com

Edited by Kathleen Krattenmaker
Production by Richard Bonk
Photography by Amelia Walchli, with additional photography by Andrea Simon and Brad Stanton
Index by Frances Bowles
Designed by Katy Homans, New York
Color separations, printing, and binding by Nissha Printing Co., Ltd., Kyoto, Japan

Library of Congress Cataloging-in-Publication Data

Philadelphia Museum of Art.
 Dreaming in black and white : photography at the Julien Levy Gallery / Katherine Ware and Peter Barberie.
 p. cm.
 This book was published on the occasion of the exhibition Dreaming in black and white: photography at the Julien Levy Gallery, held at the Philadelphia Museum of Art, June 17–September 17, 2006.
 Includes bibliographical references and index.
 ISBN 0-87633-196-7 (PMA cloth)—ISBN 0-87633-197-5 (PMA pbk)—ISBN 0-300-11643-8 (Yale cloth)
 1. Philadelphia Museum of Art—Exhibitions. 2. Julien Levy Gallery—Exhibitions. 3. Photography, Artistic. 4. Black-and-white photography. I. Ware, Katherine, 1960– II. Barberie, Peter, 1970– III. Title.
 TR655.P48 2006
 779.074'74811— dc22 200602091

Note to the Reader
Titles of works of art are provided in English. When a work was previously exhibited or published in another language, or is inscribed with a title in another language, that title is provided in parentheses.

 Measurements of the photographs refer to the image rather than to the sheet or mount; height precedes width.

 All plates are of photographs in the collection of the Philadelphia Museum of Art.

 Most of the magazine and newspaper articles from the 1930s and 1940s cited in this volume can be found as clippings mounted in the scrapbooks compiled during the run of the Julien Levy Gallery. In some cases these clippings were not labeled fully, were mislabeled, or were cropped to eliminate title and author information; incompletely documented articles are cited as clippings in the gallery scrapbooks, which are housed in the Julien Levy Archive, Connecticut.

Contents

Foreword

Anne d'Harnoncourt and Innis Howe Shoemaker

7

Introduction

Katherine Ware and Peter Barberie

9

Between Dadaism and MoMA-ism at the Julien Levy Gallery

Katherine Ware

13

Found Objects, or a History of the Medium, to No Particular End

Peter Barberie

123

Plates

171

Photography Exhibitions at the Julien Levy Gallery

320

Selected Bibliography

323

Acknowledgments

329

Index

331

Foreword

It is a joy to introduce a choice selection of photographs from the collection of Julien Levy to the public in an exhibition and publication that do so much to enlarge our appreciation of Levy's remarkable role in the history of photography. The Philadelphia Museum of Art is deeply grateful to the late Jean Farley Levy for her very generous decision in favor of Philadelphia as the repository of over 2,500 photographs from her husband's collection, and to our own Philadelphia benefactors, Lynne and Harold Honickman, for their instant and equally generous understanding of the opportunity this represented for the Museum and its audience for photography. The acquisition of the Julien Levy Collection through their joint gifts in 2001 was a spectacular component of the Museum's 125th anniversary celebrations, greatly enriching our fine existing holdings of photography and rhyming perfectly with our strength in the art of Levy's heroes and mentors, Alfred Stieglitz and Marcel Duchamp. Levy himself has joined the ranks of such legendary and adventurous patrons of modern art as Louise and Walter Arensberg and Albert E. Gallatin, whose collections also transformed the Museum when they were received many decades ago.

This handsome book is the second volume to publish treasures from the Levy Collection, following hard on the heels of *Looking at Atget*, which focused on the great French photographer whose reputation in the United States Levy, together with Berenice Abbott, did so much to enhance. Both books, and the exhibitions they complement, were made possible by a splendid grant from The Horace W. Goldsmith Foundation, which also encompassed the endowment of a curatorial fellowship in photography in the Museum's Alfred Stieglitz Center. Peter Barberie, the author of *Looking at Atget* and contributor of an essay in this volume, is the Museum's first Horace W. Goldsmith Fellow, and we salute his accomplishments. To Katherine Ware, Curator of Photographs at the Museum since 1999, whose impressive combination of a brilliant eye, thoughtful scholarship, and lucid prose is evident throughout this book, go our admiration and heartfelt thanks. We join the authors in their gratitude to the Museum's publishing team, headed with such dedication and panache by Sherry Babbitt, and, in particular, to Rich Bonk for his skillful oversight of the production of this volume, to Kathleen Krattenmaker for her sensitive and meticulous editing, and to designer Katy Homans, who gave the book its striking form.

In addition to the invaluable initiative of The Horace W. Goldsmith Foundation, we are deeply grateful to Furthermore, a program of the J. M. Kaplan Fund, for its support of this catalogue. An endowment for scholarly publications at the Museum, established in 2002 through a crucial grant from The Andrew W. Mellon Foundation, helped to bring the volume to completion, as it has so many other Museum publications in the past. Last but not least, we look forward to the forthcoming move of the Museum's Department of Prints, Drawings, and Photographs to the Ruth and Raymond G. Perelman Building, where a capacious and beautiful new home will be established in 2007 for the Julien Levy Collection and all the department's treasures, affording many more opportunities to share them with the public.

Anne d'Harnoncourt
*The George D. Widener Director and
Chief Executive Officer*

Innis Howe Shoemaker
*The Audrey and William H. Helfand
Senior Curator of Prints, Drawings, and Photographs*

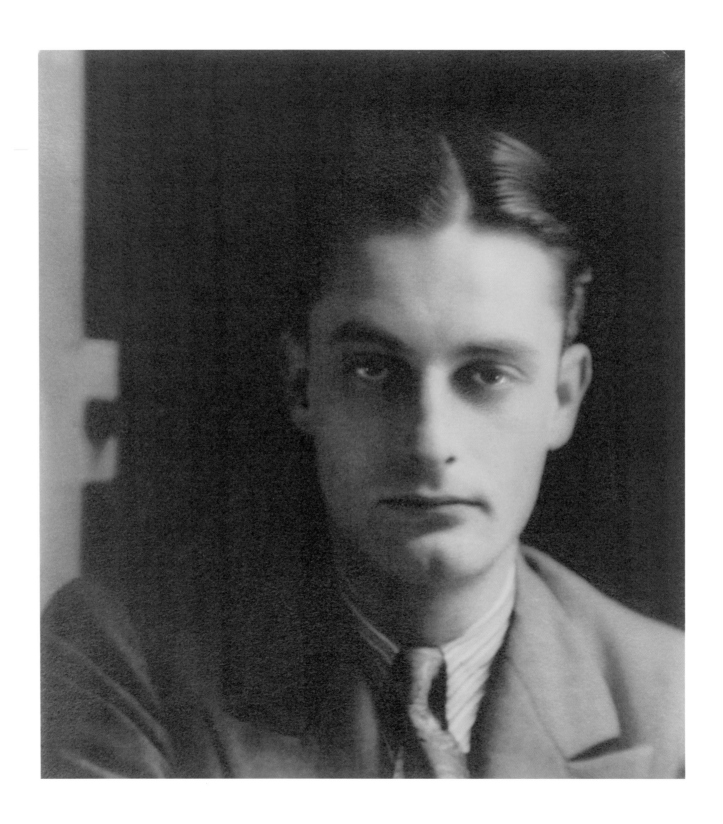

Introduction

In November 1931, Julien Levy (1906–1981) opened a gallery in New York City initially dedicated to photography, a radical proposition at the time. Photography was then considered to have mostly commercial applications and had only rarely been shown on the walls of New York galleries, with the exception of Alfred Stieglitz's Little Galleries of the Photo-Succession (291) and The Intimate Gallery. This would change dramatically over the next decade, however, with the Julien Levy Gallery at the forefront of the wider recognition of photography as a fine art. In the gallery's first season, Levy would present a series of inventive photography exhibitions, in addition to showing works in other mediums and presenting the groundbreaking *Surréalisme*, with work by ten photographers. His photography shows would include solo exhibitions of the work of Eugène Atget, Berenice Abbott, George Platt Lynes, Man Ray, and Lee Miller as well as the ambitious surveys *American Photography Retrospective Exhibition, Modern European Photography, Photographs of New York by New York Photographers*, and *Exhibition of Portrait Photography.*

During the gallery's first season, New York seemed to be at the center of a vortex of photography. The fledgling Museum of Modern Art, which had relocated to new quarters on West 53rd Street, mounted the exhibition *Murals by American Painters and Photographers*, with a section of photomurals organized by Levy. Stieglitz presented a retrospective of his photographic work at his most recent venue, An American Place, and the Art Center offered a show of applied photography that included color work. In the spring, the Brooklyn Museum of Art simultaneously hosted an international survey of photography and the *42nd Annual Exhibition of Pictorial Photography*, and in the fall, presented an exhibition of nineteenth-century photographs from the collection of Thomas E. Morris in its first-floor library gallery. The Weyhe Gallery, where Levy had briefly worked before opening his own place, installed *Photographs of Art Forms in Nature by Blossfeldt.* And far away in Oakland, California, a band of photographers who called themselves Group f.64 was advocating for "straight photography," an approach that dovetailed nicely with much of the work being shown by Levy, who soon exhibited photographs by two of the group's members. Levy also loaned extensively from the gallery's inventory in 1932 and 1933, making significant contributions to surveys of modern photography at the Brooklyn Museum, Smith College, the Albright Art Gallery, and other venues in the northeast as well as abroad.

The frenzy of photographic activity did not go unremarked. In the *New York Times*, Elisabeth Luther Cary wrote at length about the newly pervasive medium of photography, citing the exhibitions on view at the Julien Levy Gallery and the Brooklyn Museum, among others. Katharine Grant Sterne, also for the *Times*, wrote an overview of the photography scene on December 6, 1931, mentioning Levy and the growing presence of photographs in journals, Condé Nast magazines, and even monographic books. Summing up the 1931–32 art season for the *Brooklyn Daily Eagle* on May 22, Helen Appleton Read opined that one of the most important trends was "the growing recognition . . . that photography could be ranked as an art and not a soulless mechanical expression," noting that "the Julien Levy Gallery of Photography . . . was the crowning event of this trend."

Levy's confidence in the importance of photography was prescient, and his prediction about the interest and excitement it would generate during the 1930s was correct. But he was mistaken in

Plate 1
Berenice Abbott (American, 1898–1991)
Julien Levy, 1927
Gelatin silver print
7⅝ x 7 inches (19.3 x 17.8 cm)
The Lynne and Harold Honickman
Gift of the Julien Levy Collection
2001-62-4

thinking that collectors and the public would purchase photographs as works of art. The gallery, which operated from 1931 to 1949, sold only a few photographs during its entire run, and Levy quickly learned to rely on sales of paintings to keep it solvent. His disappointment is our gain, however, as it is because of his inability to sell the photographs that we have them assembled in such a large group today. The Philadelphia Museum of Art was fortunate to acquire in 2001 about 2,500 photographs from Levy's collection, thanks to the generosity of Levy's widow, Jean Farley Levy, and of Lynne and Harold Honickman, who in honor of the Museum's 125th anniversary provided funds to support the acquisition. This phenomenal group of pictures, many of which were shown at Levy's gallery in the 1930s and 1940s, presents a snapshot of the era and a window onto Levy's own attitudes toward photography.

The Levy holdings at the Philadelphia Museum of Art include works by more than 120 photographers. Rather than constituting a meticulously assembled group of images, the collection largely reflects the photography exhibitions Levy hosted at his gallery, including examples from his thematic shows, solo exhibitions, and surveys of historic European and American photographs. Leading lights of the medium, such as Berenice Abbott, Henri Cartier-Bresson, Imogen Cunningham, Walker Evans, Man Ray, László Moholy-Nagy, Charles Sheeler, and Paul Strand, are well represented. The largest group by a single artist is an exceptional collection of 361 photographs by French photographer Eugène Atget, showcased in the recent exhibition and book *Looking at Atget* (2005). Other highlights are major groups of work by Manuel Álvarez Bravo, André Kertész, George Platt Lynes, and Lee Miller. Levy's taste in pictures was far ranging, and his holdings include a large number of photographs by unknown makers, some reflecting his Surrealist sensibility and others demonstrating his fascination with popular culture and photography in all its forms. There are also a few images intended for advertising, by Maurice Tabard and Emmanuel Sougez, and a cache of photographs by Berenice Abbott, Leo Hurwitz, and others intended for use in developing household products ornamented with photographic designs, an idea of Levy's. An additional group of forty-four pictures, discovered after Mrs. Levy's death, was purchased in 2004 to augment the initial acquisition.

Levy exhibited photography at a time when the medium was rarely shown in galleries and almost never in museums, and he was often the first to present photographs by many artists now considered the most creative and influential of their time. Yet Levy's place in the history of photography is only beginning to be fully acknowledged and explored. Until the recent spate of exhibitions centering on Levy and his circle, very little had been published on his contributions to the field, with the exception of David Travis's 1976 exhibition catalogue *Photographs from the Julien Levy Collection, Starting with Atget* and Levy's own delightful *Memoir of an Art Gallery*, published in 1977. The result has been that relatively few of the photographs in his collection are publicly known. Most of the images presented in this volume have been seen by only a few specialists over the past five decades, and it is our great pleasure to reintroduce them. The diverse array within these pages is certainly representative of the best examples in the Museum's Levy holdings but is by no means comprehensive or exhaustive.

Prior to the Museum's acquisition, the most significant holding of photographs from Levy's collection was the outstanding selection of works at the Art Institute of Chicago. Curator of photographs David Travis worked directly with Levy to organize the 1976 exhibition and publication *Photographs from the Julien Levy Collection, Starting with Atget*, acquiring 268 photographs from Levy's collection between 1975 and 1978. In 1990, fifty-one additional images—many of which had been published in Levy's memoir—were donated to the collection in memory of Levy by Frank Kolodny, who had sought out Levy in Connecticut, and by his wife, Patricia. Acquisitions elsewhere were relatively few. In 1977, the year after the Chicago show, the Witkin Gallery in New York exhibited another

group of photographs belonging to Levy, some of which sold to private collectors, and produced a catalogue, *Photographs from the Julien Levy Collection*. Over the years, individuals who visited Levy, who had largely retreated from the art world and public life following the closing of his gallery, were sometimes able to purchase work from him, and in 1978–79 Levy donated a group of thirty-three pictures to the Fogg Art Museum at Harvard University, his alma mater. Levy also owned a substantial number of films (another major interest of his), ranging from reels of Fernand Léger's *Ballet mécanique* (1924) to some of his own experimental footage, which were acquired by the Museum of Modern Art in 2005.

In recent years Levy has begun to be rediscovered, most prominently in the engaging and revealing 1998 exhibition *Portrait of an Art Gallery* at the Equitable Gallery in New York and its accompanying volume by Ingrid Schaffner and Lisa Jacobs. Several of Levy's inventive exhibitions have been re-created for contemporary viewers, such as the reprisals of his 1935 show *Documentary and Anti-Graphic Photographs by Cartier-Bresson, Walker Evans, and Álvarez Bravo* at the Museo del Palacio de Bellas Artes in Mexico City in 2002–3 and the Fondation Henri Cartier-Bresson in Paris in 2004. Curatorial Assistance in Pasadena arranged *Accommodations of Desire: Surrealist Works on Paper Collected by Julien Levy*, a show traveling from 2004 to 2006 that was accompanied by a small catalogue fringed in fur. At Michigan State University, Howard Bossen organized in 2005 a surprising retrospective of the work of Luke Swank, one of the American photographers discovered and promoted by Levy, while at the Isamu Noguchi Garden Museum in Long Island City, New York, Larry List reassembled and amplified Levy's 1944 exhibition *The Imagery of Chess*. Also in 2005, Donald Albrecht organized an exhibition of the work of another Levy photographer in *Mythic City: Photographs of New York by Samuel H. Gottscho, 1925–1940* at the Museum of the City of New York, and many of Levy's announcements for his gallery exhibitions found a home in *Surrealism U.S.A.* at the National Academy Museum, New York, which included the work of several painters he represented.

It is extremely gratifying to see Levy's role in the history of art, and particularly the history of photography, so richly acknowledged. It was the dream and mission of Levy's widow, the late Jean Farley Levy, to achieve that aim, and it was toward that goal that she made a partial gift of Levy's photographs to the Philadelphia Museum of Art. With this exhibition and book we celebrate the centenary of Levy's birth, as well as Mrs. Levy's extremely generous gift and her desire to bring her husband's accomplishments to the fore. Levy's tremendous eye for pictures and his significant contributions to photography have indeed been too long neglected. By his own account, he set out not to promote a specific agenda but to unearth and celebrate all the manifestations of the camera and to create a fertile, lively, playful environment at his gallery. We hope to recapture some of that spirit in this volume.

Katherine Ware and Peter Barberie

Between Dadaism and MoMA-ism

at the Julien Levy Gallery

KATHERINE WARE

Mr. Levy's enthusiastic approach toward the subject of photography is contagious and should bring a large following to his gallery in due season.
—*Art News,* February 6, 1932

New York City experienced tremendous changes during the 1930s, and photography was there to capture it all. Despite the stock market crash at the end of the 1920s, the momentum of that decade carried events forward, at least for a while. The automobile had replaced the horse and carriage, and more women were seen behind the wheel. Though street vendors were still in evidence, consumers were increasingly drawn to the apparition of hats and shoes displayed behind the sparkling, newly installed plate-glass windows of department stores. Blacks and whites continued to live separately but sometimes came together in Harlem's music and dance parlors. Old wooden structures were razed to make way for the skyscrapers that seemed to sprout at an alarming rate. This new American urban landscape was exciting and distinctive. The New World no longer needed to fear being in the shadow of the Old World—not with the shadows being cast by the Chrysler Building and the Empire State Building.

Along with the new public interest in engineering and architectural feats came an almost cultlike worship of the machine, and what better way to record the fast pace of progress than with a machine itself, the camera? Both still and moving images on film were considered emblematic of the new age: they were contemporary and forward-looking, well suited to capturing a modern, streamlined lifestyle. But at the same time as new cities were being built up to the sky, awareness grew of what was being demolished below. While many photographers labored to celebrate the reign of the steel girder, another group—and, indeed, sometimes the two overlapped—sought out the ramshackle structures of an earlier time, combing the city's old neighborhoods for vernacular architecture and local color, the very antithesis of steel. These images, constructed by photographers fully informed by the vocabulary of modern art, were not simply records of what was disappearing from the city and from American life. Springing from the example of French photographer Eugène Atget, they represented a new approach to photography—some would say an American one—that was highly observational yet lyrical.

Photographers during the 1920s, especially in Europe, had eagerly explored and pressed outward the parameters of their flexible new medium's possibilities in a variety of experimental work. Many other practitioners appreciated the camera's special ability to quickly record with great verisimilitude whatever was placed before the lens. Photography could thus easily present quotidian aspects of life as cryptic and strange merely by isolating and describing. During the 1930s this aspect of the medium came to be applied more in the direction of cataloguing and preserving the world, studying and understanding it using the vehicle of the camera rather than reveling in its ability to

Plate 2
Ralph Steiner (American, 1899–1986)
Untitled (New York City), 1931
Gelatin silver print
9¹⁵⁄₁₆ x 7¹⁵⁄₁₆ inches (25.2 x 20.2 cm)
The Lynne and Harold Honickman
Gift of the Julien Levy Collection
2001-62-1120

render the ordinary incomprehensible. The growing interest in the photograph as a document linked contemporary photographers to their nineteenth-century predecessors, many of whom had used the camera primarily as a recording device, sparking a new interest in the history of the medium and leading to the rise of documentary photography.

In the midst of these changes, just after the repeal of Prohibition in the United States, Julien Levy opened a gallery in New York City devoted to the work of living artists and particularly to the art of photography. The many exhibitions he held there reflect his attunement to the country's struggle to define itself. Levy was a key player in a minute but extremely active and influential group of young people who wrested the cultural reins from the preceding generation and raced off in new directions. His own contributions were considerable and often prescient: the Julien Levy Gallery was usually ahead of most of the art institutions of the time, whether in the exhibitions it offered, the artists it presented, or its methods and experiments. Levy humorously but aptly described his gallery venture as having occurred between Dadaism and MoMA-ism, referring to the winding down of the Dada movement in Europe in the early 1920s and the founding of the Museum of Modern Art (MoMA) in New York in 1929 and its subsequent ascendancy through the 1930s.[1] Between the two events was a startlingly fecund period of experimentation and cross-pollination, of imagination and possibility. Everything was changing, and it was anything but dull.

THE BEGINNINGS OF A MODERNIST MAESTRO

Julien Levy, scion of upper-middle-class New Yorkers, enrolled in the class of 1927 at Harvard University intending to study literature. Despite his aspirations as a writer, he quickly proved to be an indifferent student. Concerned about her son and remembering his interest in art during a family trip to Europe, his mother arranged an interview with Paul Sachs in the Fine Arts Department, and Levy began a new course of study. A Harvard graduate himself, Sachs had in 1915 exchanged his life as an investment banker in the family firm of Goldman Sachs for a position as assistant director of the Fogg Art Museum at Harvard. Along with the Fogg's director, Edward Waldo Forbes, Sachs developed a course in museum studies, "Museum Work and Museum Problems," to prepare students for professional careers in the arts. While fine-arts courses typically require tremendous amounts of rote memorization by students, Sachs added a more participatory component. He conceived of the museum as a laboratory and used its day-to-day operations as a point of departure for discussion among the students. As Levy recalled, "in addition to art appreciation, he was able to cover the down-to-earth side of how to manage an institution, its finances and its budget, how to handle trustees, and how to interest the rich in donating funds."[2]

A further innovative addition to Levy's education was his encounters with movies under the tutelage of Harvard professor Chandler Post, who, along with his instruction in the history of art, invited students to join him after hours on his cinematic adventures at Scollay Square movie houses. According to Levy these ranged from films starring Gloria Swanson to those of Buster Keaton. Like still photography, film was an expression of modern life, and Levy was drawn to its freshness and largely unexplored creative potential.[3] The ultimate *gesamtkunstwerk* (total art work), film submerged audiences in alternate realities—waking dreams that portrayed life in a manner truer than the linear narrative of a novel or the single moment depicted in most paintings. Levy recalled that, inspired by Post, "I became seriously interested in the cinema as an art form and combined with my art history courses some work in the physics of optics and the psychology of vision."[4] He arranged an independent study project with a psychology professor who provided access to a laboratory and darkroom. During the course of this engaging but ill-conceived venture during his last term at Harvard, Levy spent "considerable time experimenting with photography." In recalling this episode in his memoir,

he makes a direct connection between his interest in film and photography as a student and his goals for his gallery: "Thus, in 1931, when I opened my gallery of contemporary art, one of my initial interests was to promote the recognition of photography as a form of modern art."[5]

Another important rite of passage in Harvard's fine-arts curriculum was a survey of technical process, informally referred to as the "egg and plaster" course. In this class, students made their own bas-reliefs, tried their hands at fresco painting, prepared plaster and gesso, and applied gold leaf. One of Levy's tutors for the class in 1926 was graduate student A. Everett ("Chick") Austin, Jr., a star of the department who would the following year be appointed director of the Wadsworth Atheneum in Hartford, Connecticut. Another leading light of the program was Alfred H. Barr, Jr. In 1927 Barr was teaching art at Wellesley College, where he organized an exhibition of contemporary work that included photography; two years later he would be chosen as the first director of the newly opened Museum of Modern Art. During this same period, Harvard student Lincoln Kirstein co-founded the literary journal *Hound & Horn* with Varian Fry in 1927 and, along with John Walker III and Edward M. M. Warburg, formed the Harvard Society for Contemporary Art at the end of 1928.[6] These young men (and a few female colleagues, such as Agnes Mongan and Agnes Rindge) were revolutionizing the art world and would continue to figure in Levy's life throughout the 1930s and 1940s.[7]

Levy's mother, born Isabel Isaacs, had attended Radcliffe College, Harvard's sister school. His father, Edgar A. Levy, was involved in developing high-end real estate along Park Avenue. Levy later described him as "prosaic" but mentions in his memoir that Edgar had studied to be an artist, only becoming a lawyer and businessman to pay off a considerable debt incurred by his own father.[8] Edgar went on to become a successful entrepreneur, and his family—including children Julien, Edgar Jr., and Elizabeth—enjoyed a period of particular financial success in the mid-1920s.[9] This comfortable time was interrupted by Isabel's sudden death in an automobile accident in July 1924, the summer following Levy's freshman year at Harvard. Despite her early departure from his life, she had set her son on his course in the fine arts. Her approval continued to be important to him, and he would later write about feeling she would have supported his idea of opening an art gallery.[10] As it turned out, Mrs. Levy provided more than moral support for the undertaking; it was the stipend she left for her son that provided the initial financing.[11]

Profoundly affected by the loss of his wife, Edgar Levy sought ways to spend time with his eldest son. The two frequented art galleries together in New York, and at the end of 1926 visited the Joseph Brummer Gallery to see an exhibition of sculpture by Romanian-born artist Constantin Brancusi. "What an awe-full experience for me, the resplendent array of primordial shapes being set on pedestals and arranged and rearranged to catch the optimum light," Levy would later write.[12] Edgar's usual consultant on art acquisitions was his friend and business associate Al Bing, whose own art adviser was American artist Walter Pach, but Julien was able to assert some influence on a purchase if Bing and Pach were both in agreement. On this occasion he persuaded his father to purchase Brancusi's marble *Bird in Space* for $1,000.

Much of the work in the Brummer show belonged to French artist Marcel Duchamp (fig. 1) and his friend Henri-Pierre Roché, who had each purchased a significant group of Brancusi sculptures from the estate of John Quinn after the collector died in 1924. Duchamp, who stayed in New York during the run of the show and accompanied it to a subsequent viewing in Chicago, was often at the gallery. Then thirty years old, he was elegant, reserved, and unprepossessing yet generally the center of attention. He was still notorious in the art world for his 1912 painting *Nude Descending a Staircase*, which had been a bull's-eye for critics when it was first exhibited in the United States at the controversial 1913 Armory Show, and for his seamless integration of art and life. Duchamp was a nationally ranked chess player in France, and the game serves as a model for his intellectual yet

Fig. 1. **Katherine S. Dreier**
(American, 1877–1952). *Marcel
Duchamp, Venice,* 1926.
Gelatin silver print, 11¾ x 8⁹⁄₁₆
inches (29.9 x 21.8 cm).
Philadelphia Museum of Art
Archives

playful—and often collaborative—approach to his many undertakings.[13] Levy was immediately drawn to Duchamp's gamesmanship and demeanor and was especially intrigued by his experimentation with film, a subject Levy would have been eager to discuss. Duchamp had collaborated with his friend and fellow artist Man Ray on a film project in 1920 and, more recently, on the 1926 *Anémic cinéma*.[14]

Already a budding collector in his Harvard days, Levy had by 1926 acquired an etching by Marc Chagall, a woodcut by Heinrich Campendonk, a color lithograph by Paul Klee, and a drawing by Egon Schiele, "all little treasures I had managed to afford while on a hiking trip in Germany," he reported.[15] This grouping of works reveals Levy's early interest in the fantastic—contemporaries Chagall, Campendonk, and Klee are all known for their inventive representations of interior states of being—and in eroticism. As a budding art adviser, he was able to persuade his father to acquire not only Brancusi's *Bird in Space* but also, in time, a painting by Georgia O'Keeffe and a photograph by Alfred Stieglitz.

Thanks to the Brancusi sale, young Levy was welcome at the Brummer Gallery and had the opportunity to meet with Duchamp on several occasions. According to Levy the two quickly became friendly and hatched a plan to travel to Paris, where they hoped to borrow camera equipment from Man Ray to create a short experimental film for which Levy had been preparing a scenario. Levy wrote to his father and his advisor at Harvard to let them know his formal education was finished, and "before six weeks were run" he was sailing for Paris with Duchamp aboard the *France*.[16]

PARIS

Levy's father was not pleased with his son's sudden withdrawal from Harvard just one term shy of graduation.[17] But Julien was eager to make his mark on the world, and given the impact he and his classmates from Harvard's Fine Arts Department were to have on the arts, his confidence was hardly

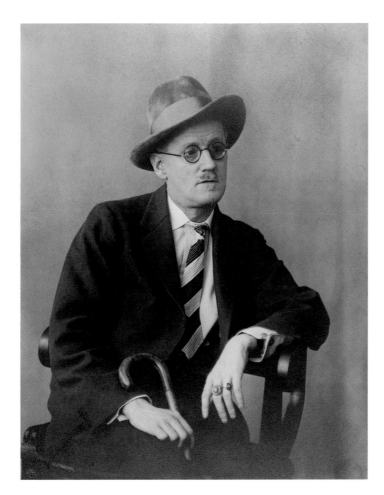

Plate 3
Berenice Abbott (American,
1898–1991)
James Joyce, 1929
Gelatin silver print
13⅛ x 10¹¹⁄₁₆ inches (34.4 x
27.2 cm)
The Lynne and Harold Honickman
Gift of the Julien Levy Collection
2001-62-12

misplaced. His conviction that he was not "an institution man" perhaps made a university degree seem superfluous, as he had no intention of working at a museum. "I knew I was not the person to cope with trustees and such," he said of this time, having begun to witness the struggles of his friends on that front.[18] Whatever misgivings he had, Levy's father apparently sanctioned the trip. No doubt Edgar's own youthful aspirations left him well equipped to understand the tensions that arose in a young man torn between dreams and necessities, and in any case, a trip to Europe was *de rigueur* for any aspiring cosmopolitan.

Aboard the *France,* one of Levy's and Duchamp's fellow passengers was the American writer and publisher Robert McAlmon, who was well established among the cultural expatriates of Paris and no doubt filled Levy's ears with stories about the many characters he was poised to meet. McAlmon suggested accommodations at the Hotel Istria in Paris, where Duchamp had lived in 1923, and guided Levy around the city during his first days there. On the night they arrived, Levy remembers being invited to a party at Peggy Guggenheim's studio. There he had the opportunity to meet some of the artists and writers whose work he most admired, along with a number of other luminaries. According to his recollection, those in attendance included American dancer Isadora Duncan, Bulgarian painter Jules Pascin, French author André Gide, Irish writer James Joyce (pl. 3), and American writers Kay Boyle and Janet Flanner. "At gatherings such as this the most fertile contacts between the best talents of Paris and New York could be made," Levy commented later.[19] Certainly, the numerous acquaintances he made in Paris would later be invaluable in the establishment of the Julien Levy Gallery.

British poet Mina Loy (pl. 4) and her nineteen-year-old daughter, Joella, were also at the party that night. Levy was immediately captivated by Joella's good looks and sophistication (see pl. 207), and the two were married at the beginning of August, with Brancusi as their witness.[20] The union cemented Levy's status among the avant-garde and provided him with an easy entrance into

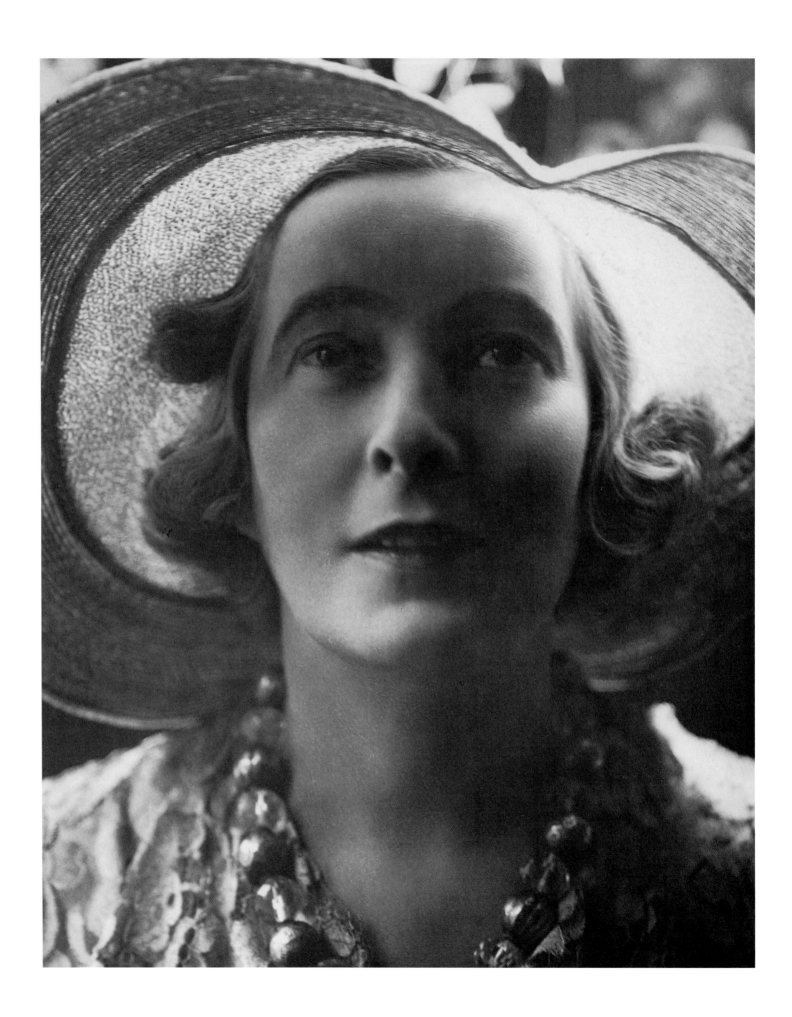

a world of contemporary artists he would soon tap heavily for his gallery enterprise. Levy spent most of the year 1927 in Europe, based in Paris. Although his objective had been to work as a filmmaker, there is no mention or record of any effort in this direction. It seems he was fully occupied mingling with the most progressive cultural figures in the world at parties, salons, and cafés. "This was a heady brew such as one could not hope to find assembled and accessible in New York in those days," he wrote in his memoir.[21]

As circumstances would have it, just as Levy and Duchamp were heading toward Paris to collaborate with Man Ray (pl. 5), the artist was en route to the United States for the country's premiere of his film *Emak Bakia* (Give Us a Rest) and his painting exhibition at the Daniel Gallery in New York. It was not long before Levy and Man Ray were to meet, however, and the expatriate artist became another important guide and role model for Levy. They already had much in common. Both harbored a passion for photography and film, which they saw as a way to distinguish themselves in the art world. Photographer Alfred Stieglitz had been a key figure for both Man Ray and Levy, and each had learned about modern art by frequenting exhibitions at his galleries in New York. Man Ray had himself been an emissary from modernist America when he arrived in Paris from New York in 1921, and just as his welcome into the Parisian avant-garde had been facilitated by his friendship with Duchamp, so Levy's connection with Duchamp served as his introduction to nearly the same circle.

It was Man Ray who introduced Levy to the work of Eugène Atget, whom he had discovered living up the street at 17 bis, rue Campagne-Première. Man Ray appreciated Atget—a commercial photographer who had been documenting Paris for around thirty years—as an artist free from the constraints of the art world's aesthetic dictums whose work was therefore unusually direct and pure. Atget's equipment, an 8 x 10–inch view camera set on a tripod, and his practice of printing all his photographs as contact prints were outdated, further underscoring for Man Ray his apparent innocence,

Plate 6
Eugène Atget (French,
1857–1927)
Shop, Les Halles, 1925
Gelatin silver chloride print
6¾ x 8¹¹⁄₁₆ inches (17.2 x 22.1 cm)
The Lynne and Harold Honickman
Gift of the Julien Levy Collection
2001-62-164

Fig. 2. **Eugène Atget** (French, 1857–1927). **Atget's Workroom,** 1910–11; printed c. 1930 by Berenice Abbott (American, 1898–1991). Gelatin silver print, 8⅞ x 6¹³⁄₁₆ inches (22.6 x 17.3 cm). Philadelphia Museum of Art. Gift of Mr. and Mrs. Carl Zigrosser, 1968-162-33

his ignorance of fashion and artifice. His extensive body of work is actually quite varied in subject, ranging from interiors to park statuary to architectural details, but Man Ray gravitated toward Atget's photographs of mannequins and store-window reflections (pl. 6). In these he found a parallel world that looked much like the Paris he inhabited—but heightened by the oddities and multiplicities of modern life. From Atget's catalogue of photographs Man Ray carefully selected a group of such images for himself and arranged for several works to be reproduced in Surrealism founder André Breton's journal *La Révolution surréaliste.* Atget was happy enough to sell his photographs but was hardly eager to be adopted by the movement, and he asked that the images be printed anonymously.[22] The lack of attribution for the published pictures further underscores their status as *objets trouvé,* Surrealism's prized found objects.

One of Man Ray's studio assistants, Berenice Abbott, was especially enamored of Atget's work and made her own pilgrimages to his studio. In 1927 Atget was seventy years old and a somewhat retiring figure. He seems to have been faintly amused by the procession of intense young artists who began frequenting his studio. Man Ray reportedly tutored the older photographer in the use of the recently introduced handheld camera, but instead of converting him ended up himself turning to the view camera in the 1930s, as did Abbott (though not exclusively). Abbott, being female and perhaps a more respectful guest, seems to have had a slightly warmer connection with Atget, and in 1927 he sat for his portrait at her studio (see fig. 13). When she went to deliver the prints, she found that Atget had died. Distressed over the fate of his work, she contacted his executor and arranged to purchase the contents of his studio.

Levy, too, visited Atget numerous times during his extended stay in Paris and avidly collected his prints. He described Atget's studio in his memoir: "Around us from floor to ceiling were neat shelves piled with photography plates, proofs, books, and heavy paper albums of prints. . . . In the

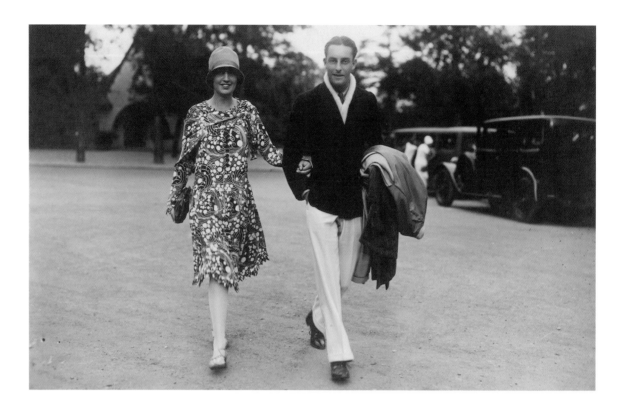

period before my return to America I haunted his rooms, bought an enormous number of his prints, which meant dozens of rewarding visits with that extraordinary man" (fig. 2).[23] Eager to please his mentors and prove his aesthetic mettle, Levy initially followed in Man Ray's footsteps, acquiring photographs by Atget that resonated with his understanding of Surrealism. These included subjects that were erotic or strange, or that depicted the domain of those living on the margins of society, such as ragpickers and street performers.[24] But beyond this emulation, Levy was genuinely captivated by Atget's work. He owned numerous prints of the statues of fauns and satyrs—mythological characters with whom he personally identified—that Atget had photographed in the parks of Paris, and that for Levy embodied liberated ideas about sexuality he had absorbed from the Surrealists (see pl. 134). He was particularly drawn to the remarkable vivacity of much of the park statuary recorded by Atget, which was undoubtedly informed by the master's training as an actor. Many appear almost as portraits but have the added twist of being lifelike portrayals of mythological beings springing entirely from the imaginations of their creators, a layering of perception that would not have escaped Levy's notice.

Levy's Surrealist musings came to an end for a time, following his August marriage to Joella, after which he was expected to act as breadwinner (fig. 3). The couple soon decamped for New York. "I agreed to accept my new responsibility, abandon my European life and dreams, my unmaterialized prospects in the cinema," Levy later wrote.[25] After his tremendous adventure abroad, it must have been quite a letdown to return to the United States to begin working in his father's real estate business. He remained with the company for only a year, ostensibly supervising a construction project on Park Avenue but feeling ineffectual in his duties and uninspired by the routine.

By 1928 Levy was working at the Weyhe Gallery, an art bookshop and gallery at 794 Lexington Avenue that had been established in 1914 by Erhard Weyhe. The gallery on the second floor was presided over by writer and critic Carl Zigrosser, a specialist in prints.[26] A contemporary account relates that there were "always one or more shows on in the gallery; prints, oils, water-colors, sculpture, and the art shown is nearly always Modern. And more important—by living artists."[27] During his apprenticeship at Weyhe, Levy observed firsthand how the shop and gallery conducted their business and met a number of contemporary artists, including Alexander Calder, who exhibited his wire

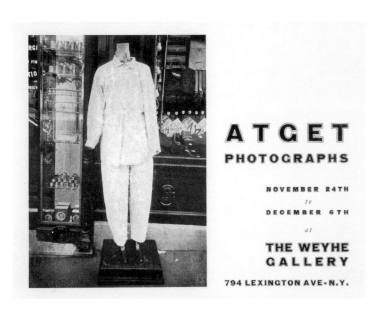

sculptures there at the beginning of 1928.[28] It was at the Weyhe Gallery that Levy had the opportu-
nity to organize his first exhibitions featuring the photographs of Atget and Abbott. Feeling the
financial strain of her purchase of the contents of Atget's workroom, Abbott contacted Levy in late
1929 for assistance, and Levy bought a share of the collection for $2,000 and insured the pictures.[29]
Learning of Abbott's preparations for a book on Atget, he persuaded Weyhe to bring out an Ameri-
can edition (in French), *Atget, photographe de Paris*.[30] To accompany the publication, Zigrosser allowed
Levy to organize an exhibition of Atget's photographs in the gallery for December 1930 (fig. 4;
pl. 7). Plans were underway by May, when Zigrosser wrote in a letter to photographer Edward
Weston that Levy's two photography shows were on the schedule that year, calling Atget "in my esti-
mation, one of the greatest photographers of all time."[31] Alongside Atget, Levy presented *Six Portraits
by Berenice Abbott*, a concise representation of her studio work in Paris.[32] In the coming decades Levy
would explore Atget's legacy in the context of contemporary photography at his own gallery, while
Abbott would toil consistently to burnish Atget's own reputation and situate him in a documentary
context. Together the two were extremely successful in establishing the importance of Atget's work,
whose significance to the next generation of photographers—and by extension the development of
the medium—can hardly be overestimated.

At the time of the 1930 Weyhe exhibition, Atget's images were little known even in Paris,
making Levy's exhibition the first exposure to his work for most visitors to the gallery, although
Abbott's book certainly had a wider distribution and perhaps a more enduring influence.[33] The
book and exhibition represented a shift toward appreciating Atget's photographs in terms of their
straightforward, documentary approach, first articulated by Pierre Mac Orlan in his essay for *Atget,
photographe de Paris*, written at Abbott's request. In 1977 Levy wrote retrospectively about Atget in
relation to his own interest in unmanipulated photography (exemplified for him by the work of

Frenchman Henri Cartier-Bresson), commenting on the "pinpoint detail" of Atget's prints (see pl. 52). He described Atget's way of taking pictures, despite "his clumsy camera's slow exposure," in terms akin to Cartier-Bresson's "decisive moment," since Atget sometimes studied a site for weeks in order to determine the best conditions for making a photograph.[34] Then "he would crouch with the black cloth over his head, connecting his eye and camera like a patient hunter in his blind until the prey posed itself to meet the shot."[35] More overtly, Levy equated Atget's approach to photography with Stieglitz's later approach in that both men believed in composing the picture on the camera's ground glass and objected to cropping or other manipulation during the printing process. For Levy, Atget was an exemplar of the photography method vigorously championed by Stieglitz and his Photo-Secessionists, and which Levy was himself to promote, although this in no way refuted for him the validity of a Surrealist reading of these same images. "The first thing you see is the marvelous amount of documentation, the last thing you see is the soul quality packed just into one picture," he later said of Atget's images.[36]

At the time of the Atget and Abbott exhibitions in December 1930, America's Great Depression was going full force. Levy was in his mid-twenties with a family to support, as he and Joella had had the first two of their three sons, Javan and Jerrold, during this time.[37] Despite the inauspicious financial climate, Levy resigned from the Weyhe Gallery sometime in 1931. He had determined that "the direction of my independence . . . must find a course among my primary passions: art, cinema, and photography."[38]

THE JULIEN LEVY GALLERY: THE SPIRIT OF 602

Levy signed a lease for rooms in a brownstone (formerly home to a beauty parlor) at 602 Madison Avenue, near the fashionable gallery district on 57th Street. "When I left Weyhe and opened my own gallery, I decided to experiment: to pioneer in photography and see if I could put it across as an art form," he told an interviewer in 1977.[39] Stationery was prepared for the new venture, with the heading "Julien Levy Gallery, Paintings, Photographs, Drawings, Books" and, at the bottom of the page, "A Gallery for Photography." Early in October, Levy wrote to Sachs in Cambridge on his new letterhead to inform him that "vita contemplativa has become vita active . . . in spite of the discouraging prospect presented by the [D]epression. The gallery is to be small and intimate, specializing in photography as other galleries specialize in prints, but will alternate its shows with exhibitions of paintings, drawings, etc." (fig. 5).[40]

Levy's apprenticeship at the Weyhe Gallery appears to have been extremely influential in the formation of his own gallery. He seems to have had the Weyhe model foremost in mind when he wrote to Sachs about his gallery plans, stating that it would be like a print shop. A year later, in a letter to photographer Imogen Cunningham in California, Levy repeated: "I have a gallery which specializes in photography as other galleries feature etchings or lithographs."[41] It is interesting that Levy defined his gallery in these terms. He was certainly familiar with galleries that showed modern art, including Brummer's and Stieglitz's, but he had received a heavy dose of artworks on paper at Harvard (Sachs was a collector of prints and drawings) and then at the Weyhe Gallery under Zigrosser's tutelage. Certainly he was committed to following Zigrosser's lead in concentrating on living artists. Perhaps he saw photographs as analogous to prints or was attracted to the populist associations of printmaking. The most likely explanation for his use of the print-shop model may be that he conceived the gallery as a place where visitors could easily leaf through a variety of pictures and books on hand, an experience common to print shops but not to paintings galleries. An article in *Art Digest* announced the opening of the gallery and its aims: "The new gallery plans to make an impartial statement of photography today in all its aspects and to be a center for photographic activity. . . . In

addition the gallery will display portfolios of the work of portrait and commercial photographers and so act as a central bureau to facilitate the execution of commissions."[42] Levy further clarified his plans in a letter to a Mr. Samuel Grierson of Brooklyn at the end of 1931: "We are not interested in the standard old style pictorial photography, gum-prints etc., but in more advanced or even experimental work, such as that of Paul Strand, Charles Sheeler, Walker Evans, [László] Moholy-Nagy, etc."[43]

At his side in the gallery enterprise were his wife, Joella (fig. 6), and John McAndrew, a friend from Harvard. McAndrew was hired as a secretary to Levy, but with his degree in architecture he was soon pressed into service in shaping the gallery's interior.[44] Contemplating "an awkward corner," Levy decided to smooth it over with a curved wall, relying on McAndrew to design it in three dimensions.[45] The curved wall would become a signature effect, elaborated in his gallery's next space (see fig. 31). The first gallery had two exhibition areas. The front room, with its curved wall, was primarily devoted to photography, while the back gallery, its walls painted red, was generally reserved for exhibitions of paintings.[46]

McAndrew was soon replaced by Allen Porter, the "most invaluable" secretary, according to Levy (fig. 7): "He was with me longest and during the exciting, crucial, pioneering years. Of all things, he was color-blind. . . . [but] in hanging shows his sense of form and balance was impeccable."[47] Porter, who had experience in graphic design, proved to be tremendously helpful in the typography work for the monthly parade of exhibition notices, "devising novel announcements that from the first departed from the cliché of engraved invitations sent by everyone else."[48] Levy remembers that Porter "loved to tease and joke" and kept spirits at the gallery on an even keel. He seems to have had a particularly close friendship with Joella but continued his association with the Julien Levy Gallery into the 1940s, even after Levy and Joella had separated. Certainly, both Joella and Porter were heavily involved in the running of the gallery, as is attested by their names and signatures on correspondence and receipts. It is undoubtedly them we have to thank for a series of scrapbooks filled with clippings related to each of the gallery's exhibitions, including announcements, press releases, and reviews.[49] The feeling of shared enterprise created a strong sense of camaraderie at the gallery. "On the whole, it was gratifying that the team spirit was such that during the life of the gallery even the elevator man and the janitor tried to bring in friends for Christmas shopping," Levy recalled.[50]

When planning his gallery, Levy had few precedents for exhibiting photographs as works of art. He devised some economical solutions, one being a frame that sandwiched the picture between two sheets of glass or, alternatively, a sheet of glass with a paper mat behind the art. According to Levy this created "a sort of transparent border, the print seemed to be suspended in air, and photographs looked particularly well shown this way."[51] Attached horizontally along the gallery walls were two rows of moldings—two feet apart and painted the same color as the wall—that could be used to hold photographs in place under glass or to hold S hooks for hanging framed pieces (fig. 8). The trend among galleries at that time was to hang pictures so they had to be looked up to, but Levy decided to make the center point between the moldings at a height of five feet, a more earthbound approach. He also objected to the "distasteful monks' cloth wallcovering" used in many galleries to disguise nail holes for hanging; he preferred smooth plaster as a background for pictures, and the walls of his front room were "white, dead white."[52]

Among his informal consultants on the gallery's appearance were Hobe Erwin, an interior decorator, and George Sakier, an artist and industrial designer, who "each possessed the most charming and fertile of imaginations asking only to be exercised."[53] Levy was striving for a "photo feeling" in the gallery and was at pains to find the correct tone of gray for the wood trim and portfolio racks. These racks ran along one wall and underneath a counter and held a series of about fifty portfolios.

602 MADISON AVENUE · NEW YORK CITY

JULIEN LEVY GALLERY
PAINTINGS · PHOTOGRAPHS · DRAWINGS · BOOKS

October 12th.

Mr. Paul J. Sachs
Shady Hill
Cambridge, Mass.

Dear Mr. Sachs:

I don't remember if I told you when I saw you last that I was contemplating opening a gallery of my own. Vita contemplativa has become vita active since then, in spite of the discouraging prospect presented by the depression. The gallery is to be small and intimate, specializing in photography as other galleries specialize in prints, but will alternate its shows with exhibitions of painting, drawings, etc. The first exhibition, scheduled for November 2nd, is being organized by Alfred Stieglitz and will be a retrospective exhibition of the art of photography in America.

You are the one man whose advice I feel would be of the greatest value, and I know you are usually interested in the activities of your former disciples. If you are not too busy I should immensely appreciate an opportunity to talk over my plans with you, either sometime when you come to New York, or perhaps after my gallery is opened and I have less work to do I could come to Boston some Sunday. In any event I should enjoy a word from you. My best regards to Mrs. Sachs.

Sincerely,

Julien Levy

A GALLERY FOR PHOTOGRAPHY · TELEPHONE PLAZA 3-7653

Fig. 5 (left). **Letter from Julien Levy to Paul Sachs,** October 12, 1931. Courtesy of the Julien Levy Archive, Connecticut

Fig. 6 (below). **Lee Miller** (American, 1907–1977). **Julien and Joella Levy in front of the Julien Levy Gallery, 602 Madison Avenue,** 1932. Gelatin silver print. Courtesy of Jonathan Bayer

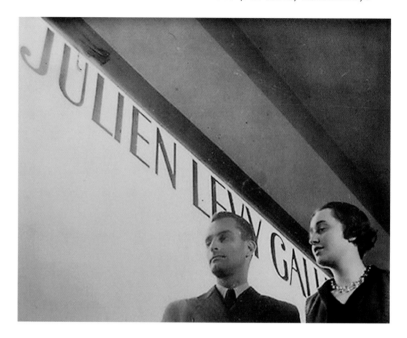

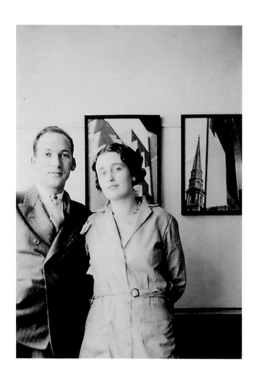

Fig. 7 (bottom left). **Allen Porter and Joella Levy at the Julien Levy Gallery during the exhibition *Photographs of New York by New York Photographers,*** 1932. Courtesy of Jonathan Bayer

Fig. 8 (bottom right). **The Julien Levy Gallery during *Remie Lohse, Exhibition of Photographs,*** 1934. Courtesy of the Julien Levy Archive, Connecticut

He considered the portfolios an important feature of the gallery, as they allowed visitors to browse through photographs by artists whose work was not on display.

"Once set on course," Levy wrote, "the tasks and pleasures of the gallery routine became automatic, hectic, and continuous." When an exhibition opened:

> Daily there was the influx of visitors, Saturdays were marked by special crowds and confusion, a mingling of artists and patrons, a lively divergence from the austerity of other galleries of the era. I was inventing showmanship as I went along. Every third week during the season saw the figurative death of one show and the birth of another. I soon found it to be a gratifying way of life, rich with human contacts of a less banal caliber than the usual business. It gave one a fine sense of creative accomplishment, and offered high-intensity ego rewards and disappointments along with the constant cliffhanging or balancing act of keeping solvent.[54]

Levy was a bit of a publicity maverick, with his series of graphically distinctive exhibition announcements, press releases for every show, and swanky cocktail party openings. He was not timid about taking advantage of unexpected opportunities. During a 1931 voyage to France, he found himself on the same ship as Mehemed Agha, the new art director of the magazine *Vanity Fair*, and claims to have barraged him with questions about his Condé Nast colleagues and how best to approach them with publicity for the gallery.[55] Levy did shine in this arena, although some contemporary galleries, such as Pierre Matisse's, also issued handsome announcements for each exhibition, often including short essays as Levy did. It is clear from the reviews of the Julien Levy Gallery's exhibitions that journalists were happy to rely heavily on the text supplied in the press releases, which Levy wrote himself and saw as a clever way to control his message.[56]

That thirteen exhibitions were presented at the gallery during its first season is a testament to the passion and energy of Levy's team and also gives the impression that Levy simply could not present his ideas fast enough. During the gallery's first few years, when photography was the primary focus, he alternated fairly evenly between exhibitions of American and European work. He was earnest about his responsibility in hanging a show, writing that "the art of gallery installation" was one in which he took "great pride."[57] Levy's practical course work at Harvard and his apprenticeship at Weyhe had given him some preparation for his role in the art world, but he frequently found himself in uncharted territory. While the Harvard museum course would have covered the valuation and pricing of works of art, these issues were explored from the perspective of the curator, leaving Levy on his own in figuring out how to negotiate with artists and the public as a gallery owner. "I thought of myself as dealing from enthusiasm and not from cupidity," he wrote of one early encounter with Salvador Dalí's wife, Gala, who "like a tiger defending a cub, took for granted I, or any other dealer, was a predator."[58] New undertakings thrive on such youthful naïveté, and Levy's passion for photography stood him well despite a few unpleasant surprises. Paul Strand, for instance, did not want to loan work to Levy's inaugural exhibition and insisted that he purchase any photographs he wanted to exhibit.[59] The encounter was to prove influential, as Levy ended up buying a considerable number of photographs for the gallery during its first year of operation.

Levy opened the gallery to a small but ready-made audience of friends and colleagues who were committed to the art of their time. This coterie intersected regularly and inevitably. Many of the men were products of the Fine Arts Department at Harvard: Lincoln Kirstein (fig. 9) and Edward Warburg had graduated and were in New York by 1931; Philip Johnson and Henry-Russell Hitchcock were establishing architecture as a modernist discipline; Chick Austin and collector James Thrall Soby were up in Hartford, Connecticut; Alfred Barr and Jere Abbott kept things lively at MoMA;

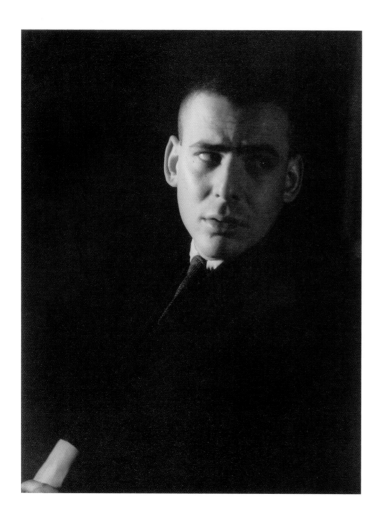

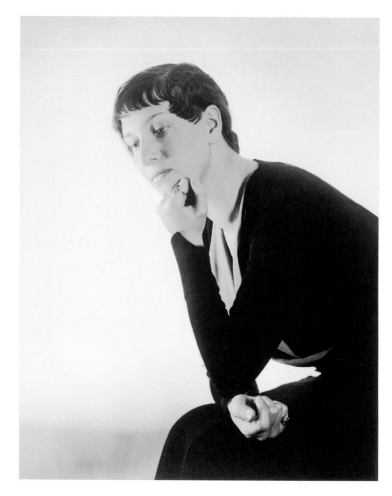

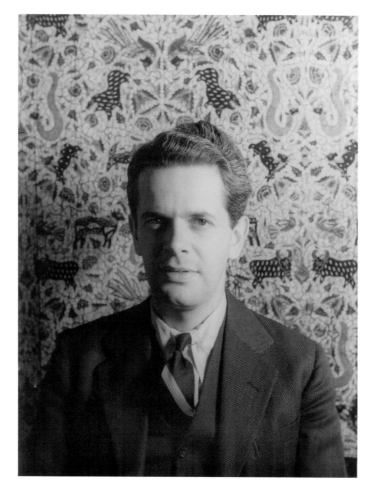

Fig. 9 (above left). **Carl Van Vechten** (American, 1880–1964). *Lincoln Kirstein,* 1933. Gelatin silver print, 8¹⁵⁄₁₆ x 6¹¹⁄₁₆ inches (22.2 x 17 cm). Philadelphia Museum of Art. Gift of John Mark Lutz, 1965-86-5702

Plate 8 (above right)
George Platt Lynes (American, 1907–1955)
Agnes Rindge, c. 1930–34
Gelatin silver print
8¾ x 7 inches (22.2 x 17.8 cm)
The Lynne and Harold Honickman
Gift of the Julien Levy Collection
2001-62-748

Fig. 10 (left). **Carl Van Vechten** (American, 1880–1964). *Kirk Askew,* 1937. Gelatin silver print, 9¹³⁄₁₆ x 7⅝ inches (25 x 19.3 cm). Philadelphia Museum of Art. Gift of John Mark Lutz, 1965-86-1959

Agnes Rindge was teaching art history at Vassar College (pl. 8); and there were others scattered throughout the Northeast. Many of these colleagues came together regularly at salons such as that held by style maven Muriel Draper or met at the Sunday gatherings of dealer Kirk Askew and his wife, Constance (fig. 10; see pl. 202). Collectors Sam and Margaret Lewisohn also hosted a regular salon for the artistically inclined. "What a desperate need there was in America for such oases," Levy wrote, describing his friends' attempts at establishing a regular gathering for companionship and the exchange of ideas. "In time my gallery became just such a place of meeting, so I have been told, since the old guard and the new talent, the monied and the threadbare, all gathered there."[60] Although these evenings were sometimes marked by competition, discord, romantic travails, bouts of drunkenness, and an occasional undercurrent of anti-Semitism, they nonetheless provided a crucial source of support, discussion, debate, and news that led to the hatching of many a scheme.[61]

Of Levy's gallery, artist Jimmy Ernst, son of painter Max Ernst, would later recall: "For me the best show in town was at Julien Levy." Comparing it to other galleries in New York, he wrote: "The place was far more formal than Nierendorf's or Neumann's, lacking their back-room camaraderie. The atmosphere was almost hallowed."[62] He remembered "a small sitting alcove" in the gallery where he would sometimes linger, hoping to see someone familiar or meet a kindred spirit. Levy himself was an important part of his gallery's attraction. In a passage that suggests his particular allure, Ernst describes Levy as carrying himself "with an elegance that constantly hovered on the edge of some menacing poetry. His smile was Mephistophelean."[63]

Once Levy had made plans for an inaugural exhibition surveying the history of American photography, he and Joella sailed to Europe in the summer of 1931 with plans to scout for the gallery. They took advantage of the opportunity to acquire work, purchasing many of the photographs that would be shown in the coming years.[64] It was on this trip that Levy met art dealer Jeanne Bucher, who introduced him to Max Ernst and encouraged his 1932 exhibition of paintings by Eugene Berman. "[Bucher] ran her gallery on a supposedly commercial basis, but her true fuel was enthusiasm for art and for people and getting them together," Levy later recalled, perhaps hoping to be remembered in a similar way.[65] He also met with Pierre Colle, who had a gallery on the rue Cambacérès where he showed the work of painters André Derain, Salvador Dalí, Henri Matisse, and, soon, Christian Bérard. Levy arranged to show Dalí's paintings in New York and purchased from Colle for $250 one of the painter's recent works, *The Persistence of Memory*, the now famous picture of melting watches.[66]

ALFRED STIEGLITZ: STRAIGHT PHOTOGRAPHY AND AMERICAN ART

Levy's direct association with European artists and his introduction of numerous European photographers to the American public have overshadowed his strong commitment to American photography. In this he was continuing Stieglitz's mission of the previous two decades, a connection he was more than happy to acknowledge. Levy and Stieglitz shared not only their desire to further the recognition of American art and artists but, even more, their commitment to promoting photography as an art form.[67] Stieglitz was fine-art photography's staunchest advocate in this country (pl. 9), and by the time Levy began frequenting art spaces in New York he was operating his second exhibition venue, The Intimate Gallery. Stieglitz had begun his campaign to firmly establish photography in the realm of fine art in the late 1890s, and as editor of the Camera Club of New York's quarterly *Camera Notes* he aggressively disseminated his views. After a contentious departure from the group in the summer of 1902, Stieglitz opened the Little Galleries of the Photo-Secession (commonly called 291) on Fifth Avenue and began publishing his own lavishly illustrated journal, *Camera Work*, to further his cause.

Plate 9
**Zlata Llamas (Doña Luisa
Coomaraswamy;** American, born
Argentina, 1905–1970)
Alfred Stieglitz, c. 1930
Gelatin silver print
9⅜ x 7¼ inches (23.8 x 18.4 cm)
The Lynne and Harold Honickman
Gift of the Julien Levy Collection
2001-62-692

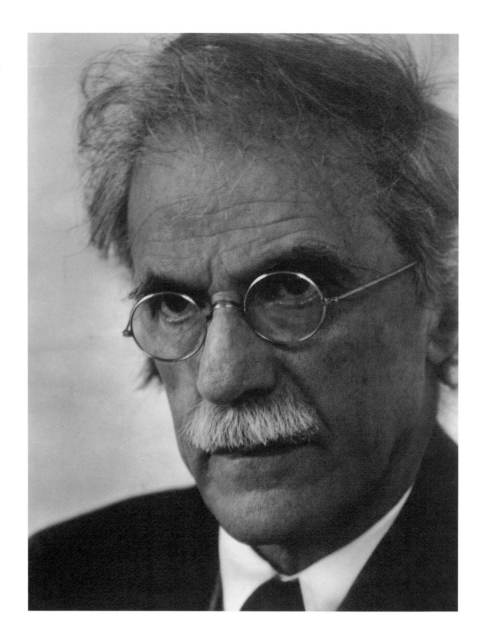

In concert with this effort, he assembled in 1902 a carefully selected cadre of sympathetic colleagues —many of whom exhibited at salons around the country and abroad and were featured in the pages of *Camera Work* as well as in exhibitions at 291—to form what he called the Photo-Secession. It was intended to be a revolution, and Stieglitz's gallery was singular in providing access to experimental work, offering an example of personal commitment to the cause of photography, and becoming the nexus for the creation of a supportive community, all goals Levy set for himself at his own gallery.

By 1907, however, Stieglitz was increasingly engaged with modern art in a broader sense, and he began exhibiting paintings and drawings by progressive American and European artists whose work was otherwise unavailable to the public. Feeling that he had made significant progress with his initial mission, Stieglitz found himself more stimulated by work in other mediums. The imaginative drawings of Pamela Colman Smith were, in 1907, the first non-photographic works to grace the walls of 291. Stieglitz was also the first to exhibit the caricature drawings of Mexican artist Marius de Zayas, who had a solo exhibition at 291 in 1909. Auguste Rodin's drawings were featured at the gallery in 1908, and Henri Matisse's works on paper, in 1908 (the artist's first solo exhibition outside France) and 1910. Three-dimensional art also found a home at 291 in the 1910s, when in 1912 Stieglitz presented the first show of Matisse sculpture ever held, and in 1914 showed a group of African sculpture. Stieglitz's expanded view of what constituted fine art was to be continued at the Julien Levy Gallery.

His embrace of caricatures by de Zayas at 291 would be carried further by Levy in his exhibitions of comic strips, animation cels, and tabloid pages. Levy in no way achieved Stieglitz's Zeus-like status in the art world, however, having a more playful attitude about himself and operating in a less isolated and more cooperative, and certainly more commercial, milieu.

Levy wrote of Stieglitz in his memoir: "Like the Ancient Mariner, with his glittering eye and skinny hand, and the wild tufts of hair that grew out of his ears, Stieglitz had his will with everyone, for who could choose but to listen when he talked, like a spellbound three-year-old?"[68] Despite his hero-worship of his mentor at the outset of their relationship, it is clear that Levy soon developed an ongoing and mutually engaged friendship with the older man. Stieglitz sought Levy's judgment on occasion, and Levy relied on Stieglitz's advice and cooperation in preparing the opening show at his gallery, which was to focus on American photography. He would later try to convince Stieglitz of the merits of photographers in his own stable, even getting into debates about it. "I tried to sell Stieglitz Atget and then I tried to sell him Cartier-Bresson, which was very funny to see Stieglitz finally open his mind to, particularly to Cartier-Bresson, which was exactly the opposite of what Stieglitz stood for," he recalled in an interview.[69] For Stieglitz, Cartier-Bresson's handheld camera aesthetic would undoubtedly have represented the antithesis of his own well-crafted, carefully composed approach to the medium, a dichotomy Levy had no trouble accommodating.

This was just the task that Levy had set for himself—picking up where Stieglitz had left off. Stieglitz's unfinished business in the realm of photography was the call for an American vision and the promotion of unmanipulated photography. His band of Photo-Secessionists were vanguard figures in shifting favor away from the Pictorialist style of photography, which remained quite popular into the 1930s, to that of "straight photography." The Pictorialist style, in which photographers tried to emulate the appearance of charcoal sketches or other handmade works by softening the outlines of their compositions or drawing on their negatives and prints, originated as a way to gain acceptance for photography as a fine art. The subject matter was tranquil, frequently domestic or pastoral. Stieglitz and his band denounced Pictorialist trickery and ruse, calling for unmanipulated camera images and more contemporary, urban subjects. In terms of his exhibitions, however, the closest Stieglitz came to showing a new generation of artists with a commitment to that approach was Paul Strand in 1917 and 1929 and his solo exhibitions for Ansel Adams and Eliot Porter at An American Place in the late 1930s.[70] Having fostered a new standard, he did not undertake to exhibit pictures by young photographers working in that mode, beyond the first flush of the Photo-Succession. Levy, on the other hand, was supremely tuned in to the emerging purist aesthetic and eager to discover and promote new talent. In the press release for his opening exhibition, *American Photography Retrospective*, he referred to the Photo-Secessionists as "pioneers in the fight for the recognition of photography as a fine art" and then continued:

> Today when its status in this respect is still fruitful subject for discussion, it is interest-
> ing to study the earlier pictures in this group, most of which have not been available to
> the public since the famous International Photography Exhibition at the Albright Gallery
> in 1910. Made in protest against a mechanical and unimaginative use of the camera
> the earliest may seem to us somewhat imitative of the painting of that day. A strongly
> American quality, a native flavor in subject matter and inspiration speedily become evi-
> dent, however, which is interesting in the light of the present public preoccupation with
> the American tradition. It is logical that this freedom from European influence should
> have asserted itself noticeably in photography which as a new art medium did not have
> the weight of a long European inheritance.[71]

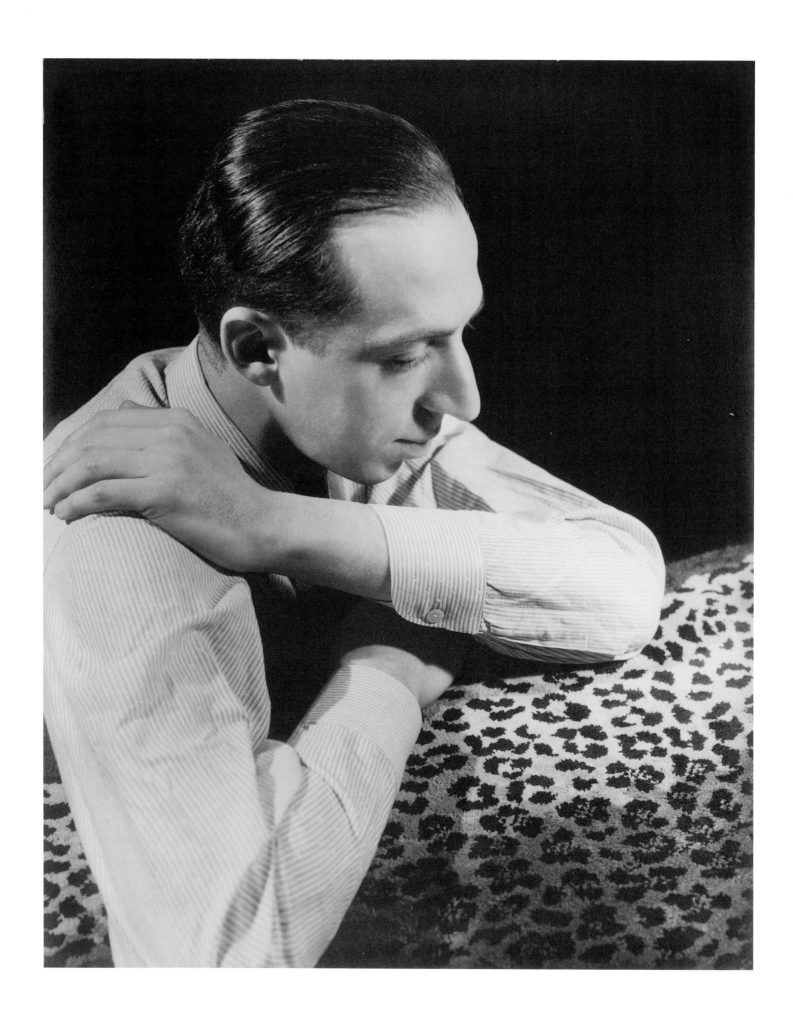

This text indicates that Levy took seriously Stieglitz's call for an American vision in the visual arts. While Stieglitz's later gallery at 509 Madison Avenue, pointedly named An American Place, supported a group of painters he believed to be furthering that mission, photography was seldom part of the mix. Levy's generation embraced photography and cinema as part of the language of modern life, finding them to be natural choices for expressing a fresh national identity.

Establishing a genuine American voice in art was a cause that was widely embraced in New York during the 1930s. Stieglitz's roster of American artists included Arthur Dove, Marsden Hartley, John Marin, and Georgia O'Keeffe. Uptown, on Madison Avenue, the Whitney Museum of American Art opened to the public in 1931 to celebrate the contributions of artists working in the United States. The impulse toward shaping genuine American art forms was also being expressed in contemporary poetry, music, and dance. In his memoir, Levy praises T. S. Eliot for "putting American rhythms into his beautifully turned style" in his 1922 poem *The Waste Land*.[72] Composer George Gershwin, a master at integrating American jazz with the classical music tradition, had in 1924 already written *Rhapsody in Blue* and followed it with *An American in Paris* in 1928, *Of Thee I Sing* in 1931, and his opera *Porgy and Bess* in 1935.[73] Aaron Copland (pl. 10) turned to a more populist style in the 1930s, writing music for ballets with American themes, including *Billy the Kid* (1938), *Rodeo* (1942), and *Appalachian Spring* (1944). Martha Graham was developing her distinctive form of dance in the early 1930s, and in 1935 drew on American subject matter for her solo *Frontier*, later choreographing her exuberant masterpiece *Appalachian Spring*.

AMERICAN PHOTOGRAPHY RETROSPECTIVE

Levy's inaugural exhibition, organized in association with Stieglitz, firmly established him as another voice in this particular chorus. "Here was my debut," he wrote in his memoir, "a flawless exhibition of American photography in the front room, showing such clean precisionists as Stieglitz, Strand, Sheeler, Steichen, Steiner. In the back room, an array of old photos" (fig. 11).[74] Given Levy's visits to Europe in preparation for his gallery, his love of Surrealism, and his enthusiasm for recent European photography, it may seem surprising that he resisted the urge to open the gallery with something utterly startling and new to the United States. But what looks to our present-day eyes to be a safe course of action was, in fact, quite extraordinary. Exhibitions of historic photographs were even rarer than those of contemporary work in the 1920s and early 1930s.[75] In choosing this route, Levy was no doubt eager to share some of the early photographs he had been collecting, but he was also intent on establishing a history of the medium as a foundation for contemporary practice. Years before Beaumont Newhall assembled his landmark survey of photography at MoMA in 1937, Levy had already examined not only the international beginnings of the medium but also, specifically, its American roots. An article about his opening exhibition in the *New York Times* noted: "This is probably the first really successful attempt to give a synthetic picture of photography's development in America, and as such it deserves wide public attention."[76]

Levy also used the survey exhibition to pay homage to Stieglitz's accomplishments in the field while positioning himself as a clear successor. The *American Photography Retrospective* included a number of photographers from Stieglitz's circle. In the exhibition press release Levy studiously provided biographical statements documenting the achievements of those he considered the most important contributors to the field. Despite a variety of challenges, he finally succeeded in including "the three great S's—Stieglitz, Strand, Sheeler—and their school" in the show.[77] Three of the other artists featured, Gertrude Käsebier, Edward Steichen, and Clarence White, had, with Stieglitz, been founding

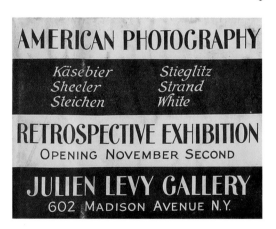

Fig. 11 (above). **Announcement for *American Photography Retrospective Exhibition* at the Julien Levy Gallery,** 1931. Courtesy of the Julien Levy Archive, Connecticut

Plate 10 (opposite)
George Platt Lynes (American, 1907–1955)
Aaron Copland, c. 1930–34
Gelatin silver print
9½ x 7¹¹⁄₁₆ inches (24.2 x 19.6 cm)
The Lynne and Harold Honickman Gift of the Julien Levy Collection
2001-62-724

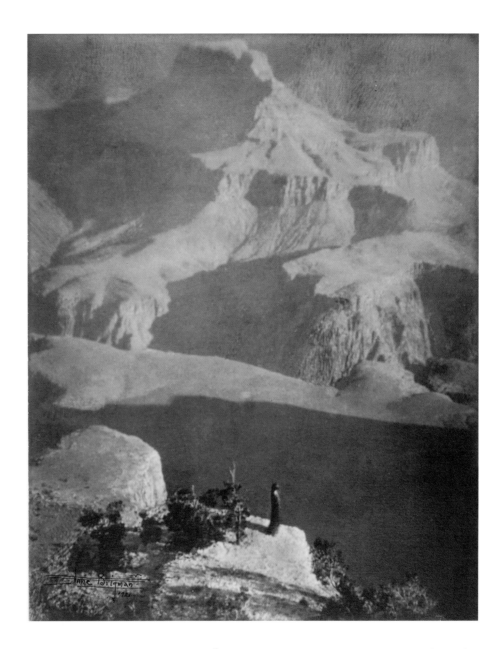

members of the Photo-Secession.[78] The *New York Times* article mentions the inclusion of additional Photo-Secessionist work by Joseph T. Keiley, Paul Haviland, Frank Eugene, and Anne Brigman.[79] Levy also added the "later recruits" Paul Strand, Charles Sheeler, and Edward Weston, who he felt had become "the prototypes for the younger men such as Ralph Steiner, Anton Bruehl and others." It was the gallery's hope, he ambitiously wrote in the press release, "that this later development, illustrated in the current show may constitute a valuable re-statement of aims and incentive for future departures."[80]

Levy had been determined to include work by Paul Strand in his opening show but found the artist unwilling to lend. He described Strand as "one of those photographers who seemed to have been born with a black cloth over his head like a caul. He was saturnine, looked wiry and quick, was tired and slow. His eyes were bright with what could have been eagerness but immediately proved to be bitterness of a most arrogant and defeated sort."[81] Strand was an important latecomer to Stieglitz's circle. Requiring that Levy purchase photographs outright for the exhibition, he reportedly said: "Testify to your sincerity. . . . I never have any success selling in an exhibition, just get my prints back frayed and dirty." While Strand hoped he was setting a precedent for artists, Levy the young gallery owner sincerely hoped he was not: "In all innocence I had expected him to lend, perhaps even present me, with one. I thought he would congratulate me, embrace me, for the temerity I was about to show in championing photography as an art."[82] Strand, whose prints were then priced at $100 each,

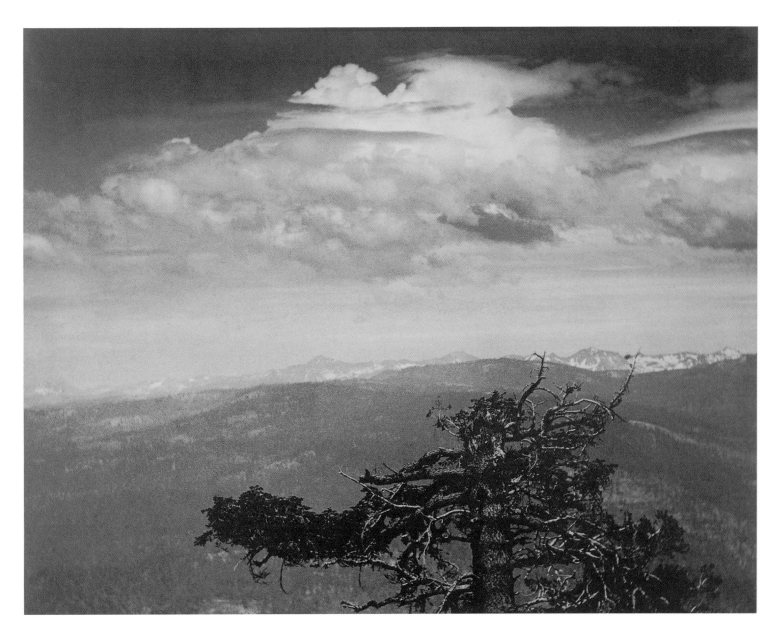

Plate 12
Alvin Langdon Coburn (British, born United States, 1882–1966)
Wawona, Yosemite, 1911
Platinum print with gum bichromate
12 x 15½ inches (30.5 x 39.4 cm)
The Lynne and Harold Honickman
Gift of the Julien Levy Collection
2001-62-473

offered Levy a two-for-one deal, resulting in the acquisition of four photographs.[83] Among these is a rich print of the 1927 *Cobweb in Rain, Georgetown, Maine* (see pl. 149). A review of the exhibition mentions that Strand was represented by "a group of practically abstract photographs, in which the textures of the machines are more important than the machines themselves and the patterns of the shadows more important than either," presumably a reference to two of his images in Levy's collection.[84] One of these shows an Akeley motion picture camera, and the other is a machine image taken in the Akeley camera shop (see pl. 156).[85]

Strand owned an Akeley motion picture camera himself and, together with fellow artist Charles Sheeler, had created *Manhatta,* a short film capturing the contemporary tenor of New York City. Sheeler, another key artist in Levy's inaugural show (and the third of his "great S's"), was then living in nearby Ridgefield, Connecticut. One of Sheeler's photographs taken around 1915 in Bucks County, Pennsylvania, was acquired by Levy, the famous *Side of White Barn, Doylestown,* along with *Shaker Stove* (see pls. 151, 155).[86] Both combine American subject matter with a straightforward, modernist style. A writer for the *Springfield Republican* compared the photographs favorably with Sheeler's paintings and described his camera pictures as "visualized sonnets."[87]

Another important contact for the inaugural exhibition was photographer Stella Simon, whose son, Louis, had been a Harvard classmate of Levy's. Levy credits Simon with first introducing

him to "the world of photographers."[88] Around 1921 she was living in San Francisco, where she befriended Photo-Secessionist Anne Brigman. Together they learned about Clarence White's school of photography in New York, which Simon went on to attend in 1923. Not long afterward, in the summer of 1925, Levy accompanied Simon and Louis to Mexico, along with White and a group of his female students.[89] The following year, Simon studied film in Berlin, where she completed her only piece in the medium, a scenario that shows only the moving hands of dancers and models and that received some critical acclaim in avant-garde circles. In 1932 she opened a commercial photography studio at 57th and Broadway, not far from the Julien Levy Gallery. From there she provided Levy with useful contacts with other photographers and loaned works from her own collection to his exhibitions.[90]

Levy learned of Anne Brigman's work from Simon and may have included some of her photographs in his first exhibition. Gallery records show that in December 1931 he received fifteen Brigman photographs from Simon, and a stellar selection of her pictures remains in his collection (pls. 11, 143, 145). Brigman had been a particular favorite of Stieglitz, who had championed her work and published it in *Camera Work*. For Levy, her Pictorialist images had the advantage of offering distinctly American subject matter: Brigman famously photographed herself and her friends, either nude or clad in diaphanous fabrics, high up in the Sierra Nevada range of the western United States.

Levy also acquired a fine group of platinum prints by Alvin Langdon Coburn, one of the youngest of the Photo-Secessionists, who later made a drastic conversion to abstraction. Several of these rich, large-scale prints by Coburn are from his 1911–12 trip west (pls. 12, 146). In the autumn of 1931 Levy must have sent an inquiry to Coburn, who replied that he had "retired to the mountains of North Wales to study philosophy!" Coburn sent Levy six photographs and, a year later, authorized him to transfer ten photographs from the Montross Gallery in New York, including half a dozen Western views (see pl. 12). "You are starting on your venture at a very unrestful time," Coburn wrote in his initial letter. "This requires courage, and confidence in one's purpose."[91] Levy's choice of images made in the western landscape again underscores his interest in uniquely American subject matter. The mountains and canyons depicted by Coburn and others found their parallel in the skyscrapers and alleyways of New York City, photographed by Abbott, Samuel Gottscho, Thurman Rotan, Ralph Steiner, and their colleagues.

Simon probably also recommended or seconded the work of other Clarence White students that are represented in the Levy collection, including a lovely image by Clara Sipprell of sloping barn roofs in the snow, which despite its softened outlines concentrates on the repetition of bold angular forms (pl. 13).[92] Two exquisite, crisp platinum prints by Paul Outerbridge present ordinary subjects in an extremely structured, formalist manner (pls. 14, 165). Simon herself, though nearly unknown today, was an interesting photographer, and Levy's collection contains several of her prints, including the 1928 *Skunk Cabbage* (see pl. 148) and the mysterious *Chinese Coat* (see pl. 147).

Levy was ever a man in search of roots, choosing Duchamp and Stieglitz as his aesthetic godfathers (see p. 124 below) and eager to formulate a history of photography, specifically American photography. In *Camera Work*, Stieglitz had occasionally presented worthy pioneers of the camera arts, such as David Octavius Hill of Scotland, whose works on paper from the 1840s were considered by many to be the first art photographs.[93] For his part, Levy included in his survey of American photography the work of Mathew Brady, an important early practitioner of the art in the United States. Brady's name does not appear on the exhibition announcement, but contemporary reviews mention photographs by him as well as a selection of daguerreotype portraits and stereographs.[94] In the 1850s Brady had operated a tremendously successful portrait studio in New York City, less elegant but no less prolific than that of Nadar in Paris. Levy's exhibition apparently featured several of his portraits

Plate 13
Clara Sipprell (American, born
Canada, 1885–1975)
Barns in Winter, c. 1926
Platinum print
7⅝ x 9⁹⁄₁₆ inches (19.3 x 24.3 cm)
The Lynne and Harold Honickman
Gift of the Julien Levy Collection
2001-62-1100

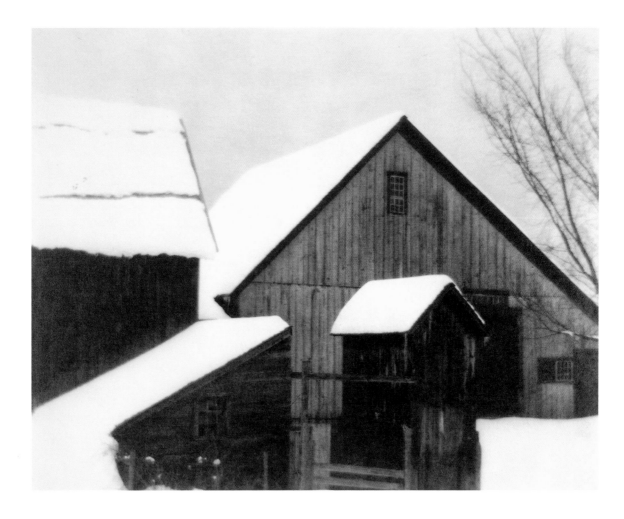

Plate 14
Paul Outerbridge (American,
1896–1958)
Rhythmic Curves, 1923
Platinum print
4⁹⁄₁₆ x 3⁹⁄₁₆ inches (11.6 x 9 cm)
The Lynne and Harold Honickman
Gift of the Julien Levy Collection
2001-62-979

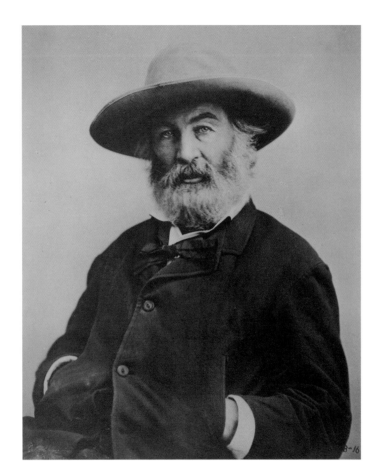

of prominent Americans, notably Walt Whitman, who was the subject of a cult of reverence in the 1930s, considered a historic example of the true American voice in literature (pl. 15). Levy's inclusion of an unabashed commercial photographer such as Brady surely would have given Stieglitz, an avowed purist and amateur, the shivers, but Levy's interest in photography was far more catholic than his mentor's, and having found worthy forefathers of the medium in France, such as Atget, he was keen to establish a parallel tradition for his own country.

Along with Brady portraits of Abraham Lincoln, Walt Whitman, General Ulysses S. Grant, and others, the show included "what are said to be the first photographs ever made of actual battle scenes."[95] Brady's studio is particularly well known for photographs made during the American Civil War, early examples of photojournalism in the United States. To show U.S. President Abraham Lincoln posing in an outdoor encampment with his generals or to capture images on film of the battlefield and the battle-scarred was indeed something new. But many of the images from Brady's New York and Washington, D.C., studios, particularly the studio portraits, were in fact made by Brady's operators. This is not a distinction that would have troubled Levy particularly, and yet he seems to have gone to some effort to secure accurate historical examples of Brady's work, especially his war scenes. The prints in the show were reportedly borrowed from the U.S. War Department. Presumably these would have been returned to the lender, but a group of eleven unblinking battlefield photographs remains in Levy's collection, the images quite startling, even today (see pls. 137, 138). Brady's "magnificent, shocking photograph[s] of the dead, the mutilated, the atrocified of the Civil War," as Levy characterized them, signaled his gallery's break with tradition as well as its recognition and continuation of tradition.[96] He and his peers valued the pictures for their immediacy and reportorial quality, their apparent presentation of raw truth. Brady and his war pictures not only set a historic tone for the exhibition but also struck the genuinely American note Levy was seeking, fulfilling his quest to find American forefathers in photography.

Unfortunately, no sales resulted from Levy's inaugural exhibition. "The photographic activities of my Gallery were financially disastrous from the start," he admitted in retrospect.[97] Before the month was up, he had installed his second offering, Italian painter Massimo Campigli's first solo show in the United States. In stark contrast to the previous exhibition, the Campigli show nearly sold out, allowing Levy to continue operating the gallery.[98]

PHOTOGRAPHS BY EUGÈNE ATGET AND NADAR

Levy's Campigli show was followed in December 1931 by two photography exhibitions: *Photographs by Eugène Atget: Intérieurs, Statues, Voitures* (Interiors, Statues, and Vehicles) and a selection of portraits by Nadar (fig. 12). Levy considered Atget and Nadar to be Europe's most important early practitioners of the camera arts. The former's importance to him had already been demonstrated by his acquisitions of Atget's prints, his financial collaboration with Abbott in saving the contents of Atget's studio, and his Atget exhibition at the Weyhe Gallery. Now Levy had the opportunity to show Atget under his own roof in context with another pioneer.[99] Both photographers had operated in a primarily commercial milieu, and Levy would have valued each for his use of an unadorned style, the same quality he admired in Brady's work. Although the two men's subject matter differed greatly—Atget seems to have photographed every cobblestone in Paris, and Nadar, every famous face—each in his own time created a catalogue of Paris and, more importantly for Levy, used the medium with artistic flair but in a straightforward manner. Between the two photographers it was almost possible to reconstitute the life of Paris in pictures on the walls of a gallery in New York City.

Fig. 12. **Exhibition announcements for *Photographs by Eugène Atget: Intérieurs, Statues, Voitures*, and *Photographs by Nadar*,** 1931. Philadelphia Museum of Art. Gift of Peter C. Bunnell (Atget announcement). Courtesy of the Julien Levy Archive, Connecticut (Nadar announcement)

The show of original prints by Atget took place in the front gallery, with Levy offering portfolios of reprints by Abbott for sale as a way to publicize Atget's work and recoup the money spent rescuing his negatives. In the back gallery, he displayed a selection of thirty-six photographs by Nadar, another master of the albumen print (again, modern reprints were offered for sale). But while Nadar's materials were similar to Atget's, his business approach to the medium was flagrantly contemporary. Atget had worked as a sailor and actor before turning to photography around the age of forty. Nadar—the *nom de celebrité* adopted by Gaspard-Félix Tournachon—began his career as a critic and journalist with a sideline in caricature. While the less flamboyant Atget toiled steadily on the streets of Paris to record the flavor of its neighborhoods and historic architecture, in 1860 the gregarious Nadar had moved his portrait studio to the newly created boulevard des Capucines, where he attached a huge signboard emulating his signature to the front of his building, lighting it at night.

Nadar's zest for living—his entrepreneurial spirit, his bohemian lifestyle, his attraction to flying machines and celebrities, his tendency to do everything on a large scale—would certainly have appealed to the adventuresome Levy.[100] Known for his red hair and moustaches, Nadar had capitalized on this trademark color by painting the walls of his commercial establishment red (pl. 16). (Whether or not in homage, the back room of the Julien Levy Gallery, where Nadar's photographs were exhibited, was painted red.) Nadar was an inventive practitioner of photography, but in addition to his genius for application, he was an accomplished portraitist. His best likenesses are of friends and colleagues, and the personalities who sat for his lens reflect his own socio-political leanings. Nadar's subjects are shown as relaxed but upright, human yet august. His portraits reveal both

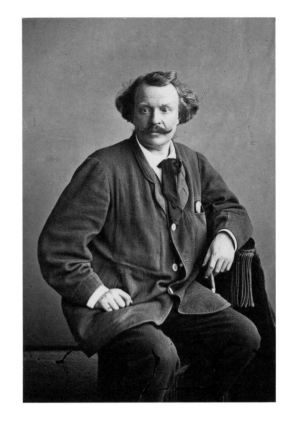

Fig. 13 (left). **Berenice Abbott**
(American, 1898–1991). *Eugène
Atget,* 1927. Gelatin silver print,
9¹⁄₁₆ x 6¾ inches (23 x 17.1 cm).
Philadelphia Museum of Art. Gift of
Mr. and Mrs. Carl Zigrosser,
1968-162-38

Plate 16 (right)
Nadar (French, 1820–1910)
Self-Portrait, c. 1860–65; printed
1900–1930 by Paul Nadar (French,
1856–1939)
Gelatin silver print
3¹¹⁄₁₆ x 2½ inches (9.3 x 6.3 cm)
The Lynne and Harold Honickman
Gift of the Julien Levy Collection
2001-62-924

respect for and familiarity with his sitters, who included Charles Baudelaire, Honoré Daumier, Gustave Doré (see pl. 132), Jacques Offenbach, and George Sand (see pl. 133), among many others.

Nadar was particularly celebrated for his series on French actress Sarah Bernhardt, herself a flamboyant character and marketing prodigy.[101] Levy was surely attracted to this popular side of Nadar's career, which produced a rich store of images of entertainers. On one of his Paris trips he had acquired a significant holding of nineteenth-century theater broadsides, among them *Galerie Contemporaine* and *Paris-Artiste* (see pl. 97 below), all of which featured woodburytype reproductions of Nadar's images of actors and other performers. Also in the collection are sheets of multiple images that were probably used for sales and advertising for Nadar's studio (see pl. 98).[102]

Nadar's negatives had been passed down to his son, Paul Nadar, himself a recognized photographer who also made prints from his father's negatives. Levy had visited Paul's studio during his summer trip to Paris in 1931, purchasing a group of the newer Nadar-*père* prints for the gallery along with a few vintage pieces. "Although lacking the subtle depth of print tone that had been in the original gold emulsion paper," Levy wrote of Paul's prints from his father's negatives, they "were nevertheless arresting, psychologically astute, and intensely fascinating historically."[103] Levy's exhibition was the first time Nadar's work was shown in the United States. Unfortunately, only one of the original albumen prints by Nadar has been found in Levy's holdings, though he did retain a choice group of photographs taken and printed by Paul Nadar (see pl. 186).[104]

Levy reported that he sold not a single Atget and only one Nadar photograph from the exhibition. The latter was purchased by his friend Kirk Askew, who "bought a lovely warm-toned original of George Sand" to display in his study.[105] Artist Joseph Cornell apparently also wanted a print of the

Sand portrait and offered to give Levy one of his own creations in exchange.[106] Levy, too, must have been fond of the image, since a variant of the portrait remained with him (see pl. 133). Joella liked the picture so much that she made a replica of Sand's generous striped gown to wear as a costume for a come-as-your-favorite-character charity ball at the Waldorf Astoria Hotel that winter.[107]

SURRÉALISME

While in Paris in 1927, Levy had been strongly attracted to Surrealism, a movement still freshly underway.[108] Aside from photography and film, this was the art he felt had a vital and ongoing relevancy to contemporary American life and about which he was to remain most passionate. Although he read extensively on the subject, Levy's most direct contact with Surrealism was through Duchamp and Man Ray, who both had roots in the Dada movement from which Surrealism sprang, were a bit older than most of the writers and artists of the official movement, and purposely remained on its fringes. Accordingly, and perhaps by choice, Levy seems to have had a fairly loose definition of Surrealism. "An exhibition of these pictures is sensational, as the showing of the first Cubists. But sensational not only for its novelty, but because the 'Surréalistes' often deliberately purpose to shock and surprise, so that you may be deprived of all preconceived standards, open to new impressions, and able to recognize this world that lies behind barriers of the conscious mind," he wrote.[109] His New York gallery offered Levy the opportunity to engage with the movement and even help shape its course in the United States.

Levy's Surrealism show came about as a direct result of his first visit to Paris, when he met a number of Surrealist artists through Joella, Mina Loy, Duchamp, Man Ray, and others. For Levy, Surrealism was not simply an art movement but offered a way of experiencing the world. He saw it as his mission to bring the movement to America—to share his commitment to this mode of expression, to promote and glorify the artists included in the show, to make available to American collectors some of the best work, and to demonstrate his own cutting-edge taste. The show also gave him a claim to fame. "My Surrealism exhibition in January, 1932, was, overnight, to turn my gallery into the unforgettable moment in art history it can still claim," he wrote in his memoir. "I could not have been more delighted with the phenomenal excitement it achieved, in New York and elsewhere, especially because from lack of money and lack of space I had worried it might seem a bit sketchy. Even Europe was suddenly conscious of the Julien Levy Gallery, it seemed."[110]

When Levy's Surrealist show opened in January 1932, the Wadsworth Atheneum had just closed its own exhibition of Surrealist art, *The Newer Super-Realism*. Levy "adored" the museum's director, his friend Chick Austin from Harvard, and he told an interviewer in 1976: "He said he would like to have the honor of giving the first surrealist show in America, and I was trying to be a dealer, not a museum man, so I thought that was the best business I could do is to have a museum show it before I even gave it, to sort of authenticate it."[111] But Austin had his own contacts and ideas, not to mention space for a more luxurious installation, including a Dalí painting loaned by Levy. The two ultimately presented quite different shows. Despite Levy's generally cooperative and even collaborative working relationship with Austin, he later in his life (with Austin long dead) was unable to leave it at that.[112] "I let the Wadsworth Atheneum have it before me but I assembled it. . . . I want history to know that," he said in the 1976 interview.[113] Certainly, there can be no dispute that Levy's show was the first presentation of Surrealism in New York.

Levy titled his exhibition *Surréalisme*, after the original French name of the movement, since he argued that it could not be properly translated (fig. 14). But he offered his own distinct vision of this art. "I wished to present a paraphrase which would offer Surrealism in the language of the new world rather than a translation in the rhetoric of the old," he wrote.[114] The show comprised paintings

(including Levy's *The Persistence of Memory*—"10 by 14 inches of Dali dynamite"[115]), drawings, books, and of course photographs, the latter having been absent from the Wadsworth exhibition. Levy showed work by several Americans: mixed-media artist Joseph Cornell and photographers George Platt Lynes and the versatile Man Ray (see pls. 36, 220), whose paintings had been part of Hartford's exhibition. European photographers included Atget, Herbert Bayer, Jacques-André Boiffard, Max Ernst, László Moholy-Nagy, Roger Parry, Maurice Tabard, and Umbo (pl. 17). The extension of

Surrealism into America was of particular importance to Levy, and it is worth noting that he chose Cornell—a New Yorker and Levy's own "discovery"—to design the announcement, rather than a more established French or German artist.[116]

As opposed to the Wadsworth presentation, which Levy later characterized as "extensive and solemn," the show at the Julien Levy Gallery "had the advantage of intimacy and enthusiasm, partly due to the limited size of my just two rooms in a building no wider than a New York brownstone. It was packed with the force of the unconscious, of our secret desires. . . . Perhaps forced compression increased the impact."[117] Levy thought of Surrealism as an organic, living impulse that encompassed a broad range of mediums. A review of his show in *Art News* asserted, "a pleasant madness prevails at Julien Levy's new and interesting gallery," while the formidable *New York Times* art critic Edward Alden Jewell called it "one of the most entertaining exhibitions of the season (possibly the most profound)" and credited Levy with "neatly and opulently drawing all the curious threads together, or at any rate, enough of them to make the movement vividly live for us and to provide an hour of the most captivating diversion."[118] Levy later speculated that his show might have been "a more orthodox representation" if Surrealism's driving force, André Breton, had been in New York at the time. Among his additions were some Jean Cocteau drawings: "They were, I was later informed, anathema to the orthodox founding fathers of Surrealism."[119] It is difficult to imagine Levy being too solicitous of any overly restrictive dictates, however. As he later recalled, his exhibition was "unpretentiously assembled with a light heart, accidents, unorthodox ideas, and plenty of pleasure; the only way I know how to do things."[120]

Levy had been absent from the inception of the movement in Paris, which contributed to his desire to bring the Surrealist franchise to New York and make some contributions of his own. For him, the creative endeavor was in finding Surrealism in the world around him and drawing it into the fold. His most significant discovery in this regard was Joseph Cornell. The inclusion of this collage and assemblage artist in the show was a coup for Levy. In the 1930s Cornell, now considered one of the most inventive and original of twentieth-century American artists, lived in nearby Flushing, New York, with his mother and brother. He was untrained in art and had been making collages out of magazine clippings and household scraps. He seems to have zeroed in on Levy's gallery from the start, and when Levy was preparing for the Surrealism show, Cornell apparently lingered over the pictures being unwrapped. He showed Levy some of his collages, concerned that they would seem derivative of Max Ernst's pictures.[121] Levy not only added Cornell's work to the Surrealism exhibition, the first time it was publicly shown, but also invited him to design the announcement for the show (and to decorate the gallery's Christmas tree). For Cornell, the Julien Levy Gallery became an important launching pad for work he had kept largely to himself, and it was also a place to meet other creative individuals who stimulated and appreciated his art. Levy considered Cornell an important

early discovery, which no doubt helped to validate his gallery's purpose and his quest to enrich Surrealism with American voices.[122]

Avid about contemporary art and film-based mediums, Cornell may well have seen the Julien Levy Gallery's initial survey exhibition of photography. Certainly he would have come across daguerreotypes and other antique photographs as he explored old bookshops, and Levy seems to have encouraged him to use photography in a few of his constructions.[123] Out of this confluence came a series of at least four small object boxes that Cornell referred to as "daguerreotype-objects." Three of these extraordinary pieces—all small boxes, a bit larger than a fourth-plate daguerreotype—remained in Levy's collection (see pls. 206, 208, 209).[124] Cornell used photographs of Levy and his mother-in-law, Mina Loy, in the boxes, further suggesting Levy's participation in their creation. Each of the images is viewed through blue-tinted glass, lending an aura of nostalgia and enchantment while also emulating the smudged and weeping glass of a deteriorating daguerreotype. These are not simply photographs inside a box; Cornell gave each a game component. One box contains a picture of Julien as a small boy and tiny pellets that rattle around, never quite coming to rest in the dimples provided; in another, which includes a sprinkling of sand inside, there is a portrait of the adult Levy above what appears to be a picture of hemlines; and the third, with a photograph of Mina Loy in a hat, holds chunks of glass that shift like ice cubes in a drink.

Another North American artist Levy placed under the aegis of Surrealism (though he was not included in the 1932 show) was Mexican photographer Manuel Álvarez Bravo. Álvarez Bravo's work had grown out of the fertile artistic climate of Mexico in the 1920s and 1930s, which was enriched by an influx of international visitors. The young Álvarez Bravo was by 1923 working with German-born photographer Hugo Brehme, who introduced him to the work of American Edward Weston and his companion Tina Modotti, both of whom photographed in Mexico. Álvarez Bravo met Modotti in Mexico City in 1927, and the two became business associates, documenting folk art and the fresco murals then being created around the city. In his personal work Álvarez Bravo had a special talent for capturing the collision of the traditional and the contemporary in his native country. He had a keen eye for juxtapositions and incongruities that for some viewers suggested an affinity with Surrealism.

Álvarez Bravo began teaching photography and, like so many artists of the time, became involved in film. In 1933 he met Paul Strand, who was photographing in Mexico and working on the film *Redes* (titled *The Wave* in English). The following year, Álvarez Bravo made his own film, *Tehuantepec*, and had the opportunity to meet the French photographer Henri Cartier-Bresson, who was visiting Mexico and making photographs there. The two men exhibited together in 1935 at the Palacio de Bellas Artes in Mexico City.[125] Using the show as a starting point, Levy amplified the project later that year at his own gallery, adding photographs by Walker Evans to create his landmark exhibition *Documentary and Anti-Graphic Photographs* (see pp. 86–90 below).[126] Levy would have the gratification of seeing Álvarez Bravo, his second Surrealist "find," approved by the movement's founder. In 1938 André Breton arrived in Mexico, where he anointed painter Frida Kahlo a Surrealist and invited Álvarez Bravo to exhibit in a show of Surrealist art in Mexico City. Breton also arranged to include the photographer's work in the 1939 exhibition *Mexique* in Paris; Álvarez Bravo's pictures were reproduced in the French Surrealist journal *Minotaur* that same year.[127]

Levy's selection of vintage Álvarez Bravo prints is stunning and includes twelve beautiful exhibition-size prints and smaller prints of two of these images. The subjects are not recognizably Mexican, and the pictures fit almost seamlessly with French street photography of the 1930s. It seems that Levy made his choices with a view toward their parallel aesthetic and resonance with Surrealism. Álvarez Bravo's *Parabola optica* (Optical Parable; see pl. 238), for instance, uses the painted sign of

Plate 18
Manuel Álvarez Bravo (Mexican,
1902–2002)
**Untitled (Mannequin with fur
stole and reflections),**
c. 1930–35
Gelatin silver print
7½ x 7⅝ inches (19.1 x 19.3 cm)
The Lynne and Harold Honickman
Gift of the Julien Levy Collection
2001-62-31

the "modern optician" E. Spirito to suggest an atmosphere of otherworldly surveillance that is witty and claustrophobic. His use of window reflections to intensify the composition reminds us of Atget, while the old-fashioned shop and signage are at home with Abbott's and Evans's images of ethnic and homespun storefronts in the United States. The cryptic *Caja de visiones* (Box of Visions), in which Lola Álvarez Bravo's face peeks out from above an eccentric bit of local masonry that has the appearance of a casket or a reliquary (see pl. 241), also plays with vision and optics. The figure could almost be the photographer under her darkcloth shawl, poised over a large camera that captures visages (and perhaps souls) that can be viewed with the stereopticon devices embedded in the bottom of the structure. In *Maniqui con voz* (Mannequin with Voice; see pl. 242), Álvarez Bravo uses the proximity of items for sale on a sidewalk—a tailor's dummy and a gramophone—to create a loudmouth Frankenstein monster that has brought the shopkeeper to his knees in the background. For Levy, the found objects, chance juxtapositions, and human stand-in would have made this photograph a Surrealist masterpiece. In other images from Levy's holdings of the artist, we see mannequins and window reflections that echo the Atget photographs favored by Man Ray (pl. 18).[128]

Levy's exhibition *Surréalisme* also included some miscellaneous objects that give us a window onto his ideas about the movement. There was, for example, a seventeenth-century painting borrowed from Alfred Barr that appeared to be either a landscape or a portrait depending on its orientation (it was later used by Barr in the MoMA exhibition *Fantastic Art, Dada, Surrealism*), and also a series of "shocking" tabloid covers from the *New York Evening Graphic* as well as Levy's "own frieze of negative photostats."[129] Having sent a group of Surrealist books and periodicals to the Wadsworth Atheneum for their show, Levy exhibited these materials in reference to Surrealism's literary roots,

along with a few assemblages, such as Man Ray's *Boule de neige* (Snow globe) and Duchamp's
Why Not Sneeze Rose Sélavy.[130] "In a period of American solemnity about art, though I realized my
Surrealist show was perhaps imperfect," Levy later wrote, "I hoped it was sufficiently provocative to
awaken everyone's curiosity and suggest the spirit if not the complete alphabet of this new tendency
in poetry and art."[131] The exhibition had a final incarnation in Cambridge, Massachusetts, under the
auspices of the Society for Contemporary Art at Harvard in February 1932.[132]

Several years later, in 1936, Levy decided to create a book encompassing his ideas about
Surrealism. Caresse Crosby, a founder of Black Sun Press, had given him "carte blanche to design
whatever [his] fancy might dictate," and Allen Porter collaborated on the imaginative layout with him,
playing "not just with various type choices but also with the colored inks and paper."[133] Levy included
illustrations of the work of a slightly different group of photographers than was represented in the
exhibition, adding two images by Cartier-Bresson, a disarticulated female nude by German artist
Hans Bellmer, and an unattributed photograph of a line of people viewing a corpse. From the world
of film he included a publicity still of the Marx Brothers for the movie *Animal Crackers* and two film
stills from the Luis Buñuel and Dalí film *Un Chien andalou* (Andalusian Dog, 1929; pl. 19). The publi-
cation coincided with MoMA's exhibition and catalogue *Fantastic Art, Dada, Surrealism,* which Levy
later repeatedly criticized for not making clear distinctions between the three categories (he had no
difficulty, however, in capitalizing on the exhibition to generate publicity for his book).[134]

Having presented exhibitions of American historical photography and of Surrealist works in
a variety of mediums, Levy introduced another of his special interests to the gallery. In keeping with
his goal of presenting all the manifestations of the camera as well as of modernism, Levy organized
screenings of films at the gallery, including Fernand Léger's 1924 *Ballet mécanique,* Jay Leyda's 1931
A Bronx Morning, and Man Ray's 1928 *L'Étoile de mer* (Star of the Sea). French composer Georges
Antheil lent a player-piano roll of his music to accompany the Léger film, and John McAndrew played
Debussy on the piano during the Man Ray film.[135]

Although their films had not been seen by large audiences, Léger and Man Ray had already

achieved notoriety as artists and had solid avant-garde credentials. Leyda, on the other hand, was a virtual unknown, and his film had been completed just the year before, giving Levy the opportunity to bring it to the fore. Leyda was only twenty-one years old when he created this tribute to human resilience during the Depression. The piece is documentary in tenor but re-creates a time just recently passed, stylishly incorporating the vocabulary of avant-garde film. On the basis of this work Leyda was awarded a scholarship to study in Moscow with the preeminent Soviet filmmaker Sergei Eisenstein. Not long after arriving, he sent a radiogram to Levy offering to arrange an exhibition for him of the "best Soviet photo reporter Debabov," a project that was never realized.[136]

Levy would continue to pursue his film interests in his gallery's early years. In November 1932 he screened Buñuel and Dalí's *Un Chien andalou*, with its notorious scene of a woman's eye being slit open, the first time the film was publicly shown in the United States.[137] The month before, he had founded the Film Society, which would host five programs in 1933 that included the screening of the French version of *The Threepenny Opera* (*L'Opéra de quat' sous*, 1931); the controversial *L'Âge d'or* (Golden Age, 1930), another collaboration between Buñuel and Dalí; and Joseph Cornell's short film *Rose Hobart* (1936). Levy's Film Society was the nucleus for what eventually became the film department of the Museum of Modern Art. In 1933 Edward Warburg was appointed head of a committee organized to explore the possibility of a film library at MoMA, and he implemented a pilot program of screenings at the Wadsworth Atheneum and other institutions. Running the program was Iris Barry, one of the directors of Levy's Film Society, who soon became the first curator of film at MoMA when that department was created in 1935.

WALKER EVANS AND GEORGE LYNES

Levy's exploration of American photography continued in February 1932 with an exhibition of the work of George Platt Lynes and Walker Evans, who might be characterized as his modern-day Nadar and Atget. Evans, whose work is so fundamental today, had only started photographing earnestly in 1928 in New York, sometimes using a view camera and sometimes handheld equipment. He published his first photographs in 1930 in *Hound & Horn*, *Architectural Review*, *Creative Art*, and Hart Crane's jazzy epic poem *The Bridge* (1930) and soon became engaged with photographing Victorian architecture. Evans greatly admired Atget's photographs, an infatuation dating back at least as far as a 1926 visit to Paris, and he surely would have seen Levy's Atget show at the Weyhe Gallery; he reviewed the monograph associated with that exhibition, *Atget, photographe de Paris*, in a 1931 article on new photography books for *Hound & Horn*.[138]

In the late 1920s Evans was finding his way around New York with the camera with mixed results. He photographed the Brooklyn Bridge, the Manhattan skyline, and industrial details along the East River. By 1930 he was photographing lighted signs, window displays, and reflections that undoubtedly would have appealed to Levy's eye, trained as it was on images by Atget and Man Ray. Evans had exhibited his work in 1931 at the John Becker Galleries in New York, but Levy's 1932 show included primarily new work. "He is a genuine artist working in the medium of photography, never attempting to approximate paintings by the photograph, but loving the camera for its own peculiar virtues and possibilities, and making the most of these with complete integrity," Levy wrote in the press release for the exhibition.[139] The earliest Evans photograph that remains in Levy's collection is an image of ornamental tin from 1929 (see pl. 157). The photograph can be viewed as documenting an antiquarian ornament of the American built landscape, but it also works as a Surrealist found object—a cryptic, evocative, decontextualized visual message. The critic for the *New York Times* wrote of Evans's work: "Mr. Evans is a sort of New York Atget. He photographs a heap of junked sheet-iron, an electric sign in process of installation . . . without sentiment and with only the faintest

Plate 20
Walker Evans (American,
1903–1975)
**Untitled (Tombstone of Colonel
Jonas Clark),** c. 1930
Gelatin silver print
4³⁄₁₆ x 2¹⁵⁄₁₆ inches (10.7 x 7.5 cm)
The Lynne and Harold Honickman
Gift of the Julien Levy Collection
2001-62-505

undercurrent of satire," while the *Brooklyn Times* stated that "his talent is to reveal in the most ordinary subjects an element of independent life, sometimes surprising and almost fabulous."[140] Like Abbott, Evans appreciated the straightforward, unsentimental style Atget brought to bear on his world and wanted to apply it to his own environment, which was changing rapidly. He sought to capture some of the quirky, old-fashioned aspects of New York that modern skyscrapers were replacing. In other instances, it was the lurid modernizations that attracted his eye, as when he quoted layers of lighted signs competing for attention in the skyline.[141]

Levy got to know Evans in the beginning days of his gallery. "I used to go photographing with him in the first year of the gallery, take some excursions when Walker would try to find something," he recalled in an interview. "I went with him when he was taking gravestones. We came up through Connecticut."[142] Several of the tombstone photographs remained with Levy and must have been part of the 1932 show (pl. 20).[143] These modest compositions are presented in a manner as dry and factual as stone, yet the nature of the subject matter compels thoughts of our fragile human existence. Evans strove for the evocative without being maudlin. "I hate sentimentality in thought or in art," he later said. "Yet, I'm attracted to things people think of as nostalgic. They're social history to me. A picture of Main Street in 1930 is not supposed to bring tears to your eyes. It's supposed to make you feel that that is the way it was."[144] By the mid-1930s Evans had hit his stride and was making accomplished pictures that developed his ideas into a visual language. His commitment to the unspectacular aspects of American architecture came to fruition in 1938, in the first solo exhibition by a photographer ever held at the Museum of Modern Art. Titled *American Photographs*, it was accompanied by a book of the same name with an essay written by Evans's friend Lincoln Kirstein.

George Platt Lynes was another young American photographer championed by Levy. Speaking of his and Evans's exhibition, Levy wrote in the press release: "Although these two photog-

Plate 21
George Platt Lynes (American,
1907–1955)
New York Series #8, c. 1930–32
Gelatin silver print
6⅝ x 4⅝ inches (16.8 x 11.8 cm)
The Lynne and Harold Honickman
Gift of the Julien Levy Collection
2001-62-723

raphers are not to be compared one with the other, the work of each showing strong individuality and personal direction, yet they both represent aspects of the most recent photographic activity in America." He went on to note that both were younger than thirty years of age and, having studied the work of older photographers, were yet "intent upon expressing the new ideas of their generation."[145] The *Brooklyn Daily Eagle* reported that the two were "exponents of the new objective type of photography" and stated that "the art lies in the selective process that the artist exercises before he opens his shutter."[146] In other words, they followed the straight photography approach that was increasingly dominating the field. Their disparate styles would only have made their juxtaposition more interesting to Levy.

Lynes was just beginning in photography and had shown his work only a few times when Levy included him in *Surréalisme* earlier in 1932.[147] Before taking up the camera he had briefly operated a bookstore with a small press in New Jersey, and, like Levy, he was already well acquainted with the expatriate cultural community in Paris. En route to Paris in the summer of 1931, the two happened to be on the same ship and collaborated on a film, later making some photographs together.[148] When Lynes returned from Paris in early 1932, his father had died, and his friendships abroad as well as his association with the Julien Levy Gallery proved to be useful as he embarked on a serious photographic career. Lynes was drawn to experimentation with the medium, such as double exposures, but his compositions also have an innate classicism. "His development has been so rapid and so purposeful that he promises to prove the most interesting of new photographers in America," Levy wrote.[149]

Although Lynes is best known today for his extensive work with the human figure, particularly the male nude, his twenty-some-year oeuvre reveals an artist of considerable versatility. A *New York Times* review stated that his exhibition at the Levy Gallery revealed Lynes "in this, his début, as a photographer of the first order" and mentioned the inclusion of "object studies, nude studies and

Plate 22
George Platt Lynes (American,
1907–1955)
Serge Lifar, c. 1933
Gelatin silver print
9⁹⁄₁₆ x 7⅜ inches (23.4 x 18.8 cm)
The Lynne and Harold Honickman
Gift of the Julien Levy Collection
2001-62-754

extraordinary photographs of Greek sculpture" (see pls. 237, 247).[150] Lynes was also a superb por-
traitist, the largest category of his material preserved in the Levy holdings. These images are comple-
mented by a few ballet photographs dominated by Russian dancer Serge Lifar (pls. 22–24). But in
the early 1930s, under the spell of Surrealism, Lynes made a number of dark and appealing urban
scenarios, his New York series.[151] In one of these he captures a man having a smoke while leaning
against the doorframe of the Reliable Express Trucking Company (see pl. 182). It is a quotidian yet
detail-rich slice of urban life, as is a broader street view showing a crumbling corner of pavement
across from a building covered in billboards (pl. 21). This work may have appeared in Levy's 1932
Surrealism show, and it seems likely that it was included in Lynes's solo exhibition, especially as some
of the compositions would have dovetailed nicely with Evans's city views.

During the first two weeks of October 1934, Levy would host a solo exhibition of Lynes's
work, *Fifty Photographs by George Platt Lynes,* which occupied both gallery spaces. In his essay for
the exhibition announcement, writer Glenway Wescott, who lived with Lynes for many years, praised
the photographer's positioning of subjects in space and wrote that, for Lynes, photography was
"more akin to sculpture in low relief than to any other representational art."[152] Included in this show
were portraits of several cultural luminaries: writers André Gide, Katherine Ann Porter, and Gertrude
Stein; dancer Serge Lifar (pls. 22–24); critic Lewis Mumford; and artists Pavel Tchelitchew and Isamu

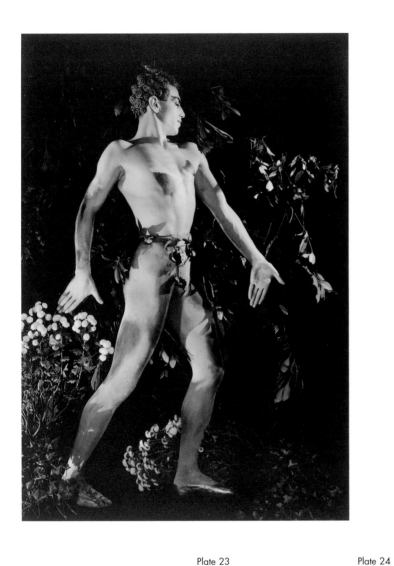

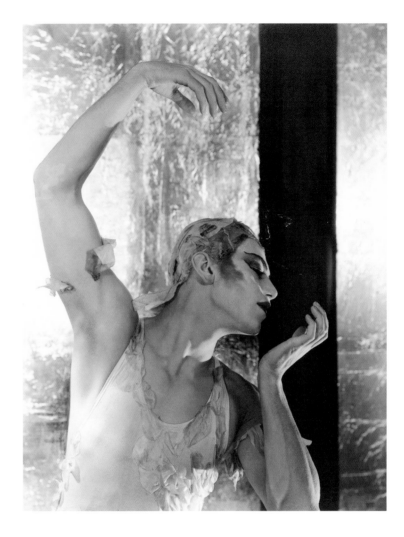

Plate 23
George Platt Lynes (American, 1907–1955)
Serge Lifar in "L'Après-Midi d'un Faune," 1933
Gelatin silver print
9 x 6¼ inches (22.8 x 15.8 cm)
The Lynne and Harold Honickman
Gift of the Julien Levy Collection
2001-62-755

Plate 24
George Platt Lynes (American, 1907–1955)
Serge Lifar in "La Spectre de la Rose," c. 1933
Gelatin silver print
9⁵⁄₁₆ x 7¼ inches (23.7 x 18.4 cm)
The Lynne and Harold Honickman
Gift of the Julien Levy Collection
2001-62-756

Noguchi, along with celebrities, beauties, friends, and a self-portrait. About a dozen works departed from portraiture, primarily scenes of local color with such un-picturesque titles as *Vulture* and *Sleeping Beggar, Valladolid* that resonated with French street photography. Lynes included one female and one male nude in his solo show, work that was becoming increasingly important to him. In 1936 Lynes rented a studio up the street from the Julien Levy Gallery at 640 Madison Avenue. He was well ensconced in the avant-garde cultural milieu in New York by that time and much sought after as a photographer. His association with the gallery continued to be an especially close one, aided by his proximity, common interests, and a mutual web of friendships.[153]

MODERN EUROPEAN PHOTOGRAPHY

Levy's next ambitious photography show, on view from February 20 to March 11, 1932, was *Modern European Photography*, a sampler of work by twenty artists living in France and Germany (fig. 15). In contrast to the recent Surrealism exhibition, with its necessary constrictions based on the parameters of the movement and its proponents, *Modern European Photography* gave Levy free license to encompass all that he found of significance across the Atlantic. The variety of artists in the show gives an early clue to his eclectic and inclusive approach to the medium. A few names, such as Man Ray and László Moholy-Nagy, would have been quickly recognizable to the cognoscenti, and some were familiar to viewers of *Surréalisme*, but only a few had ever exhibited in North America. The mix of nationalities reflected the political upheaval of the time—André Kertész, Brassaï, and Moholy-Nagy, for example, had all left their native countries under duress—and the attendant internationalism that characterized photography during the interwar period. Representing France were Brassaï, Ecce Photo, Florence Henri, André Kertész, Eli Lotar, Roger Parry, Emmanuel Sougez, and Maurice Tabard. With studios in Paris, Americans Man Ray and Lee Miller were awarded honorary European status for the purposes of the show. German and Germany-based artists included Herbert Bayer, Ilse Bing, Walter Hege, Lászlo Moholy-Nagy, Helmar Lerski, Alice Lex-Nerlinger, Oskar Nerlinger, Walter Peterhans, Peter Weller, and Umbo.

Levy would for several years make annual visits to Paris in the summertime, when he would meet with other dealers and encounter many of the artists featured in his exhibitions. He had also enlisted Man Ray in scouting for work, and, not surprisingly, many of the photographers they chose for *Modern European Photography* reflect their Surrealist leanings at that time. Among them was Roger Parry, who had been a photographer only since 1928, doing advertising work with Maurice Tabard and working for the publisher La Nouvelle Revue française. Parry created a series of cryptic pictures, thick with an atmosphere of dread and expectancy, for the publisher's 1930 edition of Léon-Paul Fargue's poems *Banalité*. The project launched Parry into the Paris avant-garde along with Tabard. In addition to several images from the book (see pl. 230), Levy owned what appear to be storyboards for another project by Parry, probably unrealized.[154] Levy's collection of photographs by Tabard is equally eerie and Surrealist-tinged, among them a print of his memorable image of a dentist's chair, which effectively evokes the anxiety and pain often associated with dentistry and its implements (see pl. 239). By emphasizing the vacant chair, Tabard suggests it as an arena for torture or foul play.

Other pictures Levy gathered in France depict the isolation and grasping camaraderie of city life, aspects to which geographically displaced artists were especially attuned. Solitary figures and men sleeping in public are recurring subjects. With no trace of sentimentality, these images suggest the fleeting fellowship available in a bar or a crowd. A common theme is the bonds formed

Fig. 15 (above). **Exhibition announcement for *Modern European Photography**, 1932. Courtesy of the Julien Levy Archive, Connecticut

Plate 25 (opposite)
Alice Lex-Nerlinger (German, 1893–1975)
***Eggs (Eier)**, c. 1930–31
Gelatin silver print
8¹⁵⁄₁₆ x 6⁷⁄₁₀ inches (22.7 x 16.4 cm)
The Lynne and Harold Honickman Gift of the Julien Levy Collection
2001-62-665

between outsiders and the socially marginalized of the city. One photographer who created such work was André Kertész. During his 1927 visit to Paris, Levy may have had the opportunity to see the critically acclaimed show of photographs by Kertész on view at the gallery Au Sacre du Printemps. Kertész, a photographer from Budapest who had moved to Paris in 1925, had to struggle to establish himself in the city yet nonetheless successfully mined its rich visual resources and cultural life. In the mid-1920s he was making night views of Paris as well as photographing flea markets and shop windows.

"I remember Kertész very well," Levy later wrote. "A charming man, and one of the most promising of the young European photographers."[155] By the time he showed Kertész's photographs at his own gallery in 1932, the artist was thirty-eight years old and was working on a series of nude distortions that he would complete in 1933. The warped figures and strange eroticism of these pictures surely would have attracted Levy, though he does not appear to have owned any. He did, however, own several of Kertész's now-famous views of painter Piet Mondrian's studio, taken in 1926,[156] and some of the artist's quirky, formalist views of Paris, such as towering vertical buildings photographed from a low angle to emphasize their shapes and their assortment of prominent advertising signs (see pl. 176) and a formalist arrangement of rooftop chimneys (see pl. 178), the latter a subject he returned to several times. Tightly composed but more tender is his close-up image of a baby (see pl. 195) and an even closer and surprisingly mesmerizing portrait of Nicolas Dinky (see pl. 226), a Siamese cat that belonged to critic Florent Fels, the editor of *L'Art vivant.*

The carousel—with its facsimile horse impaled by a pole, fated to repeat the same circular trajectory over and over—was a favorite image of the Surrealists, and Levy owned several photographs of carved horses and merry-go-rounds, including one by Kertész made in the Tuileries in Paris (see pl. 228).[157] Levy mentioned in an interview in 1978 that his favorite work by Kertész was a series of three small images of a *clochard,* a vagrant on the streets of Paris. Although their precise ordering is not evident, the images unfold narratively (Levy called it "storytelling in photography"), following the progress of the grizzled man as he passes a vehicle on the street, pauses to urinate in a doorway, and then recedes into the crowd (pls. 26–28).[158] The multiple views and journalistic style suggest the trio was made for a magazine or newspaper assignment, or perhaps Kertész merely wanted to chronicle the sad trajectory of this neglected wanderer. Some time after the *Modern European Photography* exhibition, in the mid-1930s, Kertész moved to New York, and in 1937 he was included in Beaumont Newhall's survey of photography at MoMA. Levy, however, apparently never again exhibited his work.[159]

Also represented in *Modern European Photography* was one of Kertész's friends in Paris, Gyula Halász (named simply "Halesz" on the exhibition announcement), a painter who had come to the city from Transylvania (now Romania) in 1923. Within a few years he had tried his hand at photography and changed his name to Brassaï, to honor his hometown of Brasso. Brassaï was one of the first artists in this group whom Levy encountered, and it was he who introduced him to Kertész and others. Like Kertész, Henri Cartier-Bresson, Eli Lotar, and Walker Evans, Brassaï captured the incongruousness and ignominy of everyday life, photographing homeless men sleeping on the street in front of signs advertising consumer goods, figures with their heads obscured by balloons or other objects, and, above all, the exotic denizens of Paris café life. Although Brassaï shows the City of Light as a damp, shadowy place filled with poverty and licentiousness, its dark beauty is nonetheless alluring. Brassaï was simultaneously engaged in making an extensive catalogue of artist portraits, but his most famous body of work is represented in *Paris de nuit* (Paris at Night), published in 1933. Surprisingly, given Levy's attraction to Atget's images of tramps's huts, prostitutes, and other depictions of the less traditionally picturesque aspects of Paris life, he did not own work from this series. Levy admired Brassaï's

Plate 26
André Kertész (American, born
Hungary, 1894–1985)
Untitled (Vagrant in street),
1928
Gelatin silver print
5⅛ × 6¾ inches (12.8 × 17.2 cm)
The Lynne and Harold Honickman
Gift of the Julien Levy Collection
2001-62-599

Plate 27
André Kertész (American, born
Hungary, 1894–1985)
Untitled (Vagrant in street),
1928
Gelatin silver print
4¹³⁄₁₆ × 6¼ inches (12.3 × 15.9 cm)
The Lynne and Harold Honickman
Gift of the Julien Levy Collection
2001-62-600

Plate 28
André Kertész (American, born
Hungary, 1894–1985)
Untitled (Vagrant in street),
1928
Gelatin silver print
4¹⁵⁄₁₆ × 6¹¹⁄₁₆ inches (12.6 × 17 cm)
The Lynne and Harold Honickman
Gift of the Julien Levy Collection
2001-62-601

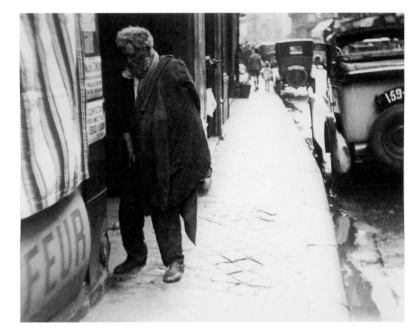

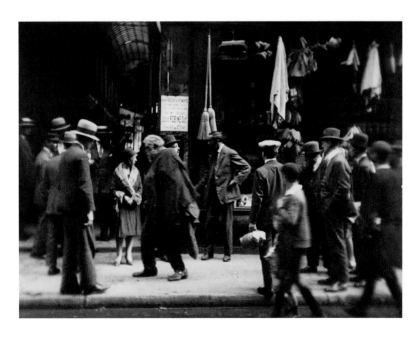

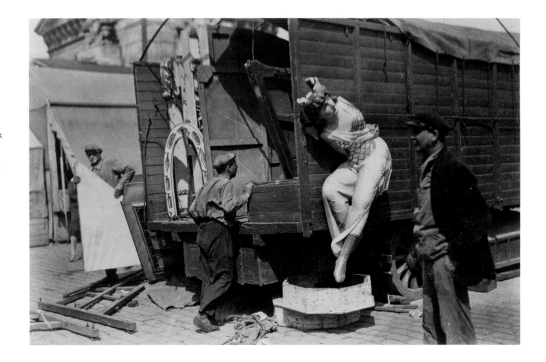

"impish vivacity" and did retain a few photographs by him.[160] Foremost among them is *Woman's Torso (Scissors)*, a witty composition that teases the viewer by equating a pair of shears with the curvaceous and potentially dangerous female form (see pl. 224).

Far less known today but certainly familiar to his contemporaries was Eli Lotar, who had learned about photography from Germaine Krull, one of the most prominent photographers then working in Paris and particularly well known for her images of industry. Lotar worked in photography and film only sporadically, at one point establishing a photography studio with Jacques-André Boiffard, who had briefly been Man Ray's darkroom assistant. He also worked for filmmaker Jean Painlevé in addition to publishing his photographs in the picture magazines of the day. Levy would have identified with Lotar's voracious but slightly scattered enthusiasm for the medium of film, and he owned several of his photographs. One shows the remnants of a street fair being loaded onto a wagon (pl. 29), while another captures the tangled legs of upturned chairs at a sidewalk café in front of a wall-sized advertisement for the bottled beverage Globe (see pl. 181). Also in the collection are two pictures made by Lotar at a slaughterhouse, part of a larger series.[161] One view is of the exterior of the *abbatoir*, while the other is a close-up view of a severed calf's head lying on the floor, the image nearly filling the picture frame (see pl. 251).[162] The latter is a stark, arresting photograph that focuses on the details of the animal's facial expression—almost a grimace, with the eye open, the lip pulled back to show the teeth, and the tongue extruded. Such grisly still lifes, a mix of Surrealism and street photography, were not uncommon in French photography of the time, and Levy collected numerous examples, no doubt reveling in their truthful but transgressive nature. These include an image of a dead horse on the street by L. Ollivier (see pl. 250), a picture of cascading viscera by Henri Cartier-Bresson (see pl. 253), and, from Germany, Alice Lex-Nerlinger's dead chicken (see pl. 254).

Another prominent photographer very active in Paris in the 1930s was Ilse Bing. Levy made a significant commitment to her work, owning forty prints, although he never gave her a solo exhibition at the gallery.[163] The German-born Bing was one of a dynamic new breed of women who made a name for themselves in photography. She had adopted the small Leica camera soon after it appeared in the 1920s, gaining the unofficial honorific "Queen of the Leica." Levy's group of her work includes several excellent examples of the observational street photography for which she was known. Two untitled images of people on the streets of Paris have a subtle air of social commentary. One shows a

Plate 30
Ilse Bing (American, born Germany,
1899–1998)
Untitled (Child), c. 1930–31
Gelatin silver print
8⅞ x 6½ inches (22.5 x 16.5 cm)
The Lynne and Harold Honickman
Gift of the Julien Levy Collection
2001-62-422

woman, her back to us, swathed in a loosely knit shawl with her hair in a bun, while in front of her is a fashionable younger woman in a fur-trimmed coat and cloche (see pl. 187). In another view, several men loiter by the side of a road in heavy coats, apparently idle (see pl. 190). Bing had a humorous side as well, exhibited in an irresistible portrait of a child bundled up in a winter coat with outlandish furry trim (pl. 30). Prominent in the Levy holdings is a series of fourteen pictures that Bing made in Veere, Holland, offering several strong waterfront scenes (see pl. 189), a more rote image of a child in traditional Dutch garb, and the requisite windmill view.[164]

Levy included in his European photography exhibition work by the more commercially minded Ecce Photo (see pls. 212, 217, 246), a husband-wife team, and Emmanuel Sougez (see pl. 274). He also owned a piece by Tabard that was evidently created as an advertisement for the Paris fashion house Lanvin, as it features one of their ball gowns and their signature perfume bottle (see pl. 225). That an artist would produce work for a fashion house was hardly remarkable during such a boundary-bending period. The burgeoning illustrated press, such as *Vu* in Paris and *Der Querschnitt* in Germany, was ravenous for photographs and provided many artists with a living. Man Ray, Lynes, and Steichen all photographed for fashion magazines. Even Dalí famously helped create some of the window displays for Elsa Schiaparelli's fashion house in Paris, and in 1939 decorated a window of New York's Bonwit Teller store (where he managed to crash through the glass).[165] In creating their images, photographers often made little distinction between pictures created for publication, advertising, or exhibition, with the result that the visual aesthetic of Surrealism and other movements became a common vocabulary. This crossover of the art world with the commercial world is strongly evident in an image like Tabard's Lanvin piece. While fulfilling its advertising function, the disembodied dress with a perfume-bottle cap for a head was equally at home in Levy's exhibition of European avant-garde photography.[166]

Plate 31
László Moholy-Nagy
(American, born Hungary,
1895–1946)
Filmstrips from *Lichtspiel*
Schwarz-weiss-grau, 1930
Gelatin silver transparency
2³⁄₁₆ x 1³⁄₈ inches (5.6 x 3.5 cm)
The Lynne and Harold Honickman
Gift of the Julien Levy Collection
2001-62-838(1, 2)

Paris in the early 1930s was a crossroads that allowed Levy access to artists working throughout Europe and even in Russia. Although he had little need of further travel, he did make one dedicated trip to Germany, during his European trip in the summer of 1931. Photography had already emerged in Germany as a vital expression of contemporary life, as it soon would in New York. The Deutsche Werkbund's 1929 exhibition *Film und Foto* had highlighted a range of international work, further underscored in *Foto-Auge: 76 Fotos der Zeit* (Photo-Eye: 76 Photos of the Period) and *Es kommt der neue Fotograf!* (Here Comes the New Photographer!), two books published that year. A monographic book of photographs by artist László Moholy-Nagy appeared the following year, and the ground-breaking Munich photography exhibition *Das Lichtbild* also took place that year.

Levy's first stop in Germany was Moholy-Nagy's Berlin studio.[167] Moholy-Nagy had been hired in 1923, at the age of twenty-eight, to teach metalwork and the foundation course at the Bauhaus, a progressive school for art and design in Dessau. He had started an ambitious publishing program there, made several films, and was becoming increasingly involved with photography. Like Man Ray, Moholy-Nagy was a dedicated modern practitioner of the nineteenth-century technique of cameraless photography, the photogram (Man Ray called his Rayographs). The two artists were also similar in refusing to be restricted to a single medium for their art making, each creating paintings, films, sculptures, and photographs and also writing. Moholy-Nagy was already distinguishing himself with his belief that the photographic image represented nothing less than a new language for contemporary life. "A knowledge of photography is just as important as that of the alphabet. The illiterate of the future will be the person ignorant of the use of the camera as well as of the pen," he wrote in 1935.[168]

When Levy met him, Moholy-Nagy had not yet shown his photographs in the United States and was in fact to have his first solo exhibition in New York at the Delphic Studios at the end of that year.[169] Levy describes looking through "albums" of Moholy-Nagy's photographs and photograms to select images for the exhibition at his gallery, and he purchased a group of work, again exhibiting excellent aesthetic judgment.[170] His timing was even better, as within a few years European travel, particularly within Germany, would become increasingly difficult owing to the political climate. The year Levy visited Germany, the Bauhaus closed for a time because municipal funding was withdrawn by the National Socialist party.[171]

Levy purchased a few of Moholy-Nagy's photograms and acquired a number of his experimental camera images, several of which were printed in reverse tonality.[172] Moholy-Nagy was one of the major proponents of what was lightly dubbed the "looking up, looking down" style at the Bauhaus, which encouraged making pictures from a variety of unusual and dramatic perspectives. Several of the works chosen by Levy reflect this approach. Moholy-Nagy's photograph of an ordinary house cat, taken from a high angle, is characteristic of both artist and feline in its contortedness (see

Plate 32
Herbert Bayer (American, born
Germany, 1900–1985)
Good Night, Marie, 1932
Gelatin silver print
3¹⁵⁄₁₆ x 2¹⁵⁄₁₆ inches (10 x 7.5 cm)
The Lynne and Harold Honickman
Gift of the Julien Levy Collection
2001-62-407

pl. 196). A beach scene seems straightforward until the photographer's emphasis on the repetitive patterning and alternation of light and dark in the sand emerges (see pl. 214). Levy also purchased a simple portrait of a woman and baby, taken during the artist's 1930 trip to Scandinavia (see pl. 188). One of Moholy-Nagy's recent projects was the 1930 film *Lichtspiel Schwarz-weiss-grau* (Light Display Black-white-gray), created by filming the shadows cast by the artist's mechanized contraption for making light displays, the Light-Space Modulator.[173] With his interest in film still quite fresh, Levy must have been especially engaged by this footage. Found with his collection was an envelope, inscribed by Moholy-Nagy, that contained a glassine wrapper holding what appear to be tiny contact prints from this film (pl. 31) and from his 1929 film *Marseille vieux port* (Old Port of Marseilles).[174]

Deeply engaged with contemporary architecture and its social implications, Moholy-Nagy showed Levy "the walls near his apartment in the district of the new, modern-design workers' housing units" and also invited him to visit a nudist camp the following weekend.[175] Levy stayed at the camp for a week, meeting a secretary from the Dorland advertising agency who introduced him to the influential artist and graphic designer Herbert Bayer. Although Bayer had "never seen himself as a Surrealist or associated with the Surrealist group in Paris," Levy considered many of his collages and gouaches to be "so full of the Surrealist spirit" that he bought a few.[176] Levy was referring to Bayer's inventive photomontages, a collage of picture elements he then re-photographed to create a seamless photographic composition, such as in *Hands Act A–Z* and *Good Night, Marie* (pl. 32).[177] At the agency he met Bayer's friend Otto Umbehr, called Umbo, one of Dorland's most versatile photographers. Levy acquired several pieces from him as well, including *Unheimliche Strasse I* (Uncanny Street I; see pl. 17), a shot of the street taken from a rooftop that transforms ordinary pedestrians and vehicles into attenuated shades that resemble Alberto Giacometti's sculptures.[178]

Levy also met Lucia Moholy, a photographer who had worked closely with Moholy-Nagy in the darkroom at the Bauhaus and assisted him with his writing and other projects (they were married from 1921 to 1929). She and Levy would have found common ground in their engagement with the history of photography; Lucia would write one of the early histories of the medium in 1939 to commemorate the centenary of its invention.[179] Representing her photographic work in Levy's collection is

a large portrait head of an unidentified woman wearing a straw hat that was loaned to a 1932 survey of international photography at the Brooklyn Museum (see pl. 199). Also in the group are six photographs of stage sets for *The Tales of Hoffmann*, designed by Moholy-Nagy for a production by the State Opera in Berlin (pl. 33). Lucia Moholy's iconic portrait of her former husband shows him in red coveralls, looking like a mechanic, the ultimate worker-artist (pl. 34).

One artist with extremely compelling work that Levy brought forward in *Modern European Photography* was Alice Lex-Nerlinger. Her excellent photographic work, though little published today, appeared in the major German photography exhibitions of the 1920s: *Film und Foto* in Stuttgart and *Das Lichtbild* in Munich. Levy must have met her in Berlin that summer, for he purchased a group of pictures.[180] Lex-Nerlinger had studied art with Emil Orlik at the Unterrichtsanstalt am Kunstgewerbemuseum (School of the Museum of Decorative Arts) in Berlin, and in 1919 she married a fellow student, Oskar Nerlinger, who is known more for his paintings and graphic work, though he also used photography (Levy acquired several of his images as well; see pl. 215).[181] The simplicity and clarity of Lex-Nerlinger's work speak of experience in the advertising and commercial realms. While it is possible that her dressmaker's dummy and chicken and egg photographs in Levy's collection were made on assignment, each is entirely successful in its own right. Lex-Nerlinger favored posing her subjects askew, lending a twist to her clean, spare compositions. Her naked *Schneiderpuppe* (Tailor's Mannequin; see pl. 243) is toppled onto the floor, stretched diagonally across the picture near a menacing pair of open shears.[182] Like Tabard's dental chair and perhaps even Evans's tombstones, it is an innocent subject that taps into primal fears of bodily harm. The poultry series is beautifully realized but more typical in its synthesis of Bauhaus photography principles with magazine journalism. In the picture of a poultry worker with one of her chickens, Lex-Nerlinger plays up the light headkerchief and the white chicken, giving an edge to the composition by posing the subject so that half her face is obscured by chicken wire.[183] A shot of a crate of eggs is an orderly production that suggests efficiency and hygiene while offering a composition of elements that are extremely satisfying to the eye (see pl. 25). A third image shows a dead chicken, its legs and feet projecting into the foreground, looking massive and foreign (see pl. 254).

In addition to Moholy-Nagy and Bayer, Levy acquired work by a few other artists associated with the Bauhaus, including paintings by the young T. Lux Feininger and photographs by Walter Peterhans. While Moholy-Nagy and others had previously incorporated photography into the curriculum at the school, it was not until 1929 that a separate department for photography was inaugurated, with Peterhans at the helm.[184] In the autumn of 1931 Peterhans sent Levy two photographs that were included in *Modern European Photography* (a review of the exhibition mentioned a photograph of "feathers and lace"),[185] and Levy invited him to send additional work for a solo exhibition. "Judging from the examples I have seen already your photographs seem to be about the best that have come from Germany," he wrote to the artist in March, offering to purchase one of the photographs for himself.[186] Unfortunately, there is no trace of Peterhans in the Levy collection.

Less predictably, another German photographer whose work Levy favored and owned in quantity was Walter Hege. A talented printer with a good eye for composition, Hege had studied photography with Hugo Erfurth in Dresden. His work was appreciated by Levy's contemporaries and appeared in the Brooklyn Museum's 1932 traveling survey of international photography as well as in Levy's *Modern European Photography*. Hege had been commissioned by the Metropolitan Museum of Art in New York to document the Acropolis, and he published a book on the subject in 1929; Levy's collection of his work is from this series (pls. 35, 158). Hege's style is fairly straightforward, but the abandoned structures he photographed have a visual resonance that can be equated with the lonely plazas painted by Giorgio de Chirico (an artist Levy was to exhibit) or the empty park spaces

Plate 33
Lucia Moholy (British, born Silesia, 1894–1989)
Stage set with shadow projection for _The Tales of Hoffmann_ (third act: Antonia; set design by László Moholy-Nagy), 1929–30
Gelatin silver print
4¹⁵⁄₁₆ x 7¹⁄₁₆ inches (12.5 x 18 cm)
The Lynne and Harold Honickman
Gift of the Julien Levy Collection
2001-62-833

Plate 34
Lucia Moholy (British, born Silesia, 1894–1989)
**László Moholy-Nagy,** 1926
Gelatin silver print
8¾ x 6 inches (22.3 x 15.3 cm)
The Lynne and Harold Honickman
Gift of the Julien Levy Collection
2001-62-830

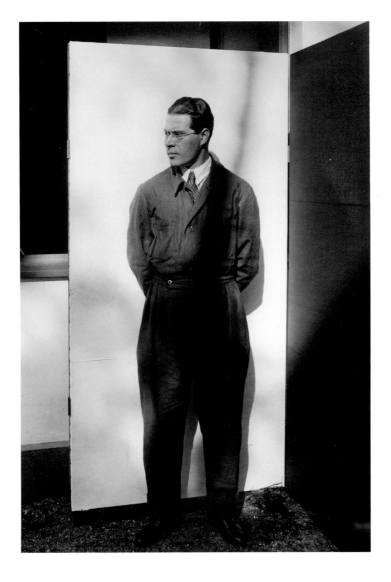

photographed by Atget. In another piece, Hege shows the end of a fallen column at close range in a way that for Levy may have made it the equivalent of a Surrealist found object.[187]

 Modern European Photography was reviewed by many newspapers in relation to the concurrent photography exhibitions on view at the Brooklyn Museum and elsewhere in the city. The Brooklyn Museum's *International Exhibition of Photography* offered a generous selection of nearly two hundred photographs by American, British, French, German, Italian, and Mexican artists, with the Levy Gallery by far the major lender, providing work by at least twenty-two photographers.[188] The *42nd Annual Exhibition of Pictorial Photography* was on view at the museum at the same time, giving visitors the extraordinary opportunity to see hundreds of photographs in one place and to compare the modernist and Pictorialist strains of the medium. Other photography shows then on view in the city included Edward Weston's work at the Delphic Studios, Stieglitz's images at his own gallery, and Lynes's photographs at the Legget Galleries in the Waldorf Astoria.[189]

 Separate mentions of Levy's show inevitably pointed out that Man Ray—who had been living in France since 1921 and whose portrait of author Sinclair Lewis, solarized image of Lee Miller, peony photogram (a popular image with critics; see pl. 220), and mannequin hand holding a corkscrew were included in the show—was American, not European. Also mentioned were two works by American Lee Miller, photographs of a Greek statue and of a woman running fingers with chipped nail polish

through her curly locks. Reviewers were interested in the "virtuoso" techniques on display, which were touted as particularly European, such as the extreme close-up head by Helmar Lerski (see pl. 198), the multiple exposures by Tabard, photograms by Moholy-Nagy and Oskar Nerlinger, and the extreme camera angles employed by several of the photographers.[190] The *New York Times* declared: "In spite of radio broadcasts, five-day steamers and the peripatetic Will Rogers, the Atlantic Ocean seems still to constitute an important intellectual and artistic barrier. Since the primitive days of photography . . . the photographers of North America and the photographers of Europe have traversed diverging paths," with the Europeans opting for "tricks of the conjurer" while Americans were "wont to employ a minimum of distortion."[191]

As it turned out, *Modern European Photography* was Levy's primary offering of photographs from abroad. Certainly the mounting political tension in Europe would have made his contacts there a bit more complicated as the 1930s progressed, but it can also be said that his taste shifted away from more abstract and Surrealist photography toward the more descriptive style being practiced by Brassaï and Kertész but particularly by American photographers, including Abbott and Evans. Nonetheless, Levy was committed to showing a variety of photography, particularly homegrown work that could stand up to its European counterparts. He owned a significant group of photographs by the versatile and much-neglected Francis Bruguière, a former West Coast Pictorialist whose conversion to modernism was as drastic as Coburn's. Bruguière's cut-paper abstractions are truly dazzling achievements and an inventive way to join abstraction with straight photography (see pl. 221). Levy also favored the multiple-exposure images from the artist's cathedral series (see pls. 222, 223). Employing a low angle and diagonal skew, Bruguière dwarfs us with the looming cathedral and further layers the picture with multiple viewpoints, giving these historic structures a contemporary cast.

Levy's third monographic photography show at the gallery, in the spring of 1932, featured one of the artists from the *Modern European Photography* show. *Photographs by Man Ray* was the

Fig. 16. **Exhibition announcement for *Photographs by Man Ray,*** 1932. Courtesy of the Julien Levy Archive, Connecticut

artist's first solo photography exhibition in New York (fig. 16). Until then Man Ray's photographs had been seen only in reproduction in a few American publications, such as *Vanity Fair*, and in *Broom*, an international magazine of the arts. Man Ray was one of the key figures in Levy's universe. The opportunity to devote an entire show to his photography on native turf would have been exciting and significant for Levy, both personally and professionally.

In contrast with his works on view in *Surréalisme* and *Modern European Photography*, Man Ray's solo exhibition at the Levy Gallery concentrated on his portraiture. Included was *Princess Bibesco* from about 1924–30, showing a woman caught in a seemingly private moment, gazing into a hand-held mirror (see pl. 234). Levy also owned a print of the

artist's 1924 *Ciné-Sketch: Adam and Eve* (see pl. 236), in which a nude Marcel Duchamp and Bronia Perlmutter are shown performing a brief interlude during the Francis Picabia ballet *Relâche*. Levy treasured his print of this image, but he never exhibited it out of deference to Perlmutter's husband, René Clair, "although he well could have taken pleased pride in that little belly, of a shapeliness both Botticelli and Cranach would admire and that few girls, even when just a little pregnant, possess."[192] A multiple-exposure image of a nude female torso is more typically Surrealist, transforming a live model into a limbless classical sculpture (pl. 36). Diverging from the portraiture focus of the show was the addition of Man Ray's 1931 portfolio *Électricité*. Comissioned by the Paris Electric Company

CPDE to promote the use of electricity in homes, the series comprised ten photograms reproduced as photogravure prints. This fun and engaging set of images was another example of the successful marriage of commercial and artistic aims, from the cameraless image of an electric fan to the nude torso of a woman suggesting another type of "electricity."[193]

The Man Ray show was another instance in which Levy's gallery led the way. In an essay for the exhibition announcement, Raoul de Roussy de Sales wrote: "Fifty years hence, when the history of photography as an art is written, the name of Man Ray will stand beside that of Nadar." Within a few years, Man Ray's photographs would receive fuller treatment in a one-man exhibition at the Wadsworth Atheneum organized by James Thrall Soby, a major collector of the artist's photographs and the author of a 1934 book on the subject.

MURALS BY AMERICAN PAINTERS AND PHOTOGRAPHERS

Levy was not only interested in innovative photography, he was also interested in photography used innovatively. Soon after the gallery opened he set to work developing a line of household products with photographic designs (see pp. 149, 153–55, pls. 111–14, 275, 278–83 below). "The gallery is promoting the application of photographic designs to furnishing and decoration" and "presents models both for quantity production and suggestions for special orders, but in general prefers to act as an agency for the photographer in placing designs with decorators and shops," one magazine feature explained, illustrating designs by Abbott and Sherril Schell.[194] Levy's plan was undoubtedly influenced by his contact with artists associated with the Bauhaus, whom he had met in Germany; the school was for many years devoted to fostering a union between craft and art, and it designed and also put into production various household goods and furniture.

Another way Levy envisioned photography transforming everyday life was with the photomural. Recent technical advances had made feasible the manufacturing of giant sheets of photosensitive paper, and Levy was obviously intrigued by the possibilities this presented for readily changeable décor in private homes and especially in contemporary public buildings, with their soaring interiors. The flowering of the Mexican cultural renaissance in the 1920s had already stimulated a revival of mural painting, a movement that found fertile ground in New York.[195] Levy would have viewed the advent of photomurals as another, more contemporary expression of this genre. In 1932 Lincoln Kirstein was organizing an exhibition of murals for MoMA and had invited American artists to submit three-part horizontal compositions on the theme of "The Post-War World," with one section to be realized at an enlarged scale. Kirstein's goal was to encourage "the possibilities of beautifying future American buildings through the greater use of mural decoration."[196] In his essay for the accompanying catalogue, *Murals by American Painters and Photographers,* he traced the history of murals back to Paleolithic cave paintings. Advocating murals as "an integral part of interior architecture," Kirstein wrote: "A blank wall suits a cloister, but in a monumental vaulted hall, or in a room of state, the blankness merely refers to the blank imaginations of the men who conceived it."[197]

Kirstein tapped Levy to organize a complementary competition of murals by photographers, offering a cash prize of several thousand dollars and the exciting opportunity to install the winning design as a full-scale mural at the Rockefeller Center. Levy enthusiastically recruited a group of fourteen photographers: Berenice Abbott, Maurice Bratter, Duryea and Locher, Arthur Gerlach, Emma Little and Joella Levy, George Platt Lynes, William Rittase, Thurman Rotan, Charles Sheeler, Stella Simon, Edward Steichen, and Luke Swank. The entries were assembled very quickly, at a cost of about $300 each, with artists given only three weeks to submit preliminary layouts. Despite the lack of time, Levy was determined and energetic in pulling together a group of interesting entries, many by the artists included in the concurrent exhibition at his gallery, *Photographs of New York by New York*

Photographers. The entries were exhibited at MoMA and included in the catalogue, which Levy clearly saw as a significant accomplishment. "This meant that photography would be given museum recognition on a large scale," he wrote in his memoir.[198]

Aside from the tremendous coup of having photographs exhibited at the Museum of Modern Art for the first time, Levy was committed to the photomural, which he viewed as a fresh expression of contemporary urban life. "The photographer is particularly well equipped to meet the problems of mural decoration as posed by the modern architect and builder," he wrote in his essay for the catalogue. Photomurals could be created quickly and inexpensively and were easy to remove or replace "with decoration of immediate topical interest for our shifting modern life. Thus the new medium satisfies at once three primary requisites of modern building: speed, economy, and flexibility."[199] Although Levy felt disappointment and betrayal when he discovered that Edward Steichen had been promised the prize before the start of the competition, he was gratified that "not only did my photographers have good exposure, but the show was to give a considerable boost to the cause of photography as an art."[200] A large-scale version of Steichen's piece was prominent in the exhibition, and other entries were presented with the central panel enlarged to suggest the potential of this format; a smaller print showing all three panels was displayed below.

The press was unified in its overwhelmingly negative response to the painted murals. In the *New York Times* Edward Alden Jewell called the results "pretty terrible," noting that "many of the artists invited to appear in this show expose little or no qualification for mural work."[201] The photography section, however, was described by various reporters as "unusual," "provocative," and "suggestive." According to Jewell the photomurals were "decidedly encouraging—in the face of all that is so palpably discouraging. . . . Not in every instance do the examples at hand score, but there are certain designs so powerful, so brilliantly and arrestingly wrought, that the spectator's response is instant and unreserved."[202] Even more effusive was the *Art News* critic, who gushed that "the vibrant beauty of the machine and the shining surfaces of metal sing out in pure symphonies of black and white," while a reporter for the *New York Sun* suggested that "by adopting the tools of the mechanical age at the outset this photographic process may succeed in catching that elusive spirit of the time for which modernist painters have been vaguely striving."[203]

Only traces of these grand projects remain. The Levy holdings include prints of one panel of William Rittase's photomural *Steel* (see pl. 174), Thurman Rotan's *Daily News Building* (pl. 37), a copy print of Luke Swank's *Steel Plant* (pl. 38), Gerlach's composition *Energy,*[204] and a negative of

Lynes's submission, *American Landscape, 1933* (fig. 17). Also in the Levy collection is a piece by Stella Simon that appears to be a mural study, a disarming image of bubbles and floating elephants, perhaps an alternate submission for the MoMA exhibition (see pl. 261). The mock-up for Charles Sheeler's glorious entry to the show, *Industry,* a view of the Ford Motor plant in River Rouge (near Detroit), is in the Levy collection at the Art Institute of Chicago. After the mural exhibition closed, one of the panels from Lynes's entry, featuring the silhouette of a classical statue montaged over an urban landscape, found a temporary home in Hartford, displayed in a modernist room in the new Avery Building at the Wadsworth Atheneum.[205] Levy's commitment to murals—painted rather than photographic—as a contemporary art form continued over the years. In January and February of 1939 he presented *Murals by Jared French* and *Mural Decoration for the House of Wright Ludington,* and in June, *Murals by Lloyd Goff.* While the photomural remained "in the air, if not on the walls," as one critic put it,[206] Levy received a tremendous amount of favorable publicity for this project and recognition as an innovator, as well as being associated with the introduction of photography at MoMA, all within the first year of his gallery enterprise.

LEVY AND CONTEMPORARY AMERICAN PHOTOGRAPHY

Concurrent with MoMA's mural exhibition was Levy's survey of contemporary American photography, *Photographs of New York by New York Photographers,* a dynamic medley of works by a diverse group of artists working in the city (fig. 18). Running from May 2 to June 11, the exhibition was a celebration of modern Manhattan and Levy's love song to his hometown. "All the photographs go to prove conclusively that New York is at once the most thrilling, exciting, and inspiring of all modern cities with bits of old-world charm for those who know where to find it," he wrote in the press release.[207] Paris had the Eiffel Tower, the decorative steel monument completed in 1889, but New York had multiple towers reaching into the sky, each inhabited like a city. Levy was fond of touring New York with foreigners, showing off the city as if it were "some adored mistress whose points acquired brilliance when noticed and praised by each new admirer." He recalled that Salvador Dalí "would flay my city alive, rearrange her limbs, serve her up to me with new sauce and relish, whereas Fernand Léger was the only visitor who ever really disconcerted me, because he liked *everything.*"[208]

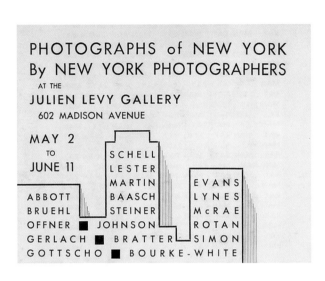

Fig. 18. **Exhibition announcement for *Photographs of New York by New York Photographers,*** 1932. Courtesy of the Julien Levy Archive, Connecticut

Berenice Abbott's view of Rockefeller Center under construction (pl. 39), with its juxtaposition of raw earth and muscular girders, would surely have been included in this exhibition, as would several of her small prints of the cityscape, both modern and modest (see pl. 159). Another star of the show was undoubtedly Ralph Steiner's dizzying view of several altitudinous buildings flanking a marquee advertising "talking pictures" (see pl. 2). Kurt Baasch may have been represented by his photograph of a rundown dwelling with resident cat (see pl. 164), while Wendell MacRae offered the sheer wall of an apartment building sprouting awnings on a hot day, an ice truck pulling up to save the day (pl. 40), and his elaborately titled *Fantasy in Concrete* (pl. 41).[209] Sherril Schell made a series of small views that beautifully compress all the intensity of the new architecture into compact dimensions (see pls. 166, 167); he was hailed by one critic as the highlight of the show. "Nothing so well portrays this splendid mass city as the bold camera work of Sherril Schell [whose] photograph *Construction, Radio City,* shows the bloodless and jejune rafters of the city brain at high tension," wrote the reviewer for the magazine *Creative Art,* who described another of Schell's photographs as "graceful as a great [ocean] liner."[210]

Samuel Gottscho's sweeping views of the city skyline were another facet of the show. Although he had been a photographer for many years, Gottscho opened his professional studio in 1925 at the age of fifty, specializing in architectural photography and finding his services much in demand.[211] In his own work, Gottscho was particularly drawn to dramatic vistas and night views that captured the sparkling lights of the "city that never sleeps." Levy acquired Gottscho's photograph of a tower of the George Washington Bridge delicately framed by tree branches in the foreground and three long views of the skyline across the Hudson taken from various vantage points (see pl. 172).[212] He also had six photographs Gottscho made of an old mill on Long Island, which offer a stark contrast with his sleeker urban structures (see pl. 154).

Perhaps Levy's greatest find for this exhibition was Texas native Thurman Rotan, who had studied photography with Ira Martin and exhibited his work earlier that spring at the Art Center, at 65 East 56th Street. This show, titled *Photo-patterns,* included thirty-eight images, divided in the accompanying catalogue into "photo-patterns" (perhaps the more graphic, repetitive patterns) and "photographs" (probably more straightforward views). "Thurman Rotan arrives with a new rhythm. Pulsating photo-patterns with good music in them," Guy Gayler Clark wrote in a short essay for the

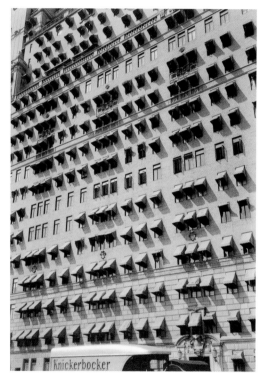

Plate 39
Berenice Abbott (American, 1898–1991)
Rockefeller Center, 1931–32
Gelatin silver print
11⁹⁄₁₆ x 9⅜ inches (29.4 x 23.8 cm)
The Lynne and Harold Honickman
Gift of the Julien Levy Collection
2001-62-9

Plate 40
Wendell MacRae (American, 1896–1980)
Summer, c. 1930–32
Gelatin silver print
6⁹⁄₁₆ x 4⅝ inches (16.6 x 11.7 cm)
The Lynne and Harold Honickman
Gift of the Julien Levy Collection
2001-62-778

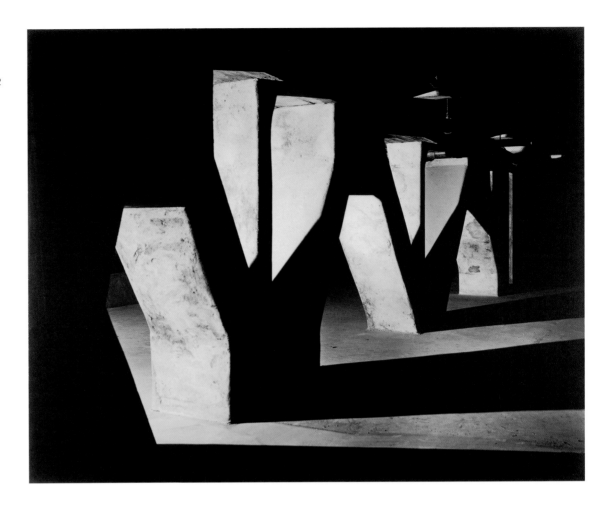

catalogue.[213] Rotan was a regular contributor to the magazine *World's Work*, published by Doubleday, Page & Co. in its expanded picture format (though it folded in July 1932). Levy had invited Rotan to submit a piece for the mural show at MoMA, a montage of the 1930 Daily News Building. It received consistent praise from the press and is now the artist's signature image (see pl. 37). Levy's collection of work by Rotan includes several camera views made from fresh perspectives. Rotan especially liked to juxtapose old and new New York. An idyllic picture of a horse and a stream, for instance, is interrupted by a towering skyscraper sprouting between the trees in the background.[214] New York under construction is another recurring theme in his work, and in one image he aims a massive sprawl of raw timber at the viewer's face, almost obscuring a view of the Empire State Building in the far distance (see pl. 168). Also included in the show was a photograph of a building site in which planks laid along the ground appear as a path leading directly to one of Gotham's towers in the far distance (pl. 42).

One of the greatest delights of Rotan's work is his penchant for the repetition of form, sometimes carried through to an almost painful degree. Two gems in Levy's collection are original collages of gelatin silver prints, one of skyscrapers and one of trees (see pls. 169, 272), each probably intended by Rotan to be re-photographed and used as designs.[215] As objects on their own, they are utterly appealing in their handmade simplicity and yet disturbingly frenetic in their optical effect. This aesthetic was carried over to Rotan's camera images. Levy owned a photograph by Rotan of pork chops filling the picture frame (see pl. 270), a photograph filled entirely with pretzels, another with wooden pilings careening in a conga line from shore to water, and a view of row upon row of oil barrels floating alongside a pier (pl. 43).[216] Surely Rotan was using the device of repetition not only as a design and compositional element but also to suggest the accelerating pace of city life and the increasing proximity of people and buildings in a growing urban landscape.[217]

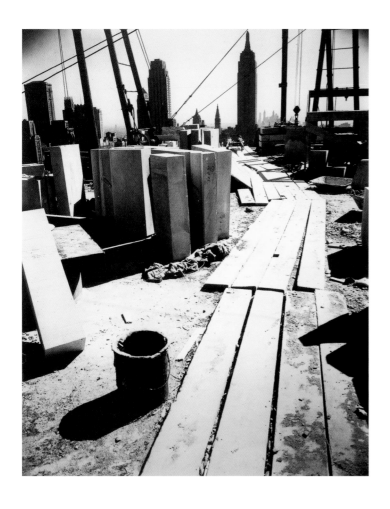

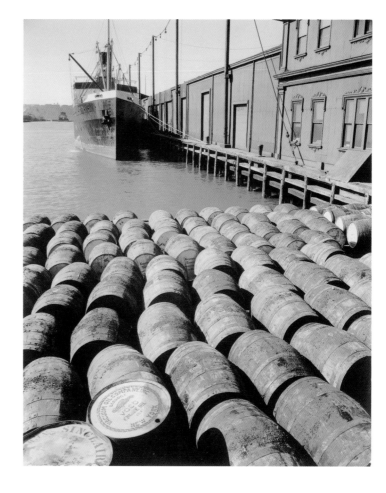

Plate 42
Thurman Rotan (American,
1903–1991)
**Untitled (Construction in
Manhattan),** c. 1930–32
Gelatin silver print
9¼ x 7⅜ inches (23.5 x 18.8 cm)
The Lynne and Harold Honickman
Gift of the Julien Levy Collection
2001-62-1032

Plate 43
Thurman Rotan (American,
1903–1991)
**Untitled (Oil barrels floating
at a pier),** c. 1930–32
Gelatin silver print
9⅛ x 7⅜ inches (23.2 x 18.8 cm)
The Lynne and Harold Honickman
Gift of the Julien Levy Collection
2001-62-1052

The many photographs of New York in Levy's collection give a tantalizing hint at what must have been not only an impressive array of talent but also a powerful installation. Artists whose work is listed as being included in the show, though it is not in the collection, are Margaret Bourke-White, Maurice Bratter, Anton Bruehl, (Herbert) Johnson, Lester, Ira Martin, and Mortimer Offner.[218] *Photographs of New York by New York Photographers* was another critical success for the gallery. The *New York Times* suggested that the show "be sealed in cellophane and bequeathed to the future as a document of our time," and Margaret Breuning, writing for the *New York Evening Post*, reported that "the individual approach of each artist reveals different facets of this incredibly rich material, with . . . power to present the subject at an unusual and provocative angle. This element of surprise and recognition combined adds much to the fascination of many of the exhibits."[219]

Levy would continue to acquire photographs of his native city in the years that followed. Among these is a group by Eliot Elisofon, who is remembered today for his accomplishments as a photographer for *Life* magazine as well as *National Geographic*. Deeply engaged with African culture, Elisofon photographed throughout the continent from about 1943 to 1973, published numerous books, created documentary films, and even co-directed the 1966 MGM movie *Khartoum*, starring Charlton Heston.[220] At the beginning of his career, however, Elisofon worked as a commercial photographer on the Lower East Side of New York. After showing his portfolio to editors at *Life*, he began getting assignments from the magazine in 1937, and the following year he left the studio to become a freelance photojournalist, a calling he pursued until his death in 1973 (he had a brief stint at MoMA in 1939 as their first staff photographer). Elisofon was committed to socially concerned work early on, exhibiting at the New School for Social Research in 1938 and in 1940 serving as president of the Photo League, an alliance of photographers committed to using documentary photography to effect social change.

In the half dozen photographs owned by Levy, however, Elisofon seems rather to have been following his own muse, simply walking around New York with his camera. These delightful street scenes, dating to about 1935–40, include a couple of exterior views of junk shops (see pl. 179) and one of a window covered with metal bars that form a composition of rectangles.[221] The other three images reveal Elisofon's awareness of the photographs of Atget and Evans, though they have an added lightness and wit. These are beautifully composed views showing the complex reflections in store windows and can be enjoyed for the sheer pleasure of seeing (pls. 44, 162). Elisofon may have been implying social inequity in some of these images, particularly in the juxtaposition of fancy table lamps with a walk-up tenement across the street (see pl. 171), but the group as a whole—in subjects such as the milliner's display, the junk vendor, and the local barbershop with its listing pole—evokes a sense of small-town America, of New York before it acquired sophistication.

Levy was somewhat unusual among his contemporaries in his interest in and support of American art. During the run of his gallery he exhibited the work of about forty-five American photographers and is known to have made additional American work available to patrons at the gallery. He presented solo exhibitions of at least ten American photographers. Recalling the scene at the time, Jimmy Ernst wrote that in the late 1930s "the relatively small number of galleries on Fifty-seventh Street showing contemporary art had been increased by newly arrived dealers from pre-Hitler Germany," most of whom were showing European painting with little emphasis on American work. But of those who chose the latter course, he recalled, "certainly the most interesting place at the time was Julien Levy's gallery."[222] Among the American photographers Levy supported were a number of women. Of all the members of Harvard's old boy arts network, he seems to have shown the highest proportion of work by female artists.

Plate 44
Eliot Elisofon (American,
1911–1973)
**Untitled (Hat-shop window
with reflections),** c. 1935–40
Gelatin silver print
7½ x 7⁹⁄₁₆ inches (19.1 x 19.2 cm)
The Lynne and Harold Honickman
Gift of the Julien Levy Collection
2001-62-496

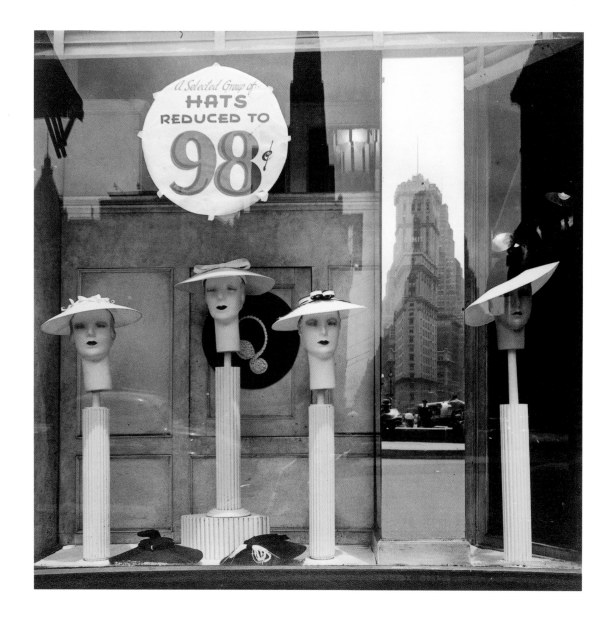

Levy's opening show of the fall season in 1932 was reserved for *Photographs by Berenice
Abbott*, a collection of portraits and city views (pls. 45, 159). In the press release for the exhibition
Levy acknowledges Abbott's accomplishments in portraiture and in bringing Atget's photography to
the United States, and then writes: "She is interested in photographing New York with an affection
and understanding such as Atget manifested for his Paris. Her documents of the New York scene
form the main part of the current show."[223] Along with Atget, Abbott had been one of the first pho-
tographers Levy exhibited, during his apprenticeship at the Weyhe Gallery. Their alliance and evolving
understanding of Atget's photographs provided a foundation for Levy's thinking about the medium
during the 1930s. Atget's pictures of the architecture of Paris—interiors as well as exteriors—are doc-
uments, to be sure, in that they are essentially records of the structures he chose to photograph. No
particular agenda is apparent in these images, and there is no evidence to suggest that Atget had any-
thing in mind other than making pictures that would be useful to his clientele and therefore salable,
although his photographs also reveal a touch of a preservationist impulse and a need to satisfy his
own aesthetic impulses. But taken as a whole, after Atget's death, his body of work was as ambitious
as the task taken up in 1910 by German photographer August Sander, who set out to create a photo-
graphic catalogue of the faces of the German people, *Menschen des 20. Jahrhunderts*, a project brought
to a halt under Nazi party rule in the 1930s. Abbott, too, was interested in documenting and catalogu-
ing. Recognizing that skyscrapers rising in the city required the razing of some of its characteristic

Plate 45
Berenice Abbott (American,
1898–1991)
Untitled (New York City),
1929–33
Gelatin silver print
6⅝ x 4½ inches (16.9 x 11.4 cm)
The Lynne and Harold Honickman
Gift of the Julien Levy Collection
2001-62-5

neighborhood haunts, she sought to capture and categorize what was being lost, a project that would come to fruition in her 1939 book *Changing New York.*

Abbott's clear-eyed vision found fans among the reviewers of her show at the Julien Levy Gallery. Numerous critics classified her as a follower of Atget, and one compared her views of New York to Stieglitz's.[224] The *New York Herald-Tribune* reported: "Miss Abbott gains her results realistically: the 'blurred focus' has no place in her cosmos, nor is she particularly concerned with ingenious affects [*sic*] in design. In her photography she tells of what she has seen simply and beautifully."[225] A writer for the *New York Post* remarked: "It is the unfamiliar aspect of the familiar which gives piquancy to much of the work. The juxtaposition of little old buildings with gargantuan masses of new architecture . . . make this collection fascinating."[226] In the *New York Times,* Edward Alden Jewell referred to Abbott as a disciple of Atget, while noting that "particularly in views of skyscraper developments, [she] succeeds in asserting her own personality, her own artistic credo." Her photographs of old New York, such as pictures of shops that specialized in selling only one thing, Jewell saw as "more palpably Atgetesque."[227] The reviewer for *Creative Art* preferred her more humble subjects, for example,

images of a cigar store Indian and an old wooden El platform "that come off successfully midway between phantasy and fact, and give off a lyric note."[228]

Levy was himself attuned to the paradox of the new urban landscape colliding with the old, and he showed work from both sides of the street: artists celebrating the engineering feats of contemporary New York (and by extension, America), among them Sherril Schell, Ralph Steiner, and Thurman Rotan; and artists committed to preserving on film the vernacular architecture of the United States, including Kurt Baasch, Walker Evans, and Luke Swank. Like cinema and photography, engineering and architecture were part of the contemporary cultural landscape and of signal importance to Levy. America's new bridges and skyscrapers were daring and unique, and they presented a dramatic break with the architecture of the Old Country. Completed at the end of 1931, the George Washington Bridge, with its radical cable-spun design, was for many years the world's longest suspension bridge and a popular subject for artists. Rockefeller Center was another wonder of modern construction—not simply a skyscraper but a complex of interconnected towers. Abbott's photograph of the construction in progress, showing the jagged maw of earth crowned with a shaft of steel towering beyond the confines of the picture, was a popular image that appeared in several publications (see pl. 39). The Chrysler Building and the Empire State Building, still among the marvels of New York's skyline, had been completed in 1930 and 1931, respectively, just as Levy was beginning his gallery.

In the United States the 1930s marked the rise of a serious consideration of contemporary architecture already underway in Western Europe. Henry-Russell Hitchcock, who had studied at Harvard just ahead of Levy, was a prominent figure among the cultural elite who specialized in the subject. He facilitated shows on contemporary architecture at museums throughout the Northeast, as well as lecturing and writing extensively on the subject.[229] In 1929 the Harvard Society for Contemporary Art had presented a show on the radical architect and designer Buckminster Fuller, which was visited by sometime Harvard student Philip Johnson.[230] In 1932 Johnson became the first director of the architecture department at the Museum of Modern Art, and during the same year he and Hitchcock organized a highly influential show and book on contemporary architecture from the years 1922–32, which they characterized as the "International Style." In more popular publications, photography and architecture overlapped in images of the startling new structures. Picture books on the subject included Gilbert Seldes's 1934 volume *This Is New York: The First Modern Photographic Book of New York*, which featured several photographers affiliated with Levy's gallery, and Frederick Lewis Allen's 1934 *Metropolis: An American City in Photographs*, with images by Edward M. Weyer. That same year Abbott collaborated with Hitchcock on an exhibition about urban vernacular architecture. Her book, *Changing New York*, was not released until 1939 and was a much more elaborate production than the celebratory picture books from earlier in the decade. Made primarily between 1936 and 1938, the photographs within document specialty shops and street vendors, bridges and elevated train platforms spanning old neighborhoods, wrought iron and iron beams, and brownstones dwarfed by skyscrapers, with historical details provided about each structure and its status in the midst of a changing landscape.

PORTRAIT PHOTOGRAPHY: OLD AND NEW

Levy's next major photography show, *Exhibition of Portrait Photography*, on display from October 15 to November 5 (fig. 19), coincided with two other photography exhibitions on view in the city, a show at the Brooklyn Museum of historical works from the collection of Thomas E. Morris and, at the Art Center, the *First National Exhibition of Photographs for Commerce, Industry, and Science*, which included a section on color photography and works by a number of photographers who had exhibited at the Julien Levy Gallery.[231] Levy had included portraits in the first photography exhibition at his gallery,

American Photography Retrospective, and just a month later, in his exhibition of work by Nadar. It was evidently a genre that was important to him. He had originally conceived portraiture as an integral part of the gallery, with the idea of having samples of work on hand for potential clients to view. His intention was to lead patrons to good practitioners, support his gallery artists, and take a commission. While members of previous generations would have been immortalized for posterity with a painting, for Levy and his forward-looking friends a photographic portrait was the chic contemporary approach.

Reviewing Levy's latest exhibition for *Creative Art,* a critic crowed: "Julien Levy, one of the most brilliant of American dealers, comes through with another first-rate picture show."[232] *Portrait Photography* was the third in a series of survey exhibitions Levy had inaugurated with his *American Photography Retrospective* in November 1931. These surveys demonstrate his commitment to a broad view of the medium through their presentation of not only a variety of topics but also a wide range of works within them. Portraits of other people are inherently difficult to market, which only underscores the fact that Levy's motivation for this particular show, as for his other surveys as well, was as much instructional as it was commercial. Undoubtedly, it was also great fun to select and install.

Just as in his American survey, Levy offered historical examples alongside contemporary work, although again in separate galleries. *Art News* reported: "Chronologically set forth by Julien Levy at his Madison Avenue gallery, the story of portrait photography comes to life with telling effect.

Starting with two little shadow-engravings touched up with color—quaint little items that preceded the reign of the daguerreotype—up to the most modern piece of photographic investigation and analysis, Mr. Levy lets us see the course of the camera artist in all the varied phases of his career" (see pl. 87).[233] Levy may have come across the early progenitors of photography during his ramblings in Paris and purchased them as curiosities, but their appearance in the exhibition along with examples of daguerreotypes and ambrotypes demonstrates a more earnest attempt to trace the history of the medium. The exhibition featured a selection of calotypes by Scottish photographer David Octavius Hill, widely considered to be the first art photographer. These were a loan from the Albright Art Gallery, which suggests Levy's determination to include Hill's work in his survey of historic photographic portraiture.[234] From his own collection of historic works he brought out some of his favorite photographs by Nadar and other nineteenth-century practitioners, including Mathew Brady, Julia Margaret Cameron, Etienne Carjat, and Napoleon Sarony. He also showed the work of Antoine Adam-Salomon (see pl. 130), whose portraits, "although his list of sitters did not include the galaxy of notables which make Nadar doubly interesting, . . . have a distinction in many ways superior," and probably the elaborately staged portrait of Princess Olga Cantacuzène, attributed to Dallemagne & Lazerges (see pl. 139).[235] From the early twentieth-century he offered portraits by Frank Eugene, Gertrude Käsebier (see pls. 141, 142), Charles Reutlinger (see pl. 85), Stieglitz, and Clarence White. Singled out by the press was a portrait by the Vandamm Studios of Katharine Cornell as Elizabeth Barrett in "The Barrets of Wimpole Street," Man Ray's visage of Tanja Ramm, and his portrait of the contemporary composer Arnold Schoenberg.[236]

In the front gallery Levy organized a bountiful contemporary section featuring Abbott, Bachrach Studios, Anton Bruehl, Arnold Genthe, George Hoyningen-Heune, Helmar Lerski, Pirie MacDonald, Man Ray, Sherril Schell, and Steichen.[237] Man Ray's elegant portrait of Joella Levy (see pl. 207) would have been a fitting contribution, and Levy surely would have included Abbott's portrait of controversial author James Joyce (see pl. 3). Abbott's portrait of Joella's sister, Fabienne Lloyd, may also have been on view (pl. 47). Lee Miller contributed the heads of two painters repre-

Plate 46
Jay Leyda (American, 1910–1988)
Aaron Perlman, c. 1932
Gelatin silver print
4¹⁵⁄₁₆ x 4 inches (12.5 x 10.2 cm)
The Lynne and Harold Honickman
Gift of the Julien Levy Collection
2001-62-670

sented by the Levy Gallery, Eugene Berman and Massimo Campigli, and Steichen sent five portraits for the show, though he wrote that he did not feel he belonged "in a portrait show as these pictures are primarily magazine illustrations—conceived and executed for the printed page."[238] Steichen, who was to take the helm of the photography department at MoMA in 1946, was at that time much occupied with photography's practical applications, and he was also pointedly distancing himself from the "art photography" he had championed with Stieglitz decades earlier. Levy, on the other hand, was not interested in such distinctions nor in limiting a photograph to a single context, such as the publication for which it had been commissioned. Steichen was indeed a marvelous portraitist, and it is interesting to note that Levy was willing to overcome lingering bad feelings between them to secure his work for this survey of superior examples of the genre.[239]

Certainly one of the highlights of Levy's latest survey exhibition was the portraiture of twenty-two-year-old Jay Leyda, who had moved to New York from Dayton, Ohio, around 1930 to work with photographer Ralph Steiner. Levy probably learned about Leyda from Steiner. At the beginning of the year he had shown the young man's *A Bronx Morning*, the film that was the catalyst for Leyda's liason with the independent, left-wing attorney Carol Weiss King (see pl. 200). Leyda's frank portrait of King, nearly fifteen years his senior and a recent widow, captures her from above in what could have been an awkward, vulnerable position but is instead open and relaxed. Leyda left for Russia in 1933 to study with Sergei Eisenstein at the Moscow State Film School and worked as a theater critic while abroad, later marrying the dancer Si-lan Chen and working with Eisenstein on the film *Bezhin Meadow*. He returned to New York in 1936 with film reels of Eisenstein's *Battleship Potemkin* and was briefly the assistant curator of films at the Museum of Modern Art, helping to build the collection there until a newspaper article cast suspicion on his close ties with the Soviet Union and he was

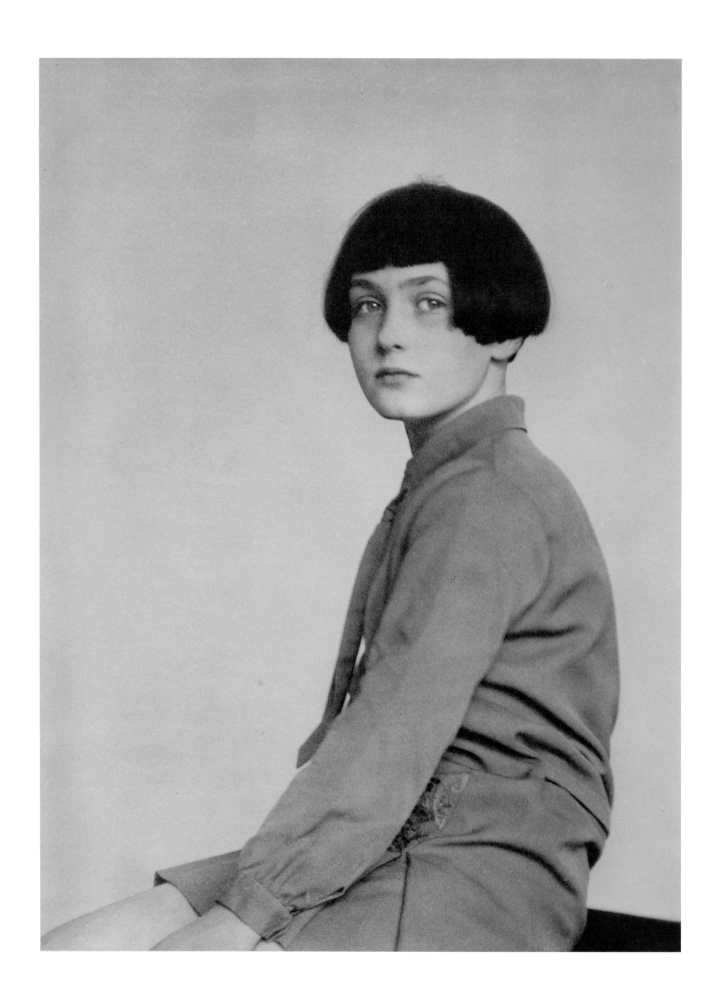

Plate 47
Berenice Abbott (American,
1898–1991)
Fabienne Lloyd, 1928
Gelatin silver print
9⁹⁄₁₆ x 6¹⁵⁄₁₆ inches (23.6 x 17.6 cm)
The Lynne and Harold Honickman
Gift of the Julien Levy Collection
2001-62-11

forced to resign. Remarkably, Leyda went on to become the author, editor, and translator of many books, not only on film but also on Herman Melville, Emily Dickinson, and Sergei Rachmaninoff, and he taught cinema at New York University from 1973 to 1988. Lost in this extraordinary career are the quite wonderful portraits he made of his friends and associates at the beginning of the 1930s, including portraits of Levy (see pl. 204), MoMA director Alfred Barr, art dealer Frank Rehn, and Aaron Perlman, the latter being menaced by a floating pair of scissors (pl. 46).[240]

After the portrait show closed, Levy, still hungry to discover American Surrealists, capitalized on the opportunity to bring Lee Miller's work forward for the first time, and at the end of December 1932 presented the first and only solo exhibition she would have during her lifetime (fig. 20). The announcement essay was by Frank Crowninshield, the editor of *Vanity Fair* whom Miller had known at Condé Nast during her years as a fashion model. Miller had begun mixing with the New York culturati in 1927, the same year she appeared as a cover model for *Vogue.* In 1929 she traveled to Italy and then to France, where she sought out Man Ray (just as Levy had a few year earlier) to study photography; soon afterward she became his assistant and lover (fig. 21). Miller was quick to master the camera. She continued to live and work in Paris and probably first met Levy during his trip to Europe in the summer of 1931, when he encountered her regularly and purchased her work for the gallery. Not only was Miller represented in his *Modern European Photography* show, but her visage had also appeared in the Man Ray exhibition at the gallery in the spring of 1932. By then she had broken away from Man Ray both personally and professionally and was romantically linked to several men, including Aziz Eloui Bey, whom she would marry in 1934, and Julien Levy.

In mid-October 1932 Miller arrived in New York to open a studio with her brother Erik at 8 East 48th Street, near the newly constructed Radio City Music Hall at Rockefeller Center, in close proximity to the Julien Levy Gallery. Between magazine and portrait assignments, she must have spent time at the gallery. She met Levy's new prodigy Joseph Cornell, whose creations she photographed along with other views of the gallery for the magazine *Town and Country.* Her Cornell portrait is an arresting view of the artist's face in profile in front of a toy ship whose mast Cornell has strung with a long hank of hair that trails behind him (he, in turn, was captivated by Miller and made a collage incorporating two photographs of her face in profile).[241] The *New York Times* reviewed Miller's show, praising her portraits and mentioning that although she had been associated with Surrealism, "her photographic work is singularly free from disconcerting tricks of overstatement, understatement, evasion and palimpsist. . . . [S]he does not try to conceal a healthy affection for subject matter . . . an affection that many modern artists have pretended was unworthy of them and their exalted calling."[242] A writer for the *New York Post* commended Miller for keeping her work "quite direct and individual, with no hint of fashionable follies" and found her photographs "as fresh and invigorating to the beholder as if he had never enjoyed the wonders of the camera plus brains before."[243] This critical commentary again suggests a shift away from the experimental and constructivist style of European photography that had initially attracted Miller, Man Ray, and others to the camera toward a plainer, less obviously manipulated style already being practiced by Abbott and Evans.

Levy's holdings by Miller are fairly extensive and are intriguing in their variety, ranging from several elegant studio portraits (pls. 48, 49) to a pastoral view of cows in the landscape.[244] In Europe, Miller was drawn to organic shapes that would yield abstract compositions when photographed. Her masterful image of tar presents the menacing tentacles of the enigmatic substance apparently advancing to envelope the viewer (see pl. 252).[245] Other amorphous forms appear in two pictures of rocks taken at an unknown location, possibly in England, which because they cannot be easily classified have a similarly unsettling effect, along with phallic and scatological overtones (see pls. 256, 257).

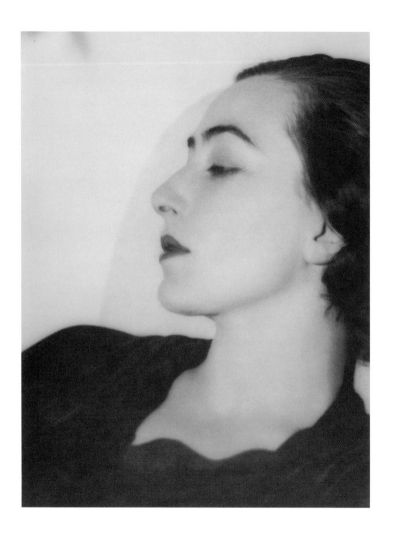

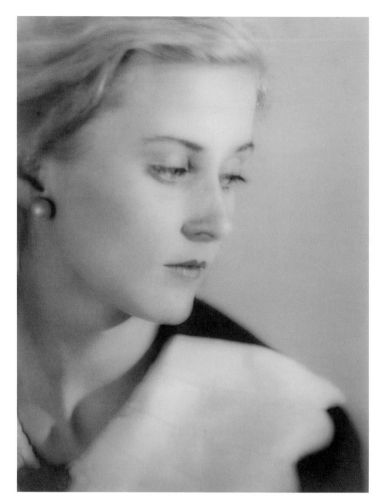

Plate 48 (above left)
Lee Miller (American, 1907–1977)
Nimet Eloui, 1930
Gelatin silver print
9¹/₁₆ x 6⅞ inches (23 x 17.5 cm)
The Lynne and Harold Honickman
Gift of the Julien Levy Collection
2001-62-806

Plate 49 (above right)
Lee Miller (American, 1907–1977)
Renée Hubbel, c. 1930–32
Gelatin silver print
9 x 6⅞ inches (22.8 x 17.5 cm)
The Lynne and Harold Honickman
Gift of the Julien Levy Collection
2001-62-814

Fig. 20 (bottom left).
Announcement for *Lee Miller,*
Exhibition of Photographs,
1932. Courtesy of the Julien Levy
Archive, Connecticut

Fig. 21 (bottom right). **Lee Miller,**
c. 1932. Courtesy of the Julien Levy
Archive, Connecticut

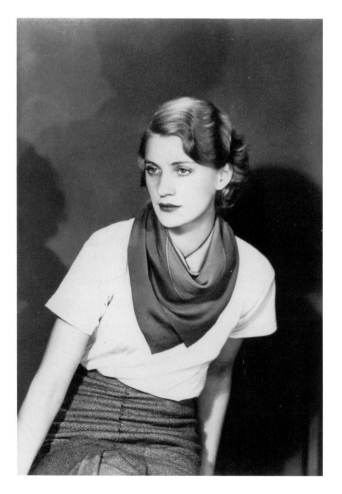

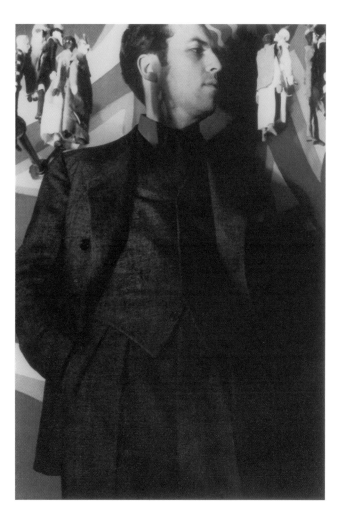

Fig. 22. **Carl Van Vechten**
(American, 1880–1964). **Max
Ewing,** 1932. Gelatin silver print,
9⅗ × 6½ inches (24.3 × 16.5 cm).
Philadelphia Museum of Art. Gift
of John Mark Lutz, 1965-86-4083

Miller's powerful portrait *Mrs. Donald Friede* is presumably of Anna Fleischer, married from 1930 to 1936 to the fearless publisher Donald Friede, whom Miller had met in Paris (see pl. 235). The image reminds us that Miller worked closely with Man Ray for several years and had observed the prevailing Surrealist aesthetic for truncated women and disembodied heads (in fact, Levy owned pictures of headless female torsos by both artists). Her picture shows a skillful use of that vocabulary without being derivative, and the emphasis on the woman's eyes is particularly disquieting. Miller was clearly interested in the possibilities of the compositional device of cropping an image, exploring it several times during the 1930s, as in a 1932 portrait of Tanja Ramm with a bell jar and the 1933 "floating head" portrait of Mary Taylor, both well realized but ultimately not as daring as *Mrs. Donald Friede*.[246] In the first, Ramm's body is hidden behind the table on which the glass dome rests, while in the second, Taylor's face appears sideways at the bottom of the composition in a position reminiscent of Man Ray's *Noir et blanche* image of Kiki de Montparnasse, in which the model's head rests on a table. Mrs. Friede, with her wide-open gaze, seems to be the most detached of all.[247]

Immediately following Miller's exhibition, on January 25–26, 1933, for one night and one day only, the Julien Levy Gallery presented *The Carnival of Venice: Photographs by Max Ewing*.[248] Ewing, a young novelist, created this body of work by photographing friends from across the social spectrum whom he had invited to appear at his apartment as "whatever they liked in Venice," according to the exhibition announcement essay by Gilbert Seldes, himself one of Ewing's subjects.[249] Ewing photographed each individual against the backdrop of a window shade featuring a Venetian scene. The roster of names begins with Berenice Abbott and, in addition to such familiar figures as Levy, Joella, Lynes (dressed as a cherub), Kirstein (clothed as a gondolier), and Allen Porter, includes writer e.e. cummings, artists Miguel Covarrubias and Isamu Noguchi, and other prominent cultural figures.

"I doubt whether Mr. Ewing was trying to penetrate to the subconscious desires of his subjects," Seldes wrote in an apparent poke at Surrealism. "I think that he wanted to make a series of entertaining and admirable photographs."[250] A portrait of Ewing by Carl Van Vechten seems to refer to his Venice project, with rows of costumed figures appearing on either side of his head; perhaps he was photographed at the opening reception (fig. 22).

All of the photographic subjects were invited to attend the exhibition opening wearing the same clothing and carrying the same props used in the photographs. A full-page spread in *Town and Country* magazine reported that "Julien Levy's gallery swarmed with celebrities in fur coats and bathing suits, brandishing telephones and fragments of sculpture."[251] The *New York Sun* called the party "quite O.K." and compared it to the lively evening atmosphere at the café-bar Boeuf sur le Toit in Paris, but with an admission charge (levied even on Seldes). "And all this, mind you, for photography! . . . It's not for me to mend the world but to accept it as it is, and the truth is it's getting to be terribly photographic."[252]

AMERICAN VERNACULAR

Levy's interest in artists and subjects indigenous to the United States is apparent in several of his 1933 photography exhibitions. Two shows in February showcased his interest in American vernacular subjects: *Photographs of the American Scene by Luke Swank* (fig. 23), which opened in January, and a solo show of photographs by Kurt Baasch that opened after the Swank exhibition closed and contin-

Fig. 23. **Exhibition announcement for *Photographs of the American Scene by Luke Swank,*** 1933. Courtesy of the Julien Levy Archive, Connecticut

ued into March. Swank, a terrific photographer who has remained in the shadows of fame, discovered Levy rather than the other way around. The son of a prominent Pittsburgh merchant, he managed the family car dealership in Johnstown while pursuing his interest in photography on weekends at sites such as Bethlehem Steel. In 1935 he was hired as a staff photographer by the University of Pittsburgh, and he later worked for many years as a photographer for the Heinz Company. An educated and well-read man, Swank saw a notice for the Julien Levy Gallery in an issue of the *New Yorker* and wrote to Levy expressing an interest in working together on an exhibition.[253]

Swank was a photographer absolutely fresh to the scene, apparently untutored, with a tremendous sensitivity for the passing traditions of American life and an unquestionable ability with the camera (see pl. 161). Levy could hardly have invented a more ideal artist for himself. Like Abbott and Evans, Swank was drawn to vernacular American architecture and in 1933 was documenting buildings constructed before 1860 for an American Institute of Architects survey.[254] Swank's depictions of architecture are less frontal than Evans's, however, and have a decidedly warmer feel (pls. 50, 51). His low-angle view of a farm door mechanism (see pl. 153) inevitably calls to mind Sheeler's barn of 1915 (see pl. 151), and even Clara Sipprell's composition of barn shapes (see pl. 13). But while Sheeler's picture is a tour-de-force of flattening, transforming a massive barn onto the one-dimensional plane of the photograph, Swank's image is more about shapes and retains an interest in intimately describing the functionally elegant yet outdated gizmo on the farm door. The central form is arresting and somewhat cryptic even though presented in sharp detail.

In the press release for the exhibition, Levy described Swank's photographs as "refreshing, and unmistakably American." He continued by quoting a letter in which Swank wrote, "I feel that I want my work to be illustrating the things that are passing in our American scene," particularly the circus, river steamboats, log cabins, mountain farms, and carnivals.[255] Swank's composition *Pittsburgh #12* (see pl. 170), showing a sidewalk display of baskets, bundled cord, and stacked containers, is

packed with description. The scene is the antithesis of consumer goods carefully arranged inside a plate-glass window, and we are aware that Swank's sympathy lay with the humble assortment. Yet like Evans, and also Atget, he simply shows us what is there rather than playing on heartstrings (pls. 50–52).[256] The piece was later selected for exhibition in the *First Salon of Pure Photography*, organized in 1934 by Group f.64 in California.

The press had a heyday with the artist's name, and a critic for *Art News* wrote: "He sounds as if Sherwood Anderson had invented him."[257] Swank "has placed an exceedingly sensitive eye behind the lens of his camera so that his record of the world as is makes engaging reading," another observed.[258] This recognition was not lost on Swank, who was particularly forthcoming in his gratitude toward the gallery. After exhibiting in the 1932 mural show at MoMA, in preparation for which he produced five separate maquettes, he wrote to Joella Levy at the gallery: "I feel that American photographers certainly owe a great debt to you and Mr. Levy. Through you[r] efforts they have been given the first opportunity to show their work in a large exhibition as a fine art, and the way is probably made easier for future recognition."[259] Swank had a fruitful career in the 1930s, participating in the Brooklyn Museum's international survey of photography, exhibiting in a one-man show at Delphic Studios, and taking part in group shows in Buffalo and Pittsburgh. In 1938 Beaumont Newhall wrote a feature on Swank's photography for the fall issue of *U.S. Camera* and acquired his work for MoMA. Swank's promising career was cut short by his death in 1944, and his impressive oeuvre became virtually unknown outside of Pittsburgh until very recently.

Kurt Baasch, whose solo exhibition immediately followed Swank's at the gallery, is another remarkable photographer who has too long been neglected (fig. 24).[260] Levy had included his work in *Photographs of New York by New York Photographers*. Already a photographer when in 1911 he arrived in the United States from Europe as a young man of twenty, Baasch immediately befriended Stieglitz, White, Strand, and other key figures. He joined the Camera Club of New York, where he had a one-person show in 1913, and was particularly close to Strand, who made several large platinum portraits of him in 1911 and 1921.[261] As a newcomer to New York, Baasch had a fresh eye on the scene, and his engagement with the city is evident in his photographs. His vision, manifested in a small body of work, was a powerful one and certainly provided inspiration for Strand in his own experimentation in the early 1910s with abstraction and even street photography.

Baasch's fascination with the details of life in New York is beautifully realized in his exquisite platinum prints, which vividly record the texture of a given scene, a concern shared by Swank. During the 1920s Baasch had found other pastimes, but around 1930 his interest in the camera seems to have re-ignited, and the new work he produced was most likely what Levy exhibited in 1933.[262] In the 1930s Baasch was increasingly drawn to American genre scenes and signage, subjects that were being explored by others, including Swank and Evans. His image in Levy's collection shows an empty window frame over a rickety storm-cellar door; it is a riot of texture and line punctuated by a white patch on the left and a white cat on the right (see pl. 164). The picture harmonizes with Elisofon's junk shops and Swank's vernacular structures. "A picture to satisfy me today must be vital by bringing out the essence of a thing in relation to our life as we live it," Baasch stated.[263] Visually, however, his work has more of an affinity with images by Ralph Steiner and Ralston Crawford, who were also exploring American themes but were similarly drawn to abstraction and structured compositions.

Fig. 24. **Exhibition announcement for *Kurt Baasch Photographs,*** 1933. Courtesy of the Julien Levy Archive, Connecticut

Plate 50 (left)
Walker Evans (American, 1903–1975)
Untitled (Doorway), c. 1930
Gelatin silver print
4³⁄₁₆ x 2¹⁵⁄₁₆ inches (10.7 x 7.5 cm)
The Lynne and Harold Honickman
Gift of the Julien Levy Collection
2001-62-503

Plate 51 (right)
Luke Swank (American, 1890–1944)
Untitled (Doorway and street light), c. 1930–33
Gelatin silver print
6 x 4 inches (15.3 x 10.2 cm)
The Lynne and Harold Honickman
Gift of the Julien Levy Collection
2001-62-1133

Plate 52 (opposite)
Eugène Atget (French, 1857–1927)
Impasse Chartière, 1924
Matte albumen silver print
8¹¹⁄₁₆ x 6¹¹⁄₁₆ inches (22 x 17 cm)
The Lynne and Harold Honickman
Gift of the Julien Levy Collection
2001-62-88

ANTI-GRAPHIC PHOTOGRAPHY: "APOTHEOSIS OF THE ACCIDENTAL"

In the gallery's third season, in keeping with his growing interest in sharp-focus pictures, Levy presented a different view of French photography in the first solo exhibition of work by Henri Cartier-Bresson. Levy had met Cartier-Bresson at Caresse Crosby's country house outside Paris in the summer of 1931. He recalls American collectors Peter and Gretchen Powel escorting their new protégé, "a baby-faced photographer damp with shyness," and urging Levy to visit his studio (fig. 25).[264] Cartier-Bresson, who was only twenty-five years old when Levy first exhibited his work, was "unquenchably eager, shockingly optimistic, wide-eyed with wonder and naïveté," as Levy later described him. "Henri was a radical in the darkroom, violating all the sacred rules." Levy speculated that this was why he liked him and "decided to defend his 'snap-shotty' miracles to the point of attacking the photo gods," such as Stieglitz, with whom he had argued Cartier-Bresson's merits.[265]

Levy fashioned the essay in the exhibition announcement in the form of a letter to himself and signed it with the pseudonym "Peter Lloyd." In it he confesses his enthusiasm for "the vigour and importance of Cartier-Bresson's idea," although "an essential part of that idea is such a rude and crude, such an unattractive presence, that I am afraid it must invariably condemn itself to the superficial observer. . . . If [only] Cartier-Bresson were more the propagandist and could efficiently promote some theory or another to excuse his work."[266] For Levy, Cartier-Bresson's work held "all the vitality of a new direction," as he stated in the press release, adding that the photographer's "alert eye and hand may achieve results which cannot be attained by methods of consideration and polish."[267]

On view from September 25 through October 16, 1933, the exhibition was accompanied by a complementary display in the back room of news photographs and images by contemporary photographers Berenice Abbott, Walker Evans, Man Ray, Lee Miller, Creighton Peet, and Dorothy Rolph that Levy believed showed similar tendencies. This collection of what Levy termed "'accidental' photographs, both old and new," was acknowledged in the show's title, *Exhibition of Anti-Graphic Photography*.[268] Levy began the press release for the two exhibitions by asking: "What is an anti-graphic photograph? It is difficult to explain, because such a photograph represents the un-analyzable residuum after all the usually accepted criterions for good photography have been put aside. It is a photograph not necessarily possessing print quality, fine lighting, story or sentiment, tactile values or abstract aesthetics. It may lack all the virtues which this Gallery has championed in supporting photography as a legitimate graphic art. It is called 'anti-graphic', but why shouldn't the Julien Levy Gallery fight for both sides of a worthy cause? After discarding all the accepted virtues, there remains in the anti-graphic photograph 'something' that is in many ways the more dynamic, startling, and inimitable."[269]

A writer for the *New York Evening Post* responded: "Anti-graphic is not so revolutionary as it sounds, for it is, in fact, a harking back to the first revolt of photography against the limitations of the 'pretty picture,' through exaggerations, bizarre spacings and tendency to eccentricity." Rejecting Pictorialism and European modernism in one fell swoop, the writer continues: "Today it takes a great artist with the camera, just as on the stage, to get away with carefully planned effects of simplicity. . . . There is a great deal to be said today for getting away from the tricks of under and over exposure, six different screens, and the over-embellished effects which these devices produce, and for concentrating on a direct and essential approach such as has long been emphasized in art and decoration. . . . All in all, it is a provocative show to open the new art season."[270] Critic Lewis Mumford devoted several paragraphs to the show in a review in the *New Yorker*:

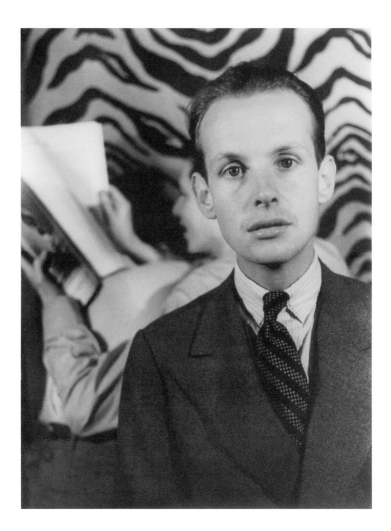

Fig. 25 (left). **Carl Van Vechten** (American, 1880–1964). ***Henri Cartier-Bresson,*** 1935. Gelatin silver print, 9¾ x 7⅜ inches (24.7 x 18.5 cm). Philadelphia Museum of Art. Gift of John Mark Lutz, 1965-86-2869

Plate 53 (right)
Henri Cartier-Bresson (French, 1908–2004)
Untitled (Woman and child), c. 1933
Gelatin silver print
9¹³⁄₁₆ x 6⁹⁄₁₆ inches (25 x 16.7 cm)
The Lynne and Harold Honickman Gift of the Julien Levy Collection
2001-62-459

Let no one who has a healthy distrust for isms and movements keep away from the Julien Levy Gallery merely because its first exhibition this season is devoted to anti-graphic photography. In one sense, all good photography is anti-graphic; it concerns itself quite properly with the things that cannot be painted or drawn by the human hand. . . . But by anti-graphic photography, Mr. Levy means something a little different from this respect for the camera's medium and method; he has gathered together a series of photographs in which the values of photography itself are secondary—in which clarity, texture, contrast of black and white, and gradation of tones are neglected, and in which the value lies not in how the camera sees but in what it sees, what it sees sometimes despite the clumsiness or lack of intention of the photographer. This exhibition is the apotheosis of the accidental, the glorification of the snapshot as such. The images are in effect puns and witticisms and flashes of comment; the photography itself may be fifth-rate.[271]

Levy had evidently been at pains to point out the humorous elements of some of the artist's pictures, as critics frequently mentioned it. Mumford perceptively connected the work with the spirit of Surrealism when he noted that in Cartier-Bresson's work "the element of wit is uppermost, as must necessarily happen when one begins deliberately to capitalize one's accidents." Elaborating further, he wrote: "The most amusing of his pictures emphasize the double-entendre, pictures in which you actually see one thing and in which he tricks you into fancying, for the moment, that you see something naughtier" (pl. 53). Perhaps referring to the photographer's lavish pile of viscera (see pl. 253), he described one picture as laying on "a touch of sheer neurotic brutality, as in some of the fancier moving pictures from Paris which were shown here last year."[272]

Plate 54
Henri Cartier-Bresson (French, 1908–2004)
"Menagerie All Day,"
Marseilles ("Ménagerie toute
la journée," Marseille), c. 1932
Gelatin silver print
4¹³⁄₁₆ x 7¼ inches (12.3 x 18.4 cm)
The Lynne and Harold Honickman
Gift of the Julien Levy Collection
2001-62-456

Reviewers uncharacteristically failed to list or describe specific pieces in the show, but many of the photographs by Cartier-Bresson that Levy acquired are somber images of drunks or vagrants on the streets of France and Mexico, their wit not entirely evident. Certainly an image such as the 1932 *Funérailles de l'acteur comique Gallipeaux, Paris* (Funeral of the Comic Actor Gallipeaux, Paris; see pl. 185) has a bit of universal whimsy to it—in the form of the officious gendarme whose elaborate mustache echoes the shape of the hat worn by the man behind him (only fitting for the passing of a comic actor). The marvelous image *"Ménagerie toute la journée," Marseille* ("Menagerie All Day," Marseilles; pl. 54) is humorous in a wry sort of way, capturing a man passed out or sleeping under remnants of a circus poster featuring the leering face of a clown. Also relying on text for its punch is the lovely, spare, untitled print of a boy, a dog, and a man peering out of his doorway toward a prominent sign painted on the building that emphatically declares, "Jesus Christ is the same, yesterday, today, forever!" (see pl. 194). Levy's collection of Cartier-Bresson pictures was extensive, initially numbering nearly forty, and is distinguished by prints made by the artist himself, in the years before he ceded that task to others.[273] These are all photographs from the early 1930s, taken on Cartier-Bresson's travels in France, Italy, Mexico, Spain, and also Africa. Several reflect his interest in capturing the fleeting moment, many are grim in tone, and a few seem uncharacteristically sentimental.

Levy returned to the theme of "anti-graphic" photography in April 1935 with the exhibition *Documentary and Anti-Graphic Photographs by Cartier-Bresson, Walker Evans, and Álvarez Bravo* (fig. 26).[274] Evans had traveled to Cuba in the spring of 1933 to take a series of photographs to illustrate a book by journalist Carleton Beals, *The Crime of Cuba*. One of the Evans photographs in Levy's collection—a variant of an image included in the Beals book—was taken in Havana and might have been included in this exhibition (see pl. 193). Along with other images he took in Cuba that were on view, it meshes well with some of the street photography being done in France around the same time, for example by Eli Lotar (see pl. 29), but most particularly for Levy, by Henri Cartier-Bresson and, in Mexico, by Manuel Álvarez Bravo. The photograph seems to echo Beals's message about the poverty

and difficult living conditions in Cuba, although in company with Cartier-Bresson's images of indigents the theme is internationalized.

During the 1930s Evans photographed in at least sixteen eastern states—Alabama, Arkansas, Connecticut, Florida, Georgia, Louisiana, Maine, Massachusetts, Mississippi, New Jersey, New York, Pennsylvania, South Carolina, Tennessee, Virginia, and West Virginia—lending credence to the title of his 1938 solo exhibition at the Museum of Modern Art, *American Photographs*. Although Levy's exhibition included a sizable group of Evans's pictures from Cuba, the photographer's American work was also a presence, particularly his pictures of buildings. The architecture is in most cases historic and often neglected, in ruins, or distinctively embellished by the owners. Levy showed Evans's well-known 1934 picture *License Photo Studio* and the madly striped façade of a barbershop with its striped pole, striped lamp, and woman in a striped top.[275] The selection included several Louisiana plantations, a horse stable in Natchez, Mississippi, and homes in the French Quarter of New Orleans ornamented with decorative ironwork. "In Evans's pictures of temples or shelters the presence or absence of the people who created them is the most

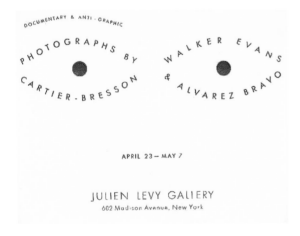

Fig. 26. **Exhibition announcement for *Documentary and Anti-Graphic Photographs by Cartier-Bresson, Walker Evans, and Álvarez Bravo,*** 1935. Courtesy of the Julien Levy Archive, Connecticut

important thing. The structures are social rather than artistic monuments," Lincoln Kirstein wrote in the catalogue for the MoMA show. "[O]ur buildings are impressive only in relation to the people who built and use them."[276] A rare interior view in Levy's show was *Bed and Stove, Truro, Massachusetts,* a 1930-31 picture in which elaborately patterned wallpaper competes for attention with the swirling lines of an iron bedstead, a framed portrait, and a plump iron stove with its own fancy finial (pl. 55). A few photographs of New York were also included, notably men in the window of a luncheonette, but for the most part the Evans pictures in the show were taken outside Manhattan.

Cartier-Bresson's work in the exhibition was characterized by shrouded and bundled forms, including a wrapped figure from Mexico oddly juxtaposed with a sport coat on a hanger (pl. 56). In *Rouen,* a man is dwarfed by the curtain of fabric suspended beside him and bundles himself into an

almost invisible pile on the ground.[277] The exhibition also featured a number of photographs of children, such as a small boy from the Ivory Coast sticking out his tongue, a jumble of Mexican children that is all legs, and a sleeping Mexican girl wrapped in her rebozo (see pl. 191).[278] These are all scenes pulled out of the flow of life by the photographer, some raw and others beautifully composed.

The third artist in the exhibition, Manuel Álvarez Bravo, was represented by several of his most splendid images, including *Caja de visiones* and *Parabola optica* (see pls. 241, 238), which seem oddly out of place in this context. Other images, however, are more harmonious with Levy's idea of anti-graphic photography (see pl. 184). Several window-reflection pictures were included, such as Álvarez Bravo's mannequin with a fur stole (see pl. 18) and a shop displaying a large model ship (see pl. 183). Very much in tune with Evans and Cartier-Bresson was his untitled image of a man leaning against a wall, his face turned away from us looking around a corner (pl. 57).

Levy's subsequent photography exhibition could be seen as a continuation of the anti-graphic theme, although it was not described as such. In February 1934 the gallery presented the work of photojournalist Remie Lohse (fig. 27). Lohse was a standout photographer for Condé Nast, his work appearing in *Vogue* and *Vanity Fair* during the 1930s. M. F. Agha, the longtime art director at *Vanity Fair,* called Lohse "the big miniature man," referring to his use of a small handheld camera. Agha praised Lohse for his ability to (like Cartier-Bresson) "Catch Life In The Act," writing in the

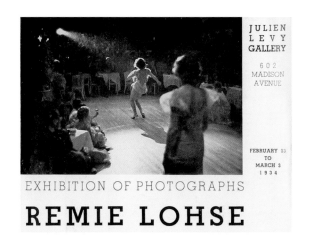

Fig. 27 (left). **Announcement for Remie Lohse, Exhibition of Photographs,** 1934. Courtesy of the Julien Levy Archive, Connecticut

Plate 58 (right)
Photographer unknown
Remie Lohse exhibition in the Julien Levy Gallery, 1934
Gelatin silver print
4⅜ x 5⅞ inches (11.1 x 14.9 cm)
The Lynne and Harold Honickman
Gift of the Julien Levy Collection
2001-62-714

JULIEN LEVY GALLERY
602 MADISON AVENUE

FEBRUARY 13 TO MARCH 3 1934

EXHIBITION OF PHOTOGRAPHS
REMIE LOHSE

exhibition announcement that "Lohse knows how to capitalize the lucky accident, but he knows also how to plan and control it."[279] The announcement promised a mix of earthy subjects, including images of theater, cinema, burlesque, street scenes, and other candids. A writer for the *New York Sun* remarked of the exhibition, "you almost begin to pity Paris and London, for those old-fashioned cities surely cannot have wares comparable to ours to offer to genuine modernists."[280] Fourteen photographs by Lohse remain in the Levy collection, including an image of women spectacularly clad in feathered costumes (see pl. 262) that would have been at home with Nadar's photographs of popular performers (see pl. 97), Atget's small group of pictures of Paris brothel workers, or the miscellaneous theater shots Levy owned (see pl. 86). Several negatives from the installation of the exhibition are extant (pl. 58).

Levy's next photography show, in April 1934, featured work by Mississippi-born photographer Wynn Richards. Richards had studied at the Clarence White School and was active as a documentary photographer as well as in advertising at her studio on 54th Street in New York. *Wynn Richards, Exhibition of Photographs of Women Prominent in Fashion* featured a series of forty-eight portraits of the behind-the-scenes female stars of the fashion world—dress designers, magazine editors, cosmetics specialists, and department-store buyers—"who have muscled their way into men's fields and established themselves as authorities to be reckoned with," wrote Alice Hughes for the *New York City American.* "These are the women whose tastes and tactics establish what this country's feminine population will wear."[281] Wynn was quoted on her choice of subjects: "By the time women have reached the top rung in their business ladder, they have often traded what they had of beauty in their faces for character and intelligence. But this makes them all the more photographic."[282] Among them was Carmel Snow, fashion editor at *Harper's Bazaar.* Levy apparently did not retain any of Richards's work, and the photographer is better known today for her gentle still lifes.

Following the solo exhibition of Lynes's photography in October 1934 (see pp. 50–52), Levy's next show to include photographs was in January 1935, when he devoted an exhibition to the work of Mexican artist Emilio Amero. It was a multi-media showing, including examples of his paintings, prints, watercolors, drawings, and photographs (fig. 28).[283] In the early 1920s Amero had worked in the fresco technique and assisted José Clemente Orozco on one of his murals. He was active as an illustrator during a 1925 trip to Havana, Cuba, then traveled to New York City and continued to do

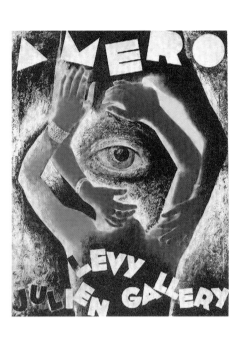

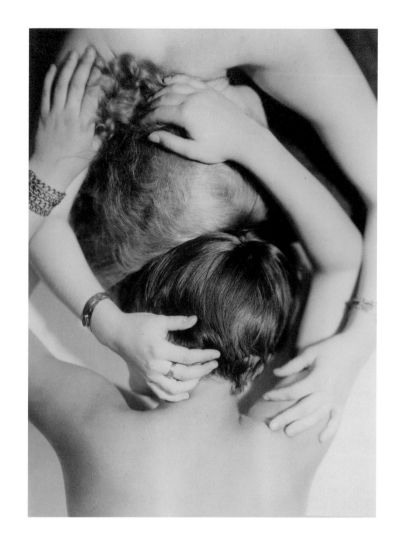

artwork for magazines and department stores, as well as doing caricatures. Still in New York in the late 1920s, Amero began working in photography and lithography and, with Mexican poet Gilberto Owen, conceived the short film *777*. In 1930 he returned for several years to Mexico, where his photographs and lithographs were published in the magazine *Contemporáneos* and he had a solo exhibition of photographs at the Galería de Arte Moderno. He taught art at his alma mater and opened the Galería Posada, organizing a one-man show of photographs by Manuel Álvarez Bravo in 1932 and having his own solo photography exhibition there at the end of the year. He arranged lectures and film screenings and started a movie club, all while continuing to work in photography and film. He was particularly close to photographer Augustín Jiménez, with whom he had shown his lithographs at the Delphic Studios in New York in 1931. Levy contacted Amero in 1932, inquiring about his photographs. In the letter he states that he is unfamiliar with Amero's work but that it was recommended to him by the artist Jean Charlot, whom he had consulted regarding names for a Mexican photography exhibition he was planning for the fall.[284]

By 1934 Amero was back in New York, where he taught at the Florence Cane Art School alongside Charlot, who wrote the essay for his 1935 show at the Julien Levy Gallery: "Whatever its medium, the core of his work consists of a delicate, always changing, often noble introspection, an ever-deepening self-analysis that juggles meaningfully with the objects of the world, using them as a double entendre for its moods."[285] While Amero's prints are closely aligned with the heroizing, almost classical style of draftsmanship that characterizes much of 1930s Mexican art, his photograms—made using the same cameraless technique employed by Man Ray, László Moholy-Nagy, and others—are astonishingly individual and fresh.[286] Three of these are in the Levy collection, including a satisfyingly

patterned study with glasses and circles, reminiscent of a Bauhaus exercise in portraying transparency (see pl. 219). Amero's hypnotic composition *S Cloud Photogram / Eyes in the Sky* (see frontispiece) uses the unseeing eye motif familiar from many photographs in Levy's collection, including examples by Álvarez Bravo and Eli Lotar, and would have appealed to the Surrealist in Levy. The third Amero photogram in the Levy collection is a layered, textural piece composed of waves of hair overlaid with seashells, and there is also the photograph used as the basis for the exhibition announcement—two women lying facedown, head-to-head, their arms twining about each other's shoulders and necks—which Amero augmented in his print version with another staring eye (fig. 28; pl. 59).[287]

Although Charlot had written that "far from being weakened through his use of many mediums, [Amero's] expression emerges enriched and fully defined," a reviewer for the *Flushing News* (Long Island) found the exhibition "a not-too-well integrated showing," writing that "a complete atmosphere of superficiality and adolescent naughtiness of concept prevent any very serious consideration."[288] Charlot's message that Amero was "unpreoccupied by the Indianism that pervaded Mexican art . . . his work is as Mexican as he is," was apparently received by the press, however, as the *New York Times* noted that Amero "looked with a sympathetic eye upon some of the modern movements in Paris, though the eye has not altogether lost its native flavor of vision," and the *New York Sun* affirmed that "Mr. Amero seems quite sufficiently Mexican for all our purposes."[289] In 1936 Amero tested some local subject matter, producing several images at Coney Island.[290]

GROUP f.64 AND THE NEW OBJECTIVE PHOTOGRAPHY

The increasing presence of photography in the United States was felt not only in New York City but elsewhere in the country. Far from the New York art scene, photography was featured in several California museums. In 1932 the M. H. de Young Memorial Museum in San Francisco organized a solo exhibition of the photographs of Ansel Adams. That same year a group of San Francisco Bay–area artists banded together to form Group f.64, their name borrowed from the small lens aperture they used to increase sharpness and depth of field in their photographs. The group included Adams, Imogen Cunningham, John Paul Edwards, Sonia Noskowiak, Henry Swift, Willard Van Dyke, and Edward Weston, and met at Van Dyke's place at 683 Brockhurst, which had formerly been the studio of Stieglitz protégé Anne Brigman. Adams had another solo exhibition at the San Francisco Museum of Art in early 1933, then set out across the country by train to New York. There he met Alfred Stieglitz, who in 1936 featured his work in one of only two photography shows at An American Place, and gallery director Alma Reed of Delphic Studios, who sold some of his photographs. Adams was also in close contact with Beaumont Newhall and his wife, Nancy, and was an important resource and sounding board for Newhall's early photography shows at MoMA.

The emergence of the f.64 movement essentially corresponded with the opening of Levy's gallery, and the group's commitment to what they called "straight photography" paralleled Levy's interest in unmanipulated photography, or what a reviewer of the Evans show had called "the new objective type of photography."[291] The f.64 photographers worked with large-format cameras, believed that pictures should be composed completely in the camera (on the negative), and printed their images full-frame as contact prints, with the size of the print matching the size of the negative. This was an outright rejection of the manipulations characteristic of Pictorialist photography, practiced previously by all the f.64 members, in which the handwork of the artist was considered a necessary and desirable element in the finished print.[292] As it happens, the f.64 approach closely corresponds to the working methods of Atget. Although Atget was not a particularly important reference point for Group f.64, for Levy the group's methods would have been an extension of that tradition.[293]

In their manifesto, Group f.64 explained that the name "signifies to a large extent the qualities

of clearness and definition of the photographic image which is an important element in the work of members of this Group."[294] John Paul Edwards wrote that f.64 photographers believed that "the greatest aesthetic beauty, the fullest power of expression, the real worth of the medium lies in its pure form rather than its superficial modifications."[295] The work of some of these photographers, Imogen Cunningham and Edward Weston in particular, bears an affinity with the Neue Sachlichkeit (New Objectivity) work of contemporaneous German photographer Albert Renger-Patzsch, who strongly advocated the use of the camera's unique, inherent qualities. In a review of Renger-Patzsch's book *Die Welt ist schön* (The World Is Beautiful), which the artist himself had titled *Die Dinge* (Things), Austrian curator and writer Heinrich Schwarz praised the work: "[I]t does not want to simulate . . . and it does not want to veil. It does not want to be anything more or less than photography."[296] Renger-Patzsch's work was not meant to be scientific in its descriptiveness; rather, his goal was to facilitate an appreciation of the essence of each thing pictured. This technical approach of unblinking description and scrutiny aligns it with reportage, but the desired effect is quite different. Schwarz referred to an "intensity" in Renger-Patzsch's work that is the vehicle for communicating with the viewer. The photographer's reverence for the object, his "things," was not immediately evident to most viewers of the time, who remained skeptical about the ability of a machine—the camera—to create something poetic. Renger-Patzsch's goals, though stylistically distinctive, were not unlike those of Walker Evans and especially Clarence John Laughlin, each of whom wanted to present a clear picture of what was before them and include in the image some reverberations of its cultural relevance.

This was a distinct shift from photography in the 1920s, particularly in Europe, where photographers reveled in using the camera and a variety of techniques to suggest invisible, interior states and the life of the mind. The 1930s, in both Europe and North America, saw a shift toward exteriority—an emphasis on portraying the existing, external world—as a way of offering a window onto the interior. Because of escalating political and social crises in these regions, some reviewers found this type of work to be irrelevant or precious, objecting to aesthetic delectation in the midst of disaster. Adams and Weston were both criticized for making beautiful landscape pictures at a time when Dorothea Lange was out in the field photographing the plight of migrant workers.[297] In Germany, critic Walter Benjamin castigated Renger-Patzsch's work as facile, "for it has succeeded in transforming even abject poverty, by recording it in a fashionably perfected manner, into an object of enjoyment."[298] From another perspective, these formalist images are visionary in their simplicity. They point to the object with apparent neutrality but, rather than simply advocating a nonjudgmental viewing, are intended to stimulate an appreciation that is almost the inevitable result of the extended gaze. As Donald Kuspit has noted: "The object, then, becomes not just a metaphor for self-transformation and re-creation, but their catalyst."[299] These objects highlight for us the fact that the elements and events of our world, however meticulously articulated and despite all the advances of science, remain ever amazing and unknowable.

During the early 1930s Edward Weston's f.64 work was aligned with this philosophy. Levy had contacted Weston in 1931 about the possibility of showing his work at the gallery, but the artist already had an arrangement with Alma Reed at the Delphic Studios. Levy apparently also inquired about the possibility of representing Weston's son, Brett, since Edward sent Levy his address in Santa Maria, along with a note: "I . . . wish you all success. As I said, I think you have vision."[300] Brett Weston had begun photographing as a teenager around 1925, while living in Mexico with his father and Tina Modotti. He rapidly showed a

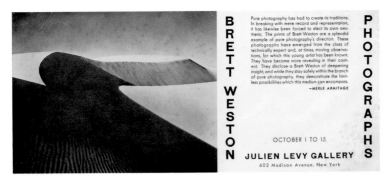

Fig. 29. **Exhibition announcement for *Brett Weston Photographs,*** 1935. Courtesy of the Julien Levy Archive, Connecticut

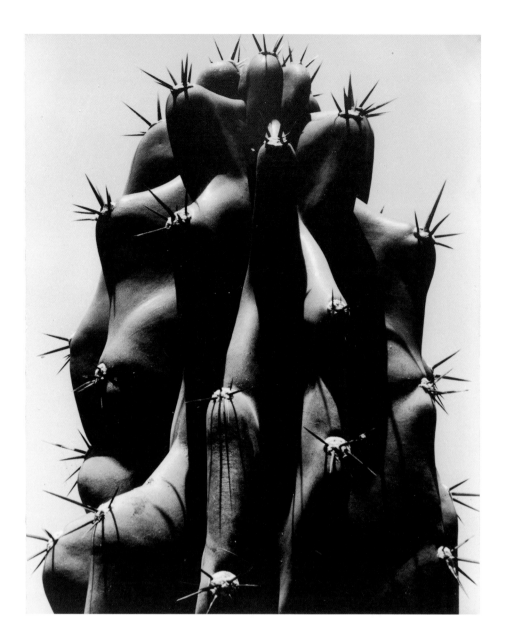

facility for the medium and, unhampered by a Pictorialist past, for the emerging modernist vocabu-
lary. Weston is yet another of the young talents premiered by Levy in solo exhibitions at his gallery,
in this case in the fall of 1935. Levy's announcement for the show reproduces one of Weston's dune
pictures and includes a laudatory paragraph by the talented book designer and writer Merle Armitage
(fig. 29). The paper cleverly folds to emphasize the abstraction of the image, which for Levy may
have represented the ideal union of "European" style (abstraction) with "American" style (straight
photography). Anticipating his show at the Levy Gallery, Brett wrote: "This N.Y. show is to be the
most important show I have given—in this country or abroad—I hope to be in N.Y. for the open-
ing."[301] In other correspondence with Levy, he mentions working on some close-up cactus images, one
of which Levy acquired and may have loaned to Newhall's 1937 exhibition at MoMA (pl. 60).[302] This
composition has all the "thing-ness" Renger-Patzsch might desire, along with the hallmarks of an f.64
picture—the centrality of a discrete subject presented up close in full light with utter sharpness on
glossy paper. Weston's photograph of a rock formation that resembles a nude torso seen from the rear
also fulfills the dictums of the group but is more playful and reveals his erotic side, an aspect that
may have prompted Levy to choose the print (see pl. 259).

Levy also became enamored of the work of f.64 photographer Imogen Cunningham, who
was similarly conversant with Neue Sachlichkeit photography; at one time he had more than fifteen

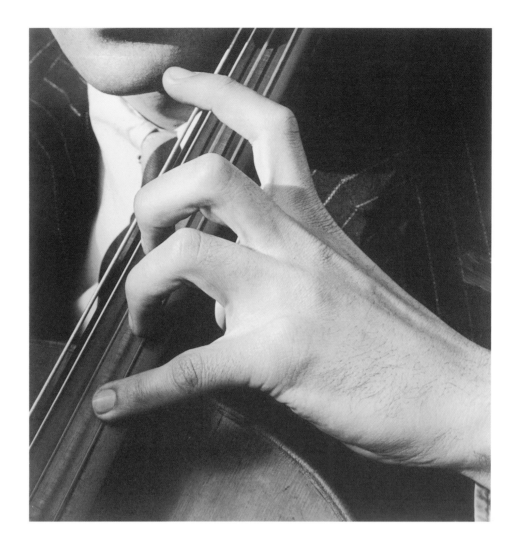

of her pictures at the gallery. Eddie Warburg, who was teaching at Bryn Mawr College in 1932, had recommended Cunningham's work to Levy, and was "so enthusiastic about them, I am writing to ask if I may see your photographs," Levy wrote to her in Oakland, California, suggesting that she send a group of pictures to him to be sold on commission.[303] Cunningham had created some of her most accomplished work by this time. Among the prints she sent to the gallery were *Magnolia Blossom, Snake, Leaf Pattern, Banana Plant,* and *Two Callas.*[304] Surrealism crosses paths with the nascent f.64 movement in her creepy and slightly mysterious picture *Growth* (see pl. 255), in which Cunningham capitalizes on the destabilizing effect of isolating and portraying an object in such clear detail that it appears alien.[305] Also from this period is *Hand of Gerald Warburg* (pl. 61), one of several views she made of Eddie's brother, a concert cellist with the New York Philharmonic and a founder of the Stradivarius Quartet. In this piece Cunningham emphasizes the span of the musician's fingers on the neck of his cello, giving Warburg's hand the appearance of an encroaching tarantula. *Rock Shadows* is a more unusual subject for her, uncharacteristically monumental (see pl. 150). Her aggressive formal presentation of the subject, balanced by soft edges, suggests the direction her work was heading at this time and offers the intersection of abstraction and sharpness that so excited Levy.

In May 1936, Levy returned to his old friend Atget, offering a different selection of the photographer's work than he had presented at the gallery at the end of 1931. *Eugène Atget, An Epoch of Contrasts: Paris Chateaus, Chiffonneries, Petites Métiers* [sic] juxtaposed scenes of grandeur with scenes of squalor.[306] Just half a dozen years after Atget's exhibition at the Weyhe Gallery, the press described his work as "now familiar to most amateurs," with *Art News* titling its review "Atget, Forerunner of New Photography."[307] Writer Elizabeth McCausland, in a long review of the exhibition for the

Springfield Republican (Massachusetts), called his work "one of the great mountain-peaks of photographic art" and praised it for showing "the potentialities of photography as a medium for the artist, the historian, the recorder of documents."[308] She made note of Berenice Abbott's role in preserving Atget's work and stated that "it is a tragedy . . . that his work is not more widely known and especially that the collection is not in a public institution," before switching to the well-worn argument that photography should not imitate painting. The lengthy article is less a review of the exhibition than an opportunity to write at length about Atget, a subject in which McCausland had a vested interest owing to her longtime personal relationship with Abbott.

THE GALLERY'S LATER YEARS

In 1936 the Levy family moved into an apartment at 55th and Madison, in a building that had apparently once been a brothel; it was here that their third son, Jonathan, was born.[309] The gallery also moved, to 15 East 57th Street in 1937. Levy considered this address a "step up—as was the monthly rent," but he hoped the change would result in increased income.[310] While the curved wall of his first gallery was a decorative signature, in the new space Levy expanded the idea (fig. 31): "The new quarters show a startling innovation in gallery design—the walls are curved, the curves deriving from the shape of a painter's palette. This shape appears not only decoratively effective, but practical too. The light follows the walls more softly than in a rectangular room, people pass by the pictures in natural, easy paths of circulation, and the pictures present themselves one by one, instead of stiffly regimented."[311] The move merited a mention in *Time* magazine, *Vogue*, and a few daily newspapers, several of which described the new space as "streamlined" and "spacious." The visitor "has the impression of being inside a great white piano," *Vogue* suggested, while the *New York Times* likened the undulating wall to a "Surrealism effect."[312]

The first show in this space, on view from October 6 to November 1, was a *Review Exhibition at Our New Address,* which included a variety of artists and a range of mediums. Photographers represented were Abbott, Atget, Cartier-Bresson, Evans, Lynes, and Man Ray (the later presumably showed photographs, as Levy is not known to have exhibited his work in other mediums until the mid-1940s). Although included in this first exhibition at 15 East 57th Street, photography was not much in evidence at the Julien Levy Gallery in its later years. Only four photography shows would be presented at the new address: solo exhibitions of the work of Sheldon Dick, Nicholas Ház, and David Hare, and a group exhibition that included photographs by Clarence John Laughlin and Eugène Atget. The last photography show at the gallery, David Hare's in December 1940, occurred almost a decade before the gallery's closing.

Fig. 30. **Exhibition announcement for *Tri-State U.S.A., Photographs by Sheldon Dick,*** 1939. Courtesy of the Julien Levy Archive, Connecticut

Sheldon Dick's exhibition represents an anomaly within the Levy Gallery's program. While Levy had a long-standing commitment to photographs as documents, social-documentary or socially responsible photography had been almost entirely absent from the gallery. Perhaps turbulent times in Europe stimulated a new tack. Whatever the motivation, in May 1939 the gallery presented *Tri-State U.S.A, Photographs by Sheldon Dick,* an exhibition of photographs of Arkansas, Kansas, Missouri, and Oklahoma miners. Dick is little known today, but in the 1930s he worked as a photographer for the Farm Security Administration. In 1938 he photographed in the Shenandoah Valley and the Mount Carmel region, including documenting labor leader John L. Lewis's visit to the latter. Levy's collection contains no examples of work by this photographer, and the overtly charged subject matter seems

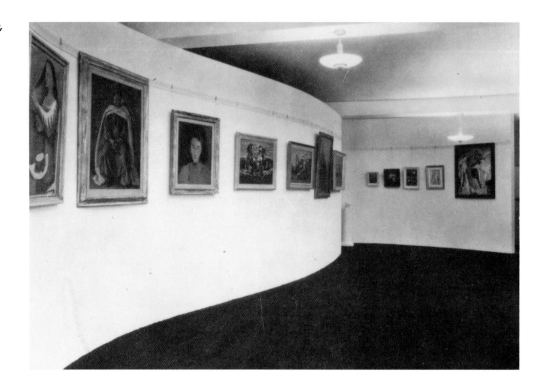

a dramatic departure for the gallery. While American workers or mining in the United States are certainly topics that can be reconciled with Levy's interest in developing an American voice in art, at this moment in time such photographs were bound to suggest labor disputes, Socialism, and conflict, not topics that particularly interested Levy. He produced a simple but extensive multi-page announcement of the exhibition, with a map of the area covered by the photographs on the cover (fig. 30).

Although he was not personally concerned with openly political or socially conscious work, Levy of course had friends and associates who were politically active, and he hosted several benefit events at the gallery over the years. Twenty-five cents was the price of admission to actress Gracie Allen's exhibition of eight paintings, for "the benefit of medical aid to China."[313] In Levy's collection is a photograph of Allen by George Platt Lynes. This multiple-exposure portrait highlights the comedienne's fashionable accessories as well as suggesting her mobile personae (pl. 62).[314]

In October 1939 Levy exhibited "color abstract photograms" by Hungarian-born artist Nicholas Ház, who had trained as a painter but later turned to photography. Ház was an important transitional figure between the Pictorialist style and sharp-focus modernism. He founded his own school of photography in New York, located at Rockefeller Plaza, and in 1937 taught a three-week course in photographic composition with Ansel Adams in Berkeley, California, which provided the basis for his 1946 book *Image Management (Composition for Photographers)*.[315] Color photography was generally used only in commercial applications at this time, although a few artists were testing its aesthetic possibilities. Moholy-Nagy had done some work with abstract color transparencies at the Institute of Design in Chicago, and his colleagues there, including Arthur Siegel and Harry Callahan, had begun working with color, but this work was seldom shared beyond artist circles. The Ház exhibition reflects Levy's ongoing interest in experimental approaches to the medium and his continuing pride and pleasure in presenting something new to the public. In the press release he compared the artist's work to the black-and-white photograms of Man Ray and boasted that "with the new color-sensitive papers they are in full color, the first time color photograms have ever been exhibited in a one-man show."[316] It was not until 1943, when Nancy Newhall presented a selection of dye-transfer photographs by Eliot Porter at the Museum of Modern Art, that color photography was shown at a major museum.

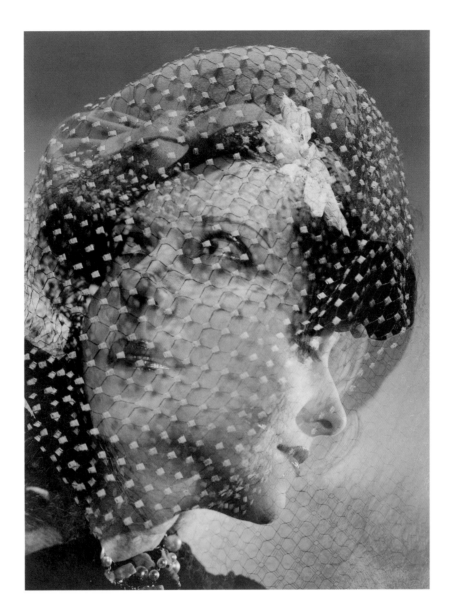

In addition to his gallery shows during 1938–39, Levy was preoccupied with a project for the 1939 World's Fair, which was to be held in New York. In 1938 he and architect Ian Woodner submitted an application for a concession in the fair's Amusement Zone—a Surrealist House that would update the traditional funhouse.[317] Ultimately, this became Salvador Dalí's Dream of Venus Pavilion, a fantastic, erotic funhouse that featured a lavish grotto, topless women in outlandish marine-inspired costumes who cavorted in an aquarium, and a nude Venus reclining on a 36-foot-long bed. A snapshot by an unknown photographer captures Levy and Dalí at the pavilion with a naked model and a fish; the photograph must have delighted Levy, who evidently posted it somewhere for his enjoyment, as confirmed by the cluster of pinholes at the bottom left corner (pl. 63).[318]

Levy's fascination with Surrealism, straight photography, American vernacular subject matter, and architecture as an expression of the human spirit perhaps reached the pinnacle of juxtaposition in his exhibition of the work of Clarence John Laughlin in November 1940. Levy apparently discovered Laughlin's work on a trip to New Orleans, but Laughlin had already contacted the gallery by mail.[319] Frustrated by cultural limitations and lack of recognition, Laughlin had written to Stieglitz and Margaret Bourke-White and had contacted several magazines about his work, eventually coming to New York, where for three weeks he attended to his exhibition at the Levy Gallery and photographed for *Vogue* magazine and *Harper's Bazaar.*

Self-educated, Laughlin was stirred by the writings of the French Symbolist poets and began

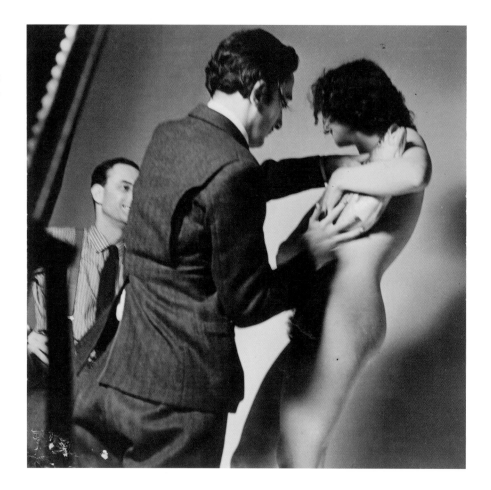

taking photographs in 1930, inspired by the work of Atget, Man Ray, Stieglitz, Strand, and Edward Weston.[320] He worked as a photographer for the U.S. Engineer Department, New Orleans District, from 1936 to 1941 documenting the architecture of the city, a task he also took on as a personal project. It was this material he showed at the Julien Levy Gallery.[321] Laughlin's work, like Atget's, is consistently described as "haunting." But while Atget was firm in his role as a documentary photographer, Laughlin was interested in capturing not only the disappearing architectural heritage of the South but also its resonances. Laughlin loved the mausoleums (pl. 64) and abandoned plantations of his city and sometimes employed shadows and masked or shrouded figures to suggest an atmosphere clouded with layers of history and memories. His wonderfully poetic titles add another element of suggestiveness to the works and undoubtedly would have evoked for Levy the creative and nonsensical titles of some of the artists associated with Surrealism.[322] Laughlin was suspicious of technique as an end in itself but believed strongly in the transcendance of the object, an idea not unlike Renger-Patzsch's.[323] The various threads of interest in Laughlin's work represent a synthesis of the styles Levy had explored at the gallery.

Levy may have seen Laughlin's 1937 image *The Eye #1*, subtitled *Homage to de Chirico*.[324] Having once represented de Chirico at the gallery, he would easily have made the connection between Laughlin's lonesome façades and scenes featuring a lone figure and the painter's empty or almost empty plazas. Laughlin's *Three Vistas Through One Wall* (see pl. 233), for instance, is a fairly straightforward shot of a damaged brick wall, but the title focuses our attention on the three openings and the views glimpsed through them—apertures on an alternate reality. "The physical object, to me, is merely a stepping-stone to an inner world where the object, with the help of subconscious drives and focused perceptions, becomes transmuted into a symbol whose life is beyond the life of the objects we know and whose meaning is a *truly human* meaning," Laughlin said.[325]

Plate 64
Clarence John Laughlin
(American, 1905–1985)
Untitled (Cemetery, New Orleans), c. 1940
Gelatin silver print
10⅜ x 13⅝ inches (26.4 x 34.4 cm)
The Lynne and Harold Honickman
Gift of the Julien Levy Collection
2001-62-604

Levy returned to color photography in December 1940, when in conjunction with an exhibition of daguerreotypes and other objects by Joseph Cornell the gallery showed a group of color photographs by David Hare, the artist's first solo exhibition.[326] Hare is known primarily as a sculptor, but he began photographing in the 1930s, becoming particularly engaged with color. In the late 1930s he was commissioned by the American Museum of Natural History in New York to document the Pueblos of North America and created a portfolio of twenty dye-transfer prints. In 1939 he showed his color photographs at the Walker Galleries in New York, and Peggy Guggenheim gave him several solo exhibitions at her gallery Art of This Century during the mid- to late 1940s. Like Levy, Hare was a latter-day Surrealist, having taken up the banner around 1940 during the influx of European émigrés to New York. In 1942 he co-founded the American magazine *VVV* with Breton, Duchamp, and Ernst and devised an automatist method of creating photographic images by applying heat to his negatives.

The concurrent showing of objects by Joseph Cornell was described in the exhibition announcement as an assortment of "miniature glass bells, soap bubble sets, shadow boxes, an homage to the romantic ballet," and "daguerreotypes."[327] Levy, perhaps feeling a proprietary interest in his "discovery," had shown Cornell's work several times since including him in *Surréalisme* in 1932. Cornell incorporated all sorts of materials into his collages and assemblages, with photography generally appearing via the printed pages of magazines and newspapers. He certainly was no stranger to the power of the photographic image, given as he was to worshipping the (graven) idols of celebrity snapshots. It was sometime during his association with the gallery, and probably with Levy's collaboration, that Cornell created the objects he referred to as "daguerreotypes" (see pp. 42–44 above), but this is the first reference to their having been shown. Levy cleverly scheduled an exhibition of these unique and whimsical but grown-up toys at the end of the calendar year, when shoppers are particularly intent on finding special gifts.

Fig. 32 (left). **The Julien Levy Gallery's temporary space in Los Angeles,** 1941. Courtesy of the Julien Levy Archive, Connecticut

Fig. 33 (right). **Julien Levy in uniform,** c. 1942. Courtesy of the Julien Levy Archive, Connecticut

The 1940s were a difficult time for Levy, who had started the 1930s so promisingly. "In 1941 business was not only terrible, it was nonexistent," he recalled in his memoir.[328] Max Ernst, whom Levy had represented for some years, married Peggy Guggenheim, who was able to get him out of Germany and assumed representation of his work. Someone came up with the idea of a traveling gallery, so Levy packed up his inventory and headed to California, setting up during September and October at Guthrie Courvoisier's gallery at 133 Geary Street in San Francisco, where he presented a show of Surrealist painters, followed by an exhibition of Neo-Romantic painters.[329] The gallery then relocated to Los Angeles for the months of November and December. Levy found southern California more congenial, no doubt partly owing to the presence of his friends Man Ray and art patrons Louise and Walter Arensberg. He rented a space at 8704 Sunset Boulevard in West Hollywood (fig. 32), near the Frank Perls Gallery. Perls and his brother Klaus were sons of Berlin art dealer and scholar Hugo Perls. They immigrated to New York in 1940 and continued the business there, specializing in twentieth-century art. Frank had already established his own gallery in 1939 and was on collaborative terms with Pierre Matisse in New York. He was an outgoing character with adventurous artistic tastes and apparently hit it off with Levy. Perls reportedly brought the actor John Barrymore to the opening of Levy's Surrealism show in Los Angeles. Levy organized four paintings exhibitions in the storefront space: a Dalí show, a solo presentation of work by Tamara de Lempicka, a group show of Neo-Romantic painters, and a closing sampler of *Surrealist Paintings, Documents, Objects.* In January the rolling gallery was scheduled to stop in Pittsburgh on its way back to New York.

In February 1942 Levy was back in New York. He and Joella separated, and then divorced. That same year Levy joined the armed services—as had several members of his circle, including Kirstein and Warburg—and was trained in aerial photography (fig. 33). While Levy was in uniform, Kirk Askew minded the business of the gallery for him, presenting seven shows between 1942 and 1943 from his post at Durlacher Brothers.[330] In the summer of 1942, Levy arranged for his collection of photographs to be stored at the Museum of Modern Art during his military service. In a confirmation

letter to Levy, Beaumont Newhall wrote: "We are very glad indeed to have the opportunity of free access to your collection during your absence from New York. . . . It is extremely kind of you to want to let us have some of the photos at a future date as a gift."[331] Suffering from a difficult-to-diagnose thyroid disorder, Levy never saw active duty and was discharged in 1943.

After returning to the city, Levy moved into an apartment on Grove Street in Greenwich Village, near the Chilean-born artist Matta, whose paintings he had shown at the gallery in January 1940; the two had photographed children's sidewalk chalk drawings together in 1939 (see fig. 37, pl. 70). He reopened the Julien Levy Gallery in a smaller, fourth-floor space at 42 East 57th Street, featuring an exhibition of Matta drawings as his initial offering, the artist's first solo exhibition. But the job was no longer as compelling to him as it had been in the early days, and others had stepped into the breach, including Askew, who until then had specialized in seventeenth-century Italian art.[332] The Julien Levy Gallery was to continue through 1948, "during those crucial years between Dadaism and the apotheosis of Moma-ism," as Levy wrote in his memoir.[333] By the 1940s, however, the cultural, artistic, and social landscape had changed considerably. The Museum of Modern Art, while experiencing cutbacks related to the war, was firmly established as a force to be reckoned with and had organized solo exhibitions of several photographers. Levy reported that Peggy Guggenheim's influence "suddenly became much more important than anything I was able to do. I was crippled by it in a way. But I was in the army and she opened a whole museum, had a lot more money than I ever had, and she had Max [Ernst] to advise her for a while."[334] By 1942 several of Levy's artists were showing at the Pierre Matisse Gallery, which presented an exhibition of *Artists in Exile.* (The sculptor Isamu Noguchi, who was of partial Japanese descent, was himself exiled to an internment camp in Arizona.) Levy and his friends, so enamored of new and contemporary art, found themselves less than enthusiastic about the newest style of painting, Abstract-Expressionism, which was dominating New York. While some of this work had roots in Surrealism, most was for them too arcane and analytical. Levy later mentioned that he found the movement's work too American, perhaps responding to the tenor of the country, which was increasingly separatist, and New York's struggle for dominance as the capital of the international art world.[335] One artist Levy continued to support with great zeal and affection was Arshile Gorky, whose work he showed at the gallery in at least four solo exhibitions.

On a brighter note, Levy found a new companion in the young painter Muriel Streeter, whom he married in 1944. That summer the couple shared a place on Long Island with Max Ernst and painter Dorothea Tanning (pl. 65). A collection of expatriate artists was nearby, creating a mirage of their former European gatherings. The seaside idyll inspired the last of Levy's great theme shows at the gallery, *The Imagery of Chess*, which opened in December 1944.[336] This show consisted of chess sets designed by a variety of artists, as well as paintings and sculpture on the theme by more than twenty additional contributors. Levy took some of the plaster Ernst was working with to cast his own chess set in discarded eggshells so they could sink the pieces in the sand and play at the beach. The result was a delightfully biomorphic set irresistible to the touch (later altered somewhat and made from oak). He followed up with a chessboard with seashells to mark the squares. Ernst designed a set from wood, inspired by the forms of African and Oceanic carvings. Alexander Calder created several flamboyant chess sets during the 1940s and was included in the show. André Breton and Nicolas Calas contributed a mirrored board with varying shapes of cordial glasses serving as the chess men, filled with white wine on one side and red wine on the other; the liquor was consumed by the victor as each piece was vanquished. Man Ray, who had designed his first chess set in 1920, made a new set of pieces, seizing on the idea of marketing them and earning some cash. The show also included paintings by Muriel Streeter, Dorothea Tanning, and others, as well as sculpture by Ernst and David Hare and an elaborate assemblage by former Bauhaus artist Xanti Schawinsky. There were even a few

Plate 65
International News Photos
(American, active c. 1930s–1940s)
Muriel Streeter (Levy), Julien Levy, Max Ernst, and Dorothea Tanning, 1944
Gelatin silver print
6½ x 5½ inches (16.5 x 14 cm)
The Lynne and Harold Honickman
Gift of the Julien Levy Collection
2001-62-1504

photographs, appropriated by Stefi Kiesler, wife of architect Frederick Kiesler, who created at least two displays. One of these, titled *Is Chess a Martial Game?* featured press photos related to the film *The Moon and Sixpence* (1943), which included a chess-playing scene. The other, *A Chess Village,* showed children in the German village of Ströbeck toting their chessboards, for according to the text, "everyone [*sic*] of the 1252 inhabitants (Census 1933) plays chess."[337] As a special feature, Marcel Duchamp arranged an exhibition match at the gallery with reigning "blindfold chess master" George Koltanowski. Playing against him simultaneously were Ernst, Tanning, Schawinsky, Levy, Alfred Barr, composer Vittorio Rieti, and Kiesler. The latter played to a draw, but everyone else lost to the master.

The chess show garnered a tremendous amount of press coverage. The excitement must have buoyed Levy's spirits, but his enthusiasm for the gallery was waning. By the late 1940s it was not doing well financially, and the continuous round of exhibitions and promotion was no longer a thrill. In 1948 he purchased property in Bridgewater, Connecticut, that included a farmhouse dating to 1799, and there he retreated from New York and the art world while remaining conveniently close to friends in nearby towns. Alexander and Louisa Calder and their two daughters lived in Roxbury, as did David Hare; Arshile Gorky and his family moved into a house in Sherman, the town where painter Peter Blume and writer Malcolm Cowley also lived; Schawinsky lived in Wellfleet; and Yves Tanguy and Kay Sage were nearby in Woodbury. Snapshots from this time give evidence of excursions into the country by the Bretons, Max Ernst, the Miró family, painter Enrico Donati, and Hans Richter, who was associated with the Dada movement that preceded Surrealism and had made a number of short, experimental films.

With so much talent prowling around in rural Connecticut, it is no surprise that a collaborative project arose. Richter conceived a film titled *Dreams That Money Can Buy* (completed in 1947;

Plate 66
Photographer unknown
Untitled (Hans Richter and
Man Ray with the poster for
Dreams That Money Can
Buy), 1947
Gelatin silver print
9⁹⁄₁₆ x 7½ inches (24.3 x 19 cm)
The Lynne and Harold Honickman
Gift of the Julien Levy Collection
2001-62-2344

pl. 66), which revolved around the character of Joe, a dream salesman who elicits dreams from seven people. Richter invited five artists—Alexander Calder, Duchamp, Ernst, Fernand Léger, and Man Ray—to compose the dream sequences for the film (Calder created two and Richter himself contributed a dream). Levy had a prominent acting role in Ernst's segment (titled *Desire*), playing a lover eavesdropping on his girlfriend who is talking in her sleep. Promotional material for the film describes this first dream as "a romantic study of sex in 1850, with music by Paul Bowles and a 'stream of consciousness' monologue by Max Ernst," adding that it was inspired by a collage that appeared in Ernst's book *Une Semaine de Bonté* (1934).[338] Levy also participated in Richter's later color film *8 x 8*, described in the publicity materials for its world premier in New York on March 15, 1957, as "equal parts of Freud and Lewis Carroll with Cocteau and bullfights, surrealism, magic and beautiful women."[339] Perhaps stimulated by Levy's 1944 exhibition, this piece was "A Chess Sonata for Film. Eight improvisations, with a prologue and epilogue, on the game of chess."[340] Levy's role in the scenario "First Move" is again that of a lover, the Black Knight who as an agent of the Black King seduces the White Queen.[341] Much of the filming was done in Connecticut, and it was most likely around this time that Levy photographed Richter relaxing outdoors and pasted his likeness onto an FBI wanted poster.[342]

Despite the parties and hijinks and collaborative projects, the late 1940s remained a troubled time for many. For Levy, the suicide of his friend Arshile Gorky was particularly painful. On the evening of June 24, 1948, after having spent the day together, Levy was driving Gorky home in the rain when his car spun out of control and ended up in a ditch. Levy's collarbone was broken, and Gorky was also hurt in the accident—rather seriously, it was later discovered. His injury, a broken neck, restricted him to his house, where he ruminated over his wife's infidelity and recent departure

with their children. Levy recalled that on the evening of July 20, Gorky made a series of fairly per-
functory phone calls to his friends, who sensed he might be in trouble but did not reach him before
he had hanged himself in the woodshed on his Sherman property.[343] Gorky was only forty-three years
old and deeply engaged in a fertile period of artistic production. His death was a profound loss for
his community of artists and a great personal blow for Levy. In November the Julien Levy Gallery
presented a solo exhibition of Gorky's work. Not long afterward, in May 1949, it closed for good.

Levy was philosophical about his gallery venture in later years and gradually came to recog-
nize his own achievements, but his disappointment over what he was not able to accomplish for
photography comes through in his 1977 memoir:

> I was to fail in my attempt to bring photographs into the market as fine art in a price
> range adequate to justify limited editions. True, museums later slowly admitted photo-
> graphs into their collections of prints and the graphic arts, and some modern art histori-
> ans were persuaded to include a chapter of photographic reference as part of the story of
> art, but my three early years of effort seemed a total loss and did not meet with sufficient
> support to continue to nourish the photography hope for my gallery. . . . It was fortunate
> that mine was also an art gallery; thus I was not without another string to my bow with
> oil-on-canvas paintings, even if most of these were neither conventional nor easily sold.[344]

Retired from the gallery, Levy entertained some writing projects, taught at Sarah Lawrence
College and S.U.N.Y.-Purchase, and was a visiting curator at S.U.N.Y.'s Neuberger Museum. He served
for a time on the board of directors for the Copley Foundation, which provided grants to struggling
artists chosen by the board. And on January 20, 1957, he married Jean McLaughlin Davis, a stylish
and vivacious woman who worked in fashion advertising for Bloomingdales, Wanamakers, and
Bullocks department stores across the United States (fig. 34). Jean had met Levy in New York after
he had closed the gallery. Following their marriage, the two took up residence at the Bridgewater
farmhouse, where they entertained friends and artists. Jean enjoyed hearing tales of her husband's
gallery days, and her talent for parties and socializing revitalized Levy in his later years. In telling
Jean about his life he began to realize that his achievements had been largely forgotten, and that
even his children were unaware of his contributions to the art world.

In the mid-1960s Levy decided to undertake a monograph on the work of Gorky. His motiva-
tion was surely personal, as the Whitney Museum of American Art had already presented an exhibition

and catalogue on Gorky in 1957, and Harold Rosenberg had written a book about the artist in 1962, both acknowledged sources for Levy's writing. Their work absolved Levy of the burden of a full critical treatment, and his own contribution is highly impressionistic. Generous passages of poetry and prose dot the text, and Levy's references encompass Leonardo da Vinci, Shakespeare, Anton Chekhov, Paul Klee, and André Breton. He writes of Gorky's death as "a significant tragedy for art in our century."[345] Undoubtedly, he felt a debt to Gorky, and the book, published in 1966, was meant as a tribute. "I was very depressed by the suicide of Arshile Gorky," Levy recalled. "I got a psychological malaise from the fact that as soon as he was dead, his prices started to go up. . . . I hadn't been able to get collectors to look at it while he was alive, and now they came running. . . . I wondered what kind of commercial madness I had been laboring in."[346]

The other monographic book Levy chose to write during his Connecticut years was on Eugene Berman, whom he had also represented at the gallery. It seems likely that, to a large extent, Levy saw Berman and Gorky as his contributions to the history of painting. He would later demur from having "discovered" anyone: "My vanity would like to say I discovered the artists I chose. . . . I can say I was both early and helpful in their recognition."[347] In the last years of the gallery he had been mostly engaged with painters, having fostered the Neo-Romantic group along with Chick Austin and James Thrall Soby, so it is not surprising that painters were the focus of his writing. One cannot help but wonder, however, what books he might have written about photography had the subject been closer to his heart at the time.

In 1968 Levy was one of the participants in artist William Copley's project *SMS*. Copley, an American Surrealist like Levy, concocted the idea of a series of portfolios that would be mailed to subscribers. The resulting six "issues" included mass-produced work by a fascinating variety of artists, among them John Cage, Bruce Connor, Marcel Duchamp, Man Ray, On Kawara, Yoko Ono, Meret Oppenheim, and Lawrence Weiner. Levy's work appeared in the first group, *SMS1*, along with James Lee Byars, Christo, Walter de Maria, Richard Hamilton, Sol Mednick, and others. Levy contributed the piece *Pharmaceuticals*, a "specially printed prescription pad for 'conception control'" on which he prescribes drugs for a trio of artists: "'Dream-a-Mean' for Leonardo to be taken 'introVENUSly'; 'Stop-It-All' for Michelangelo; and 'GO-STs' for Stuart Davis," with actual (empty) drug capsules included.[348]

Levy continued to assert the relevancy of Surrealism and frequently took the opportunity to share his ideas. In 1971 he worked with a group of local young people to create the film *Surrealism Is . . .*, intended as a fun but informative exploration of the movement and its ongoing vitality. After being markedly unfashionable during the 1950s, Surrealism was again being invoked in the work of artists associated with the Pop art movement. In the 1960s and 1970s, Harvard's Fogg Art Museum presented a survey of Surrealism, the Institute of Contemporary Art in Boston worked with Levy on a show examining Surrealism's impact on art of the 1960s and early 1970s (unfortunately, never realized), and the Richard Feigen Gallery in Chicago offered *Surrealism and New Romanticism: Poetry in Painting from the Collection of the Julien Levy Gallery*.[349] Levy worked with a couple of institutions interested in establishing a center for the study of Surrealism: SUNY-Purchase and Pennsylvania State University. Penn State sponsored a major symposium on the subject in November of 1978, inviting Levy to give a lecture and to show his own film work.[350] Although no center for Surrealism was formed with Levy's assistance, he was able to continue speaking on behalf of the movement's ongoing relevance, which he saw as borne out by Pop art.

Surrealism Is . . . was made on Levy's property and has a certain charm, but it is most noteworthy simply for being the longest film he ever completed. After college Levy had worked briefly as a prop boy for Dudley Murphy (who served as Léger's cameraman for *Ballet mécanique*) at the Cosmopolitan Studios in New York, in the hope of gaining some experience in film work. That did

not pan out, but he ultimately did make a few films of his own. He mentions in his memoir having planned a series of filmed portraits of artists, each in three sections with the final one being directed by the artist himself.[351] Apparently the only surviving example is footage from an intended portrait of Max Ernst in which his wife, Marie-Berthe Aurenche, Levy, and their friend Caresse Crosby also appear.[352] Much later, Levy could not resist trying his hand at videotape and told one interviewer he was creating a video guest book of his visitors.[353]

Levy and Jean spent summers in the French village of Bonnieux, in the Vaucluse, and in 1975 Levy stayed into the fall to teach art history for the Sarah Lawrence College semester abroad program. He also turned his attention back to photography, which in the 1970s was enjoying a new surge of interest. Early in the decade he began working with assistant curator David Travis at the Art Institute of Chicago and shipped his collection of photographs there for study. Their conversations ultimately resulted in Travis's 1976 exhibition and catalogue *Photographs from the Julien Levy Collection, Starting with Atget*, which for many decades was the only critical resource on Levy and his gallery.[354] The Witkin Gallery in New York followed in 1977 with their exhibition *Photographs from the Julien Levy Collection*, publishing a catalogue designed to harmonize with Chicago's but with a different group of photographs; they also offered a poster for sale featuring images by Emmanuel Sougez, Ralph Steiner, and Umbo. "Those of us now prospering in the world of photography owe homage to Julien Levy," owner Lee Witkin is quoted as saying in the press release for the show. "A man of exquisite taste, sensibility, talent, and courage . . . [h]is exhibitions and his concern stand as milestones always to be acknowledged and honored."[355] More than a dozen photographs from the exhibition were sold, but the fact that many of the listed works are now in Philadelphia suggests that the undertaking was a limited success in that regard. More importantly, aside from earning him a bit of money, these shows put Levy in the spotlight at a time when interest in photography was again coming to a boil, positioning him as a leader in the field and allowing him to enjoy, at last, some of the accolades he had hoped for during the gallery years. The cover of the Witkin catalogue shows an image of carousel horses made in Cuba by Cartier-Bresson; inside, Levy thanks Lee Witkin and writes: "The merry-go-round which moved me forty years ago now turns again, this time not with empty saddles."[356]

In the winter of 1978, Harvard's Fogg Art Museum presented Chicago's exhibition *Photographs from the Julien Levy Collection, Starting with Atget* in time for Levy's fiftieth college reunion, stimulating him to donate two photographs to their collection. Levy was scheduled to give a short gallery walk-through. As it turned out, he was trailed for two hours by an audience eager for his anecdotes. He returned to Harvard in the fall to deliver an illustrated lecture on Surrealism at the Carpenter Center, and he ultimately gave thirty-three pictures to the Fogg, a fitting tribute to his alma mater.

Encouraged by Jean, Levy continued his writing in an A-frame cottage on the edge of their property (fig. 35). There he began to sift through his gallery papers and capture some of his memories, many of which, unfortunately, had to be edited from the final manuscript of his memoir for legal reasons and to protect the parties involved. Nonetheless, *Memoir of an Art Gallery* is a juicy account of Levy's gallery adventure and of the New York art scene of the 1930s and early 1940s. Levy was also at work on a book of his correspondence with Mina Loy, the British poet who had been his first mother-in-law and whose influence had been so important to him in the 1930s, but the project was never realized. Admiring young art lovers—among them Frank Kolodny and Robert Shapazian— began finding their way to Levy, making pilgrimages to his Connecticut house to share their enthusiasm for the art he had shown at his gallery, to show him their own work, and to try to convince him to sell some of his. The Levys moved to a nearby property they called the Barn House and shortly

thereafter to the Main House across the street. The latter, once owned by writer Norman Mailer, appeared in an *Architectural Digest* feature on Levy.[357] Family, friends, and admirers continued to visit them in Connecticut. Jean, in particular, was interested in having parties to rival the old days. It seems to have been a very fulfilling time.

When Levy died at San Rafael Hospital in New Haven, Connecticut, at the age of seventy-five, on February 10, 1981, the *New York Times* obituary referred to the far-reaching reputation of his gallery and called him an art-world legend.[358] His collection of photographs was at that time stored throughout the house and outbuildings on the property but was placed in commercial storage before Mrs. Levy moved out at the end of 1999 and began considering a new home for them.

It is a bit poignant but also quite wonderful that the collection has survived largely intact in the group of images at the Art Institute of Chicago, the selections at the Fogg Art Museum, and the large holding at the Philadelphia Museum of Art. Levy's photographs are an extraordinary collection of images, a fitting tribute to his combination of high standards and flexible taste. Certainly the foremost characteristic of the collection is its ability to delight. Laying aside art-historical considerations, the photographs themselves are treasures, whether one prefers the lovely craftsmanship of a Käsebier gum print, the cool contours of Paul Strand's precisionism, modernist photograms and photomontages, the restrained beauty of Walker Evans's buildings, the immediacy of Cartier-Bresson's pictures snatched from life, or the unadorned but riveting images of preening boxers captured by an unknown photographer (pls. 67, 100, 101). There is so much in Levy's collection to catch the eye and engage the curiosity. The number of rather unextraordinary themes—including clotheslines, horses (both fleshy and wooden), scissors, cats, and, more explicably, vagrants, run-down shacks, mannequins, and circus people—that recur throughout the collection is also remarkable and confounding. It bears repeating that another prominent feature of the collection is the breadth of artists and works contained therein, a history of 1930s photography that is missing few names of significance and includes many surprises. Levy had an excellent eye for images, and his choices were almost without exception validated during his lifetime and certainly after his death.

Levy came along at a particularly dynamic time for a medium on the cusp of change, a time

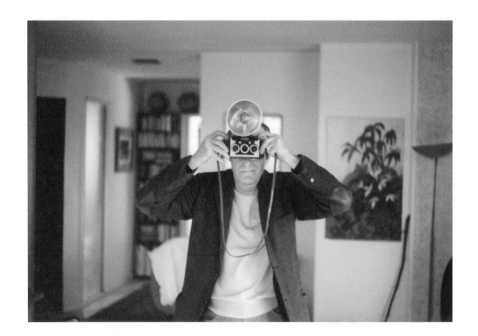

when photography was finally ready to break step with its pictorial past to keep up with the increasing tempo of urban life. Press reviews of his photography shows regularly contrasted American and European photography, equating Europe with its own techniques and trickery and the United States with a more straightforward, naturalistic approach. Missing from this characterization is a more nuanced understanding of the field, and the realization that lensmen on both continents were shifting toward a camera-oriented approach to photography that relied less on the darkroom for the realization of an image. This was a pitched battle between passionate combatants, one side feeling that photography had finally been accepted into the art world and should continue to offer aesthetic pleasure as well as fine craftsmanship, and the other asserting the unique quality of the camera image as an apt expression of modern life that needed no prettifying or precedents. The war was waged in newspapers, magazines, and eventually museums, and Levy was at the forefront of the fight, arguing photography's primacy in everyday life—from family portraits, to interior décor, to home furnishings—and advocating for the artists he gathered at his gallery. As a critic for the *Brooklyn Eagle* stated in 1931, at the outset of the gallery enterprise: "Mr. Julien Levy has not only shown himself a sensitive observer of the Zeitgeist but has given concrete evidence of the courage of his convictions. Others have concurred that photography very well might be the art of the 20th century, but to back this idea with [a] gallery and to put the idea to the test is another matter."[359]

Levy had admired the intertwining of art and life achieved by Stieglitz and Duchamp, each in his own way, and he lived up to his choice of these two as his lodestars, his "godfathers." Photography was always part of his life, starting with his summer trip to Mexico with the Clarence White School when he was still a student at Harvard. Thereafter, he periodically came up with schemes for film or video, and snapshots from his Connecticut years often show him with a camera (fig. 36). Levy was far ahead of his time in advocating the integration of new mediums into everyday life. He was unquestionably a maverick and deserves to be recognized as such, but it is also important to place him in the context of his circle of friends, among whom a great deal of cooperative effort was carried out. Levy had his share of "firsts"—presenting the first solo exhibitions by Henri Cartier-Bresson, Lee Miller, Frida Kahlo, and others—but to say that he was virtually always "among the first" is hardly faint praise. He was part of a generation that did not wait for opportunity to knock and that by their actions changed the landscape of the art world and to some extent American culture, with Tommy Dorsey playing in the background.

1. Julien Levy, *Memoir of an Art Gallery* (New York: G. P. Putnam's Sons, 1977), p. 12.

2. Ibid., pp. 10–11.

3. Film caught the imaginations of numerous artists as well as "museum men." A. Everett Austin, Jr., arranged for films to be shown at the Wadsworth Atheneum in Hartford, Connecticut, in 1927; and Alfred H. Barr, Jr., during his 1927–28 travels in Russia, prior to assuming the directorship of the Museum of Modern Art (MoMA), New York, met the innovative film director Sergei Eisenstein and became engaged with the medium. Many of the photographers Levy would show at his gallery were also interested in filmmaking and experimented with the medium.

4. Levy, *Memoir*, p. 11.

5. Ibid.

6. The Harvard Society for Contemporary Art was incorporated at the end of 1928 and dissolved in 1936. While still in college, Warburg and Kirstein served on the Junior Advisory Committee of the Museum of Modern Art, and Warburg soon became a trustee. Together Warburg and Kirstein co-founded the School of American Ballet in New York in 1934. John Walker III later served as director of the National Gallery of Art.

7. For a discussion of this influential group from Harvard's Fine Arts Department, see Nicholas Fox Weber, *Patron Saints: Five Rebels Who Opened America to a New Art, 1928–1943* (New York: Alfred A. Knopf, 1992).

8. Levy, *Memoir*, pp. 18–19.

9. Ibid., p. 51.

10. Ibid., p. 46.

11. Levy was highly attracted to women all his life, marrying three and having affairs with many, but the maternal presence is one he seems to have missed and sought substitutes for during his twenties and early thirties.

12. Levy, *Memoir*, p. 18. Joseph Brummer (1883–1947) was a Hungarian-born sculptor who had studied with Rodin before opening galleries with his brothers in Paris and New York, where they advised some of the major collectors of the day in contemporary and medieval art. The Brancusi exhibition was on view at 55 East 57th Street from November 17 to December 15, 1926, and included a publication. Coincidentally, Mina Loy (who soon would become Levy's mother-in law) had published a poem celebrating this sculpture in the literary journal *The Dial*, vol. 73, no. 5 (November 1922), pp. 507–8. The poem was titled "Brancusi's Golden Bird."

13. The Armory Show's full title was *The International Exhibition of Modern Art*, its nickname deriving from its location in New York's 69th Regiment Armory building on Lexington Avenue. This massive exhibition included work in a variety of mediums by more than three hundred American and European artists. The show, which traveled to Chicago and Boston after it closed in New York, was well attended by the public and much reviewed by the critics, some of whom were affronted by the art while others were inspired by it; the exhibition had a profound influence on the subsequent course of American art. Walter Pach, an artist who advised Levy's father in art purchases, was one of the organizers.

14. *Anémic cinéma* is a seven-minute film created by Duchamp with Man Ray and Marc Allégret; the film was shown at the Fifth Avenue Theatre in New York in late 1926 during one of Duchamp's visits to the United States. Levy does not mention having seen the film but would certainly have discussed it with Duchamp. In 1938 he apparently screened it daily at his gallery under the title *Spiral* during the exhibition *Old and New "Trompe l'Oeil*," March 8–April 3, 1938.

15. Levy, *Memoir*, p. 104. Levy included Campendonk in an exhibition at his gallery in the fall of 1934.

16. Ibid., p. 19. Perhaps the sudden and unexpected death of his mother also influenced him to leave school and experience life more fully and without haste.

17. Julien Levy, interview with Paul Cummings, May 30, 1975, transcript, p. 4, Archives of American Art, Smithsonian Institution, Washington, D.C.

18. Julien Levy, talk given at the Fogg Art Museum, Harvard University, Cambridge, Massachusetts, January 13, 1978, recording, Julien Levy Archive, Connecticut. See also interview with Paul Cummings, May 30, 1975, transcript, p. 3, Archives of American Art, Smithsonian Institution, Washington, D.C.

19. Levy, *Memoir*, pp. 34–35, quotation on p. 35.

20. Ibid., p. 46. James Joyce was to have been the second witness, but he did not attend. As a wedding gift, Brancusi gave the couple one of his sculptures, *Le Nouveau-né* (The Newborn), now in the collection of the Museum of Modern Art. The piece inspired a chess set Levy designed and featured in his 1944 exhibition *The Imagery of Chess*; for an illustration, see Larry List, ed., *The Imagery of Chess Revisited* (New York: Isamu Noguchi Foundation and Garden Museum in association with George Braziller, 2005), p. 38.

21. Levy, *Memoir*, p. 35.

22. See *La Révolution surréaliste*, no. 7 (June 15, 1926), cover and pp. 6, 18; no. 8 (December 1, 1926), p. 20. Man Ray's album of Atget photographs is in the collection of the George Eastman House International Museum of Photography and Film in Rochester, New York. For an extended discussion of this group of images, see Susan Laxton, *Paris as Gameboard: Man Ray's Atgets*, exh. cat. (New York: Miriam and Ira D. Wallach Art Gallery, Columbia University, 2002).

23. Levy, *Memoir*, pp. 90, 93. Levy claims to have purchased "several hundred" photographs by Atget in 1927. Atget was only willing to sell a few prints per visit to give himself time to replenish his stock, so Levy supplemented his holdings with additional prints he found for sale in bookstalls along the Seine. Ironically, by limiting the number of prints he would sell at a time, Atget was only ensuring repeat visits by his new devotees.

24. See, for example, Philadelphia Museum of Art, 2001-62-187 and 2001-62-392.

25. Levy, *Memoir*, p. 46.

26. For a history of the Weyhe Gallery, see Reba White Williams, "The Weyhe Gallery Between the Wars, 1919–1940" (Ph.D. diss., City University of New York, 1996). Carl Zigrosser was an author and specialist in graphic arts who in December 1940 became print curator at the Philadelphia Museum of Art.

27. W. S. Hall, "Angusta ad Augusta," *Saturday Review of Literature*, June 2, 1934, p. 736.

28. Levy later claimed to have organized Calder's Weyhe Gallery exhibition. See Julien Levy, interview with Paul Cummings, May 30, 1975, transcript, p. 10, Archives of American Art, Smithsonian Institution, Washington, D.C. Calder had a show of mechanical sculpture at the Julien Levy Gallery in the summer of 1932, but when his contraptions blew the fuses in the new gallery, Levy was unhappy and Calder switched to the Pierre Matisse Gallery.

29. The Abbott-Levy Collection now at the Museum of Modern Art, New York, is the primary legacy of their collaboration. A separate group of images, Levy's own holdings of work by Atget, are principally divided between the Philadelphia Museum of Art, with 350 photographs, and the Art Institute of Chicago, with a fine group of seventeen photographs. See Peter Barberie, *Looking at Atget* (Philadelphia: Philadelphia Museum of Art, 2005).

30. Eugène Atget, with a preface by Pierre Mac Orlan, *Atget, photographe de Paris* (New York: E. Weyhe, 1930). For an English translation, see Christopher Phillips, ed., *Photography in the*

Modern Era: European Documents and Critical Writings, 1913–1940 (New York: Metropolitan Museum of Art; Aperture, 1989), pp. 41–49. Zigrosser owned six of Abbott's prints from Atget's negatives and her portrait of Atget, which were likely acquired from this exhibition. The photographs were donated to the Philadelphia Museum of Art in 1968.

31. Carl Zigrosser to Edward Weston, May 22, 1930, Weston correspondence, Carl Zigrosser Papers, Special Collections Department, Van Pelt-Dietrich Library, University of Pennsylvania, Philadelphia.

32. Williams, "The Weyhe Gallery Between the Wars," p. 425. Both shows ran from November 24 to December 6, 1930. The six portraits by Abbott were of Eugène Atget, Jean Cocteau, André Gide, James Joyce, Princess Eugène Murat, and Sophie Victor.

33. Atget had placed some of his photographs in public institutions in France, but they were not seen by many viewers. Posthumously, through Abbott's efforts, his work was exhibited in the 1928 *Premier salon indépendant de la photographie* (First Independent Salon of Photography) in Paris, and in 1929 an article about him appeared in the journal *L'Art vivant*. His photographs were also included in the important 1929 exhibition *Film und Foto* in Stuttgart. In 1930, Atget photographs were shown in an exhibition devoted to the medium arranged by the Harvard Society for Contemporary Art, Cambridge, Massachusetts.

34. Levy, *Memoir*, p. 92. See also Henri Cartier-Bresson, *The Decisive Moment: Photography by Henri Cartier-Bresson* (New York: Simon and Schuster, 1952).

35. Levy, *Memoir*, p. 92.

36. Julien Levy, interview with Walter Hopps and Lynda Roscoe Hartigan, July 17, 1976, transcript, p. 54, Julien Levy Archive, Connecticut. About a half dozen Atget photographs in the Levy holdings at the Philadelphia Museum of Art can be traced back to that first show at the Weyhe Gallery, including oblique views of the Fête de Vaugirard grandstand (Philadelphia Museum of Art, 2001-62-392) and the bar at boulevard Masséna (see pl. 7 above).

37. Jonathan Levy Bayer kindly supplied dates for his older brothers, Javan Bayer (July 14, 1928–December 28, 2001) and Jerrold Edgar Levy (March 9, 1930–February 7, 2002).

38. Levy, *Memoir*, p. 46.

39. See Gretchen Berg, "Julien Levy: The Eyes; Excerpts from an Interview for *Photograph*," in Witkin Gallery, *Photographs from the Julien Levy Collection*, exh. cat. (New York: The Witkin Gallery, 1977), n.p.

40. Julien Levy to Paul Sachs, October 12, [1931], Julien Levy Archive, Connecticut. Many years later, in 1978–79, Levy was to honor Harvard's contributions to his education by donating a group of thirty-three photographs to the Fogg Art Museum.

41. Julien Levy to Imogen Cunningham, January 11, 1932, Julien Levy Archive, Connecticut. Levy's press release for the opening of the gallery specified that it would "in particular devote itself to and specialize in photography, as other galleries have specialized in etchings and lithographs." Several newspaper articles from October echo this phrase; see, for example, the *New York Sun*, October 24, gallery scrapbook, Julien Levy Archive, Connecticut.

42. "Art by Camera," *Art Digest*, November 15, 1931, p. 9.

43. Julien Levy Gallery to Samuel Grierson, December 1, 1931, Julien Levy Archive, Connecticut.

44. McAndrew worked at the gallery for six months, staying on at least through the Surrealism exhibition. Levy credits him with introducing Monroe Wheeler to the gallery and thus Glenway Wescott (*Memoir*, p. 86). McAndrew later taught the history of architecture at Vassar College, served as curator of architecture and industrial art at the Museum of Modern Art in New York, and was director of the art museum at Wellesley College in Massachusetts, in addition to writing several books. He is best known for his founding of the organization Save Venice, Inc., in 1970.

45. Levy, *Memoir*, p. 13.

46. At least one exception was the 1932 exhibition of photographs by Luke Swank in the red room. See Julien Levy to Luke Swank, December 14, 1932, Julien Levy Archive, Connecticut.

47. Levy, *Memoir*, p. 87.

48. Ibid., p. 88. Porter was interested in architecture from an early age. He initially worked as a journalist and typographer before spending a year in Germany. Levy hired him to replace John McAndrew at the gallery, and Porter remained with him until the late 1930s, though he did travel to California when Levy took the gallery on the road. He then worked in the film library at the Museum of Modern Art and continued at the museum in a number of capacities. See Allen Porter, interview with Butler Coleman, May 24, 1967, transcript, Archives of American Art, Smithsonian Institution, Washington, D.C.

49. Gallery scrapbooks, Julien Levy Archive, Connecticut.

50. Levy, *Memoir*, p. 88.

51. Ibid., p. 55.

52. Ibid., p. 56. These were the early days in the development of the art gallery toward a pristine white cube. The rooms used by the Harvard Society for Contemporary Art had also been painted a stark white. See Weber, *Patron Saints*, p. 7. The Museum of Modern Art opened in 1929 with ecru monk's cloth on its walls; see Russell Lynes, *Good Old Modern: An Intimate Portrait of the Museum of Modern Art* (New York: Atheneum, 1973), p. 50. Stieglitz, too, had broken with the tradition of salon-style installations and helped to establish the model of works hung separately at eye level to encourage individual viewing. While the walls of 291 were covered in burlap, the walls of An American Place were painted a cool gray.

53. Levy, *Memoir*, p. 56.

54. Ibid., p. 69.

55. Ibid., p. 60.

56. Levy claims to have personalized the press releases he sent to each newspaper, writing each in the style of that paper's critic, but there is no evidence to support this. See Julien Levy, interview with Paul Cummings, May 30, 1975, transcript, p. 15, Archives of American Art, Smithsonian Institution, Washington, D.C. However, many newspapers did use the text of his press releases verbatim. Levy also claimed to have initiated the cocktail reception for exhibition openings (ibid.).

57. Levy, *Memoir*, p. 184–85.

58. Ibid., p. 73.

59. Ibid., p. 53.

60. Ibid., pp. 100–101.

61. In a July 5, 1991, telephone interview with Eugene Gaddis, Joella Levy mentioned anti-Semitic remarks; recording, Wadsworth Atheneum, Hartford, Connecticut. Allen Porter spoke of Levy, with whom he worked very closely at the gallery, in stereotypical terms in his interview with Butler Coleman, May 24, 1967, transcript, p. 6, Archives of American Art, Smithsonian Institution, Washington, D.C. During the 1920s, Harvard shifted its enrollment policies to regulate the number of Jews and other ethnic groups admitted; Warburg and Kirstein were also Jewish, as was prominent collector Sam Lewisohn. For a recent examination of Harvard University's admission policies for Jewish students in the 1920s and 1930s, see Jerome Karabel, *The Chosen: The Hidden Mystery of Admission and Exclusion at Harvard, Yale, and Princeton* (Boston: Houghton Mifflin, 2005).

62. Jimmy Ernst, *A Not-So-Still Life: A Memoir* (New York: St. Martin's Press/Marek, 1984), p. 151. Jimmy Ernst, whose father, artist Max Ernst, exhibited work at the Julien Levy Gallery on several occasions, is comparing the gallery to the Karl Nierendorf and J. B. Neumann galleries in New York in the 1930s. He reports that Levy got him a mailroom job in the film library at MoMA, out of kindness and to end his loitering in the gallery.

63. Ibid., pp. 147–48.

64. Evidence for this is provided by numerous letters Levy wrote to artists between 1931 and 1932 and the many receipts to photographers for the deposit of work at the gallery, and sometimes for the outright purchase of work by Levy; these materials are in the Julien Levy Archive, Connecticut. See Levy, *Memoir*, p. 59.

65. Ibid., p. 64.

66. Ibid., pp. 70–71. Levy mentions that his father was in Paris when he bought the painting and that he liked it. Despite enjoying his father's support, he wrote: "I was almost disappointed by his easy acceptance" of Dalí's strange composition (p. 71). The painting was loaned to numerous exhibitions and is now in the collection of the Museum of Modern Art.

67. In 1964 Levy wrote to John Szarkowski, curator of photographs at the Museum of Modern Art, recalling the opening of his gallery: "In humble admiration of Alfred Stieglitz and his 'Camera Work' I had meant to contribute towards the recognition of photography as an art form." Julien Levy to John Szarkowski, October 8, 1964, Julien Levy Archive, Connecticut.

68. Levy, *Memoir*, p. 47. Stieglitz's letters to Levy are preserved at the Julien Levy Archive, Connecticut.

69. Julien Levy, interview with Walter Hopps and Lynda Roscoe Hartigan, July 17, 1976, transcript, p. 55, Julien Levy Archive, Connecticut.

70. The Ansel Adams show was on view from October 27 through November 25, 1936; Eliot Porter's exhibition ran from December 29, 1938, through January 18, 1939. In addition to these two exhibitions, Stieglitz, perhaps now following Levy's lead, showed two films at An American Place, Henwar Rodakiewicz's *Portrait of a Young Man* and Miguel Covarrubias's film of Bali.

71. Press release for *American Photography Retrospective Exhibition*, November 2–20, 1931, Julien Levy Archive, Connecticut.

72. Levy, *Memoir*, p. 32. In fact, the poem was to have been the basis for the film Levy planned to make in Paris in 1927 (ibid., p. 97).

73. Gershwin collected art and was a sponsor of the Film Society that Levy founded in October 1932.

74. Levy, *Memoir*, p. 76.

75. A surprising exception was the fall 1932 show of nineteenth-century photographs from the collection of Thomas E. Morris at the Brooklyn Museum, in the first-floor Library Gallery, which included photographs of upstate New York by Seneca Ray Stoddard and of the western states by William Henry Jackson.

76. "Synthetic View on Photography," *New York Times*, November 3, 1931.

77. Levy, *Memoir*, p. 48.

78. Only one photograph by White remained in Levy's hands; it is now at the Art Institute of Chicago (1988.157.89). His several works by Käsebier are divided between Philadelphia, Chicago, and the Fogg Art Museum, Cambridge, Massachusetts.

79. "Synthetic View on Photography," *New York Times*, November 3, 1931. These artists are not listed on the exhibition announcement.

80. Press release for *American Photography Retrospective Exhibition*, November 2–20, 1931, Julien Levy Archive, Connecticut.

81. Levy, *Memoir*, p. 48.

82. Ibid., pp. 50–51.

83. Ibid., p. 50. Three of the works Levy purchased from Strand are in Philadelphia, and an untitled landscape with dunes, grasses, and clouds is at the Art Institute of Chicago (1988.157.82). The $100 price was steep (Clarence White also sometimes charged $100) but reasonable compared with Stieglitz's price of $1,000 a print, undoubtedly the top of the market at that time (ibid., p. 51).

84. "Attractions in [cut off]," clipping from an unidentified newspaper, undated, gallery scrapbook, Julien Levy Archive, Connecticut.

85. For the former, see Philadelphia Museum of Art, 2001-62-1122.

86. The Julien Levy Archive has a receipt for the sale of a print of *Side of White Barn*, which earned Sheeler $23.35; Levy may have purchased the photograph for himself, since it remains in the collection. A review of *American Photography Retrospective Exhibition* in an unidentified newspaper ("Attractions in [cut off]," undated, gallery scrapbook, Julien Levy Archive) mentions "one of [Sheeler's] famous studies of the Ford Plant," probably one of those in the collection of the Art Institute of Chicago (1979.112, 1979.113).

87. Walter Gutman, ". . . Our Photographe . . . [cut off]," *Springfield Republican* (New York), November 8, 1931, gallery scrapbook, Julien Levy Archive, Connecticut.

88. Levy, *Memoir*, p. 55. For Stella Simon, see Lori Pauli, "Stella F. Simon, 1878–1973," *History of Photography*, vol. 24, no. 1 (Spring 2000), pp. 75–83.

89. Only a couple of days after the group arrived in Mexico, White died suddenly, and Simon accompanied his body back to the United States. Another alumna of the Clarence White School, Allie Bode, two of whose photographs remain in Levy's collection, may also have gone on the Mexico trip (see pl. 144).

90. For his opening exhibition, Levy remembered borrowing some works by White from Simon, as well as some photographs by Gertrude Käsebier (*Memoir*, p. 55), although his gallery records indicate that he borrowed these works from the artists' families. Three excellent examples of Simon's work from Levy's collection are in the Fogg Art Museum (P1979.202–204), and one is at the Art Institute of Chicago (1988.157.76).

91. Alvin Langdon Coburn to Julien Levy, October 20, 1931, Julien Levy Archive, Connecticut. The letter authorizing transfer of the Montross Gallery photographs to Levy was written on November 23, 1932, but the photographs were not transferred until January 1933. Levy delayed in requesting them because of Montross's death at the end of the year. Coburn's photographs were priced at $50 each, with one third going to the Julien Levy Gallery.

92. Sipprell later wrote to Levy, saying: "Your gallery makes me very happy." Clara Sipprell to Julien Levy, April 20, 1932, Julien Levy Archive, Connecticut.

93. Hill's collaborator, Robert Adamson, was not at this time recognized as an integral partner.

94. See, for example, "Photograph Gallery," *Time*, November 16, 1931, p. 28.

95. "Exhibition of Historic Photographs Opens Today," clipping from an unidentified newspaper, November 2, 1931, gallery scrapbook, Julien Levy Archive, Connecticut.

96. Levy, *Memoir*, p. 76. The Brady photographs in the Levy collection seem to correspond to those reputedly borrowed from

the government, but in his memoir (p. 76), Levy mentions Joseph Cornell bringing a Brady photograph to the gallery in 1932 to trade for a Nadar portrait of George Sand.

97. Julien Levy to John Szarkowski, October 8, 1964, Julien Levy Archive, Connecticut.

98. Levy, *Memoir*, p. 75.

99. Levy was later to include photographs by Atget in *Surréalisme* and in another Atget solo exhibition in May 1936, *An Epoch of Contrasts: Paris Chateaus, Chiffonneries, Petites Métiers* [sic].

100. Nadar photographed Paris from a hot-air balloon and belonged to "The Society for the Encouragement of Aerial Locomotion by Means of Heavier-than-Air Machines," for which he financed a journal and the monstrously large balloon *Le Géant* from which anti-ballooning tracts were dropped in 1863. His personality is said to have inspired several fictional characters of the time.

101. At least one portrait of Bernhardt was in Levy's possession, as it was listed in the catalogue for the Witkin Gallery exhibition and sale; see Witkin Gallery, *Photographs from the Julien Levy Collection*, [p. 49]. Its present location is unknown. There is also an example in the collection of the Fogg Art Museum at Harvard University (P1979.197). A number of Nadar's portraits of the actress were shown in the exhibition *Sarah Bernhardt: The Art of High Drama*, Jewish Museum, New York, December 2, 2005–April 2, 2006.

102. For these sheets of multiple images by Nadar, see Philadelphia Museum of Art, 2001-62-952 through 2001-62-972.

103. Levy, *Memoir*, p. 94. Levy offered the modern prints from Nadar's negatives for sale at $10 each, pricing the original Nadar prints at $50 to $100.

104. An original albumen print by Nadar, a portrait of Gustave Doré, is in the Levy holdings at the Art Institute of Chicago (1975.1143).

105. Levy, *Memoir*, p. 94.

106. Ibid., p. 76.

107. Ibid., p. 94.

108. André Breton published his *Manifeste du surréalisme* in 1924. Levy wrote about his desire to be part of Surrealism in his *Memoir*, pp. 12–13.

109. Press release for *Surréalisme*, January 9–29, 1932, Julien Levy Archive, Connecticut. When asked to define the term in the late 1970s, he said: "Surrealism is likely to be provocative, to conjure up a dream world. Many people mix it up with the fantastic. It's not. . . . Surrealism is fundamentally a revolt against logic and reason." See Julien Levy, interview with Nancy Hall-Duncan, c. 1979, transcript, [p. 1], Julien Levy Archive, Connecticut.

110. Levy, *Memoir*, p. 79.

111. Julien Levy, interview with Walter Hopps and Lynda Roscoe Hartigan, July 17, 1976, transcript, p. 10, Julien Levy Archive, Connecticut. The show at the Wadsworth Atheneum was indeed a sensation; the exhibition catalogue lists works by Giorgio de Chirico, Salvador Dalí, Max Ernst, André Masson, Joan Miró, Pablo Picasso, Pierre Roy, Leopold Survage, and a painting by an unknown artist contributed by Alfred Barr.

112. Austin was an important client for the gallery, purchasing for the Wadsworth Atheneum works by Calder, Cornell, Dalí, Ernst, and Matta, along with an entire collection of drawings and designs for the Ballets Russes that had belonged to dancer Serge Lifar.

113. Julien Levy, interview with Walter Hopps and Lynda Roscoe Hartigan, July 17, 1976, transcript, p. 9, Julien Levy Archive, Connecticut.

114. Levy, *Memoir*, p. 80.

115. Ibid.

116. Admittedly, as a New Yorker Cornell was more accessible than were the European Surrealists, but Levy was clearly very excited about his new recruit. Although Cornell was not able to devote himself fulltime to art until 1940, his work appeared in three solo exhibitions at the gallery and in at least three groups shows between 1932 and 1940. The exposure led to his inclusion in a 1935 group show at the Wadsworth Atheneum, which the following year became the first museum to purchase a piece by Cornell.

117. Levy, *Memoir*, p. 80.

118. "'Surréalisme': Julien Levy Gallery," *Art News*, vol. 30, no. 16 (January 1932), p. 10; Edward Alden Jewell, "Art: A Bewildering Exhibition," *New York Times*, January 13, 1932.

119. Levy, *Memoir*, pp. 79–81. Later, during a visit to the United States, Breton told Levy that he could never be a true Surrealist because he was "too *humoristique*" (ibid., p. 278). Certainly, being evicted from the Surrealist group by Breton was one of the unifying experiences of membership, but in any event, Levy was never aligned with the movement in any official or theoretical sense.

120. Ibid., p. 81. Reflecting his rather open view of what could be viewed as Surrealist, in his press release for the exhibition Levy wrote that in fact "many of the pictures in the present exhibition do not, strictly speaking, belong to 'Surréalisme,'" Julien Levy Archive, Connecticut.

121. Levy, *Memoir*, p. 77.

122. Apparently even Breton eventually came to accept Cornell as a Surrealist, inviting Levy in 1941 to write about the artist for an issue of the Surrealist journal *VVV*. See Levy, interview with Walter Hopps and Lynda Roscoe Hartigan, July 17, 1976, transcript, p. 24, Julien Levy Archive, Connecticut. For Cornell, the label was problematic. He brought up the matter in a letter to MoMA director Alfred Barr concerning the 1936 exhibition *Fantastic Art, Dada, Surrealism*, but he was still classified as a Surrealist in the catalogue for that show. His work was reproduced in the Surrealist journal *Minotaur* the following year.

123. The two also shared an interest in film. In 1933 Cornell wrote a film scenario about a photographer, titled *Monsieur Phot*, but he did not begin making films until 1936. Levy presented a matinee screening of Cornell's films *Rose Hobart* and *Goofy Newsreels* at the gallery in December 1936, along with Duchamp's *Anémic cinéma* and Man Ray's *L'Étoile de mer*. See Schaffner and Jacobs, eds., *Portrait of an Art Gallery*, p. 179.

124. A fourth daguerreotype-object in the same format is reproduced in Kynaston McShine, ed., *Joseph Cornell*, exh. cat. (New York: Museum of Modern Art, 1980), pl. 32 (present location unknown). It seems to have been made using a nineteenth-century portrait photograph, with glass shards inside the box. Cornell seldom used actual photographs in his work, and their appearance in several pieces suggests a date of 1933 for these objects, when he was frequenting the Julien Levy Gallery. He returned to using photographs in a few collages in the mid-1960s. For additional discussion of Levy's Cornell boxes, see p. 162 below.

125. American poet Langston Hughes, who lived in Mexico for a time and knew Henri Cartier-Bresson, is believed to have written an essay for the exhibition, now apparently lost. See Roberto Tejada, "Documentary and Anti-Graphic: Three at the Julien Levy Gallery, 1935," *Afterimage*, winter 2003, pp. 15–16nn18–19.

126. For further discussion of Levy's important exhibition *Documentary and Anti-Graphic Photographs*, see pp. 128–30 below.

127. Rather than purchasing the works outright, Breton most likely took a group of pictures to Paris for the exhibition and

kept them, as at least sixteen of the vintage prints were sold at his estate auction in 2003. See the Drouot-Richelieu auction catalogue for April 15–17, 2003. Several of the images are the same ones chosen by Levy.

128. Álvarez Bravo was certainly educated in the art of his time, and in 1939 he wrote an essay, "Atget: Documentos para Artistas," for the publication *Artes plásticas*, vol. 3 (Fall 1939).

129. Levy, *Memoir*, p. 82. The nature of the work contributed by Levy is as yet unclear.

130. Ibid., p. 83. *Why Not Sneeze Rose Sélavy* is in the collection of the Philadelphia Museum of Art (1950-134-75a–e). For an illustration of *Boule de neige*, see Merry Foresta et al., *Perpetual Motif: The Art of Man Ray*, exh. cat. (Washington, D.C.: National Museum of American Art, 1988), fig. 175.

131. Levy, *Memoir*, p. 81.

132. The exhibition *Surréalisme* was on view in the Harvard Cooperative Society building from February 15 through March 6, 1932. It included paintings, photographs, and montages, although the only artists listed who made photographs or photomontages were Bayer, Ernst, and Man Ray. See the files in the Harvard University Art Museum (HUAM) Archive, Cambridge, Massachusetts.

133. Levy, *Memoir*, p. 88. Levy's book *Surrealism* was reissued in a black-and-white paperback version by Da Capo Press in 1995.

134. A reviewer of the book for *Harper's Bazaar*, November 1936, mentioned the extensive collection of Surrealist literature available at the Julien Levy Gallery, virtually all of it in French, noting that not only did Levy's book cover "American Surrealism" but that it was "helpfully written in English" ("Shopping Bazaar," p. 50). The volume was as much anthology as original text, as Levy provided translations of writings by André Breton, Salvador Dalí, Paul Eluard, and others.

135. Levy, *Memoir*, pp. 95–96, 98. Levy had procured a 16-mm print of *Ballet mécanique* from Léger the previous summer. Antheil and Levy talked about working together on a color film of Goethe's *Faust*, which the composer planned to pitch to a Hollywood studio. See Lincoln Kirstein's review of Levy's film program, "Experimental Films," *Arts Weekly*, March 26, 1932, p. 52, in which he refers to the Léger and Man Ray films as dated and Leyda's as competent. He mentions Levy screening a montage of sports clips by Albrecht Viktor Blum, whom Levy had met in Berlin, as well as Stella Simon's "Ballet of Hands" and Lynn Rigg's "A Day in Santa Fe."

136. Radiogram from Jay Leyda to Julien Levy, February 2, 1932, Julien Levy Archive, Connecticut. Dmitri Debabov studied film and photography with Eisenstein at the High State Institute of Cinematography (VGIK), from which he graduated in 1926. He worked as a photojournalist for several newspapers and traveled extensively with his wife, Margarita Debabov, who was also a photographer. Surprisingly, given visits to Russia by such Levy associates as Leyda and Barr, as well as the crossover of Russian artists in Berlin, Levy did not show any photographs by Russian artists at the gallery; he did, however, exhibit sculptures by Naum Gabo and paintings by Pavel Tchelitchew and by Leonid and Eugene Berman, as well as dancer Serge Lifar's collection of art related to the Ballets Russes.

137. The Julien Levy Gallery offered private screenings of *Un Chien andalou* during *Surréalisme*. A reviewer for *Town and Country* magazine, December 1, 1932, noted that "truly, young Mr. Levy's gallery is the most advanced in the city," with its private viewings or rental of this "Surrealist movie that rocked ecclesiastical Paris to its Sacré Coeur," gallery scrapbook, Julien Levy Archive, Connecticut. An article in the *Philadelphia Public Ledger* indicates that Levy showed the film at the studio of Emlen Etting in Philadelphia, along with unedited footage by Etting. See Eric M. Knight, "The Films," *Philadelphia Public Ledger*, [1932], gallery scrapbook, Julien Levy Archive,

Connecticut; see also Walter Gutman, "News and Gossip," *Creative Art*, vol. 11, no. 3 (November 1932), p. 229. In a fall 1932 letter to László Moholy-Nagy, Levy writes that he is "talking over the possibility of establishing a film society for experimental films both here [New York City] and in Philadelphia." Julien Levy to László Moholy-Nagy, October 10, 1932, Julien Levy Archive, Connecticut.

138. "The Reappearance of Photography," *Hound & Horn*, vol. 5 (October–December 1931), pp. 125–28. In his interview with Levy, Walter Hopps said Evans told him the Atget book was extremely influential for him. See Julien Levy, interview with Walter Hopps and Lynda Roscoe Hartigan, July 17, 1976, transcript, p. 55, Julien Levy Archive, Connecticut.

139. Press release for *Walker Evans and George Lynes*, February 1–19, 1932, Julien Levy Archive, Connecticut. Lynes did not use his full name at this early date but was using it by October 1934, when he had his solo exhibition at the Julien Levy Gallery.

140. K.G.S., "Photographs That Interest," *New York Times*, February 4, 1932; *Brooklyn Times*, January 31, 1932, gallery scrapbook, Julien Levy Archive, Connecticut.

141. See, for example, Evans's *Times Square/Broadway*, in Judith Keller, *Walker Evans: The Getty Museum Collection* (Malibu, Calif.: J. Paul Getty Museum, 1995), nos. 68, 69.

142. Julien Levy, interview with Walter Hopps and Lynda Roscoe Hartigan, July 17, 1976, transcript, p. 57, Julien Levy Archive, Connecticut.

143. See Witkin Gallery, *Photographs from the Julien Levy Collection*, [p. 48]; the Art Institute of Chicago has two of the tombstone photographs, along with a terrific sign picture.

144. See Fine Arts Museum of San Francisco, *America Observed: Etchings by Edward Hopper, Photographs by Walker Evans*, exh. cat. (San Francisco: Fine Arts Museums of San Francisco, 1976), pp. 8–9.

145. Press release for *Walker Evans and George Lynes*, February 1–19, 1932, Julien Levy Archive, Connecticut. Levy appears to have shown the artists' work in separate rooms but to have considered it a single exhibition.

146. "The New Photography," *Brooklyn Eagle*, February 7, 1932, gallery scrapbook, Julien Levy Archive, Connecticut.

147. One of Lynes's photographs, *As a Wife Has a Cow*, was printed on the cover of the catalogue for *Newer Super-Realism* at the Wadsworth Atheneum but was not included in the show. See Eric Zafran and Paul Paret, *Surrealism and Modernism from the Collection of the Wadsworth Atheneum* (New Haven, Conn.: Wadsworth Atheneum in association with Yale University Press, 2003), p. 75, fig. 55.

148. See Levy, *Memoir*, pp. 59–60. See also the essay by Peter Barberie in this volume, pp. 162–63. Lynes had gamely collaborated with Levy on an uncompleted shipboard movie, and the two later worked together on some multiple-exposure photographs in New York. The footage of the unfinished film is now in the collection of the Museum of Modern Art.

149. Press release for *Walker Evans and George Lynes*, February 1–19, 1932, Julien Levy Archive, Connecticut.

150. *New York Times*, February 7, 1932, gallery scrapbook, Julien Levy Archive, Connecticut. Lynes had shown his work at his own bookshop in New Jersey and had a solo exhibition of his photographs in Hartford, Connecticut, in 1931.

151. Other works from this series are in the collection of the Art Institute of Chicago, including *New York Series #4* (1988.157.44), *#5* (1978.1082), and *#6* (1988.157.45).

152. Exhibition announcement for *Fifty Photographs by George Platt Lynes*, October 1–13, 1934, Julien Levy Archive, Connecticut.

153. Lynes showed at the Pierre Matisse Gallery in November 1941 (when the Levy Gallery was temporarily in California) in the solo exhibition *Two Hundred Portraits, Plus an Assortment of Less Formal Pictures of People*. Matisse's Gallery in the Fuller Building opened in the fall of 1931 and was devoted to modernist masters. "Pierre's gallery and mine carried on a friendly rivalry. Our lines never really crossed," Levy wrote in his memoir (p. 117). A few other artists associated with Levy eventually transferred their representation to Matisse in the 1940s, including Alberto Giacometti, Matta, and Yves Tanguy.

154. For the Parry storyboards, see Philadelphia Museum of Art, 2001-62-994 through 2001-62-1002.

155. Julien Levy to John Szarkowski, October 8, 1964, Julien Levy Archive, Connecticut.

156. These works are now in the collection of the Art Institute of Chicago (1975.1136, 1975.1137).

157. Other carousel images that Levy acquired are by Álvarez Bravo (pl. 248 below), Atget (Philadelphia Museum of Art, 2001-62-376), and Cartier-Bresson (see Witkin Gallery, *Photographs from the Julien Levy Collection*, cover image).

158. Julien Levy, talk given at the Fogg Art Museum, Harvard University, Cambridge, Massachusetts, January 13, 1978, recording, Julien Levy Archive, Connecticut.

159. Levy mentioned in his 1978 gallery talk at the Fogg (ibid.) that Kertész came to see his 1977 show at the Witkin Gallery.

160. Levy, *Memoir*, p. 68.

161. Three of Lotar's slaughterhouse photographs appeared in *Documents*, no. 6 (1929), pp. 328–30, to illustrate Georges Bataille's entry *Abbatoirs* in the "Critical Dictionary."

162. For Lotar's photograph of the *abbatoir*, see Philadelphia Museum of Art, 2001-62-721.

163. Fourteen prints by Bing are at the Philadelphia Museum of Art, while a group of twenty-six are in the collection of the Art Institute of Chicago.

164. For these other pictures by Bing in Levy's collection, see Philadelphia Museum of Art, 2001-62-420, -423, -424, -426. Additional images from this series are at the Art Institute of Chicago.

165. See Dilys Blum, *Shocking: The Art and Fashion of Elsa Schiaparelli* (Philadelphia: Philadelphia Museum of Art, 2003), p. 124.

166. Interestingly, later in life Levy strenuously objected to Surrealism being used in this manner, despite his own involvement in escapades such as the 1939 window display by Salvador Dalí at Bonwit Teller department store in New York City. See Julien Levy, interview with Nancy Hall-Duncan, c. 1979, transcript, [p. 5], Julien Levy Archive, Connecticut.

167. Levy, *Memoir*, p. 65.

168. László Moholy-Nagy, *Vision in Motion* (Chicago: Paul Theobald, 1947), p. 208.

169. The exhibition at the Delphic Studios gallery was on view October 12–25, 1931.

170. Levy, *Memoir*, p. 66.

171. Although the Bauhaus briefly reopened in Berlin in October 1932, it closed permanently in the spring of 1933.

172. Three of the camera images are now in Philadelphia, and a wonderful selection of two photograms and eleven camera images purchased by Levy from Moholy-Nagy are in the collection of the Art Institute of Chicago.

173. See Katherine Ware, *In Focus: László Moholy-Nagy; Photographs from the J. Paul Getty Museum* (Malibu, Calif.: J. Paul Getty Museum, 1995), p. 80, pls. 42–44. Levy wrote to Moholy-Nagy in October 1932 and, apparently in response to a suggestion from the artist, encouraged him to send the "filmbildchen" from his recent movies for Levy to see and propose to the Film Society, accounting for these unusual objects in the collection (Levy showed the film on February 26, 1933). Julien Levy to László Moholy-Nagy, October 10, 1932, Julien Levy Archive, Connecticut.

174. For the contact print from *Marseilles vieux port*, see Philadelphia Museum of Art, 2001-62-838.

175. Levy, *Memoir*, p. 65.

176. Ibid., p. 68. Bayer studied at the Bauhaus and in 1925 was appointed head of the printing and advertising department. A lowercase typeface he designed was adopted as the standard for Bauhaus publications and was thus widely disseminated. In 1938, after the resignation of director Walter Gropius, he left his teaching post and moved to New York, where he worked with Gropius on the Bauhaus exhibition presented at MoMA later that year. He married Joella Levy after she was divorced from Levy in 1942.

177. For Bayer's *Hands Act A–Z*, see Philadelphia Museum of Art, 2001-62-406.

178. This image is commonly known as *Unheimliche Strasse*; the print in the Philadelphia Museum of Art is inscribed on the back "Mysteriose Strasse" (Mysterious Street).

179. See Lucia Moholy, *A Hundred Years of Photography, 1839–1939* (Harmondsworth [London]: Penguin Books, 1939).

180. The Art Institute of Chicago has what can perhaps be considered Lex-Nerlinger's masterpiece, *Die Näherin*, a multiple-exposure image of a woman at a sewing machine (1988.157.40).

181. Among the works Levy gave to the Fogg Art Museum are two additional works by Nerlinger, both untitled (P1979.198, 199).

182. Brassaï and Leyda also played with images of scissors; see plates 46 and 224 in this volume.

183. For this image, see Philadelphia Museum of Art, 2001-62-663.

184. See Katherine C. Ware, "Photography at the Bauhaus," in *Bauhaus*, eds. Jeanine Fiedler and Peter Feierabend (Cologne: Könemann, 2000), pp. 506–29.

185. "Julien Levy Gallery," *New York Times*, February 28, 1932.

186. Julien Levy to Walter Peterhans, March 24, 1932, Julien Levy Archive, Connecticut. No photographs by Peterhans with a Levy provenance are known, nor does Levy appear to have retained anything from Florence Henri, who was also represented in the show and was among the artists whose work Levy loaned in 1932 to a survey at the Brooklyn Museum.

187. For this image by Hege, see Philadelphia Museum of Art, 2001-62-576.

188. In addition to his extensive loans to the show at the Brooklyn Museum, Levy was extremely active in lending to other venues in 1932 and 1933. A group of about forty-nine photographs was borrowed from the gallery for the exhibition *Modern Photography at Home and Abroad* at the Albright Art Gallery in February 1932. In early February of the following year, Levy loaned a selection of nearly seventy photographs for an exhibition at the Conservatory of Music in Englewood, New Jersey (Julien Levy to Mrs. Katz, March 7, 1933), followed by thirty-six pictures for an exhibition at the Smith College Museum of Art, Northampton, Massachusetts, by mid-month. He appears to have been involved in sending photographs abroad as well, handling the shipment of ten photographs by Kurt Baasch to Germany in February 1933 for an exhibition in Berlin; Julien Levy Gallery to Kurt Baasch, February 18, 1933, Julien Levy Archive, Connecticut.

189. See, for example, *New York Evening Post*, March 1932 (gallery scrapbook, Julien Levy Archive), which also mentions an exhibition of photographs by Wyatt Davis at the Argent Gallery.

190. See *New York Evening Post*, February 27, 1932, gallery scrapbook, Julien Levy Archive; "Modern European Photography: Julien Levy Gallery," *Art News*, vol. 30, no. 22 (February 27, 1932), p. 10. For Tabard's multiple exposures, see Philadelphia Museum of Art, 2001-62-1149 through 2001-62-1151.

191. K.G.S., "European Photography on View," *New York Times*, February 25, 1932.

192. Levy, *Memoir*, p. 96.

193. For the portfolio *Électricité*, see Philadelphia Museum of Art, 1987-86-1 through 1987-86-10.

194. "Looking Thru the Lens," *Interior Architecture and Decoration*, March 1932, p. 61.

195. Innis Howe Shoemaker, "Crossing Borders: The Weyhe Gallery and the Vogue for Mexican Art in the United States, 1926–1940," in *A Revolution in the Graphic Arts: Mexico and Modern Printmaking, 1920–1950*, forthcoming.

196. Museum of Modern Art, *Murals by American Painters and Photographers*, exh. cat. (New York: Museum of Modern Art, 1932), p. 5.

197. *Murals by American Painters and Photographers*, p. 7.

198. Levy, *Memoir*, p. 114.

199. *Murals by American Painters and Photographers*, p. 11.

200. Levy, *Memoir*, p. 115.

201. Edward Alden Jewell, "Art in Review," *New York Times*, May 3, 1932. Among the painters who submitted mural designs were George Biddle, Stuart Davis, Reginald Marsh, Jan Matulka, Georgia O'Keeffe, Ben Shahn, and Franklin Watkins.

202. Ibid.

203. Mary Morsell, "The Museum of Modern Art Opens in Its New Home," *Art News*, vol. 30, no. 32 (May 7, 1932), p. 6; "The Photo-Mural Appears," *New York Sun*, May 10, 1932.

204. For Gerlach's *Energy*, see Philadelphia Museum of Art, 2001-62-512. Rotan's *Daily News Building* appears to have been mimicked in 1939 for *The Sun* newspaper in Sydney, Australia, which published a montage of a half dozen major structures erected over the previous three years in Sydney. That photograph is now in the collection of the State Library of New South Wales (PXD 930). Rotan's skyscraper image became part of Levy's holding of photographs available to commercial designers, as indicated by a blue slip of paper attached to the photomontage in the collection of the Fogg Art Museum at Harvard University, which matches the paper labels on other commercially oriented photo designs in Levy's collection.

205. The piece was not entered into the collection and has disappeared, although a photograph of its installation at the Wadsworth Atheneum exists in their archives.

206. Lillian Semons, "Easel Painters, Murals in Modern Museum Show," *Brooklyn Daily Times*, May 8, 1932.

207. Press release for *Photographs of New York by New York Photographers*, May 2–June 11, 1932, Julien Levy Archive, Connecticut.

208. Levy, *Memoir*, p. 187.

209. In MacRae's correspondence with Julien Levy, and on a number of his photographs in the Julien Levy Collection, he signs his name McRae. According to the photographer's daughter, he changed the spelling to MacRae sometime in the 1930s with the intention of making it sound "less Irish." Scotia MacRae, telephone conversation with Peter Barberie, January 27, 2006.

210. Melvin Geer Shelley, "Around the Galleries," *Creative Art*, vol. 10, no. 6 (June 1932), p. 471. Schell was also singled out by the reviewer for the *New York Sun*, who called his work "the special sucess [sic] at the Levy Galleries." See Henry McBride, "City Museum Shows Drawings of the City's Clustered Towers: Photographs at the Levy Galleries Add to the Record Scenes that Will Soon Be Historical," *New York Sun*, May 14, 1932.

211. See Donald Albrecht, *The Mythic City: Photographs of New York by Samuel H. Gottscho, 1925–1940* (New York: Museum of the City of New York; Princeton Architectural Press, 2005).

212. For Gottscho's other views across the Hudson, see Philadelphia Museum of Art, 2001-62-525 and 2001-62-526, and for his photograph of a tower of the George Washington Bridge, see 2001-62-524.

213. Art Center, *Thurman Rotan, Photo-patterns*, exh. cat. (New York: Art Center, 1932); collection of the Frick Art Reference Library, New York.

214. For this image, see Philadelphia Museum of Art, 2001-62-1058.

215. The skyscraper image appears in orange and white as the endpapers for H. G. Wells's two-volume book *The Work, Wealth, and Happiness of Mankind* (1931). The volumes also include photographic illustrations by Rotan and Philadelphia photographer William Rittase.

216. For the photographs of pretzels, wooden pilings, and another image of oil barrels, see Philadelphia Museum of Art, 2001-62-1042, 2001-62-59, and 2001-62-1028, respectively.

217. In the press release for a 1982 exhibition of Rotan's work by art dealer Keith de Lellis in New York, Rotan stated that he considered himself "one of the last of the living Pictorialists" and had been a member of the Pictorial Photographers of America; artist file, Department of Prints, Drawings and Photographs, Philadelphia Museum of Art. Rotan exhibited nationally in the 1930s and worked as the staff photographer for the Frick Art Reference Library for more than fifty years. He also made the photographs for a 1935 children's book, *Five Cats from Siam*, featuring Siamese cats he and his wife owned.

218. A photograph by Anton Bruehl is in the collection of the Art Institute of Chicago. Its subject, a flower vendor, suggests it may have been in this exhibition. For an illustration, see Witkin Gallery, *Photographs from the Julien Levy Collection*, p. 9. The Fogg Art Museum at Harvard also has a print of this image from Levy (P1979.183).

219. "These Photographs Delight," *New York Times*, May 8, 1932; Margaret Breuning, "Photographs of the City Scene Form Exhibition at Julien Levy Gallery," *New York Evening Post*, May 14, 1932.

220. Elisofon was also a founding trustee of the National Museum of African Art, Smithsonian Institution, Washington, D.C. He bequeathed thousands of images to the museum, establishing the Eliot Elisofon Photographic Archives. His papers are housed at the Harry Ransom Humanities Research Center at the University of Texas, Austin. Levy donated three examples of his work to Harvard's Fogg Art Museum (P1979.188–190).

221. For the latter, see Philadelphia Museum of Art, 2001-62-495.

222. Ernst, *A Not-So-Still Life*, pp. 147–48 (Jimmy Ernst arrived in New York in 1938 as a young man of eighteen). In November 1940, the Museum of Modern Art published the essay "American Art and the Museum" in their *Bulletin*, at least tactily acknowledging criticism of their neglect of American artists.

223. Press release for *Photographs by Berenice Abbott*, September 26–October 15, 1932, Julien Levy Archive, Connecticut.

224. See "Exhibitions in New York," *Art News*, vol. 31, no. 2 (October 8, 1932), p. 11.

225. *New York Herald-Tribune*, October 2, 1932, gallery scrapbook, Julien Levy Archive, Connecticut.

226. "Berenice Abbott," *New York Post*, October 1, 1932.

227. Edward Alden Jewell, "Art: Photographs by Miss Abbott," *New York Times*, September 29, 1932.

228. Melvin Geer Shelley, "Around the Galleries," *Creative Art*, vol. 11, no. 2 (October 1932), pp. 143–44. The reviewer did not care for Abbott's more ambitious images, finding that "those photographs which try to do bigger things do not succeed."

229. Levy presented an exhibition of models by Cuban architect Emilio Terry at the gallery in 1934.

230. In 1949, as a master's thesis, Johnson designed his Glass House in New Canaan, Connecticut. Former Bauhaus director Walter Gropius was hired to teach at Harvard University in 1937 and was another profound influence on bringing architecture into contemporary discourse.

231. See "Past and Present in Photography," *Brooklyn Eagle*, October 23, 1932.

232. Melvin Geer Shelley, "Around the Galleries," *Creative Art*, vol. 11, no. 3 (November 1932), p. 222.

233. "Portrait Photography: Julien Levy Gallery" *Art News*, vol. 31, no. 4 (October 22, 1932), p. 5.

234. Levy owned one photograph he believed to be by Hill, a portrait of Jean-Baptiste Biot that is now attributed to Henri Victor Regnault (see pl. 88 below), as well as a later carbon print of a Hill and Adamson image.

235. Press release for *Exhibition of Portrait Photography*, October 15–November 5, 1932, Julien Levy Archive, Connecticut.

236. For mentions of the Vandamm Studios portrait, see "Miss Cornell's Portrait on Exhibition," *Women's Wear Daily*, October 13, 1932; "Cornell Portrait," *New York Sun*, October 18, 1932; "Cornell Portrait on Exhibition," *New York World-Telegraph*, October 20, 1932. For the Man Rays, see *New York Sun*, October 22, 1932, gallery scrapbook, Julien Levy Archive, Connecticut.

237. Photographs by only a few of these contemporary artists remained in Levy's collection, so perhaps the portraits were borrowed from sitters or from the artists. Somewhat surprisingly, Levy wrote to Ralph Steiner for suggestions on whom to include in the portrait exhibition. See Ralph Steiner to Julien Levy, September 26, 1932, Julien Levy Archive, Connecticut.

238. Edward Steichen to Julien Levy, undated, Julien Levy Archive, Connecticut.

239. In his undated letter to Levy (ibid.), Steichen says he does not "have anything 'agin' [Levy]," and will see him "when I get back about the misunderstanding last year," probably a reference to the MoMA photomural competition.

240. The Philadelphia Museum of Art has a group of nine Leyda portraits, 2001-62-670 through 2001-62-678; Leyda's portrait of Alfred Barr is in the collection of the Art Institute of Chicago, as is his portrait of Julien Levy. Leyda's papers are at New York University and at the University of California, Los Angeles. In April 2005, New York University sponsored a conference celebrating Leyda's achievements.

241. Miller's image of Cornell is now in the collection of the Lee Miller Archive in East Sussex, England. For Cornell's collage incorporating images of Miller, see McShine, ed., *Joseph Cornell*, pl. 269.

242. "Two 'One-Man' Shows," *New York Times*, December 31, 1932.

243. *New York Post*, January 5, 1933, gallery scrapbook, Julien Levy Archive, Connecticut.

244. For the latter, see Philadelphia Museum of Art, 2001-62-805.

245. A variant of the image in the collection of the Museum of Modern Art (1785.2001) is equally fine but includes the legs of a man, grounding the image in reality in a way that makes it a more typical Surrealist image but less successful as pure abstraction.

246. Miller's Tanja Ramm and Mary Taylor portraits are in the collection of the Lee Miller Archives, Sussex, England.

247. Levy owned a "floating head" portrait that Man Ray made of Miller; it is now in the collection of Thomas Walther.

248. See Levy, *Memoir*, pp. 101–3. Ewing wrote the novel *Going Somewhere*, published in 1933; he committed suicide later that year. Because of his brief career, the artist's work is unknown to us today, and there are no photographs in the Levy holdings that seem to correspond to the exhibition.

249. Gilbert Seldes, exhibition announcement for *Carnival of Venice: Photographs by Max Ewing*, January 26, 1933, Julien Levy Archive, Connecticut. Seldes was the author of the 1924 book *The Seven Lively Arts*, an important publication for Levy and his friends for its early treatment of the interest in and importance of popular culture.

250. Seldes, exhibition announcement for *Carnival of Venice: Photographs by Max Ewing*, January 26, 1933, Julien Levy Archive, Connecticut.

251. "So You're Going Somewhere," *Town and Country*, February 1, 1933, p. 15.

252. "Max Ewing as a Camera Man," *New York Sun*, January 28, 1933.

253. See Luke Swank to Julien Levy, December 31, 1931, Julien Levy Archive, Connecticut; and "On and Off the Avenue," *New Yorker*, December 19, 1931, p. 60. For a full treatment of Luke Swank's life and career, see Howard Bossen, *Luke Swank, Modernist Photographer* (Pittsburgh, Pa.: University of Pittsburgh Press, 2005).

254. Swank talks about his AIA survey work in a letter to the gallery; see Luke Swank to Allen Porter at the Julien Levy Gallery, March 20, 1933, Julien Levy Archive, Connecticut.

255. Luke Swank to Julien Levy, undated, cited in the press release for *Photographs of the American Scene by Luke Swank*, January 28–February 18, 1933, Julien Levy Archive, Connecticut.

256. Swank's subject matter in many cases parallels that of Atget, another artist intent on capturing the character of a city in the midst of change, and Levy's description of Atget in his memoir (p. 95) could just as easily have been applied to Swank: "He was simply preserving carefully the vanishing world that he loved, and keeping an archive of important classified documents. He was a remarkably simple man, extremely modest. In truth, he was unaware of his achievement."

257. "Around the Galleries," *Art News*, vol. 31, no. 19 (February 4, 1933), p. 6.

258. *New York Evening Post*, February 4, 1933, gallery scrapbook, Julien Levy Archive, Connecticut. The reviewer mistakenly refers to the photographer as James Strang.

259. Luke Swank to Joella Levy, undated, Julien Levy Archive, Connecticut.

260. The largest known holding of Baasch's photographs and correspondence is probably that of the Center for Creative Photography at the University of Arizona, Tucson.

261. Four large platinum prints of two of Strand's portraits of Baasch are in the collection of the J. Paul Getty Museum, Los Angeles.

262. In the press release for *Kurt Baasch Photographs*, February 24–March 18, 1933, Levy attributes Baasch's fallow period to his dismay at the ongoing prevalence of Pictorialist photography; Julien Levy Archive, Connecticut.

263. Baasch is quoted in the press release for the exhibition (ibid.).

264. Levy, *Memoir*, p. 131.

265. Ibid., p. 48.

266. Ibid., p. 49. It is interesting to note that Levy reproduced the full text of this short essay in his memoir, and that it appears within the first fifty pages of this nearly three hundred-page account.

267. Press release for *Photographs by Henri Cartier-Bresson* and an *Exhibition of Anti-Graphic Photography*, September 25–October 16, 1933, Julien Levy Archive, Connecticut.

268. Ibid.

269. Ibid.

270. "New Forms of Art Shown: Julian [sic] Levy Gallery and John Becker's Open Season," *New York Evening Post*, September 30, 1933.

271. Lewis Mumford, "The Art Galleries: Anti-Graphic Photographs—Kent, Hale, and Orozco," *New Yorker*, October 14, 1933, p. 48.

272. Ibid., p. 49.

273. Levy greatly admired Cartier-Bresson's work and in April 1933 wrote to him to purchase four (unspecified) photographs for himself. Julien Levy to Henri Cartier-Bresson, April 13, 1933; reproduced in *Documentary and Anti-Graphic Photographs by Cartier-Bresson, Walker Evans, and Álvarez Bravo*, exh. cat. (Göttingen: Steidl. 2004), p. 16. fig. 6. Cartier-Bresson later acknowledged that Levy's prints were unusual in having been printed by himself. The two men maintained a lifelong connection, both having homes in the south of France (see ibid., p. 96, fig. 23).

274. This show was re-created in a 2004-5 exhibition at the Fondation Henri Cartier-Bresson, Paris, and traveled to the Musée de l'Elysée, Lausanne. See ibid.

275. For images of these works, see Walker Evans, with an essay by Lincoln Kirstein, *Walker Evans: American Photographs* (New York: Museum of Modern Art, 1938), pp. 18, 10, respectively.

276. Ibid., pp. 193, 192, respectively.

277. For *Rouen*, see Philadelphia Museum of Art, 2001-62-455; reproduced in *Documentary and Anti-Graphic*, p. 121.

278. For these other images of children by Cartier-Bresson in the Philadelphia Museum of Art, see 2001-62-624 and 2001-62-453.

279. Exhibition announcement for *Remi Lohse, Exhibition of Photographs*, February 6–March 3, 1934, Julien Levy Archive, Connecticut.

280. *New York Sun*, February 17, 1934, gallery scrapbook, Julien Levy Archive, Connecticut. A. J. Liebling wrote a lengthy article on Lohse for the *New York World-Telegram* on February 20, 1934.

281. Alice Hughes, "Exhibition of Women's Pictures On," *New York City American*, April 22, 1934, gallery scrapbook, Julien Levy Archive, Connecticut.

282. Wynn Richards, quoted in ibid.

283. We are indebted to Ariel Zuñiga and Charmaine Picard for sharing research on Amero.

284. The two exchanged several letters into the beginning of 1933; these are in the collection of the Julien Levy Archive, Connecticut. The Mexican photography show was never mounted, but Amero had a solo show at the gallery in 1935.

285. Exhibition announcement for *Emilio Amero, Paintings, Watercolors, Drawings, Photographs*, January 5–31, 1935, Julien Levy Archive, Connecticut. During the run of the Amero exhibition, the Brooklyn Institute of Arts and Sciences held a lecture by M. F. Agha on "The So-Called Modern Photography." See *Bulletin of the Brooklyn Institute of Arts and Sciences*, vol. 39, no. 9 (December 29, 1934), p. 143; vol. 39, no. 10 (January 12, 1935), p. 155.

286. For one of the images Levy included in his Amero exhibition, see Philadelphia Museum of Art, 1972-145-72.

287. In addition to the third photogram in the Levy Collection at the Philadelphia Museum of Art (2001-62-981), the Art Institute of Chicago owns a photogram by Amero from Levy's collection (1988.157.3). See Carlos Mérida, "Fotografía y Cinematógrafo: Emilio Amero," *Revista de Revistas*, vol. 1178 (December 11, 1932) for images of three additional photograms: *Fantasía, Caracoles*, and an untitled study with stemware that is a variation of that in the Philadelphia Museum of Art (see pl. 219 below). See also A. Núñez Alonso, "Emilio Amero, Foujita y Pedro Rendón," *El Universal Illustrado*, vol. 815 (December 22, 1932), and Horatio Fernández "Emilio Amero," in *Mexicana: Fotografía Moderna en México, 1923–1940* (Valencia: Ivam Centre Julio González, 1998), pp. 163–93.

288. Jean Charlot, exhibition brochure for *Emilio Amero, Paintings, Watercolors, Drawings, Prints, Photographs, Photograms*, January 5–31, 1935; R. U. Godsoe, *Flushing News* (New York), January 17, 1935, gallery scrapbook, Julien Levy Archive, Connecticut.

289. E.A.J., *New York Times*, January 13, 1935; *New York Sun*, January 12, 1935, gallery scrapbook, Julien Levy Archive, Connecticut.

290. During the years 1938–1940, after returning to Mexico, where he was a cameraman for Pathé, Amero worked on a book project about Mexico. Though never published, the work was exhibited at the Seattle Art Museum in 1942 and at the University of Oklahoma Museum of Art in 1951. The Weyhe Gallery produced a portfolio of thirty gelatin silver prints from the series, a body of work that includes several portraits, some genre scenes, and a few compositions inspired by modernism, such as Amero's close-up of an abundant pile of fish. See the copy in the collection of the Philadelphia Museum of Art, *Amero Picture Book: Photographs of Mexico* (New York: E. Weyhe, 1940), Gift of Carl Zigrosser, 1975-187-1-30.

291. "The New Photography," *Brooklyn Eagle*, February 7, 1932, gallery scrapbook, Julien Levy Archive, Connecticut.

292. This is not to say that the f.64 photographers did not have their own darkroom tricks but that, importantly, their goal was a straight camera image.

293. In a letter sent to Carl Zigrosser in 1930, during the Weyhe Gallery's Atget exhibition, Weston wrote: "I wish I was nearer, to see Atget's show, I have no opportunity out here, to view fine photographs. I don't know Atget's work." Edward Weston to Carl Zigrosser, July 22, 1930, Carl Zigrosser Papers, Special Collections Department, Van Pelt-Dietrich Library, University of Pennsylvania, Philadelphia.

294. For the Group f.64 Manifesto, see Therese Thau Heyman, "Modernist Photography and the Group f.64," in *On the Edge of America: California Modernist Art, 1900–1950*, ed. Paul J. Karlstrom (Berkeley: University of California Press, 1996), p. 252.

295. John Paul Edwards, "Group f.64," *Camera Craft*, vol. 42 (March 1935), pp. 107–12.

296. Heinrich Schwarz, review of *Die Welt ist schön*, by Albert Renger-Patzsch, *Photographische Korrespondenz* (Vienna), vol. 65,

no. 5 (May 1929), pp. 156–57, translated in *Albert Renger-Patzsch: Joy Before the Object* (New York: Aperture in association with the Philadelphia Museum of Art, 1993), p. 6. Dr. Schwarz (1894–1974) was an early scholar in the history of photography and wrote the influential book *David Octavius Hill: Der Meister der Photographie* in 1931; see also an English translation by Helen E. Fraenkel, *David Octavius Hill: Master of Photography* (New York: Viking Press, 1931).

297. In 1944, Adams did photograph with Lange at the Manzanar Relocation Center in the mountains of northern California and published a book on the subject, *Born Free and Equal: Photographs of the Loyal Japanese-Americans at Manzanar Relocation Center, Inyo County, California*, published by U.S. Camera.

298. Walter Benjamin. "The Author as Producer," 1934; reprinted in *Reflections: Essays, Aphorisms, Autobiographical Writings* (New York: Harcourt Brace Jovanovich, 1978), p. 230; quoted in *Albert Renger-Patzsch: Joy Before the Object*, p. 66.

299. Donald Kuspit, "Albert Renger-Patzsch: A Critical-Biographical Profile," in *Albert Renger-Patzsch: Joy Before the Object*, p. 68.

300. Edward Weston to Julien Levy, October 19, 1931, Julien Levy Archive, Connecticut. By 1935 Edward Weston was more interested in working with Levy, writing, "I liked the way you handled Brett's show." Edward Weston to Julien Levy, October 27, 1935, Julien Levy Archive, Connecticut.

301. Brett Weston to Julien Levy, September 1, 1934, Julien Levy Archive, Connecticut.

302. Brett Weston to Julien Levy, August 2, 1934, Julien Levy Archive, Connecticut.

303. Julien Levy to Imogen Cunningham, January 11, 1932, Julien Levy Archive, Connecticut.

304. These prints are part of the Art Institute of Chicago's excellent group of nine Cunningham photographs from Levy, which were made, like the Philadelphia examples and one in the Fogg Art Museum, before Cunningham began printing on the glossy, higher contrast paper f.64 members came to favor.

305. This print was later exhibited in a show of Cunningham's work at the Witkin Gallery, July 16–August 1980, when it was offered for $2,500. Levy was to receive seventy-five percent. See Evelyne Daitz to Julien Levy, June 18, 1980, Julien Levy Archive, Connecticut.

306. Schaffner and Jacobs list this as occurring along with a selection of "modern photography" (*Portrait of an Art Gallery*, p. 179), but no records to confirm this have been found in the Julien Levy Archive.

307. See *New York Sun*, May 23, 1936, gallery scrapbook, Julien Levy Archive, Connecticut; and "Atget, Forerunner of New Photography," *Art News*, vol. 34, no. 34 (May 23, 1936), p. 8.

308. Elizabeth McCausland, "A Genius of the Camera: Atget's Photographs in New York Exhibition," *Springfield Republican* (Massachusetts), May 17, 1936.

309. Levy, *Memoir*, p. 179. Jonathan Levy Bayer was born on March 28, 1936. He is a photographer who lives and works in London.

310. Ibid., p. 203.

311. Press release announcing the Julien Levy Gallery's move to a new space, Julien Levy Archive, Connecticut.

312. "Vogue Covers the Town," *Vogue*, October 1, 1937, p. 60; *New York Times*, October 22, 1937, gallery scrapbook, Julien Levy Gallery, Connecticut.

313. "Welsh Rarebits Inspire Artist in Gracie Allen," *New York Herald Tribune*, September 27, 1938.

314. See David Leddick, *George Platt Lynes, 1907–1955* (Cologne: Taschen, 2000), p. 202, where it is listed as being made for *Harper's Bazaar*.

315. Nicholas Ház, *Image Management (Composition for Photographers)* (Cincinnati, Ohio: N. Ház Book, 1946). The three-week photography course taught with Adams in 1937 was held in the Berkeley home of Cedric Wright. Wright and Adams were close friends, both being musicians, photographers, and avid members of the Sierra Club.

316. Press release for *Full Color Abstract Photograms by Nicholas Ház*, October 17–30, 1940, Julien Levy Archive, Connecticut. At this point Levy was no longer using printed letterhead and typed "Julien Levy Studio" above the address (15 East 57) as well as in lieu of a signature at the bottom.

317. This project informed the 1970s prospectus for Levy's "Center of Surrealist Studies of Alternative Thinking and Expanding Experience," Julien Levy Archive, Connecticut.

318. The photograph, one of a handful from the Dream of Venus Pavilion in the Julien Levy Collection at the Philadelphia Museum of Art, may be by Eric Schaal, who documented the project. See Ingrid Schaffner, *Salvador Dalí's Dream of Venus: The Surrealist Funhouse from the 1939 World's Fair*, exh. cat. (New York: Princeton Architectural Press, 2002).

319. See Charles Desmarais, "Julien Levy: Surrealist Author, Dealer, and Collector," *Afterimage*, January 1977, p. 6. Laughlin had written to the gallery in 1933 to request copies of photography exhibition announcements for their essays and to purchase copies of *Creative Art* and *Minotaur*; Clarence John Laughlin to the Julien Levy Gallery, January 14, 1933, Julien Levy Archive, Connecticut.

320. Laughlin was an avid reader and by about 1925 had discovered the writings of Charles Baudelaire, whose volume of poems *Les Fleurs du mal* had inspired other writers and painters who emphasized the vitality of imagination over realism. Laughlin took up photography after seeing published images by some of the artists mentioned. See Philadelphia Museum of Art, *Clarence John Laughlin: The Personal Eye* (Philadelphia: Philadelphia Museum of Art, 1973).

321. Laughlin exhibited work from two series at the Levy Gallery, listed on the exhibition announcement as *Lost New Orleans* and *Poems of Desolation*, Julien Levy Archive, Connecticut. This work was included in a group exhibition featuring sculpture by Theodore Roszak, photographs by Laughlin, and paintings by Italian Futurist Enrico Prampolini. Titled *Severity and Nostalgia in 1940*, the exhibition also included some photographs by Eugène Atget and paintings by Stuart Davis, Herbert Bayer, and Max Ernst. "No controversial theory is intended by the show," Levy wrote in the press release, but rather "an inquiry concerning certain elements of nostalgia and severity which seem symptomatic as of our time, this month of November in the year 1940." See press release for *Severity and Nostalgia in 1940*, November 12–December 7, 1940, Julien Levy Archive, Connecticut. Levy's phrasing sounds portentous, and, indeed, the year was marked by food rationing in Europe, the occupation of Paris by German troops, a devastating bombing campaign on the United Kingdom, and the creation of the now-infamous concentration camp at Auschwitz.

322. Levy sold Laughlin photographs to Eugene Berman and Pavel Tchelitchew, according to David Travis, *Photographs from the Julien Levy Collection Starting with Atget*, exh. cat. (Chicago: Art Institute of Chicago, 1976), p. 46.

323. See *Clarence John Laughlin: The Personal Eye*, pp. 13–14.

324. For an illustration of this work, see Keith F. Davis, *Clarence John Laughlin: Visionary Photographer* (Kansas City, Mo.: Hallmark Cards, 1990), p. 38, fig. 26.

325. *Clarence John Laughlin: The Personal Eye*, p. 14.

326. David Hare (1917–1992) had close ties with Surrealism and is known as an Abstract Expressionist sculptor. In 1939 he showed color photographic work at the Walker Galleries in New York, prior to his exhibition at the Julien Levy Gallery.

327. Exhibition announcement for *Joseph Cornell, Exhibition of Objects: Daguerreotypes, Miniature Glass Bells, Soap Bubbles, Shadow Boxes, Homage to the Romantic Ballet*, December 10–26, 1940, Julien Levy Archive, Connecticut.

328. Levy, *Memoir*, p. 255.

329. An announcement of his Los Angeles exhibitions in the Julien Levy Archive, Connecticut, refers to "a series of three exhibitions of important modern paintings."

330. See the letter of agreement from Levy to Kirk Askew, January 7, 1942, and an engraved announcement stating Askew's temporary assumption of the Julien Levy Gallery's business, Julien Levy Archive, Connecticut. Also in 1942, Levy deposited a sculpture and a group of 111 paintings at the Wadsworth Atheneum in Hartford, Connecticut, for safekeeping, many of which were exhibited in Austin's fall show *Painters of Fantasy*. See Zafran and Paret, *Surrealism and Modernism from the Collection of the Wadsworth Atheneum*, p. 28.

331. Beaumont Newhall to Julien Levy, July 17, 1942, Julien Levy Archive, Connecticut.

332. Levy, *Memoir*, p. 265. Levy further commented that it was at this time that his father "relaxed his purse strings" (ibid.).

333. Ibid., p. 12.

334. Julien Levy, interview with Walter Hopps and Lynda Roscoe Hartigan, July 17, 1976, transcript, p. 52, Julien Levy Archive, Connecticut. Collector Peggy Guggenheim opened her exhibition space Art of This Century at 50 West 57th Street in New York, with interiors by Frederick Kiesler.

335. See Julien Levy, interview with Nancy Hall-Duncan, c. 1979, transcript, [pp. 5–6], Julien Levy Archive, Connecticut.

336. See Larry List, ed., *The Imagery of Chess Revisited*, exh. cat. (New York: Isamu Noguchi Foundation and Garden Museum and George Braziller, 2005), p. 96.

337. The text is in the Julien Levy Archive, Connecticut, and three of the photographs of children are in the Philadelphia Museum of Art, 2001-62-2202, 2001-62-2245, and 2001-62-2247. See also ibid., p. 95.

338. The promotional material for *Dreams That Money Can Buy* can be found in the Julien Levy Archive, Connecticut.

339. "5th Avenue Cinema Presents March 15, 1957, the World Premier of '8 x 8'," Julien Levy Archive, Connecticut.

340. "World Premier of *8 x 8*, March 7, 1957, New York City, for the benefit of 'Film Culture'," Julien Levy Archive, Connecticut.

341. The scenario can be found in the Julien Levy Archive, Connecticut.

342. For Richter's face montaged onto an FBI wanted poster, see Philadelphia Museum of Art, 2001-62-1254.

343. See Levy, *Memoir*, p. 293.

344. Ibid., pp. 68–69.

345. Julien Levy, *Arshile Gorky* (New York: H. N. Abrams, 1966), p. 10. Breton had written the foreword to the catalogue of the Gorky exhibition held at the Julien Levy Gallery in 1945.

346. See Judith Parker, "'Art to me is almost a religion': A Talk with Julien Levy," *Harvard Magazine*, vol. 82, no. 1 (September–October 1979), p. 44.

347. Levy, *Memoir*, p. 69.

348. See Philadelphia Museum of Art 1995-49-1 through 1995-49-11; see also Carter Ratcliff, *SMS* (New York: Reinhold-Brown Gallery, 1968); object file, Department of Prints, Drawings, and Photographs, Philadelphia Museum of Art.

349. See Richard Feigen, *Tales from the Art Crypt: The Painters, the Museums, the Curators, the Collectors, the Auctions, the Art* (New York: Alfred A. Knopf, 2000), pp. 168–74. In 1968 Levy was a lender to MoMA's Dada and Surrealism show, which traveled to Los Angeles and Chicago; see William S. Rubin, *Dada, Surrealism, and Their Heritage* (New York: Museum of Modern Art, 1968).

350. See the transcript of Levy's gallery talk at the Pennsylvania State University, November 8, 1978, Julien Levy Archive, Connecticut.

351. Levy, *Memoir*, p. 148. In the transcript of his introduction to the film shown on November 8, 1978, at the Pennsylvania State University, Levy also mentions making film portraits of Brancusi, Léger, and Dalí; Julien Levy Archive, Connecticut.

352. Levy, *Memoir*, p. 129. The footage was made in the summer of 1932 when Levy, Ernst, and Aurenche were driving out to visit Crosby at her country house; it is now in the collection of the Museum of Modern Art.

353. See Charles Desmarais, "Julien Levy: Surrealist Author, Dealer, and Collector," *Afterimage*, January 1977, p. 6. The video guest book has not been located.

354. Travis did not have access to Levy's papers when he was putting together his exhibition and catalogue because Levy was using them to complete his memoir and was not ready to share them. The Fogg Art Museum had contacted Levy as early as 1973 about doing an exhibition on the history of the Julien Levy Gallery, but due to personnel changes, the project was never realized. The Fogg later took the Chicago show, its appearance at Harvard coinciding with Levy's fiftieth class reunion.

355. Press release for Witkin Gallery, *Photographs from the Julien Levy Collection*, October 12–November 12, 1977, Julien Levy Archive, Connecticut.

356. Witkin Gallery, *Photographs from the Julien Levy Collection*, [p. iii].

357. *Architectural Digest*, August 1981.

358. Grace Glueck, "Julien Levy, an Art Dealer, Dies; First to Show Cornell, Giacometti," *New York Times*, February 11, 1981.

359. "A New Gallery of Photography," *Brooklyn Eagle*, November 8, 1931.

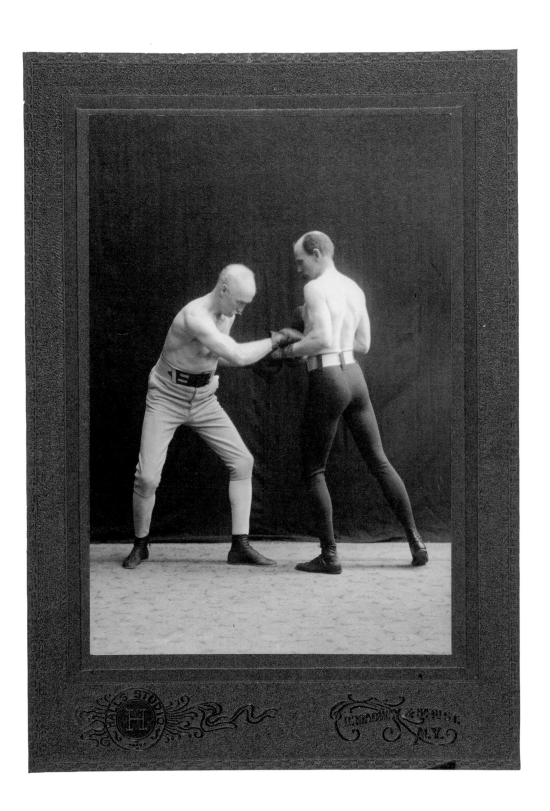

Found Objects, or a History of the Medium, to No Particular End

PETER BARBERIE

The gallery days (yours, the earliest) are not "the past" for me; they resurge in dreams at times with creative force, and are significant but too deep and elusive for practical purposes.
—Joseph Cornell to Julien Levy, 1959[1]

The story of photography at the Julien Levy Gallery is a mixed narrative of modernist master-works, found treasures, applied commercial work, and ephemeral pictures of every sort. The found, applied, and ephemeral are the topics of this essay. Julien Levy's trove of bygone celebrity portraits, press photos, *cartes-de-visite*, girlie pictures, film stills, snapshots, and much else is an amazing group of found pictures, perhaps the best that remains intact from Surrealist circles. André Breton had a collection of photographs comparable to Levy's, including everything from Manuel Álvarez Bravo photographs to Photomat portraits, but it was dispersed at auction in 2003.[2] And most of Breton's photographs were in one way or another documents of his life and of the Surrealist movement. Levy had such documents, too, but he had other things besides, and at one time or another he had many of them in his gallery for others to look at, play with, collect.

Photography—the whole of it, in its various manifestations—was a vital component of what Ingrid Schaffner has called the alchemy of the Julien Levy Gallery.[3] Levy arrived at adulthood loving movies and photographs, and it was by these modern means that he came to champion modernist art. In 1927, at age twenty-one, he traveled to Paris with Marcel Duchamp, hoping to make films, and he returned home later that year having encountered and collected the photographs of Eugène Atget. Four years later he would open the Julien Levy Gallery with an ambitious program of photography exhibitions, believing they would distinguish his new undertaking as the most forward-looking gallery of modern art in New York. He also showed experimental films and, later, Walt Disney anima-tions, and he kept examples of most types of applied and commercial photography on hand in the gallery. Like others in his circle—Joseph Cornell, Frida Kahlo, Mina Loy—who made accumulation an aesthetic in their art and in the decoration of their personal spaces, Levy collected stuff, especially photography and ephemera, and he incorporated it into the gallery's offerings. Many of photography's partisans in the 1920s and 1930s exhibited and published a wide range of photographs, including scientific, advertising, and journalistic examples. Levy knew the books that featured such imagery: László Moholy-Nagy's 1925 Bauhaus publication *Malerei, Fotografie, Film* (Painting, Photography, Film); Franz Roh and Jan Tschichold's *Foto-Auge* (Photo-Eye), the book that accompanied the 1929 exhibition *Film und Foto*; and *Photographie*, the photo annual published by the French journal *Arts et métiers graphiques*. In these examples photography's breadth stood as exciting evidence of its rele-vance to modern life. But for Levy the collecting of disparate photographs was a Surrealist endeavor. This is clear from a passage he wrote about Breton in his 1936 book *Surrealism*: "His own house is a treasury of collected items from a multitude of voyages of taste-discovery. Rare books, rare images,

Plate 67
Hall's Portrait Studio (American, active late nineteenth–early twentieth century)
Untitled (Boxing pose),
c. 1880–1910
Matte collodion print
5½ x 3⅞ inches (14 x 9.8 cm)
The Lynne and Harold Honickman Gift of the Julien Levy Collection
2001-62-1483

and accidental objects, documents, curious minutiae, all contributing to the completion of a larger pattern."[4] The idea, exemplified in Breton's novels *Nadja* and *L'Amour fou*, but perhaps most vividly realized in the illustrated pages of the various Surrealist journals, was that an intensely subjective response to any "accidental object" would spur the beholder to lucid engagement with his or her own drives and hence to a Surrealist point of view (Surrealism, Levy argued, is essentially a point of view; in his book he went so far as to suggest that any act of imagination could qualify as surreal).[5]

Levy's engagement with photography underpinned his whole approach to twentieth-century art. This is seen in two dialectical oppositions he formulated that proved fundamental to him. The first opposition has to do with influences; the second, with photography itself: Levy claimed a pair of "spiritual godfathers," Alfred Stieglitz and Marcel Duchamp; and he devised a pair of terms to account for divergent impulses in photography, *documentary* and *anti-graphic*. Levy's choice of dialectical pairs to formulate his ideas was no accident. In *Surrealism*, in the section titled "Politics," he quotes Breton on dialectics, which Breton had imported into Surrealism from Marxist thought: "How allow that the dialectical method is only to be applied validly to solving social problems? It is the whole of surrealism's ambition to supply this method with the nowise conflicting possibilities of application in the most immediate conscious domain."[6] Breton went on to list matters of love, dreaming, madness, art, and religion as legitimate objects of the dialectical method. Unlike Breton, Levy was largely indifferent to the political implications of Surrealism, but he was in other respects quite literally a "textbook" Surrealist. Wanting to participate in the movement, and admittedly smitten with many of its figures, he avidly read all the avant-garde literature he could get his hands on.[7] His book *Surrealism*, written as an introduction to the topic for an American audience, is largely a compendium of statements, scenarios, and poems by others, including leaders of the movement such as Breton and Paul Eluard; co-opted figures such as the Marquis de Sade and Sigmund Freud; and Levy's own "discovery," Joseph Cornell.[8] In this book and in other ventures, including his own photographs, Levy often worked in the manner of others, trying out an approach or technique he admired as if attempting to understand it fully. It is quite characteristic that, having absorbed Breton's insistence on the squaring off of contradictory positions, Levy tried it out with some provocative stances of his own.

GODFATHERS

Given the diminutive New York art world of the 1920s, it is not surprising that Levy discovered the examples of both Stieglitz and Duchamp; the two were themselves old allies. Even so, they make a startling duo of mentors. Within the rarified confines of the modernist avant-gardes, one could not find more seemingly opposed figures: Stieglitz, who spent his life pursuing photography as a fine art, who insisted on the elusive category Art as life's most meaningful purpose, a vessel for the highest thoughts and the deepest emotions, more or less explicitly in the face of capitalism; and Duchamp, who rejected painting in the middle of his life, who made only a handful of photographs himself (all documents), and who spent much of his career undermining notions of any separate or desirable aesthetic realm, venturing to "break even" with various combinations of art and commerce.[9]

Levy knew Stieglitz and Duchamp by the time he was twenty-one. His initial experiences with both men involved their roles as dealers and impresarios. In the 1920s Stieglitz was most visible as a promoter of other American artists, chiefly painters, although Levy knew about the European work Stieglitz had introduced to New York, as well as the photography—Stieglitz's own and others'— that he had championed. Levy recalled that he would visit Stieglitz's Intimate Gallery on excursions to New York during college.[10] It was an obvious destination for anyone interested in modern art, but it is likely, given Julien's budding interests, that Levy's father, Edgar, directed his son to Stieglitz, with whom the elder Levy shared mutual friends and a similar background: both were from prominent

Plate 68
Marcel Duchamp (American,
born France, 1887–1968)
**Plate for a photomechanical
relief print,** 1945
Zinc
8³⁄₁₆ x 9⁵⁄₁₆ inches (20.8 x 23.6 cm)
The Lynne and Harold Honickman
Gift of the Julien Levy Collection
2001-62-489a

Plate 69
Reproduction after **Marcel
Duchamp** (American, born France,
1887–1968)
**Brochure for the exhibition
*Man Ray: Objects of My
Affection* at the Julien Levy
Gallery,** 1945
Photomechanical relief print
11⁹⁄₁₆ x 9¹⁄₁₆ inches (29.3 x 23 cm)
The Lynne and Harold Honickman
Gift of the Julien Levy Collection
2001-62-489c

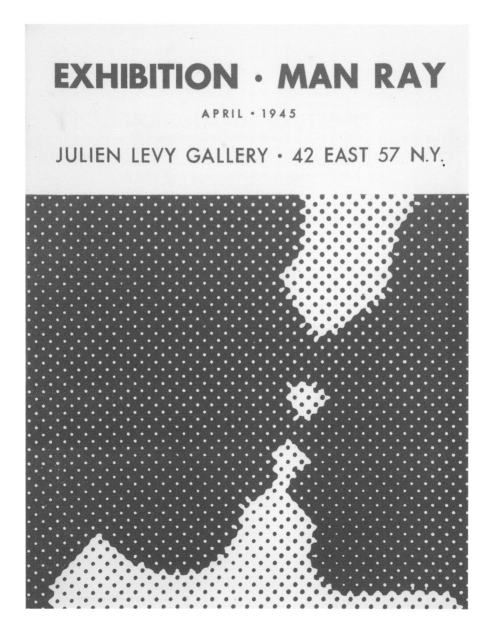

EXHIBITION · MAN RAY

APRIL · 1945

JULIEN LEVY GALLERY · 42 EAST 57 N.Y.

New York Jewish families.[11] Julien later insisted that he never became a Stieglitz acolyte in the manner of other young admirers, but from surviving correspondence it is clear he spent time with Stieglitz at the Intimate Gallery and, later, at An American Place, and sought his guidance and approval during the first years of the Julien Levy Gallery.[12]

Levy met Duchamp at the Brummer Gallery in late 1926, when he convinced his father to buy a version of Constantin Brancusi's sculpture *Bird in Space*, one of a group of Brancusis partially owned by Duchamp, who was shepherding them through the New York art market for the sculptor.[13] Despite their nineteen-year age difference the two struck up a friendship, and Levy recalled that Duchamp invited him to travel to Paris with him six weeks later, to make a film with a movie camera belonging to Duchamp's friend Man Ray (presumably Levy was to underwrite the modest project, which was never realized).[14] Reminiscing about their voyage across the Atlantic, Levy described Duchamp as something of an older brother—one with whom he could exchange salacious stories and outrageous propositions about art. If Stieglitz served as an art-world father figure for Levy, Duchamp proved an inspiring study in cool filial rebellion.

Duchamp liked photographs' unaesthetic potential, which he located in their suitability for endless and varied reproduction. He submitted photographs—rather as he did his own artworks—to precise, extended alterations through copying. Levy's favorite example was the announcement for a Man Ray exhibition at his gallery in 1945 (pl. 69). Duchamp started with a film still that supposedly depicted the first cinematic kiss; he enlarged the image, printed it, reduced it, printed it again, and so on, ultimately producing a metal stamp based on the final photographic version (pl. 68). The announcement was printed from this plate. For all the effort behind it, it is the most rudimentary sort of print, and it looks so: a Rorschach abstraction of Benday dots and ground, in two colors. (The dots are perhaps a pseudo-imitation of half-tone reproduction, but it is just as likely that Duchamp produced the printing plate from a half-tone screen made from an inter-negative.) In his memoir, Levy gleefully suggested that all its stages of production meant nothing, and he was right.[15] In order to arrive at the final blur of the present example, Duchamp's precise instructions for each step lead nowhere; only their altered results count. Every step introduces more chance, Duchamp's true preferred medium. Chance and reproduction work in concert at every turn, bringing the image farther from any creative act, and wiping the kiss itself clean of affect, almost.

Levy picked up on Duchamp's photographic play. In 1939 he and the painter Matta photographed graffiti around Greenwich Village in New York. On one wall they came across chalk faces drawn above a short plumbing pipe that projected outward (pl. 70). In another photograph made there, two additional pipes and a bunch of wire leaning against the wall form a "body" between the largest drawn head and the phallic plumbing pipe (fig. 37). Levy liked what he called the "ready-made" quality of the assemblage. In the photograph without the extra elements, faces and pipe float disembodied, not unlike a painting by Joan Miró, the artist Levy thought of while looking at the drawn heads. But Levy was not seeking artistic genius in the graffiti, or in the photographs he and Matta made. He showed the photographs to Duchamp, and together they imagined making similar records of the scrawls on public restroom walls and then submitting the prints to a complicated series of enlargements, projections, and re-photographs, resulting in a library of graffiti pictures on microfilm, waiting to be projected onto the bathroom walls of private homes, at any scale of reduction or enlargement.[16] This is a powerful idea. Its impact lies in the communal intelligibility of restroom graffiti and the unsettling superimposition of such imagery onto private spaces. Like the kiss on the exhibition announcement, it reduces the final work to almost nothing, certainly not a work of art by an identifiable artist. But the thing that remains—more residue than tangible object—magnifies photography's peculiar ability to stir its beholder, all questions of artistry aside.

Fig. 37 (above). **Julien Levy** (American, 1906–1981) and **Roberto Matta** (Chilean, 1911–2002). **Untitled (Wall graffiti)**, 1939. Gelatin silver print, 2¹⁵⁄₁₆ x 1⁹⁄₁₆ inches (7.4 x 3.9 cm). Courtesy of the Julien Levy Archive, Connecticut

Plate 70 (opposite)
Julien Levy (American, 1906–1981) and **Roberto Matta** (Chilean, 1911–2002)
Untitled (Wall graffiti), 1939
Gelatin silver print
9³⁄₁₆ x 5¹³⁄₁₆ inches (23.7 x 14.7 cm)
The Lynne and Harold Honickman Gift of the Julien Levy Collection
2001-62-1277

In the light of Duchamp's pranks, Stieglitz's pronouncements about art seem particularly windy. In his memoir, Levy recalls the old man endlessly holding forth about the meaning of life and art, his tufts of overgrown ear hair bristling: "When I am asked why I do not sign my photographs, I reply: 'Is the sky signed?'"[17] Despite the unkind image, Levy professed undiminished awe for Stieglitz's devotion to American art, and he linked it with Duchamp's efforts at thought-provocation in the 1913 Armory Show. Stieglitz himself warmly supported Duchamp's work over the years. In a 1934 note to Levy he wrote: "It was good of you to send me Duchamp's latest. He is ever the master of masters. But what a lone soul in a way he is. That may be sentimental & both he & you will reject such a notion. At any rate in whatever he does he always amazes me and fills me with great delight."[18]

Levy admired Stieglitz's criteria for great photography: pictures made with an eye to all the artistry possible in pristine, unmanipulated negatives and prints. He jokingly called such work the photography of the "great S's"—Stieglitz, Strand, Sheeler—all of whom he eagerly sought to exhibit in his gallery.[19] For him their photography remained a benchmark of modern art, and an example against which to measure new photography. Tellingly, though, within the realm of crystalline photographs Levy was drawn more to the heated subjects and sumptuous prints of George Platt Lynes or the disturbing mysteries of Clarence John Laughlin than to the stern sincerities of Paul Strand or of Edward Weston, who undoubtedly qualified as one of the "great S's" in spirit if not in name.

DOCUMENTARY VERSUS ANTI-GRAPHIC

In 1933 Levy's enthusiasm for the rough, streetwise work of Henri Cartier-Bresson led him to coin the term *anti-graphic photography*, which he opposed to *documentary photography*. By the latter he did not mean social documentary photography, which in the 1930s flourished elsewhere than the Julien Levy Gallery. He had in mind what he also called "graphic" photography: the Stieglitz tradition of perfect contact prints made from careful negatives. Cartier-Bresson's 1930s work is a forceful counterpoint. The French photographer used a handheld 35-millimeter camera, so all his prints were enlargements from the negative, and most of his subjects were off-the-cuff, often captured in mid-motion. What is more, Cartier-Bresson dispensed with concern for photographic finish. Although he still printed his own work in 1933 (an aspect of production he would eventually turn over to others), he welcomed the scratches, dust particles, and accidents that marred his negatives and prints. Levy was quite surprised, and he recalled years later that he was delighted to present Stieglitz with such powerful photography in an utterly different mode.[20] He organized a monographic exhibition of Cartier-Bresson's photographs for the autumn of 1933, and to complement it he mounted a "qualifying program" of so-called accidental photographs—press pictures and other anonymous things, along with sympathetic work by younger American photographers—in the smaller back room of the gallery.

Levy's words about this pair of shows, contained in two pieces of writing, are worth quoting at length. The single exhibition brochure for both exhibitions included an essay in the form of a letter that Levy addressed to himself and signed with the pseudonym Peter Lloyd. Its text captures something essential about the photography program Levy envisioned for his gallery: he reprinted it in *Surrealism* and, many decades later, in his *Memoir of an Art Gallery*.[21] In it "Peter Lloyd" compares Cartier-Bresson to Charlie Chaplin, whose "bad" photography is "a protest against the banal excellencies of the latest Hollywood films." By "bad" photography Levy presumably meant the rough quality of Chaplin's cinematography, although Chaplin's awkward, improvisatory performance style resonates just as forcefully with his phrase. Having thus provided an example of the "anti-graphic," Levy (still in the voice of Peter Lloyd) quickly turns to the question of exhibiting such "bad" photographs: "You have two exhibition rooms in your gallery. Why don't you show the photographs of

Plate 71

M. Rol (French, active early
twentieth century)

***January 11, 1913, Paris: The
Champion Aviator Tabuteau Is
Decorated with the Legion of
Honor Medal with the Title
of Military Airman (11.1.13,
Paris: Le Champion aviateur
Tabuteau qui vient d'être
decoré de la Légion d'honneur
au titre de sapeur),*** 1913

Gelatin silver print

6⁹⁄₁₆ x 4⁷⁄₁₆ inches (16.7 x 11.2 cm)

The Lynne and Harold Honickman
Gift of the Julien Levy Collection

2001-62-1633

Cartier-Bresson in one, and the innumerable, incredible, discreditable, profane photographs that form a qualifying program for his idea in the other room? Septic photographs as opposed to the mounting popularity of the antiseptic photograph? Call the exhibition amoral photography, equivocal, ambivalent, anti-plastic, accidental photography. Call it anti-graphic photography." Lloyd closes the letter with a clear statement of Levy's intentions: "There is no reason why your gallery should not fight for both sides of a worthy cause."

Levy was equally forceful and less coy in a press release about the exhibitions: "What is an anti-graphic photograph? It is difficult to explain, because such a photograph represents the un-analyzable residuum after all the usually accepted criterions for good photography have been put aside. It is a photograph not necessarily possessing print quality, fine lighting, story or sentiment, tactile values or abstract aesthetics. It may lack all the virtues which this Gallery has championed in supporting photography as a legitimate graphic art."²² The press release identifies news photographs as a good source for dynamic "accidents." Levy had a collection of them, most by French agencies such as Meurisse and M. Rol, and they undoubtedly formed part of the back-gallery exhibition that complemented the Cartier-Bresson show.²³ Not surprisingly, many examples resemble Cartier-Bresson's

Plate 72 (left)

Henri Louis Meurisse (French, 1872–1935)

At the Congress, an
Unexpected Candidate:
Monsieur Hersan, Contender
for the Presidency (Autour du
Congrés, un candidat inattendu:
M. Hersan, postulant à la
Présidence), c. 1910–14

Gelatin silver print

6¼ x 4⁷⁄₁₆ inches (15.9 x 11.2 cm)

The Lynne and Harold Honickman

Gift of the Julien Levy Collection

2001-62-2118

Plate 73 (right)

Keystone View Company

(American, active 1892–1963)

Untitled (Press photograph
of women holding ropes),

c. 1920–30

Gelatin silver print

6 x 6½ inches (15.2 x 16.5 cm)

The Lynne and Harold Honickman

Gift of the Julien Levy Collection

2001-62-2155

urban street imagery. In one, a celebrated aviator, Maurice Tabuteau, poses with his new Legion of Honor medal (pl. 71). Despite his heroic off-camera gaze, he is upstaged by his bedecked and delighted fellow medalists. The grouping's comical air, an even mix of vanity, banality, and high-mindedness, is indeed worthy of Chaplin, not to mention Cartier-Bresson (see pl. 185). In other press pictures, figures whose actions the camera partially crops—a gesturing presidential candidate, a group of ladies pulling ropes—elicit similar comedy (pls. 72, 73). Only when the photographs still carry their captions are we able to fill in the blanks. The rope-tugging ladies' purpose is lost to us; the caption for the presidential candidate, Monsieur Hersan, tells us he is an unexpected contender, although whether that accounts for his salute is unclear. Another political photograph happily bears an explanation: an absurdly small man perched on a ladder is nowhere else but the Palace of Versailles, wall-papering the enormous bedroom of the new president (pl. 74).

Like the photographs of Messieurs Tabuteau and Hersan, newsworthy in their day but relegated to cast-off status when Levy bought their portraits around 1930, most of the press pictures Levy gathered depict the momentarily notable of half a generation before (poignantly, many of them are dated 1912 or 1913, just before the outbreak of World War I). Giving a talk at Harvard's Fogg Art Museum in 1978, Levy recalled that he would browse through the files at a photo agency on the rue de Seine in Paris, where photographs were organized by subject matter.[24] He was talking about finding Atgets among the news pictures, but it seems he picked up other things as well. Numbers of his press photographs fall into a handful of subjects. He found plenty of comedy in the politics section. Not surprisingly, he also collected the sexier topics of modern life: athletes, airplanes, bicycles (pl. 79), and still other emblems of speed and youthful leisure. Athletes were usually in the news because they had won. The runner Jacques Keyser, in a portrait so banal it could be a "document" in one of Breton's novels, is captioned as the victorious champion—for his sixth time—in the prix

Plate 74

A. Harlingue (French, active early twentieth century)

Versailles Congress: Wallpapering the Bedroom of the New President at the Palace of Versailles (Congrés de Versailles: On tapisse la chambre à coucher du nouveau Président au Palais de Versailles), c. 1910–14

Gelatin silver print

4⅝ x 6½ inches (11.8 x 16.5 cm)

The Lynne and Harold Honickman Gift of the Julien Levy Collection

2001-62-1502

Lemonnier (pl. 75). The balloonists Kaulen and Schmidt, photographed in their ship, the Duisburg, had just broken records for duration and distance (pl. 77). Léon Georget, the great cyclist who went on to win the Bol d'Or nine times, is shown having his leg massaged during a break at the Palais des Sports (pl. 76).

Among Levy's finds are several photographs of early biplanes, circled and marked in graphite for some editorial purpose (pl. 78).[25] There are also press pictures of the Velo-Torpille, or bicycle-torpedo, a fantastical racing machine invented by Marcel Berthet in 1913 (pls. 80, 81). Like the other photographs shown here, these were of course exciting symbols of the twentieth century, but outmoded and slightly ridiculous ones by the time Levy collected them. The writer Walter Benjamin called similar subjects "wish symbols," utopian images from an earlier moment that exposed the limits of the present. He credited the Surrealists, and particularly Breton, with being the first to invest them with critical power.[26]

Several writers since Benjamin have celebrated the Surrealists' wide use of photographs, which involved the most basic kinds of visual record just as often as surprising subjects like the Velo-Torpille, or things made unfamiliar through camera and darkroom manipulation.[27] The photographs in Breton's novel *Nadja* are a good example: They are in large part documents to illustrate places and figures mentioned in the text, without in any way supporting Breton's narrative. Many of the portraits are stock press portraits by the large commercial studio of Henri Manuel, whose photographs Levy also collected—for example, a portrait of the explorer Madame Dieulafoy (see pl. 92). As with *Nadja*, the pages of Surrealist journals like *La Révolution surréaliste* and *Documents* were replete with such "documents," which parodied illustrations in the serious journals of the learned disciplines. These pictures offered basic information (the portrait of a noted personality), or basic proof (a given event), or evidence (a portrait of a murderer showing his physiognomy, which demonstrates

Plate 75
Henri Louis Meurisse (French, 1872–1935)
The Prix Lemonnier, Versailles to Paris on Foot; Jacques Keyser, Who Won This Contest for the Sixth Time—His Most Recent Portrait (Le Prix Lemonnier, Versailles–Paris à pied; Jacques Keyser qui s'est adjugé cette épreuve pour la sixième fois—son portrait le plus récent), c. 1910–14
Gelatin silver print
6½ x 4½ inches (16.5 x 11.5 cm)
The Lynne and Harold Honickman
Gift of the Julien Levy Collection
2001-62-1604

Plate 76
M. Rol (French, active early twentieth century)
January 13, 1913. The Six Days' Course at the Palais des Sports—Léon Georget, One of the Favorites, Having a Massage during a Break (13.1.13. La Course de Six Jours au Palais des Sports— Léon Georget un des favoris se faisant masser pendant un repos), 1913
Gelatin silver print
4⁹⁄₁₆ x 6⁹⁄₁₆ inches (11.6 x 16.7 cm)
The Lynne and Harold Honickman
Gift of the Julien Levy Collection
2001-62-1629

Plate 77

M. Rol (French, active early
twentieth century)

***October 23, 1913. The
Balloonists Kaulen and
Schmidt, Who Have Just
Broken the Records for
Distance and Length in an
Untethered Balloon, on Their
Balloon "Duisburg" (23.10.13.
Les aéronautes Kaulen &
Schmidt, qui viennent de battre
les records de distance et de
durée en ballon libre sur leur
aérostat "Duisburg"),*** 1913

Gelatin silver print

6⅝ x 4⅝ inches (16.8 x 11.7 cm)

The Lynne and Harold Honickman
Gift of the Julien Levy Collection

2001-62-1625

Plate 78
Photographer unknown
Untitled (Biplanes on the ground), c. 1905–1910
Gelatin silver print
7⁹⁄₁₆ x 7 inches (18.3 x 17.8 cm)
The Lynne and Harold Honickman
Gift of the Julien Levy Collection
2001-62-846

Plate 79
Photographer unknown
Possibly by **Eugène Atget** (French, 1857–1927)
Untitled (Man on a bicycle), c. 1890–1900
Albumen silver print
6 x 8¼ inches (15.2 x 21 cm)
The Lynne and Harold Honickman
Gift of the Julien Levy Collection
2001-62-315

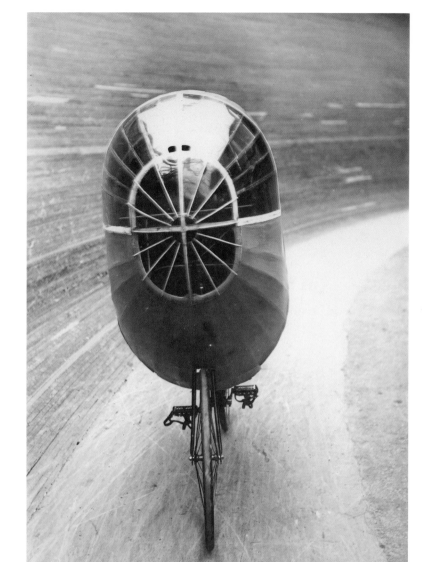

Plate 80
Henri Louis Meurisse (French,
1872–1935)
***The Bicycle-Torpedo, Frontal
View (Le Velo-Torpille,
Vu de face),*** 1913
Gelatin silver print
6⁷⁄₁₀ x 4⁷⁄₁₀ inches (16.3 x 11.3 cm)
The Lynne and Harold Honickman
Gift of the Julien Levy Collection
2001-62-1588

Plate 81
Henri Louis Meurisse (French,
1872–1935)
***The Bicycle-Torpedo
(Le Velo-Torpille),*** 1913
Gelatin silver print
4½ x 6⁷⁄₁₀ inches (11.4 x 16.4 cm)
The Lynne and Harold Honickman
Gift of the Julien Levy Collection
2001-62-1589

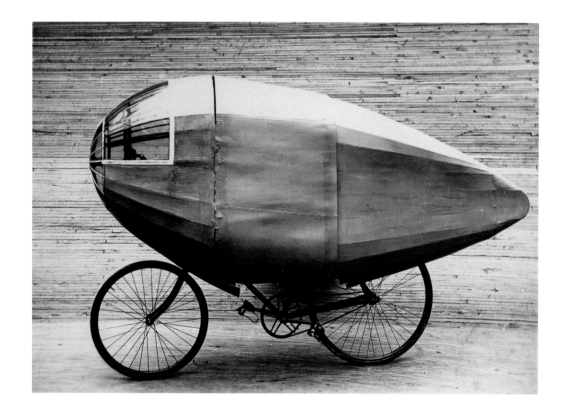

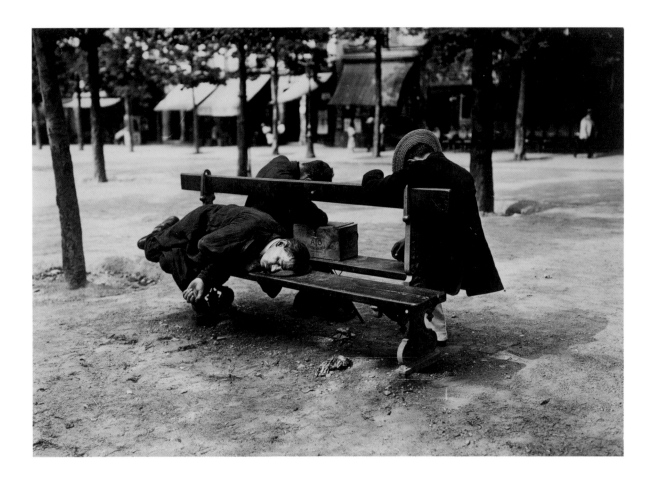

his propensity to criminal behavior). Breton and other Surrealists mocked the positivistic faith in photographic evidence, the notion that a photograph could be tamed to demonstrate one fact or another—that a stock portrait of Madame Dieulafoy, for example, offered a transparent record of her features and nothing more. This is the source of much of the comedy in Levy's trove of found pictures: each photographic "document" sparks with possible meanings.[28]

By contrast, others of Levy's press pictures capture the experiences of the street almost as powerfully as do the photographs of Cartier-Bresson, Walker Evans, or Manuel Álvarez Bravo. One shows park-bench dwellers, castoffs marooned in a Paris heat wave, motionless before a blurred, evocative backdrop of urban square (pl. 82). The elements of the picture parallel those in Evans's scene of a public square in Cuba (see pl. 193). A different sort of photograph, a large-format record of a fallen horse by one L. Ollivier, is equally ignoble, despite its careful construction and field of details (see pl. 250). The animal lies prone and exposed on the curb of a city street, its visible eye glazed in death or exhaustion. The photograph was presumably made to document the horse's collapse, and it does not share the disorienting air of similar subjects photographed by Eli Lotar and Cartier-Bresson (see pls. 251, 253). But it is equally unsettling.

Levy's exhibitions of work by leading American and European photographers are catalogued above (pp. 33–102). The gallery's début exhibition was a retrospective survey of American photography that comprised a range of photographs chosen under the palpable influence of Stieglitz, including Pictorialist work by Anne Brigman, Gertrude Käsebier, and Paul Strand. In that exhibition, and in subsequent shows of photographs by Eugène Atget and Nadar, Levy sketched a history of the medium, a platform of sorts from which his gallery's program could take shape. But as can be seen in the photographs reviewed here, that program was never very programmatic. One thing Levy clearly liked about photographs was their presence everywhere in his midst. He did not hesitate to pick up those he found attractive. So although he honored Stieglitz's careful selection of serious artistic work and

the tradition it fostered, he also valued anonymous things, and not only "septic" prints in the manner of Cartier-Bresson. Examples such as L. Ollivier's collapsed horse or an unknown photographer's small, crystal-clear record of some onions (pl. 83) undoubtedly appealed to Levy as examples of "graphic" photography.

On occasion Levy sought photographic incunabula for their rarity, such as a portrait he believed to be by mid-nineteenth-century Scottish photographer David Octavius Hill that turns out to be an even scarcer find, a portrait by the early amateur Henri Victor Regnault of the French scientist Jean-Baptiste Biot (pl. 88). Other times, Levy acquired old photographs evidently unaware of their historical interest, such as a beautiful early print of an Arab horse from Félix-Jacques-Antoine Moulin's album *L'Algérie photographiée* (Algeria Photographed; see pl. 131).[29] Often he valued such pictures for personal reasons. His greatest photographic prize perhaps came from Joseph Cornell. In his memoir, Levy writes that from his first exhibition of American photographs, Cornell haunted the gallery, drawn in particular to the older prints on view. Wanting some of them, perhaps cabinet portraits of the nineteenth-century actresses he adored (pls. 85, 86), Cornell suggested a trade. As Levy recalled: "He brought me, some days later, the tightly curled roll of an original forbidden [Mathew] Brady print. I still have it. A magnificent, shocking photograph of the dead, the mutilated, the atrocified of the Civil War, never reproduced in any of the official histories, suppressed and perhaps forever lost but for that savior-scavenger, J.C."[30] In fact, Levy owned eleven such pictures, presumably all given to him by Cornell, fragile square albumen prints by an unknown photographer in the Brady circle, each one showing dead fighters in muddy battle trenches (see pls. 137, 138).

In his travels through Europe, Levy collected quantities of historical material: physionotraces (pl. 87), woodburytype portraits of stage actors and politicians (pls. 84, 95), cabinet cards and *cartes-de-visite* (pls. 89, 90). Many of these have a strange or comic air, such as the photograph of Mlle Rouge, contestant in a beauty pageant between the produce markets of Paris (she represented Les

Plate 84 (top)
Photographer unknown
Possibly by **Lock and Whitfield,
London** (British, active 1857–1895)
***J. L. Toole as Barnaby
Doublechick,*** c. 1879
Woodburytype on printed sheet
9⅛ x 5¹¹⁄₁₆ inches (23.2 x 14.5 cm)
The Lynne and Harold Honickman
Gift of the Julien Levy Collection
2001-62-1543

Plate 85 (bottom left)
Charles Reutlinger (French,
1816–after 1880)
Cléo de Mérode, c. 1895–1900
Albumen silver print
5¹¹⁄₁₆ x 4⅛ inches (14.5 x 10.5 cm)
The Lynne and Harold Honickman
Gift of the Julien Levy Collection
2001-62-1847

Plate 86 (bottom right)
W. & D. Downey (British, active
late nineteenth–early twentieth
century)
Madame Sarah Bernhardt,
1901–10
Albumen silver print
5⅝ x 4¹⁄₁₆ inches (14.3 x 10.3 cm)
The Lynne and Harold Honickman
Gift of the Julien Levy Collection
2001-62-1810

Halles; pl. 91); or the above-mentioned portrait of Madame Jane Dieulafoy, celebrated explorer of Persia and Spain, who was also noted for her masculine dress (pl. 92). Another press photograph, heavily marked with editor's crayon and depicting a "polite" English suffragette named Lady Liliane G. (the rest of the name is illegible), makes a superb foil to the ambiguity of Mme Dieulafoy (pl. 93).[31]

Not knowing the history of photography any better than did most people in the 1930s (the medium's history largely remained to be written), Levy collected these things because he loved photographic imagery of every sort, and because he responded to the outmoded look they had for modern eyes. He put many of them up for sale in bins in the gallery, wanting them to be Surrealist secret messages, like the photographs and other objects Breton picked up at flea markets and used as touchstones for his writing. A nineteenth-century album from Levy's collection, Louis-Jean Delton's *Album hippique,* depicts prize purebred horses standing against painted backgrounds (pls. 94, 140). The horses are attended by grooms or carry their high-society owners, who are identified in the captions; the painted settings, several of which appear repeatedly, suggest grand estates. In the album's preface Delton explains that these photographs are meant to complement the "Stud Book," the official tome of thoroughbred bloodlines. But to a modern sensibility, the disjuncture between the photographs' live subjects and their imagined settings, combined with the indirectly sexual subject matter (the measurable results of calculated breeding decisions), offers a witty perspective on upper-class manias and preoccupations. Levy considered putting the album in his 1932 Surrealism exhibition.[32]

Plate 89 (top left)

V. Mas (French, active late nineteenth century)

Untitled cabinet card (Portrait of a sailor), c. 1890

Gelatin silver print

6⁷⁄₁₆ x 4³⁄₁₆ inches (16.4 x 10.6 cm)

The Lynne and Harold Honickman Gift of the Julien Levy Collection 2001-62-1837

Plate 90 (top right)

André-Adolphe-Eugène Disdéri (French, 1819–1889)

Untitled *carte-de-visite* **(Child with a drum),** c. 1855–65

Albumen silver print

3⅜ x 2¹⁄₁₆ inches (8.6 x 5.2 cm)

The Lynne and Harold Honickman Gift of the Julien Levy Collection 2001-62-2078

Plate 91 (bottom)

Arthur Braunstain (French, active early twentieth century)

Mlle Rouge, Halles, c. 1912

Gelatin silver print

4⅝ x 3⅞ inches (11.7 x 9.8 cm)

The Lynne and Harold Honickman Gift of the Julien Levy Collection 2001-62-1386

Plate 92
Henri Manuel (French, active
c. 1880s–1925)
Madame Dieulafoy,
c. 1900–1910
Gelatin silver print
5¼ x 3¹¹⁄₁₆ inches (13.3 x 9.4 cm)
The Lynne and Harold Honickman
Gift of the Julien Levy Collection
2001-62-1841

Plate 93
Henri Louis Meurisse (French,
1872–1935)
Lady Liliane G., Women's
Suffrage by Gentle Means (Le
Suffrage des femmes par la
douceur),
c. 1910–14
Gelatin silver print
6⁷⁄₁₆ x 4½ inches (16.3 x 11.5 cm)
The Lynne and Harold Honickman
Gift of the Julien Levy Collection
2001-62-1599

The art historian Hal Foster has written that the Surrealists dwelled upon late nineteenth-century imagery not only because it depicted an earlier "modernity" whose objects seemed suddenly quaint or macabre, but also because it was the imagery of the Surrealists' childhoods, their "primal scenes," as it were.[33] In the parade of great men photographed during the nineteenth century, there are indeed many fathers to kill, and Levy had their portraits on hand (pls. 95, 96). Their authority is undermined by many little disruptions. Among the stacks of *Galerie contemporaine* and similar publications with portraits pasted on their covers, the upstanding citizens are countered in equal numbers by their less respectable counterparts, stage actors and actresses (pls. 97, 98). Similarly, a whole album of large-format portraits by French photographer and sculptor Antoine-Samuel Adam-Salomon, mostly depicting stolid men and their young sons in a draped studio setting, is discombobulated by a single portrait of a man in Middle Eastern costume (see pl. 130). And in the cabinet-card celebrity series *Nos Contemporains chez eux* (Our Contemporaries at Home), the portrait of Ernest Renan, nineteenth-century philosopher and historian of Christianity, shows the shaggy, portly writer in his library amid a dense geometry of books, attended by his apparent equal, a grand fluffy cat—or possibly a lap dog—sprawled on the desk (pl. 99).

Even in his efforts to exhibit a historical survey of photographs, Levy veered into strange and modest byways with a decidedly Surrealist turn. From Nadar's son, Paul Nadar, he acquired a small number of vintage Nadar prints and a group of modern prints made by Paul from his father's negatives. But Levy also purchased many of Paul's own photographs, including a small portrait of a belle-époque actress with a creeping garden of flowers in her hair (see pl. 263). Even more fabulous is a post-mortem portrait of a middle-aged man, his white coverlet strewn with long-stemmed roses around a carefully placed crucifix (see pl. 186). Like all the Paul Nadar prints that Levy acquired, these are richly printed on thick paper and mounted on larger brown and gray papers in the manner of studio portraits of the time. As with the *Album hippique*, through the screen of Levy's sensibility they appear as transparent documents of an uncanny unwholesomeness at the heart of "normal" life.

BARON TAYLOR

Plate 95
Nadar (French, 1820–1910)
Baron Taylor, c. 1855–60; printed
1876–80
Woodburytype on printed sheet
9⁷⁄₁₆ x 7⁷⁄₁₆ inches (23.9 x 18.9 cm)
The Lynne and Harold Honickman
Gift of the Julien Levy Collection
2001-62-851

Plate 96
**Attributed to Dallemagne &
Lazerges** (French, active 1860s)
Portrait of a Man, c. 1860s–70s;
printed 1900–1930 by Paul Nadar
(French, 1856–1939)
Gelatin silver print
8¼ x 6⁵⁄₁₆ inches (21 x 16 cm)
The Lynne and Harold Honickman
Gift of the Julien Levy Collection
2001-62-628

Plate 97
Nadar (French, 1820–1910)
Mademoiselle E. Bonnaire,
c. 1898–1900
Woodburytypes on printed sheet
14¹³⁄₁₆ x 11 inches (37.6 x 28 cm)
The Lynne and Harold Honickman
Gift of the Julien Levy Collection
2001-62-868

Plate 98
Paul Nadar (French, 1856–1939)
Plate from *Paris-Photographe*
(*Mademoiselle Gilberte,*
du Théatre des Folies-
Dramatiques; Mademoiselle
de Labounskaya, du Théatre
de la Gaité; Mademoiselle
Bignon, du Théatre des Folies-
Dramatiques), 1891–94
Photogravure
10½ x 6¹¹⁄₁₆ inches (26.6 x 17 cm)
The Lynne and Harold Honickman
Gift of the Julien Levy Collection
2001-62-970

Plate 99
Dornac et Cie (French, active
1900s)
Ernest Renan, from the series
*Our Contemporaries at Home
(Nos Contemporains chez eux),*
1889
Gelatin silver print
4⅝ x 6⅞ inches (11.7 x 17.5 cm)
The Lynne and Harold Honickman
Gift of the Julien Levy Collection
2001-62-1400

Among Levy's heroes was Arthur Cravan—not quite a fable, certainly the nephew of Oscar Wilde, probably Levy's own stepfather-in-law—who disappeared off the coast of Mexico in 1918, leaving Mina Loy with a baby daughter, Fabienne (see pl. 47), and the arbiters of Dada and Surrealism with a shadow saint. Like Duchamp, who admitted he never liked him, Cravan generated himself out of aliases and multiple identities (Duchamp told Levy he thought Cravan was "a Marcel Duchamp").[34] Cravan's real name was Fabian Avenarius Lloyd; his professed occupations included boxer, poet, painter, jewel thief, sailor, itinerant, and deserter (his movements after 1914 were largely directed toward avoidance of military service). Cravan's fame rested on his beauty, his Dada journal *Maintenant*, his drunken performance at a New York Dada event in 1917, and his boxing matches with heavyweight champion Jack Johnson. Levy, who imagined a talismanic connection to his "related-in-law" Mina Loy (born Mina *Lowy*, another form of *Levy*), eagerly extended the notion to Cravan/ Lloyd: hence his use of the pseudonym Peter Lloyd for his essay on documentary and anti-graphic photography.[35] Levy's adoption of Cravan the "boxer-poet" for his own genealogy perhaps explains why he owned two-dozen elegant photographs of boxers from the late nineteenth century (pls. 67, 100, 101). Most of these are cabinet cards produced by Hall's Portrait Studio of New York and depict men in various boxing poses. Like the mythic Cravan, these handsome fighters are engaged in an almost ethereal ballet of gamesmanship—all artfulness and no gore. In that sense, they are also emblematic of Levy's dialectical oppositions: Stieglitz vs. Duchamp, documentary vs. anti-graphic.

The posed boxers are beautifully photographed and serve as another popular example of what Levy called documentary photography, although by status and subject matter they could easily find a place on the "anti-graphic" side of his equation, just like the anonymous record of onions or L. Ollivier's fallen horse. Yet another group of pictures that straddle the divide are film stills. As is clear from his essay for the Cartier-Bresson and "anti-graphic" exhibitions, Levy, like other writers in the 1920s and 1930s, loved Charlie Chaplin's movies as expressions of popular culture. He invoked Chaplin in his essay to compare his work favorably with the "slick" productions of Hollywood, which clearly lacked the critical edge Levy sought for his "anti-graphic" category. Though he did have film stills among his photographic finds, they were from Hollywood's earlier, silent days. He exhibited recent Walt Disney animation cels in 1938, but stills from up-to-date talkies had no place in the gallery's mix of popular stuff. Film stills do not carry the same unintentional affect of press snapshots: their subjects, trained actors all, strike poses even more contrived than the banal conventionalities of studio portraits. Unless one wants to sift out the artifice, as Duchamp did with his cinematic kiss distilled through endless reproduction, the qualities to prize in such publicity shots are precisely artificiality and its occasional, accidental opposite—the strange whiff of another era's sense of chic, or drama, or history (pls. 102, 103). Parallel to the movie stills are a small number of theater stills Levy acquired, made by a forgotten photographer or firm named Grinnell-Wolf. At their best, the Grinnell-Wolf photographs take theatrical artifice to a delicious extreme of props and expressions, as in the portrait of two characters posed in soulful union near a piano (see pl. 203). The set-up is combined with the camera's perfect machine-age clarity, and the result looks like a campy echo of George Platt Lynes's best work.

In his memoir, Levy recounts going with Lee Miller to visit André Dignimont, an artist-illustrator most noted as a collector of erotica and pornography.[36] Dignimont had a diverse collection of photographs, erotic and otherwise, and Miller had heard the collection might be for sale; Levy hoped to add from it to his historical and popular material. Dignimont could not bear to part with it all, but Levy came away with duplicate materials and, he recalled, some treasured erotica. One nude photograph from his collection bears Dignimont's name on the back of the mount (pl. 104). Others might be from the same source, including a small albumen print still encased in its tin and paper

Plate 100

Hall's Portrait Studio

(American, active late
ninteenth–early twentieth century)

Untitled (Boxing pose),

c. 1880–1910

Matte collodion print

5½ x 3⅞ inches (14 x 9.8 cm)

The Lynne and Harold Honickman

Gift of the Julien Levy Collection

2001-62-1475

Plate 101

Hall's Portrait Studio

(American, active late
ninteenth–early twentieth century)

Untitled (Boxing pose),

c. 1880–1910

Matte collodion print

5⁵⁄₁₆ x 3⅞ inches (14.1 x 9.8 cm)

The Lynne and Harold Honickman

Gift of the Julien Levy Collection

2001-62-1476

Plate 102
Photographer unknown
Untitled film still (Ruth Roland in *White Eagle*), 1922
Gelatin silver print
7⅜ x 9¼ inches (18.6 x 23.5 cm)
The Lynne and Harold Honickman
Gift of the Julien Levy Collection
2001-62-2340

Plate 103
Photographer unknown
Untitled film still, c. 1915–20
Gelatin silver print
7¹¹⁄₁₆ x 9¾ inches (19.5 x 24.7 cm)
The Lynne and Harold Honickman
Gift of the Julien Levy Collection
2001-62-2341

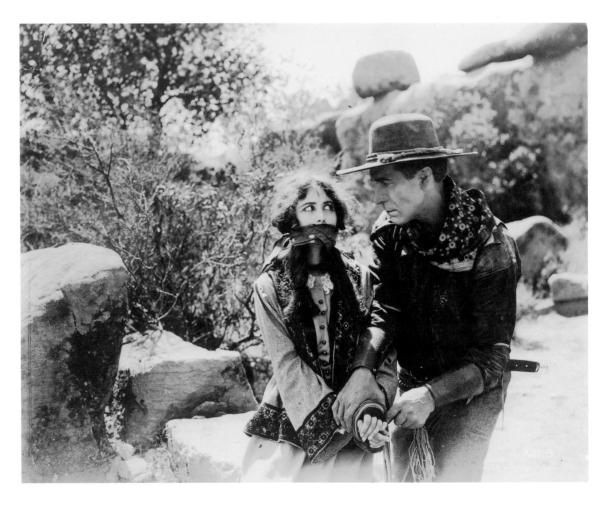

mount (pl. 105). Levy fancied himself a great ladies' man (some of his female friends concurred), and like the Surrealists he used sex as a weapon of disruption, both social and personal, so it is no surprise that he liked erotic photographs. But as with other subjects, Levy collected some nudes and "cheesecake" photographs simply because they were old-fashioned or bizarre. A Paul Nadar picture shows a dancer supine on an improbable looking balustrade, posed in front of a painted seaside backdrop (see pl. 264). In a group of male nudes, presumably made as artist studies, athletic models cling to backdrop panels or hold props in inexplicable poses (pls. 106–8).

Like Man Ray, who introduced him to Eugène Atget's photographs, Levy avidly collected Atget's small production of nudes. His collection of these pictures is more complete than Man Ray's. Among his trove is one prized nude by Atget himself, made in a bordello; another, anonymous nude that Atget had given him; and fifteen prints made by Berenice Abbott from negatives that Atget made from other, unknown photographers' pictures of female models.[37] It is unclear why Atget re-photographed these pictures; probably he had business for them but did not like making such photographs himself. Dignimont was a client for whom he had photographed bordello façades and prostitutes posed in doorways, and also probably the handful of nudes he did pose himself; Atget had recounted to a friend his run-in with the police while working on the project.[38] The copy nudes printed by Abbott are untrimmed contact prints not destined for exhibition, and are evidently the only prints she made from the negatives, probably at Levy's request (pls. 109, 110).

In addition to the multifarious display of photographs in the gallery, Levy sought other ways to encourage an audience for photography and to give certain photographers business. At the gallery's outset he invited photographers to leave portrait portfolios for visitors to review, in the hope of attracting sitters for them.[39] He also hired people for various tasks and projects. Lee Miller, for example, photographed at the gallery (see fig. 6) and made copy prints of other photographers' work for publicity purposes.[40] In 1931, in the gallery's first months, Levy also pursued an idea to manufacture decorative household objects and architectural elements with photographic designs. He hired Berenice Abbott, George Platt Lynes, Scherril Schell, the architectural photographer Drix Duryea, and the Whiting-Salzman Studio, a now-forgotten firm, to produce photographic designs for textiles, murals, lampshades, and cigarette boxes, at least some of them based on Levy's ideas (pls. 111, 113, 114).[41] He envisioned the gallery functioning as an "agency" for such photographic work and did not intend to sell the products themselves for very long. With this plan in mind he secured two articles about the designs, one for the architectural trade journal *Interior Architecture and Decoration* and another for the upscale women's magazine *House and Garden*.[42] He commissioned objects based on photographs by Abbott, Schell, and the Whiting-Salzman Studio from George Henne, a Manhattan manufacturer of decorative items, and he hired Stella Simon and Leo Hurwitz to make installation photographs of the objects in the gallery (pls. 112, 281–83).[43]

Perhaps Levy's inspiration for his photographic objects was Mina Loy's lampshade atelier in Paris. Loy never used photographs in her lampshade designs as far as we know, but the romance of both her workshop and her esoteric industry captivated Levy, who wrote about them in his memoir: "Mina moved crossly and imperiously about the studio, the 'factory' she called it. Always dreaming of sugar angels; producing lampshades of her own design, of spun glass and frosted cellophane, *mappemondes* and arum lilies, cherubs, flowers, and *passe-partouts* caught in modern manacles of electric light. . . . These miracles cost $5."[44] Levy no doubt wished to capture something of the atelier's bohemian air for the Julien Levy Gallery. Of his "photograph designs" he recalled: "I tried . . . to interest fabric companies in making photographic textiles by sensitizing their cloth and then printing the cloth with a photo. I suggested a rock, the photo of a real and uncomfortable-looking rock covered with lichens, photographed by someone like Paul Strand or Ansel Adams. As a Surrealist I intended

Plate 104 (top)
Photographer unknown
Untitled (Female nude),
c. 1870–80
Albumen silver print
4⁷⁄₁₆ x 6⅝ inches (11.3 x 16.8 cm)
The Lynne and Harold Honickman
Gift of the Julien Levy Collection
2001-62-1715

Plate 105 (bottom)
Photographer unknown
Untitled (Female nude),
c. 1855–75
Albumen silver print
3¼ x 2 inches (8.3 x 5.1 cm)
The Lynne and Harold Honickman
Gift of the Julien Levy Collection
2001-62-1716

Plate 106 (opposite, top)
Photographer unknown
Untitled (Male nude),
c. 1890–1910
Gelatin silver print
4½ x 5¾ inches (11.5 x 14.6 cm)
The Lynne and Harold Honickman
Gift of the Julien Levy Collection
2001-62-1681

Plate 107 (opposite, bottom left)
Photographer unknown
Untitled (Male nude),
c. 1890–1910
Gelatin silver print
5¾ x 4⁹⁄₁₆ inches (14.6 x 11.6 cm)
The Lynne and Harold Honickman
Gift of the Julien Levy Collection
2001-62-1682

Plate 108 (opposite, bottom right)
Photographer unknown
Untitled (Male nude),
c. 1890–1910
Gelatin silver print
6³⁄₁₆ x 4⁷⁄₁₆ (15.7 x 11.3 cm)
The Lynne and Harold Honickman
Gift of the Julien Levy Collection
2001-62-1683

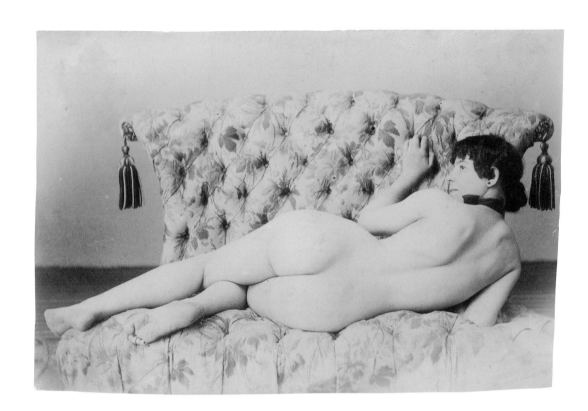

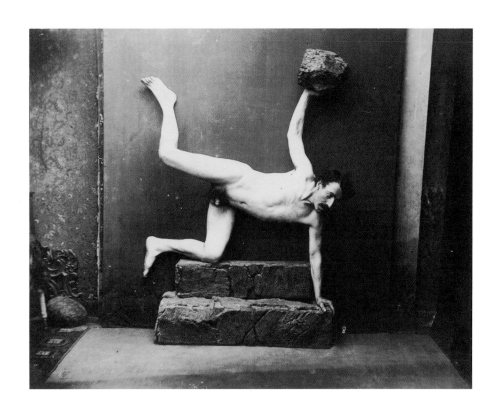

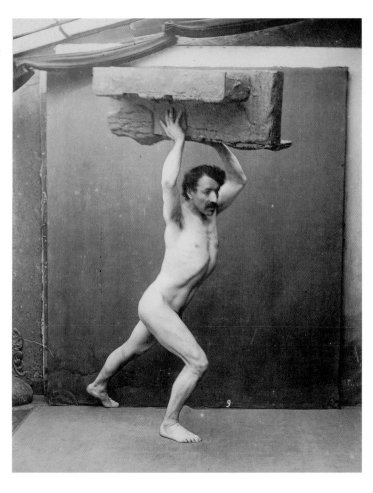

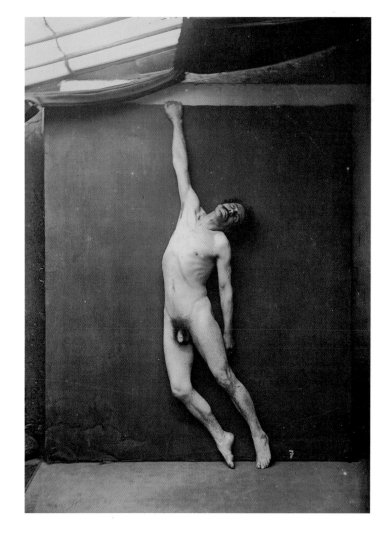

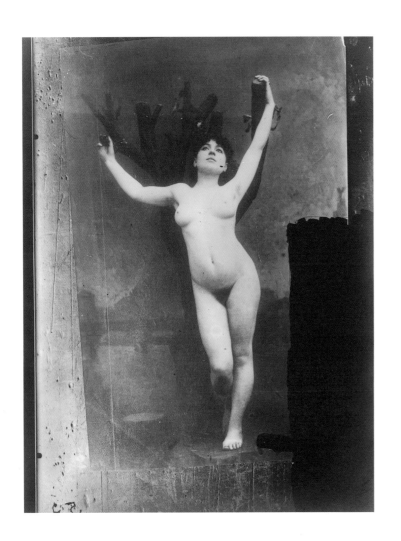

Plate 109
Eugène Atget (French,
1857–1927) from a photograph by
an unknown practitioner
**Untitled (Copy photograph of a
female nude),** 1924–25; printed
c. 1930 by Berenice Abbott
(American, 1898–1991)
Gelatin silver print
8⅞ x 6¹³⁄₁₆ inches (22.5 x 17.3 cm)
The Lynne and Harold Honickman
Gift of the Julien Levy Collection
2001-62-1700

Plate 110
Eugène Atget (French,
1857–1927) from a photograph by
an unknown practitioner
**Untitled (Copy photograph of a
female nude),** 1921; printed
c. 1930 by Berenice Abbott
(American, 1898–1991)
Gelatin silver print
9³⁄₁₆ x 6⅞ inches (23.3 x 17.5 cm)
The Lynne and Harold Honickman
Gift of the Julien Levy Collection
2001-62-1712

to use some of this rocky textile for my daybed cushions. Pleasant to rest one's head on the surprise of a soft stone."[45]

Looking at the photographs by Abbott and the Whiting-Salzman Studio, we see that the illusory surprise of photographed textures—crumpled paper, buckshot, zebra skin—is a recurring theme of the designs (pls. 113, 114, 279, 280). So is the chic sophistication of photography itself. In one installation view by Simon of a lampshade based on a photograph by Abbott (see pl. 283), the lamp rests on a Bauhaus-style table, accompanied by a cigarette holder and a copy of *Photographie*, the international photography annual that Levy no doubt included among the avant-garde literature for sale at the gallery.

Levy's commercial efforts in 1931 included several ideas for architectural applications of photography, preceding his involvement with the 1932 exhibition *Murals by American Painters and Photographers* at the Museum of Modern Art. He hired George Platt Lynes and Drix Duryea to create murals—including designs that would mimic architectural elements—for the decoration of rooms. In a letter to *House and Garden* in November 1931, Levy also mentioned panels "made from enlargements of the photographs by Eugène Atget."[46] One enlargement of an Atget photograph exists in the Julien Levy collection, a 12½ by 16⅝-inch print of a tree, presumably made by Abbott.[47]

The inclusion of another image in the *House and Garden* article, a section of a Thurman Rotan "photo-pattern," demonstrates the fluidity that much photography enjoyed at the Julien Levy Gallery. Rotan, whose work was included in the gallery's exhibition *Photographs of New York by New York Photographers* in May and June 1932, and who was also featured in Levy's contribution to *Murals by American Painters and Photographers*, exhibited his photo-patterns—collages composed of multiple prints of a single image—in a solo show at another New York venue, the Art Center, in 1932. The photo-pattern illustrated in *House and Garden* (like all of Rotan's photo-patterns, unlikely to have been conceived for applied purposes or commissioned by Levy) is similar to a collage in the Julien Levy Collection, a syncopated repetition of the Daily News Building photographed at a dizzying angle (see pl. 169). The *House and Garden* photo-pattern, evidently composed from another view of the same building, is recommended as the basis for curtains in a modern office. Another image by Rotan in the same article shows the Daily News Building in yet another repetitive pattern, this time arranged in a circle for dramatic floor tiling at the base of a spiral staircase. Neither idea was ever developed, perhaps, but another Rotan collage of the Daily News Building did find one real application: it was used to decorate the endpapers in H. G. Wells's 1931 book *The Work, Wealth, and Happiness of Mankind*.[48]

Given the array of photographs entering the Julien Levy Gallery (and most often staying there), it is not surprising that Levy experimented with photography himself, often tracking the style of other photographers' pictures. His photographs are not distinguished, but they demonstrate agility and a desire to really inhabit the work of other artists.[49] On a trip to the southwestern United States in the 1930s he imitated Cartier-Bresson's style. One of his photographs is a study in mismatched scale, like Cartier-Bresson's well-known photograph of children amid apartment-house ruins in Seville, Spain, in 1933: a girl peeks above rocks looming in the foreground, an adobe building behind her (pl. 115). In another photograph, a woman rushes by carrying a child (pl. 116). On the same trip Levy made a pair of photographs of dancers performing (see pls. 267, 268), perhaps thinking of André Kertész, whose "story-groupings" he particularly valued (see pls. 26–28). For another photograph he found a sculpture bust of a man and a photographed portrait of a woman on display in a shop front and framed them in the manner of Walker Evans or Manuel Álvarez Bravo, even managing to capture some window reflections as would these photographers and their shared model, Atget (pl. 118).

Plate 111
Whiting-Salzman Studio
(American, active early twentieth century)
Photograph design for a cigarette box, 1931
Gelatin silver print
4⅛ x 6 inches (10.5 x 15.2 cm)
The Lynne and Harold Honickman
Gift of the Julien Levy Collection
2001-62-1205

Plate 112
Leo Hurwitz (American, 1909–1991)
Lampshade made from a photograph design by Berenice Abbott, and cigarette box made from a photograph design by the Whiting-Salzman Studio, 1931
Gelatin silver print
5¹⁵⁄₁₆ x 8⅛ inches (15.1 x 20.7 cm)
The Lynne and Harold Honickman
Gift of the Julien Levy Collection
2001-62-1212

Plate 113
Whiting-Salzman Studio
(American, active early twentieth
century)
**Photograph design with zebra
skin,** c. 1931
Gelatin silver print
8⅛ x 6¼ inches (20.6 x 15.8 cm)
The Lynne and Harold Honickman
Gift of the Julien Levy Collection
2001-62-1242

Plate 114
Whiting-Salzman Studio
(American, active early twentieth
century)
Photograph design with beans,
c. 1931
Gelatin silver print
3⅞ x 4¹¹⁄₁₆ inches (9.9 x 11.9 cm)
The Lynne and Harold Honickman
Gift of the Julien Levy Collection
2001-62-1207

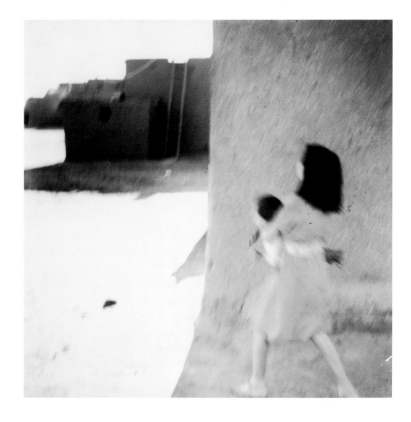

Plate 115 (above left)
Julien Levy (American,
1906–1981)
**Untitled (Child and adobe
houses),** c. 1935–40
Gelatin silver print
9⁷⁄₁₆ x 7½ inches (24 x 19 cm)
The Lynne and Harold Honickman
Gift of the Julien Levy Collection
2001-62-656

Plate 116 (above right)
Julien Levy (American,
1906–1981)
Untitled (Woman and child),
c. 1935–40
Gelatin silver print
7¹⁵⁄₁₆ x 8¹⁄₁₆ inches (20.1 x 20.5 cm)
The Lynne and Harold Honickman
Gift of the Julien Levy Collection
2001-62-654

Plate 117 (right)
Photographer unknown
Possibly by **Julien Levy** (American,
1906–1981)
Untitled (Dog's hindquarters),
c. 1930–40
Gelatin silver print
3⅛ x 2½ inches (7.9 x 6.3 cm)
The Lynne and Harold Honickman
Gift of the Julien Levy Collection
2001-62-2138

Plate 118
Julien Levy (American,
1906–1981)
**Untitled (Portraits in a
window),** c. 1935–40
Gelatin silver print
6⅝ x 9⅜ inches (16.9 x 23.8 cm)
The Lynne and Harold Honickman
Gift of the Julien Levy Collection
2001-62-655

Plate 119
Julien Levy (American,
1906–1981) and **Pavel
Tchelitchew** (American, born
Russia, 1898–1957)
Untitled (Pavel Tchelitchew),
c. 1935–45
Gelatin silver print with ink additions
7⅝ x 9³⁄₁₆ inches (19.3 x 23.4 cm)
The Lynne and Harold Honickman
Gift of the Julien Levy Collection
2001-62-657

In the 1940s, when Levy moved to the Connecticut countryside, he photographed friends who came to visit, still following in the tracks of other artists. A sylvan portrait of Pavel Tchelitchew is a simple record of their friendship (pl. 119). Levy printed the photograph on the lower half of a large sheet, and Tchelitchew added an ink drawing of treetops in the blank upper half. The result of their collaboration captures the weave of illusionism and attenuated fantasy that a number of Levy's artists—the Neo-Romantics Tchelitchew, Leonid, and Eugene Berman, and the Surrealists Salvador Dalí and Yves Tanguy—strove for, and it speaks to photography's central place in the gallery's program. Other photographic games were more ribald. When entertaining a group of friends, including Duchamp, Yves Tanguy and Kay Sage, Enrico and Claire Donati, Duchamp's lover Maria Martins, and Dada artist and filmmaker Hans Richter, Levy made mug shots of each one—front and profile views (pl. 120). He mounted the photographs to FBI wanted posters in fairly direct imitation of Duchamp's 1923 piece *Wanted—$2,000 Reward* (fig. 38), or the "Compensation Portraits" Duchamp suggested as substitutes for the catalogue of the 1942 New York exhibition *First Papers of Surrealism*.[50] In a closer effort at Surrealism, Levy or someone in his circle photographed a dog's hindquarters and cropped the picture to evoke a human visage (pl. 117). The result, a classic instance of photographic displacement, recalls the nude female torsos painted by René Magritte to look like faces, or photographs by Man Ray and Brassaï that play similar games with the human figure (see pl. 224).[51]

An exception to Levy's copycat approach in his own photography is a remarkable group of portraits he made of Frida Kahlo, probably in a single session in New York around the time of Kahlo's solo exhibition at the gallery in November 1938. The two met then for the first time and commenced a playful friendship. Looking at the results of their photo session, which include tiny contact prints and nineteen larger prints of selected frames, one imagines that Kahlo had as much to do with the photographs' production as Levy did, if not more (pls. 121–124, 265, 266). The daughter of a photographer as well as the subject of most of her own paintings, she eagerly posed before cameras all

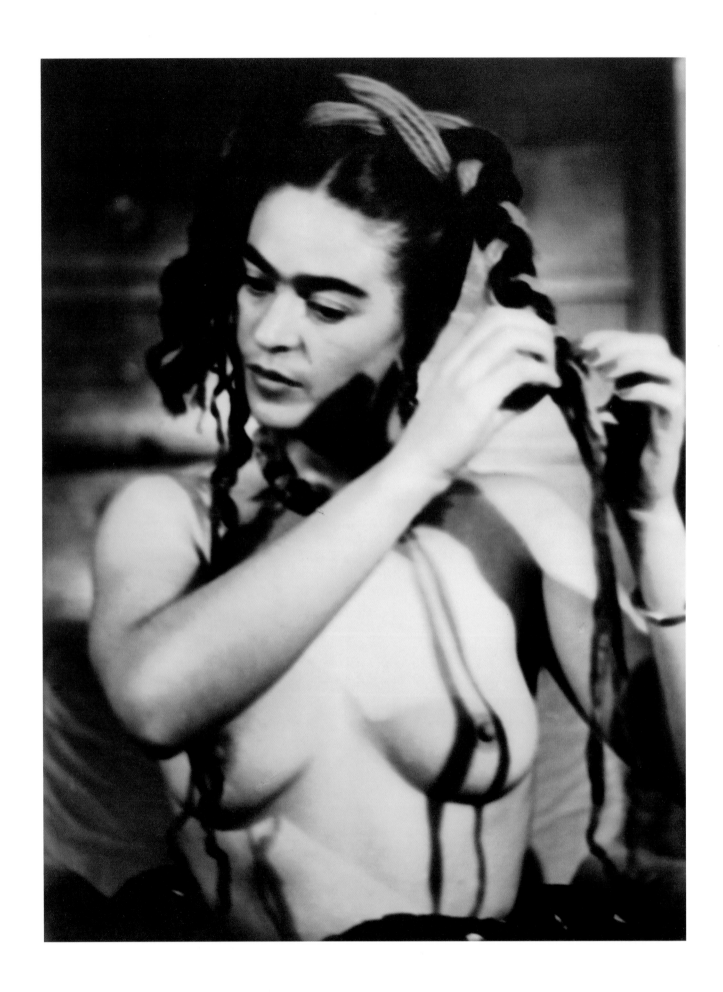

Plate 121 (opposite)
Julien Levy (American,
1906–1981)
Frida Kahlo, c. 1938
Gelatin silver print
9¼ x 7 inches (23.5 x 17.8 cm)
The Lynne and Harold Honickman
Gift of the Julien Levy Collection
2001-62-635

Plate 122 (top)
Julien Levy (American,
1906–1981)
Frida Kahlo, c. 1938
Gelatin silver print
6¹¹⁄₁₆ x 6⁵⁄₁₆ inches (17 x 16 cm)
The Lynne and Harold Honickman
Gift of the Julien Levy Collection
2001-62-640

Plate 123 (bottom)
Julien Levy (American,
1906–1981)
Frida Kahlo, c. 1938
Gelatin silver print
6¹⁵⁄₁₆ x 6⅝ inches (17.6 x 16.8 cm)
The Lynne and Harold Honickman
Gift of the Julien Levy Collection
2001-62-641

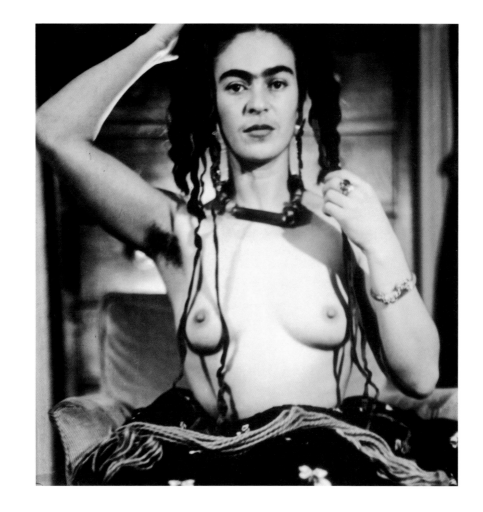

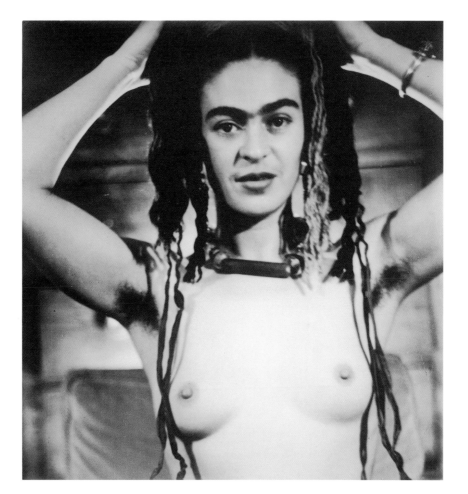

her life, maybe more curious than anyone else about what the results would look like. The session with Levy, during which Kahlo removed most of her clothes and let her braids down, looks to have been intense, but the pictures are perhaps not as heated as Levy hoped. He may have been thinking of Stieglitz's extended photographic exploration of Georgia O'Keeffe's body, which made a strong impression on him, but Levy's photographs of Kahlo seem less like the record of an erotic engagement than a documentation of Kahlo's experimentation with different states of undress.[52]

Discussing these photographs, Levy recalled that he was fascinated by the ceremony with which Kahlo unbraided and braided her hair.[53] He reported that he gave one of the photographs, along with a lock of Kahlo's hair, to Joseph Cornell, who used it to fashion a portrait box with blue glass (presumably like the ones he made of Levy and Mina Loy; see pls. 206, 208, 209), and that he himself gave Kahlo's portrait box to her. He also cut up a few of the prints from the group, silhouetting Kahlo's figure in one and paring down another to a single eye and her braids, perhaps planning to use them in a collage.[54] These cutouts, Levy's memory of Cornell's Kahlo box (for whose existence there is no evidence save Levy's word), and an obsessive trio of duplicate prints Levy made of one of the photographs (an image of Kahlo topless, printed with various tonal contrasts; see pl. 123) all manifest his fascination with Kahlo. They also demonstrate his understanding of the talismanic power of photographs—what Cornell might have called their magic, or Duchamp might have called their kiss.[55]

No doubt Kahlo also savored these images of her beautiful, youthful body. She was injured in a bus accident at the age of eighteen and spent the rest of her life in pain, ailing from her injuries and the many surgeries that followed. In August 1940 she sent Levy a very different picture of herself, perhaps by photographer Nickolas Muray, "taken when I had an awful aparatus [*sic*] on the head" (pl. 125).[56] The apparatus was the traction device her doctors placed her in whenever her spinal pain became too great.

Levy was not the only amateur with a camera in his circle. His friendship with the Connecticut collector and writer James Thrall Soby began when Soby wrote to him requesting a photography tutor and Levy recommended Ralph Steiner.[57] Soby was more ambitious than Levy about his photographs, often carefully printing and mounting them for display. But like Levy's photography, Soby's often documents his life and friends. He photographed a summer trip to various spots in Italy in 1937. Among the party were Levy, A. Everett (Chick) Austin, Jr., Leonid and Eugene Berman, Charles Henri Ford, Eleanor Howland Soby (pl. 126), and Pavel Tchelitchew. Soby occasionally made work in the spirit of the Surrealist and Neo-Romantic paintings he collected. One portrait from the Italian trip depicts Leonid emerging from the ocean, looming before the low horizon line with a head covered in seaweed (see pl. 260). In an abstracted scene on the roof of an urban building, someone's hand and bald head loom in from the left, nearly connecting with an unidentified object at right, while behind them a foreshortened figure, mysteriously lying in the corner, protrudes into view feet first (see pl. 258).

Levy and Soby's photographs are interesting in the context of the Julien Levy Gallery because they demonstrate the playful, casual attitudes about photography that held sway there. Beyond the roster of impressive photographers whose work hung on the walls, it was a place to look at and play with photographs in many modes. Levy's collection includes a number of cut-up photographs, evidently intended for use in collages, and two negative-image "holiday cards" made with Victorian cabinet-card portraits and other ephemera, probably designed by Levy to send as unique seasonal greetings (pl. 127). The most intriguing example of photographic playfulness in Levy's circle is a photomontage by George Platt Lynes that belonged to Allen Porter, a friend of both Lynes and Levy and a key employee at the gallery in its beginning years (pl. 128). The image is dominated by a simple line drawing of a man's profile, which overlays a scene of an unmade bed in the bottom third of the picture and the lean torso of a nude male above, printed in negative. The nude figure's sexual

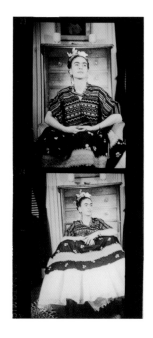

Plate 124 (left)
Julien Levy (American,
1906–1981)
Frida Kahlo, c. 1938
Gelatin silver print
3¹⁄₁₆ x 1⁵⁄₁₆ inches (7.7 x 3.4 cm)
The Lynne and Harold Honickman
Gift of the Julien Levy Collection
2001-62-622

Plate 125 (right)
Attributed to **Nickolas Muray**
(American, born Hungary,
1892–1965)
*Frida Kahlo with Her Head in
a Brace,* 1940
Gelatin silver print
4³⁄₈ x 6⁵⁄₈ inches (11.1 x 16.8 cm)
The Lynne and Harold Honickman
Gift of the Julien Levy Collection
2001-62-644

organs help form the drawn eye of the profile face. This montage is less polished than most of Lynes's work, but its overall darkness and the obscurity of the negative-printed nude have a purpose: the joke of the picture is most effective when one has had to look closely at the composition for several moments before finally understanding all the pieces. However atypical for Lynes, the picture is familiar as one of numerous abstract, often witty portraits made in American art circles in the early twentieth century. Walker Evans, himself experimenting in an uncharacteristic mode, made a similar photomontage portrait of Berenice Abbott around 1930 (fig. 40).

Levy owned a separate print of the nude used in the photomontage (fig. 39), and it is possible that Lynes meant the montage to be a playful portrait of Levy, who sported a fashionable bald pate for a while and who prided himself on his willingness to follow his sexual drives wherever they might lead.[58] Although male nudes were not Levy's "thing," the punning, bawdy wit of the picture seems precisely his sensibility. But the subject is probably Allen Porter, who also had an elegant profile like that seen here and who prided *himself* as one of the gay cognoscenti of the 1930s art scene (Joella Levy Bayer recalled that it was Porter who kept her apprised of everyone's love affairs, and of which friends in their circle were homosexual).[59] The portrait is a witty, fun, private picture, and it would no doubt have pleased Levy and Porter to know that today no one is quite sure which of them it depicts.[60] It is a great emblem of photography at the Julien Levy Gallery, where visitors encountered the subtleties of sexual tension and its representations, and also the pleasures of photographic play—whether looking at framed prints on a wall, or cutting and pasting, or sifting through bins of miscellaneous pictures for a personal trophy.

To be sure, not every kind of photograph was to be found in Levy's gallery in the 1930s. The most noticeable and consistent absence is that of documentary photography. Not the "graphic" work Levy held up as the important tradition of the "great S's," but the American social-documentary photography formulated by Lewis Hine at the beginning of the century, and elaborated by Farm Security Administration (FSA) photographers and others in the 1930s. Superb practitioners such as

Plate 126 (opposite)
James Thrall Soby (American,
1906–1979)
**Untitled (A. Everett Austin and
Pavel Tchelitchew, Pompeii),**
1937
Gelatin silver print
8¹⁄₁₆ x 7³⁄₁₆ inches (20.4 x 18.2 cm)
The Lynne and Harold Honickman
Gift of the Julien Levy Collection
2001-62-1113

Plate 127 (right)
Photographer unknown
Possibly by **Julien Levy** (American,
1906–1981)
Bonne Année, c. 1930–40
Gelatin silver print
10¹¹⁄₁₆ x 6⅞ inches (27.1 x 17.5 cm)
The Lynne and Harold Honickman
Gift of the Julien Levy Collection
2001-62-2243

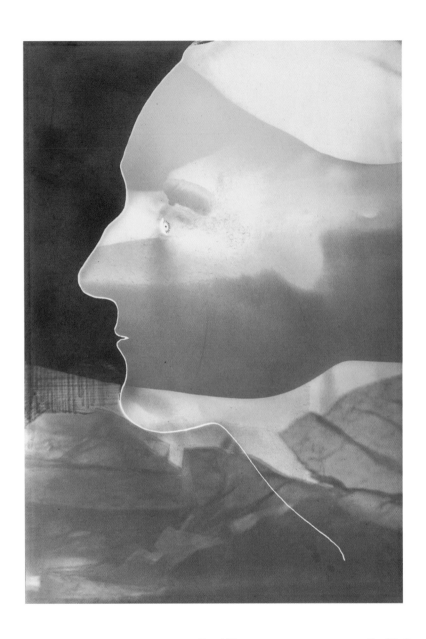

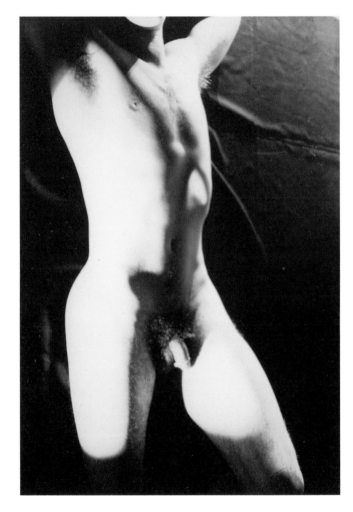

Plate 128
George Platt Lynes (American, 1907–1955).
Untitled (Allen Porter?),
c. 1930–34
Gelatin silver print, with pen and ink
6⅝ x 4⅝ inches (16.8 x 11.8 cm)
Purchased with the Lola Downin Peck Fund, 2004-4-1

Fig. 39. **George Platt Lynes** (American, 1907–1955). **Untitled (Male nude),** c. 1930–34. Gelatin silver print, 6¹⁵⁄₁₆ x 5 inches (16.4 x 11.4 cm). The Art Institute of Chicago. Julien Levy Collection, Gift of Jean and Julien Levy, 1978.1081

Fig. 40. **Walker Evans**
(American, 1903–1975).
Berenice Abbott, c. 1930.
Gelatin silver print, 4⁵⁄₁₆ x
2½ inches (11 x 6.4 cm).
The Art Institute of Chicago. Gift
of David C. and Sarajean
Ruttenberg, 1988.396.18

Dorothea Lange and Marion Post Wolcott were never visible among the Julien Levy Gallery's rich mix of 1930s work. Lange, Wolcott, and others working in their vein probably did not seek gallery representation. Their FSA colleague Walker Evans did seek it, of course, and he found a warm reception in the 1930s New York art world, including the Julien Levy Gallery.[61] Evans denied the presence of overt social content in his photography, however, and Levy was similarly impatient with political art. His one effort at showing the socially driven paintings of Ben Shahn (who was himself an FSA photographer) ended in dissatisfaction on both sides, and Levy alluded to Shahn's political self-righteousness as an underlying reason.[62] Elsewhere, he clearly stated (though without explanation) his mistrust of politically oriented art.[63]

Given Levy's catholicity of photographic taste, we can perhaps assume that had he been approached by committed social-documentarians he might have given their photography some space in his gallery. But the two sides did not seek each other out. In 1933 Levy corresponded with Lewis Hine, perhaps at the behest of Stieglitz or Stella Simon, but he never showed Hine's work, which glorified American immigrants and workers but also exposed deep inequities in the industrial economy.[64] Similarly, as Berenice Abbott honed her urban photography into the Works Progress Administration (WPA) project and book *Changing New York* in the second half of the 1930s, Levy's interest in her photography evidently waned, as did her interest in his gallery. The most visible place for such work in New York was the left-leaning Photo League, which was formed in 1935 from the earlier Film and Photo League.[65]

Levy's desire to be always provocative yet barely political is a familiar avant-garde position. Such political remove is not so easily accommodated in photographs, which are, among other things, social tools. In the Julien Levy Gallery, this meant that frank representation of social relations turned up in photography of other places, if at all, and that surprise and shock were typically encountered

Plate 129
Photographer unknown
Untitled (Police photograph),
1909
Gelatin silver print
2⅞ x 4¹³⁄₁₆ inches (7.3 x 12.2 cm)
The Lynne and Harold Honickman
Gift of the Julien Levy Collection
2001-62-2150

within the confined arena of Surrealist play. Consider the single example of police photography in the Julien Levy Collection, an Italian mug shot (pl. 129). In the context of Levy's gallery, the image has as little purchase on the political implications of photography as it does on the instrumental purpose for which it was made. It is simply another Surrealist surprise, like the FBI wanted posters Levy devised for friends who came to visit him in the country.

Levy's dis-engagement from one important vein of photography stands out because of his wide-ranging commitment to the medium. The Julien Levy Gallery was among the best and most exciting places in New York to see photographs in the 1930s and 1940s. That is due in no small part to the modest pictures reviewed in this essay. Levy exhibited a "history" of photography at his gallery in the early 1930s, one strongly inflected by Stieglitz in its American slant, its attention to a select group of masters, and its surprising inclusion of Pictorialist examples. Yet like his other "godfather," Duchamp, and unlike Stieglitz (or for that matter, André Breton), Levy refused to be dogmatic.[66] He was adventurous, superbly opinionated, and open to visual and intellectual risks. His dialectical oppositions—Steiglitz vs. Duchamp, documentary vs. anti-graphic—led to no resolved categories, but simply opened up the satisfying tensions of differing modes. The result, in his gallery, was a bouquet of photographic possibilities. Levy gave us, then, photography on the terms of both Stieglitz and Duchamp: a history of the medium, but one that comes to no particular end.

1. Joseph Cornell to Julien Levy, February 27, 1959, Julien Levy Archive, Connecticut.

2. CalmelsCohen, Paris, *André Breton, 42, rue Fontaine*, April 15–17, 2003 (sale catalogue).

3. Ingrid Schaffner and Lisa Jacobs, eds., *Portrait of an Art Gallery* (Cambridge, Mass.: MIT Press, 1998), p. 20.

4. Julien Levy, *Surrealism* (New York: Black Sun Press, 1936), p. 13.

5. Ibid., p. 7. Levy reinforced this idea in the 1968 introduction to a reissue of his book *Surrealism* (New York: Arno Press, 1968).

6. Levy, *Surrealism*, p. 55, quoting André Breton, *Second manifeste du surréalisme* (Paris: Editions Kra, 1930), pp. 26–27: "Comment admettre que la méthode dialectique ne puisse s'appliquer valablement qu'à la résolution des problèmes sociaux? Toute l'ambition du surréalisme est de lui fournir des possibilités d'application nullement concurrentes dans le domaine conscient le plus immédiat."

7. Levy sold avant-garde journals and books at the gallery, so that much of this literature passed through his hands. See Schaffner and Jacobs, eds., *Portrait of an Art Gallery*, pp. 22–23, 33.

8. Levy's was the first gallery to show Cornell's work. But as several writers have pointed out, Cornell was a connoisseur of the New York gallery scene, so it could be said that he "discovered" Levy. See, for example, Lynda Roscoe Hartigan, "Joseph Cornell: A Biography," in *Joseph Cornell*, ed. Kynaston McShine, exh. cat. (New York: Museum of Modern Art, 1980), esp. pp. 95–99.

9. Paradoxically, given their divergent practices, Stieglitz and Duchamp both structured their work in reaction to the industrial and finance capitalism of their historical moment. On Stieglitz, see Allan Sekula, "On the Invention of Photographic Meaning," *Artforum*, vol. 13, no. 5 (January 1975), pp. 36–45; and Alan Trachtenberg, "Camera Work/Social Work," in Trachtenberg, *Reading American Photographs: Images as History, Mathew Brady to Walker Evans* (New York: Hill and Wang, 1989), pp. 164–230. On Duchamp, see David Joselit, *Infinite Regress: Marcel Duchamp, 1910–1941* (Cambridge, Mass.: MIT Press, 1998). For another comparison of Duchamp and Stieglitz, see Deborah Bricker Balken, *Debating American Modernism: Stieglitz, Duchamp, and the New York Avant-Garde*, exh. cat. (New York: American Federation of Arts, 2003).

Plate 130

Antoine-Samuel Adam-Salomon (French, 1818–1881)

Untitled (Reclining figure in costume), c. 1859

Salted paper print

10½ x 8³⁄₁₆ inches (26.7 x 20.8 cm)

The Lynne and Harold Honickman Gift of the Julien Levy Collection, 2001-62-23

Plate 131

Félix-Jacques-Antoine Moulin (French, 1802–after 1875)

Boghari, Arab Horse (Boghari, cheval arabe), 1856–57

Albumen silver print

8⅟₁₆ x 6¼ inches (21.7 x 15.9 cm)

The Lynne and Harold Honickman Gift of the Julien Levy Collection, 2001-62-1662

Plate 132

Nadar (French, 1820–1910)

Gustave Doré, 1856–58; printed 1900–1930 by Paul Nadar (French, 1856–1939)

Gelatin silver print

8¼ x 6⁵⁄₁₆ inches (21 x 16.1 cm)

The Lynne and Harold Honickman Gift of the Julien Levy Collection, 2001-62-925

Plate 133

Nadar (French, 1820–1910)

George Sand, c. 1864–65; printed 1900–1930 by Paul Nadar (French, 1856–1939)

Gelatin silver print

9¹³⁄₁₆ x 7⅛ inches (24.9 x 18.1 cm)

The Lynne and Harold Honickman Gift of the Julien Levy Collection, 2001-62-880

Plate 134

Eugène Atget (French, 1857–1927)

Versailles, 1922–23

Albumen silver print

8⅝ x 7³⁄₁₆ inches (21.9 x 18.3 cm)

The Lynne and Harold Honickman Gift of the Julien Levy Collection, 2001-62-237

Plate 135

Eugène Atget (French, 1857–1927)

Hearse (1st Class) (Voiture—Pompes funèbres [1er classe]), 1910

Albumen silver print

8⁷⁄₁₀ x 6¹³⁄₁₀ inches (21.4 x 17.6 cm)

Purchased with the Lola Downin Peck Fund, the Alice Newton Osborn Fund, other Museum funds,
and with the partial gift of Eric W. Strom, 2004-110-22

Plate 136
Eugène Atget (French, 1857–1927)
Saint-Cloud, 1910–14
Albumen silver print
8 x 6¾ inches (20.3 x 17.1 cm)
Purchased with the Lola Downin Peck Fund, the Alice Newton Osborn Fund, other Museum funds,
and with the partial gift of Eric W. Strom, 2004-110-27

Plate 137
Photographer unknown (American)
Formerly attributed to **Mathew Brady** (American, 1823–1896)
Untitled (Dead Civil War soldiers in a trench), 1861–65
Albumen silver print
8 x 7³⁄₁₆ inches (20.3 x 18.2 cm)
Purchased with the Lola Downin Peck Fund, the Alice Newton Osborn Fund, other Museum funds,
and with the partial gift of Eric W. Strom, 2004-110-37

Plate 138

Photographer unknown (American)

Formerly attributed to **Mathew Brady** (American, 1823–1896)

Untitled (Dead Civil War soldier in a trench), 1861–65

Albumen silver print

8¹⁄₁₆ x 7³⁄₁₆ inches (20.5 x 18.3 cm)

Purchased with the Lola Downin Peck Fund, the Alice Newton Osborn Fund, other Museum funds,
and with the partial gift of Eric W. Strom, 2004-110-35

Plate 139

Attributed to **Dallemagne & Lazerges** (French, active 1860s)

Princess Olga Cantacuzène, c. 1860s–70s; printed 1900–1930 by Paul Nadar (French, 1856–1939)

Gelatin silver print

11⅞ x 7¹⁵⁄₁₆ inches (29 x 20.1 cm)

The Lynne and Harold Honickman Gift of the Julien Levy Collection, 2001-62-627

Plate 140

Louis-Jean Delton (French, 1807–1891?)

Mr. Brewer's American Trotting Horses (Trotteurs américains à Mr. Brewer),

from *Album hippique,* c. 1867

Albumen silver print

5⁵⁄₁₆ x 10½ inches (13.5 x 26.6 cm)

The Lynne and Harold Honickman Gift of the Julien Levy Collection, 2001-62-1244(7)

Plate 141

Gertrude Käsebier (American, 1852–1934)

The Family, c. 1909

Gum print

11⅟₆ x 9⅟₆ inches (29.3 x 24 cm)

The Lynne and Harold Honickman Gift of the Julien Levy Collection, 2001-62-591

Plate 142
Gertrude Käsebier (American, 1852–1934)
The Grandmother (La Grand-mère), 1894
Gelatin silver print
6¾ x 4⅝ inches (17.1 x 11.8 cm)
The Lynne and Harold Honickman Gift of the Julien Levy Collection, 2001-62-590

Plate 143
Anne Brigman (American, 1869–1950)
Self-Portrait with Mask, 1922
Gelatin silver print
9¹³⁄₁₆ x 7⅞ inches (25 x 20 cm)
The Lynne and Harold Honickman Gift of the Julien Levy Collection, 2001-62-440

Plate 144
Allie Bode (American, 1891–1975)
Mexican Madonna, 1925
Platinum print
9³⁄₁₆ x 7¹⁄₁₆ inches (23.4 x 18 cm)
The Lynne and Harold Honickman Gift of the Julien Levy Collection, 2001-62-428

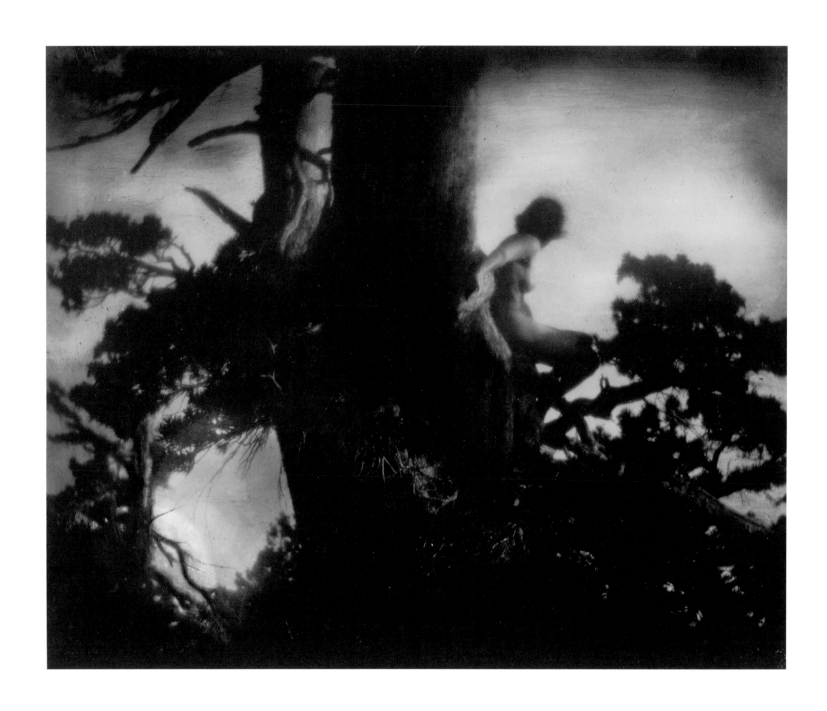

Plate 145
Anne Brigman (American, 1869–1950)
The Pine Sprite, 1912
Gelatin silver print
7⅝ x 9⁹⁄₁₆ inches (19.4 x 23.7 cm)
The Lynne and Harold Honickman Gift of the Julien Levy Collection, 2001-62-443

Plate 146
Alvin Langdon Coburn (British, born United States, 1882–1966)
Snow in the Canyon, 1911
Platinum print with gum bichromate
12⅜ x 15⅝ inches (31.4 x 39.7 cm)
The Lynne and Harold Honickman Gift of the Julien Levy Collection, 2001-62-467

Plate 147

Stella Simon (American, 1878–1973)

Chinese Coat, c. 1920–31

Gelatin silver print

9⅝ x 6½ inches (24.4 x 16.5 cm)

The Lynne and Harold Honickman Gift of the Julien Levy Collection, 2001-62-1096

Plate 148

Stella Simon (American, 1878–1973)

Skunk Cabbage, 1928

Platinum print

9⅛ x 6¹³⁄₁₆ inches (23.2 x 17.7 cm)

The Lynne and Harold Honickman Gift of the Julien Levy Collection, 2001-62-1099

Plate 149

Paul Strand (American, 1890–1976)

Cobweb in Rain, Georgetown, Maine, 1927

Gelatin silver print

9¹¹⁄₁₆ x 7¹³⁄₁₆ inches (24.6 x 19.8 cm)

The Lynne and Harold Honickman Gift of the Julien Levy Collection, 2001-62-1125a

Plate 150
Imogen Cunningham (American, 1883–1976)
Rock Shadows, c. 1924–31
Gelatin silver print
10½ x 8⅞ inches (26.6 x 22.6 cm)
The Lynne and Harold Honickman Gift of the Julien Levy Collection, 2001-62-487

Plate 151
Charles Sheeler (American, 1883–1965)
Side of White Barn, Doylestown, 1915
Gelatin silver print
7¹¹⁄₁₆ x 9⁹⁄₁₆ inches (19.5 x 24.3 cm)
The Lynne and Harold Honickman Gift of the Julien Levy Collection, 2001-62-1088

Plate 152

Luke Swank (American, 1890–1944)

Catalpa Tree, c. 1930–33

Gelatin silver print

6⁷⁄₁₆ x 4½ inches (15.7 x 11.5 cm)

The Lynne and Harold Honickman Gift of the Julien Levy Collection, 2001-62-1134

Plate 153

Luke Swank (American, 1890–1944)

Untitled (Farm-door mechanism), c. 1930–33

Gelatin silver print

5⅞ x 4⁵⁄₁₆ inches (15 x 11 cm)

The Lynne and Harold Honickman Gift of the Julien Levy Collection, 2001-62-1126

Plate 154

Samuel Gottscho (American, 1875–1971)

Interior of Mill at Hayground, Long Island (First Story), c. 1925–35

Gelatin silver print

12⅞ x 9⅜ inches (32.7 x 23.8 cm)

The Lynne and Harold Honickman Gift of the Julien Levy Collection, 2001-62-522

Plate 155

Charles Sheeler (American, 1883–1965)

Shaker Stove, c. 1930

Gelatin silver print

7¹⁄₁₆ x 9⁹⁄₁₆ inches (17.9 x 24.3 cm)

The Lynne and Harold Honickman Gift of the Julien Levy Collection, 2001-62-1089

Plate 156

Paul Strand (American, 1890–1976)

Untitled (Machine, Akeley camera shop), 1923

Gelatin silver print

9⅝ x 7¹³⁄₁₆ inches (24.4 x 19.9 cm)

The Lynne and Harold Honickman Gift of the Julien Levy Collection, 2001-62-1123

Plate 157

Walker Evans (American, 1903–1975)

Stamped-Tin Relic, 1929

Gelatin silver print

4½ x 6½ inches (11.4 x 16.5 cm)

The Lynne and Harold Honickman Gift of the Julien Levy Collection, 2001-62-507

Plate 158
Walter Hege (German, 1893–1955)
Acropolis, 1928–30
Gelatin silver print
10¹⁵⁄₁₆ x 8¾ inches (27.8 x 22.2 cm)
The Lynne and Harold Honickman Gift of the Julien Levy Collection, 2001-62-564

Plate 159

Berenice Abbott (American, 1898–1991)

Untitled (New York City), 1929–33

Gelatin silver print

6½ x 4⁷⁄₁₆ inches (16.5 x 11.2 cm)

The Lynne and Harold Honickman Gift of the Julien Levy Collection, 2001-62-7

Plate 160
Sherril Schell (American, 1877–1964)
Window Reflection—French Building, c. 1930–32
Gelatin silver print
7¹⁵⁄₁₆ x 6⅛ inches (20.2 x 15.6 cm)
The Lynne and Harold Honickman Gift of the Julien Levy Collection, 2001-62-1082

Plate 161

Luke Swank (American, 1890–1944)

Untitled (Tenement), c. 1930–33

Gelatin silver print

6 x 4⁷⁄₁₆ inches (15.3 x 11.3 cm)

The Lynne and Harold Honickman Gift of the Julien Levy Collection, 2001-62-1130

Plate 162
Eliot Elisofon (American, 1911–1973)
Untitled (Barber shop), c. 1935–40
Gelatin silver print
7¹⁄₁₆ x 7⅜ inches (17.9 x 18.7 cm)
The Lynne and Harold Honickman Gift of the Julien Levy Collection, 2001-62-494

Plate 163 (top)
Luke Swank (American, 1890–1944)
Untitled (Victorian house), c. 1930–33
Gelatin silver print
4½ x 6⁷⁄₁₆ inches (11.5 x 16.3 cm)
The Lynne and Harold Honickman Gift of the Julien Levy Collection, 2001-62-1147

Plate 164 (bottom)
Kurt Baasch (American, born Venezuela, 1891–1964)
Untitled (Cellar door and cat), c. 1930–33
Gelatin silver print
4½ x 6⁹⁄₁₆ inches (11.5 x 16.7 cm)
The Lynne and Harold Honickman Gift of the Julien Levy Collection, 2001-62-2122

Plate 165
Paul Outerbridge (American, 1896–1958)
New York from a Back Window, 1923
Platinum print
4⁷⁄₁₆ x 3⁹⁄₁₆ inches (11.3 x 9 cm)
The Lynne and Harold Honickman Gift of the Julien Levy Collection, 2001-62-980

Plate 166
Sherril Schell (American, 1877–1964)
Reflection in Window Pane of Empire State Building, 1931–32
Gelatin silver print
8 1/16 x 6 1/8 inches (20.5 x 15.6 cm)
The Lynne and Harold Honickman Gift of the Julien Levy Collection, 2001-62-1078

Plate 167
Sherril Schell (American, 1877–1964)
Buildings on West 33rd Street, c. 1930–32
Gelatin silver print
7¹⁵⁄₁₆ x 6¼ inches (20.1 x 15.9 cm)
The Lynne and Harold Honickman Gift of the Julien Levy Collection, 2001-62-1083

Plate 168

Thurman Rotan (American, 1903–1991)

Untitled (Logs and Empire State Building), 1931–32

Gelatin silver print

7 x 8⅞ inches (17.8 x 22.5 cm)

The Lynne and Harold Honickman Gift of the Julien Levy Collection, 2001-62-1049

Plate 169

Thurman Rotan (American, 1903–1991)

Daily News Building, 1930–31

Collage of gelatin silver prints

10 x 11¹⁵⁄₁₆ inches (25.4 x 30.3 cm)

The Lynne and Harold Honickman Gift of the Julien Levy Collection, 2001-62-1030

Plate 170
Luke Swank (American, 1890–1944)
__Pittsburgh #12,__ c. 1930–33
Gelatin silver print
6 x 4⅝ inches (15.2 x 11.7 cm)
The Lynne and Harold Honickman Gift of the Julien Levy Collection, 2001-62-1145

Plate 171

Eliot Elisofon (American, 1911–1973)

Untitled (Store window display with reflections), c. 1935–40

Gelatin silver print

7⅝ x 6⅞ inches (19.4 x 17.5 cm)

The Lynne and Harold Honickman Gift of the Julien Levy Collection, 2001-62-499

Plate 172

Samuel Gottscho (American, 1875–1971)

Untitled (New York City skyline at dusk), c. 1932

Gelatin silver print

10¼ x 13¼ inches (26.1 x 33.7 cm)

The Lynne and Harold Honickman Gift of the Julien Levy Collection, 2001-62-527

Plate 173

Wendell MacRae (American, 1896–1980)

Seed of Mars, c. 1932

Gelatin silver print

7½ x 9⅞ inches (19 x 23.9 cm)

The Lynne and Harold Honickman Gift of the Julien Levy Collection, 2001-62-775

Plate 174

William M. Rittase (American, 1887–1968)

Forgers, Midvale Steel, c. 1930–32

Gelatin silver print

9½ x 7⅝ inches (24.2 x 19.3 cm)

The Lynne and Harold Honickman Gift of the Julien Levy Collection, 2001-62-1025

Plate 175

Sherril Schell (American, 1877–1964)

Construction of Rockefeller Center, 1930–32

Gelatin silver print

8¹¹⁄₁₆ x 6⅝ inches (22 x 16.8 cm)

The Lynne and Harold Honickman Gift of the Julien Levy Collection, 2001-62-1077

Plate 176

André Kertész (American, born Hungary, 1894–1985)

Place Saint-André-des-Arts, Latin Quarter, c. 1930

Gelatin silver print

6¼ x 8¾ inches (15.8 x 22.2 cm)

The Lynne and Harold Honickman Gift of the Julien Levy Collection, 2001-62-598

Plate 177
Eugène Atget (French, 1857–1927)
Boulevard de la Villette, 1924–25
Gelatin silver chloride print
6¹¹⁄₁₆ x 8¹¹⁄₁₆ inches (17 x 22 cm)
The Lynne and Harold Honickman Gift of the Julien Levy Collection, 2001-62-64

Plate 178

André Kertész (American, born Hungary, 1894–1985)

Old Chimneys, Montparnasse, c. 1930

Gelatin silver print

8¾ x 6⁵⁄₁₆ inches (22.2 x 16 cm)

The Lynne and Harold Honickman Gift of the Julien Levy Collection, 2001-62-597

Plate 179

Eliot Elisofon (American, 1911–1973)

Untitled (Junk shop), c. 1935–40

Gelatin silver print

5⅞ x 8 inches (14.9 x 20.3 cm)

The Lynne and Harold Honickman Gift of the Julien Levy Collection, 2001-62-497

Plate 180

Thurman Rotan (American, 1903–1991)

Untitled (Poultry crates at Washington Market, New York City), c. 1930–32

Gelatin silver print

7⅜ x 9⅛ inches (18.7 x 23.2 cm)

The Lynne and Harold Honickman Gift of the Julien Levy Collection, 2001-62-1034

Plate 181
Eli Lotar (French, 1905–1969)
Untitled (Globe advertisement), c. 1928–32
Gelatin silver print
6⁵⁄₁₆ x 8¾ inches (16 x 22.2 cm)
The Lynne and Harold Honickman Gift of the Julien Levy Collection, 2001-62-718

Plate 182

George Platt Lynes (American, 1907–1955)

New York Series #3, c. 1930–32

Gelatin silver print

6⁹⁄₁₆ x 4⅝ inches (16.7 x 11.8 cm)

The Lynne and Harold Honickman Gift of the Julien Levy Collection, 2001-62-722

Plate 183 (top)

Manuel Álvarez Bravo (Mexican, 1902–2002)

Untitled (Window with a ship model), c. 1930–35

Gelatin silver print

2¹⁵⁄₁₆ x 3¾ inches (7.4 x 9.6 cm)

The Lynne and Harold Honickman Gift of the Julien Levy Collection, 2001-62-27

Plate 184 (bottom)

Manuel Álvarez Bravo (Mexican, 1902–2002)

Laughing Mannequins (Maniquis riendo), 1930

Gelatin silver print

2¾ x 3¾ inches (7 x 9.5 cm)

The Lynne and Harold Honickman Gift of the Julien Levy Collection, 2001-62-29

Plate 185

Henri Cartier-Bresson (French, 1908–2004)

Funeral of the Comic Actor Gallipeaux, Paris (Funérailles de l'acteur comique

Gallipeaux, Paris), 1932

Gelatin silver print

6⅛ x 9⅟₁₆ inches (15.6 x 23 cm)

The Lynne and Harold Honickman Gift of the Julien Levy Collection, 2001-62-463

Plate 186

Paul Nadar (French, 1856–1939)

Untitled (Deathbed portrait), c. 1885–1930

Gelatin silver print

6⁹⁄₁₆ x 8¼ inches (16 x 21 cm)

The Lynne and Harold Honickman Gift of the Julien Levy Collection, 2001-62-951

Plate 187
Ilse Bing (American, born Germany, 1899–1998)
Untitled (Figures in street), c. 1930–31
Gelatin silver print
6⁹⁄₁₆ x 8⅞ inches (16.7 x 22.5 cm)
The Lynne and Harold Honickman Gift of the Julien Levy Collection, 2001-62-414

Plate 188

László Moholy-Nagy (American, born Hungary, 1895–1946)

Untitled (Woman and baby, Finland), 1930–31

Gelatin silver print

8³⁄₁₆ x 11⁹⁄₁₆ inches (21.1 x 29.4 cm)

The Lynne and Harold Honickman Gift of the Julien Levy Collection, 2001-62-848

Plate 189

Ilse Bing (American, born Germany, 1899–1998)

Untitled (Harbor at Veere, Holland), 1931

Gelatin silver print

8³⁄₁₆ x 11¹⁄₁₆ inches (18.3 x 28.1 cm)

The Lynne and Harold Honickman Gift of the Julien Levy Collection, 2001-62-424

Plate 190

Ilse Bing (American, born Germany, 1899–1998)

Untitled (Figures in street), c. 1930–31

Gelatin silver print

6⁹⁄₁₆ x 8¹⁵⁄₁₆ inches (16.7 x 22.7 cm)

The Lynne and Harold Honickman Gift of the Julien Levy Collection, 2001-62-418

Plate 191

Henri Cartier-Bresson (French, 1908–2004)

Untitled (Girl sleeping, Mexico), c. 1934

Gelatin silver print

9¹³⁄₁₆ x 6⁹⁄₁₆ inches (24.9 x 16.7 cm)

The Lynne and Harold Honickman Gift of the Julien Levy Collection, 2001-62-462

Plate 192

M. Rol (French, active early twentieth century)

December 23, 1912. The Arrival of Christmas Geese at a Train Station in the Capital

(23-12-12-Paris. L'Arrivée dans une gare de la capitale, d'oies pour le réveillon), 1912

Gelatin silver print

4¹¹⁄₁₆ x 6⁹⁄₁₆ inches (11.9 x 16.7 cm)

The Lynne and Harold Honickman Gift of the Julien Levy Collection, 2001-62-490

Plate 193

Walker Evans (American, 1903–1975)

Public Square, Havana, 1933

Gelatin silver print

6⅝ x 9⁹⁄₁₆ inches (16.8 x 23.6 cm)

The Lynne and Harold Honickman Gift of the Julien Levy Collection, 2001-62-504

Plate 194

Henri Cartier-Bresson (French, 1908–2004)

Marseilles, c. 1932

Gelatin silver print

5¹³⁄₁₆ x 9⅛ inches (14.8 x 23.1 cm)

The Lynne and Harold Honickman Gift of the Julien Levy Collection, 2001-62-451

Plate 195
André Kertész (American, born Hungary, 1894–1985)
Untitled (Baby), c. 1930
Gelatin silver print
6⅝ x 9 inches (16.8 x 22.9)
The Lynne and Harold Honickman Gift of the Julien Levy Collection, 2001-62-594

Plate 196
László Moholy-Nagy (American, born Hungary, 1895–1946)
Untitled (Cat on a chair), c. 1925–31
Gelatin silver print
10¹⁵⁄₁₆ x 8¼ inches (27.8 x 21 cm)
The Lynne and Harold Honickman Gift of the Julien Levy Collection, 2001-62-847

Plate 197
André Durst (French, 1907–1949)
Untitled (Head of a woman), c. 1930
Gelatin silver print
9⁷⁄₁₆ x 6⅞ inches (23 x 17.5 cm)
The Lynne and Harold Honickman Gift of the Julien Levy Collection, 2001-62-492

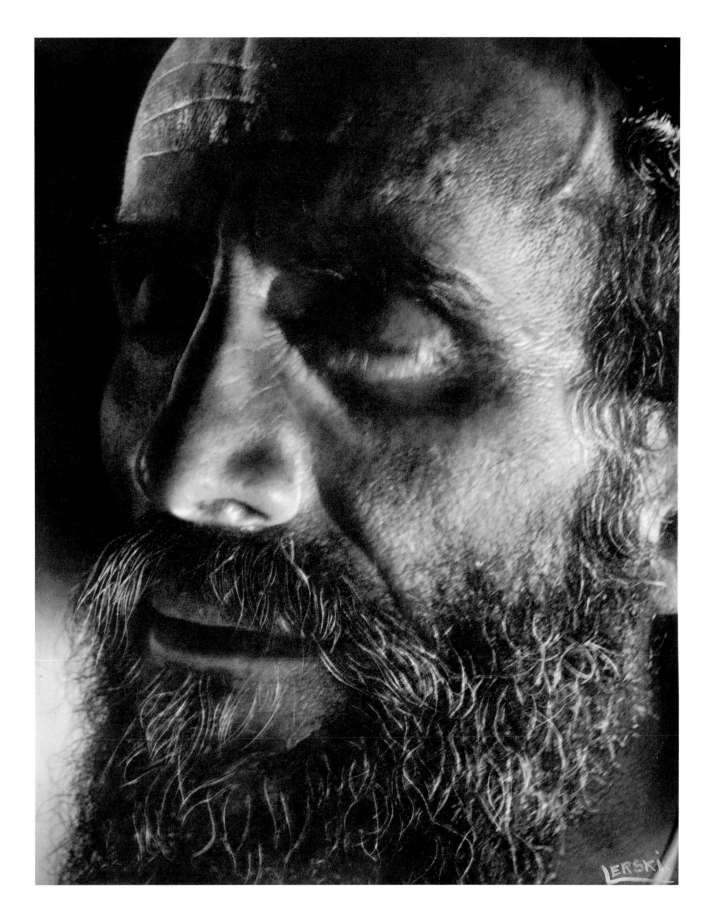

Plate 198
Helmar Lerski (Swiss, 1871–1956)
Head of a Bearded Man, c. 1931
Gelatin silver print
11⅝ x 9³⁄₁₆ inches (29.3 x 23.3 cm)
The Lynne and Harold Honickman Gift of the Julien Levy Collection, 2001-62-606

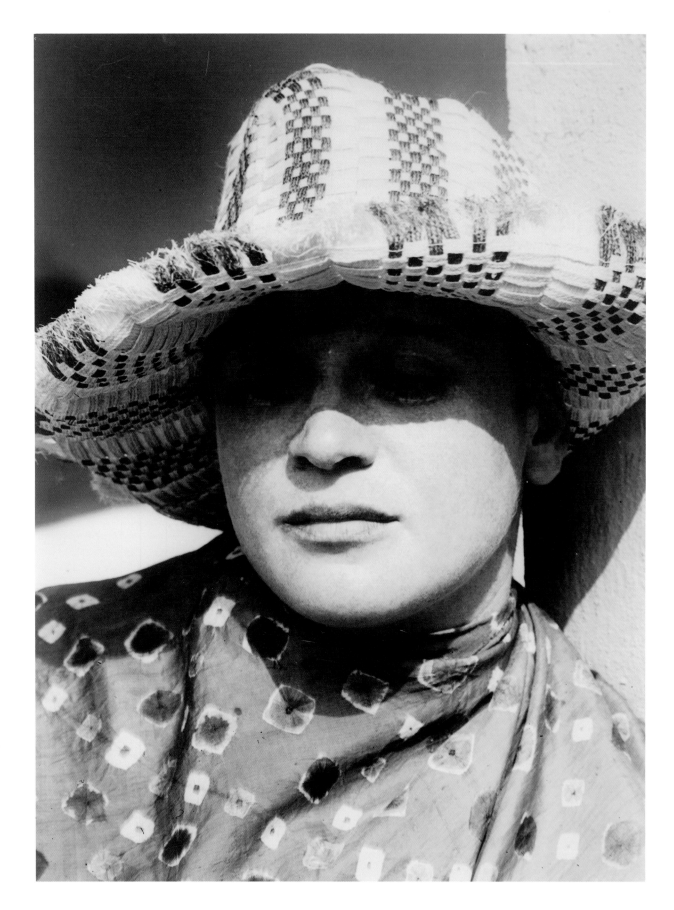

Plate 199

Lucia Moholy (British, born Silesia, 1894–1989)

Straw Hat (Strohhut), c. 1926–31

Gelatin silver print

14¹³⁄₁₆ x 11 inches (37.3 x 28 cm)

The Lynne and Harold Honickman Gift of the Julien Levy Collection, 2001-62-829

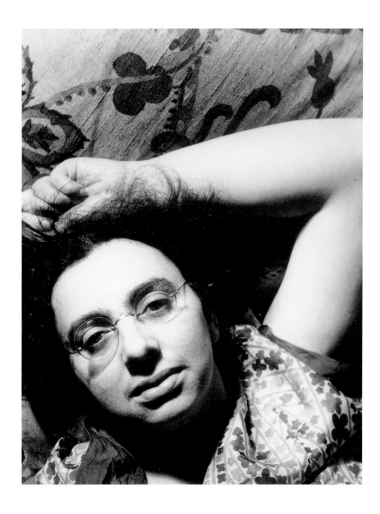

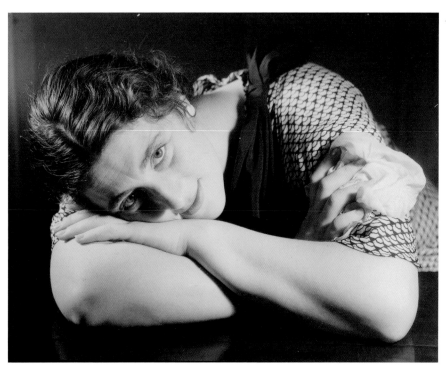

Plate 200 (top)
Jay Leyda (American, 1910–1988)
Carol Weiss King, 1931–33
Gelatin silver print
5¹/₁₆ x 4¹/₁₆ inches (12.8 x 10.3 cm)
The Lynne and Harold Honickman Gift of the Julien Levy Collection, 2001-62-671

Plate 201 (bottom)
Jay Leyda (American, 1910–1988)
Sonya Schultz, c. 1932
Gelatin silver print
3⅞ x 4¹⁵/₁₆ inches (9.9 x 12.5 cm)
The Lynne and Harold Honickman Gift of the Julien Levy Collection, 2001-62-678

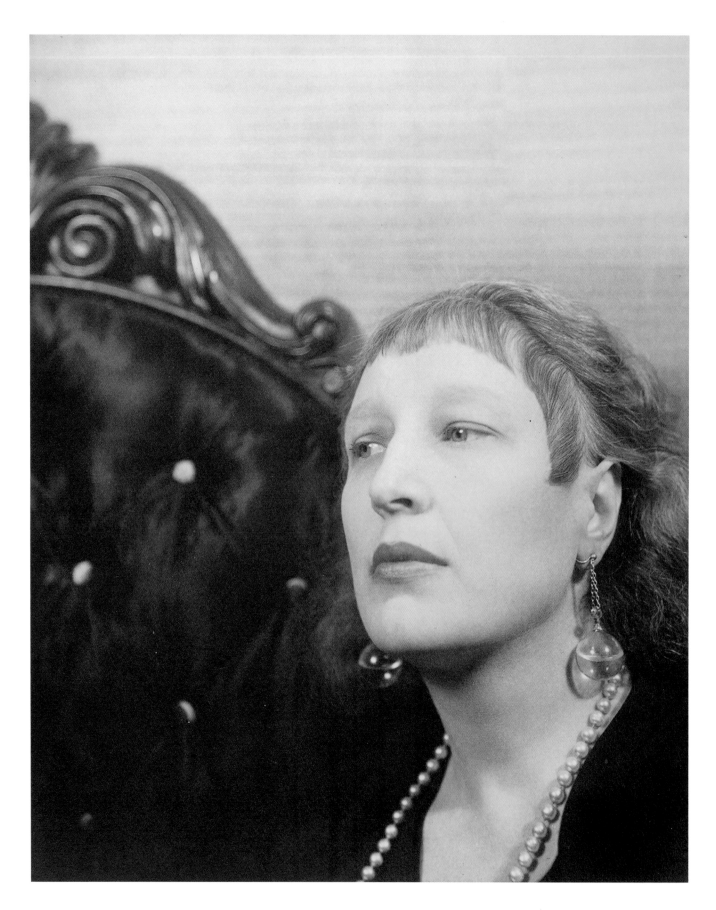

Plate 202

George Platt Lynes (American, 1907–1955)

Constance Askew, c. 1930–34

Gelatin silver print

9⁹⁄₁₆ x 7¹¹⁄₁₆ inches (24.3 x 19.5 cm)

The Lynne and Harold Honickman Gift of the Julien Levy Collection, 2001-62-725

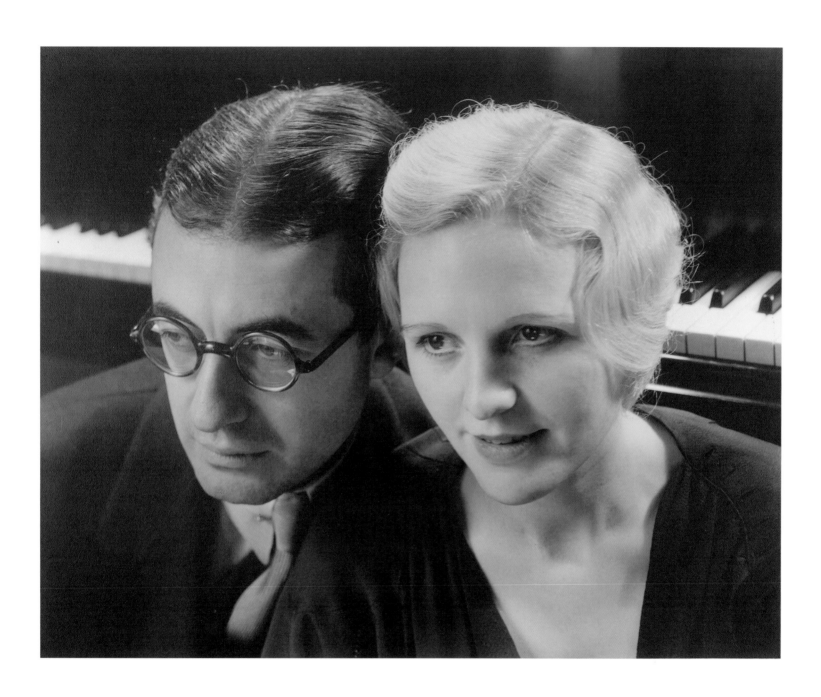

Plate 203

Grinnell-Wolf (American, active early twentieth century)

Untitled (Theater still), c. 1930

Gelatin silver print

5⅞ x 8 inches (14.9 x 20.3 cm)

The Lynne and Harold Honickman Gift of the Julien Levy Collection, 2001-62-1460

Plate 204

Jay Leyda (American, 1910–1988)

Julien Levy, c. 1932

Gelatin silver print

4⅞ x 4 inches (12.4 x 10.2 cm)

The Lynne and Harold Honickman Gift of the Julien Levy Collection, 2001-62-676

Plate 205

Nadar (French, 1820–1910)

Alexandre Dumas, Père, 1855; printed 1900–1930 by Paul Nadar (French, 1856–1939)

Gelatin silver print

3¹¹⁄₁₆ x 2⁷⁄₁₆ inches (9.3 x 6.2 cm)

The Lynne and Harold Honickman Gift of the Julien Levy Collection, 2001-62-879

Plate 206

Joseph Cornell (American, 1903–1972)

Portrait of Julien Levy, Daguerreotype-Object, 1939

Assemblage with silvered glass, mirrored glass shards, black sand, gelatin silver prints, and other materials

5⁵⁄₁₆ x 4⅛ x 1 inches (13.2 x 10.5 x 2.5 cm)

The Lynne and Harold Honickman Gift of the Julien Levy Collection, 2001-62-1

Plate 207

Man Ray (American, 1890–1976)

Joella Levy, c. 1927–30

Gelatin silver print

11³⁄₁₆ x 8⁷⁄₈ inches (28.4 x 22.5 cm)

Purchased with the Lola Downin Peck Fund, the Alice Newton Osborn Fund, other Museum funds,

and with the partial gift of Eric W. Strom, 2004-110-43

Plate 208

Joseph Cornell (American, 1903–1972)

Photograph by **Man Ray** (American, 1890–1976)

"Imperious Jewelry of the Universe" (Lunar Baedecker): Portrait of Mina Loy,
Daguerreotype-Object, 1938

Assemblage with silvered glass, glass shards, cut-out printed illustration, gelatin silver print, and other materials

5⅜₆ x 4³⁄₁₆ x 1 inches (13.2 x 10.6 x 2.5 cm)

The Lynne and Harold Honickman Gift of the Julien Levy Collection, 2001-62-3

Plate 209

Joseph Cornell (American, 1903–1972)

Portrait of Julien Levy, Daguerreotype-Object, c. 1938–39

Assemblage with silvered glass, colored balls, gelatin silver print, and other materials

5³⁄₁₆ x 4³⁄₁₆ x 1 inches (13.2 x 10.6 x 2.5 cm)

The Lynne and Harold Honickman Gift of the Julien Levy Collection, 2001-62-2

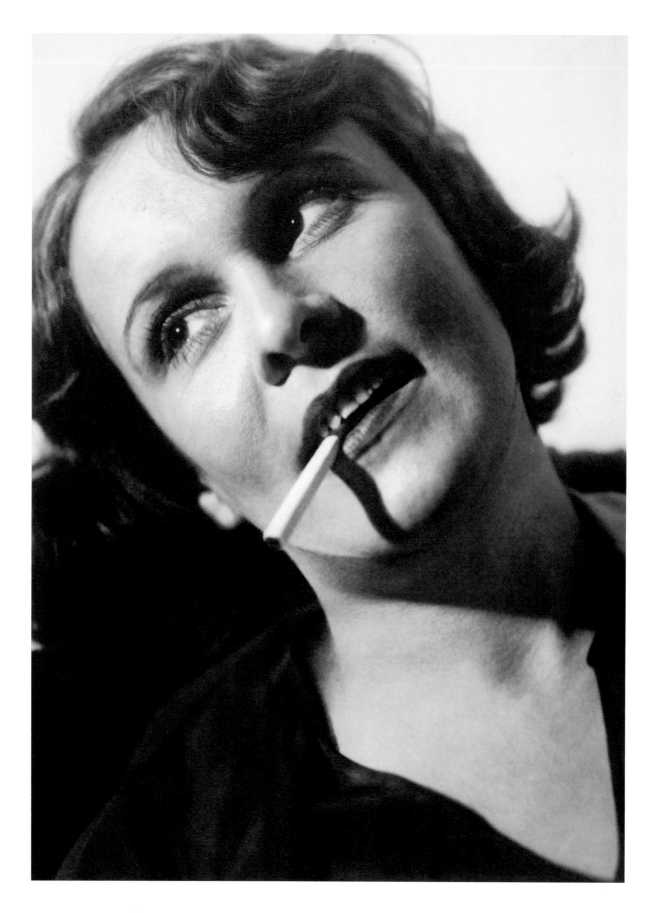

Plate 210

Peter Weller (German, 1868–1940)

Untitled (Woman with cigarette), c. 1930

Gelatin silver print

9³⁄₁₆ x 6¾ inches (23.3 x 17.1 cm)

The Lynne and Harold Honickman Gift of the Julien Levy Collection, 2001-62-1166

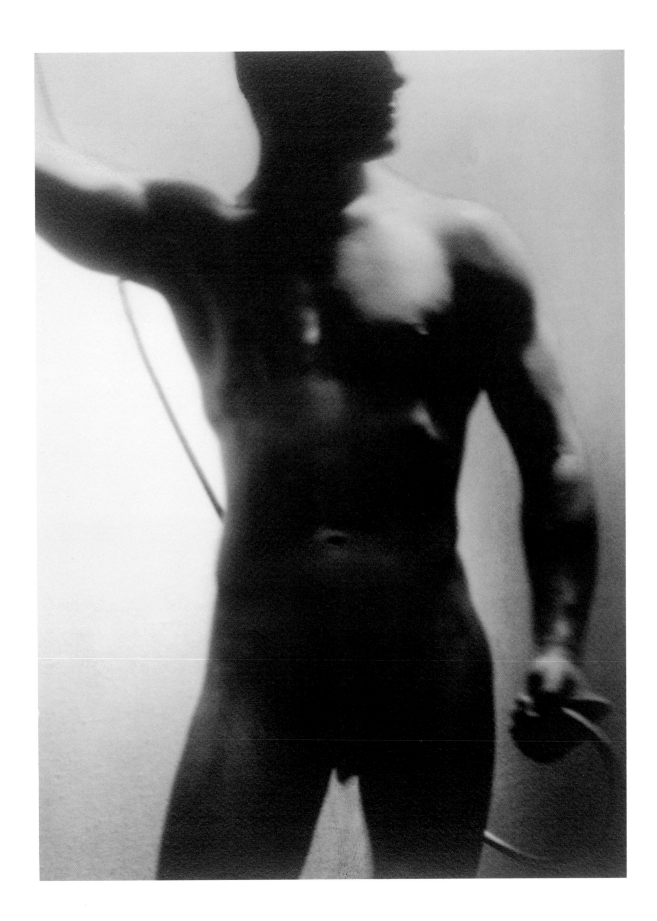

Plate 211

Peter Weller (German, 1868–1940)

Untitled (Male nude), c. 1930

Gelatin silver print

8¹¹⁄₁₆ x 6⁷⁄₁₆ inches (22.1 x 16.4 cm)

The Lynne and Harold Honickman Gift of the Julien Levy Collection, 2001-62-1172

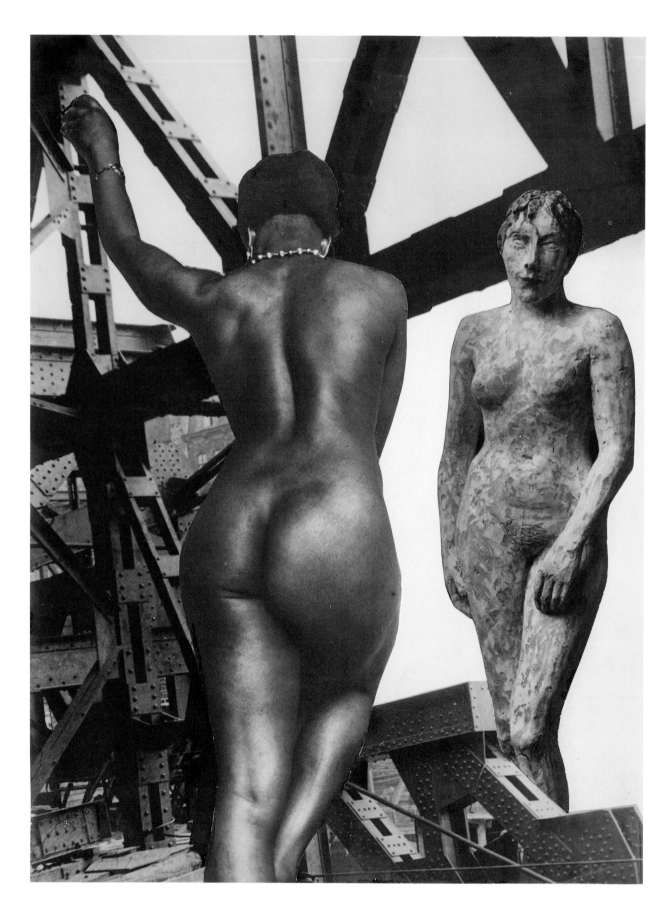

Plate 212

Ecce Photo (French, active early twentieth century)

Untitled (Nude figures and girders), c. 1930–32

Collage of gelatin silver prints

10¼ x 8⅛ inches (26 x 20.7 cm)

The Lynne and Harold Honickman Gift of the Julien Levy Collection, 2001-62-841

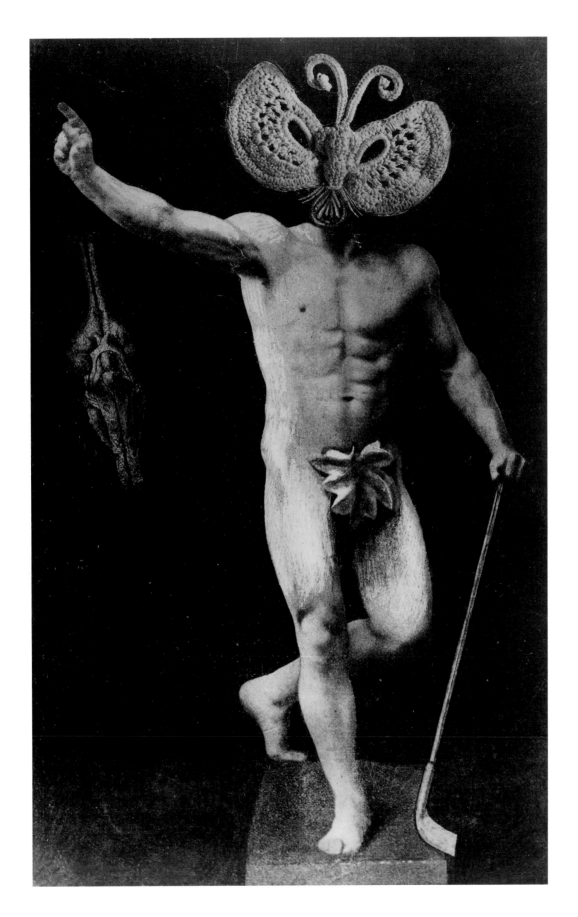

Plate 213

Max Ernst (American, born Germany, 1891–1976)

Health Through Sports (La Santé par le sport), c. 1929

Gelatin silver print

8⅞ x 5⅝ inches (22.5 x 14.3 cm)

The Lynne and Harold Honickman Gift of the Julien Levy Collection, 2001-62-500

Plate 214

László Moholy-Nagy (American, born Hungary, 1895–1946)

Untitled (Beach scene), c. 1925–32

Gelatin silver print

11⁷⁄₁₆ x 8⅛ inches (29 x 20.6 cm)

The Lynne and Harold Honickman Gift of the Julien Levy Collection, 2001-62-837

Plate 215
Oskar Nerlinger (German, 1893–1969)
Doll (Puppe), c. 1925–32
Gelatin silver print
8⁹⁄₁₆ x 6¹¹⁄₁₆ inches (21.7 x 17 cm)
The Lynne and Harold Honickman Gift of the Julien Levy Collection, 2001-62-975

Plate 216

Roger Parry (French, 1905–1977)

Untitled (Composition with feathers, rocks, shells, and burlap), c. 1932

Gelatin silver print

8⅞ x 6⁷⁄₁₆ inches (22.5 x 16.3 cm)

The Lynne and Harold Honickman Gift of the Julien Levy Collection, 2001-62-991

Plate 217

Ecce Photo (French, active early twentieth century)

Untitled (Figures, sculptures, and machine), c. 1930–31

Collage of gelatin silver prints

11¾ x 9⅜ inches (29.8 x 23.8 cm)

The Lynne and Harold Honickman Gift of the Julien Levy Collection, 2001-62-1280

Plate 218

Ilse Bing (American, born Germany, 1899–1998)

Untitled (Flowers in vase), c. 1930–31

Gelatin silver print

8¾ x 11¹⁄₁₆ inches (22.2 x 28.1 cm)

The Lynne and Harold Honickman Gift of the Julien Levy Collection, 2001-62-415

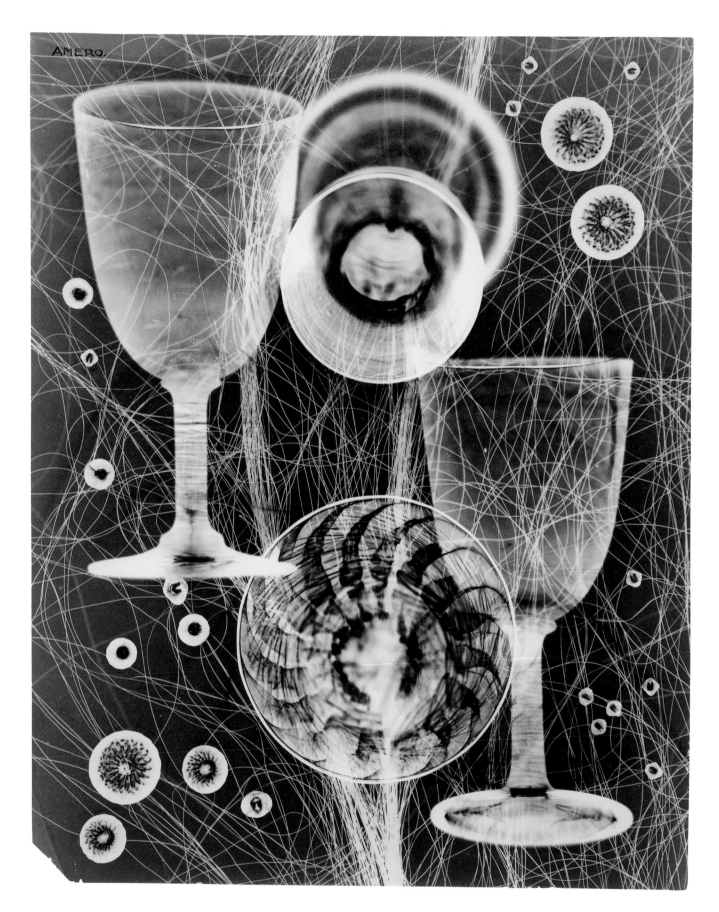

Plate 219

Emilio Amero (American, born Mexico, 1901–1976)

Untitled (Study with glasses and circles), c. 1932–34

Gelatin silver print

9⅝ x 7¹³⁄₁₆ inches (24.5 x 19.9 cm)

The Lynne and Harold Honickman Gift of the Julien Levy Collection, 2001-62-40

Plate 220

Man Ray (American, 1890–1976)

Untitled (Peony and glove), 1924

Gelatin silver print

11 x 8¼ inches (27.9 x 21 cm)

The Lynne and Harold Honickman Gift of the Julien Levy Collection, 2001-62-798

Plate 221
Francis Bruguière (American, 1879–1945)
Untitled (Cut-paper abstraction), 1927–29
Gelatin silver print
7½ x 9⁷⁄₁₆ inches (19.1 x 24 cm)
The Lynne and Harold Honickman Gift of the Julien Levy Collection, 2001-62-448

Plate 222

Francis Bruguière (American, 1879–1945)

Untitled (Cathedral montage), 1931

Gelatin silver print

13⅜ x 9⁵⁄₁₆ inches (34 x 23.7 cm)

The Lynne and Harold Honickman Gift of the Julien Levy Collection, 2001-62-447

Plate 223

Francis Bruguière (American, 1879–1945)

Untitled (Cathedral montage), 1931

Gelatin silver print

13⅜₆ x 9⅜₆ inches (33.8 x 23 cm)

The Lynne and Harold Honickman Gift of the Julien Levy Collection, 2001-62-446

Plate 224

Brassaï (French, born Hungary, 1899–1984)

Woman's Torso (Scissors) (Torse de femme [ciseau]), c. 1930–31

Gelatin silver print

6¹¹⁄₁₆ x 9¹⁄₁₆ inches (17 x 23 cm)

The Lynne and Harold Honickman Gift of the Julien Levy Collection, 2001-62-431

Plate 225

Maurice Tabard (French, 1897–1984)

Untitled (Lanvin advertisement), 1931

Gelatin silver print

8¾ x 6¼ inches (22.3 x 15.9 cm)

The Lynne and Harold Honickman Gift of the Julien Levy Collection, 2001-62-1148

Plate 226

André Kertész (American, born Hungary, 1894–1985)

Siamese Cat, Paris, 1928

Gelatin silver print

6⅜ x 6⅞ inches (16 x 17.5 cm)

The Lynne and Harold Honickman Gift of the Julien Levy Collection, 2001-62-596

Plate 227

Ilse Bing (American, born Germany, 1899–1998)

Untitled (Birds), c. 1930–31

Gelatin silver print

8¾ x 11⅛ inches (22.2 x 28.3 cm)

The Lynne and Harold Honickman Gift of the Julien Levy Collection, 2001-62-419

Plate 228

André Kertész (American, born Hungary, 1894–1985)

Carousel Horses in the Tuileries (Les Chevaux de bois des Tuileries), c. 1930

Gelatin silver print

6⅞ x 8⁷⁄₁₆ inches (17.4 x 21.5 cm)

The Lynne and Harold Honickman Gift of the Julien Levy Collection, 2001-62-595

Plate 229

Dora Maar (French, 1907–1997)

Léonor Fini, 1936

Gelatin silver print

11¾ x 9⅛ inches (29.9 x 23.2 cm)

The Lynne and Harold Honickman Gift of the Julien Levy Collection, 2001-62-764

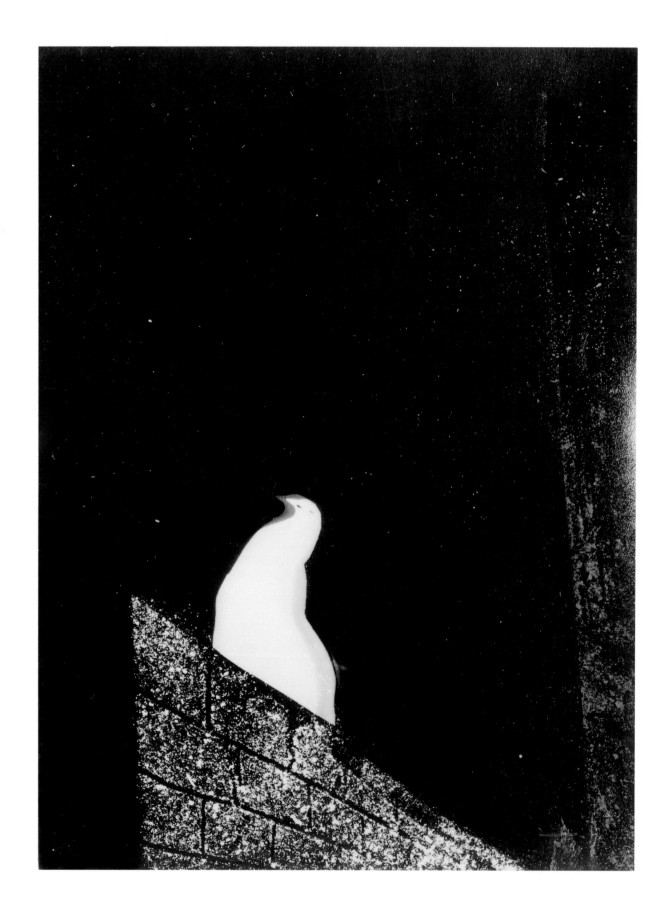

Plate 230
Roger Parry (French, 1905–1977)
Untitled (from *Banalité*), 1930
Gelatin silver print
8⅝ x 6½ inches (21.9 x 16.5 cm)
The Lynne and Harold Honickman Gift of the Julien Levy Collection, 2001-62-983

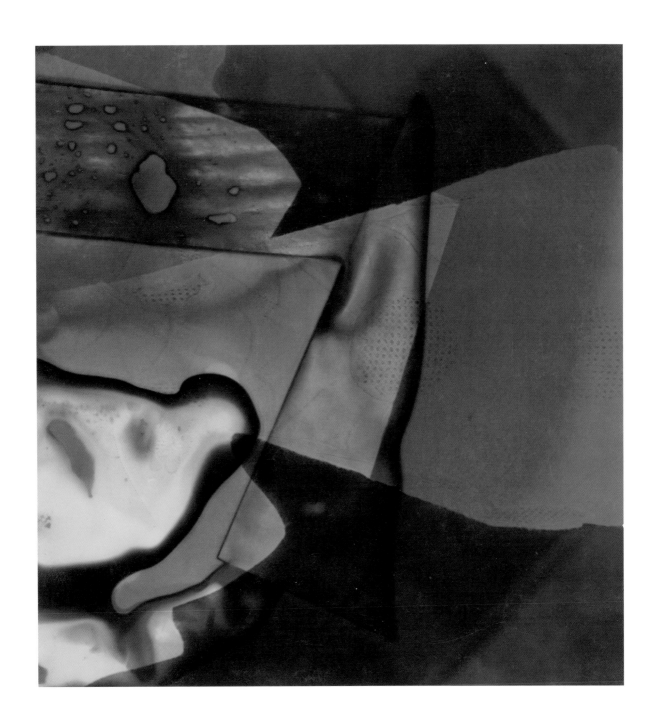

Plate 231
Roger Parry (French, 1905–1977)
Untitled (Abstraction), c. 1930
Gelatin silver print
6¹¹⁄₁₆ x 6⅜ inches (17 x 16.2 cm)
The Lynne and Harold Honickman Gift of the Julien Levy Collection, 2001-62-989

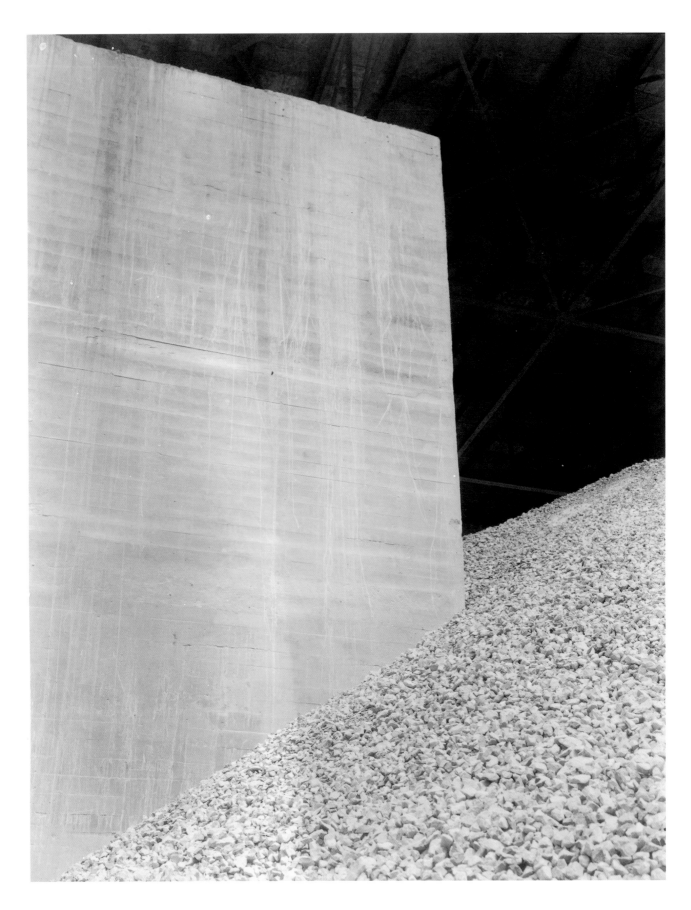

Plate 232
Manuel Álvarez Bravo (Mexican, 1902–2002)
The Toltec (La Tolteca), 1931
Gelatin silver print
9½ x 7⁷⁄₁₆ inches (24.1 x 18.9 cm)
The Lynne and Harold Honickman Gift of the Julien Levy Collection, 2001-62-30

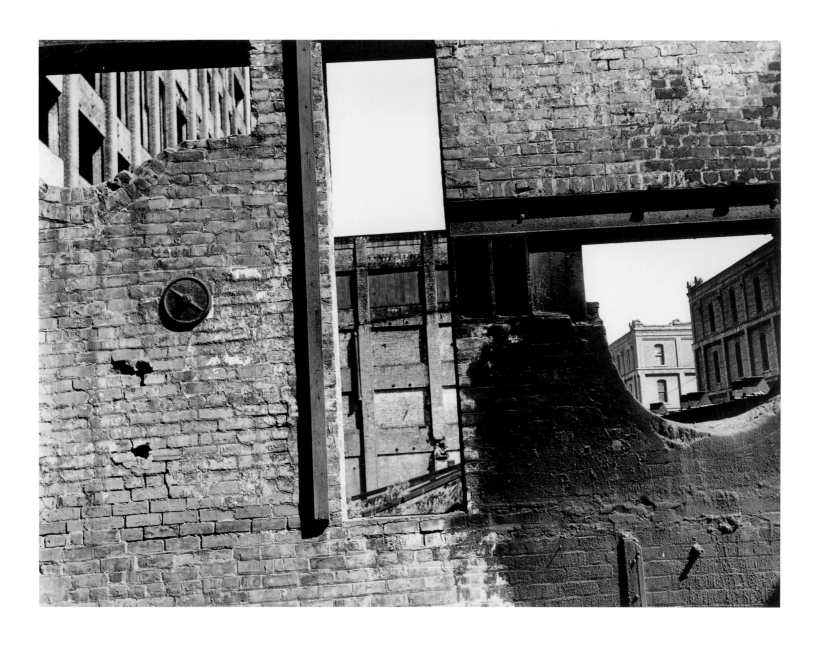

Plate 233

Clarence John Laughlin (American, 1905–1985)

Three Vistas Through One Wall, 1937

Gelatin silver print

10¼ x 13¾ inches (26 x 34.9 cm)

The Lynne and Harold Honickman Gift of the Julien Levy Collection, 2001-62-603

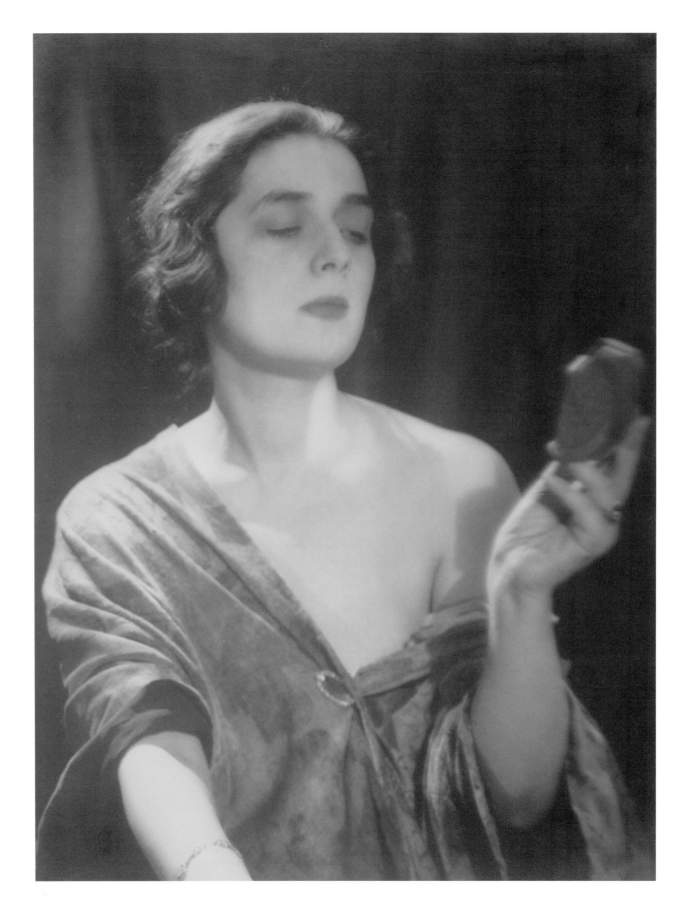

Plate 234

Man Ray (American, 1890–1976)

Princess Bibesco, c. 1924–30

Gelatin silver print

11⅛ x 8⅜ inches (28.3 x 21.3 cm)

The Lynne and Harold Honickman Gift of the Julien Levy Collection, 2001-62-796

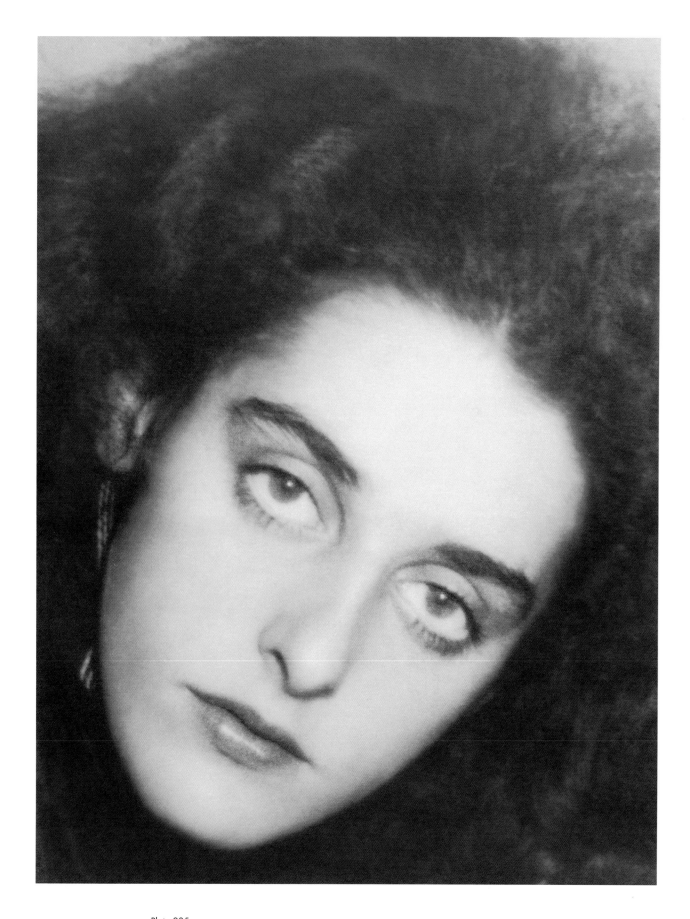

Plate 235

Lee Miller (American, 1907–1977)

Mrs. Donald Friede, c. 1930–32

Gelatin silver print

9⅛ x 6¹⁵⁄₁₆ inches (23.1 x 17.6 cm)

The Lynne and Harold Honickman Gift of the Julien Levy Collection, 2001-62-811

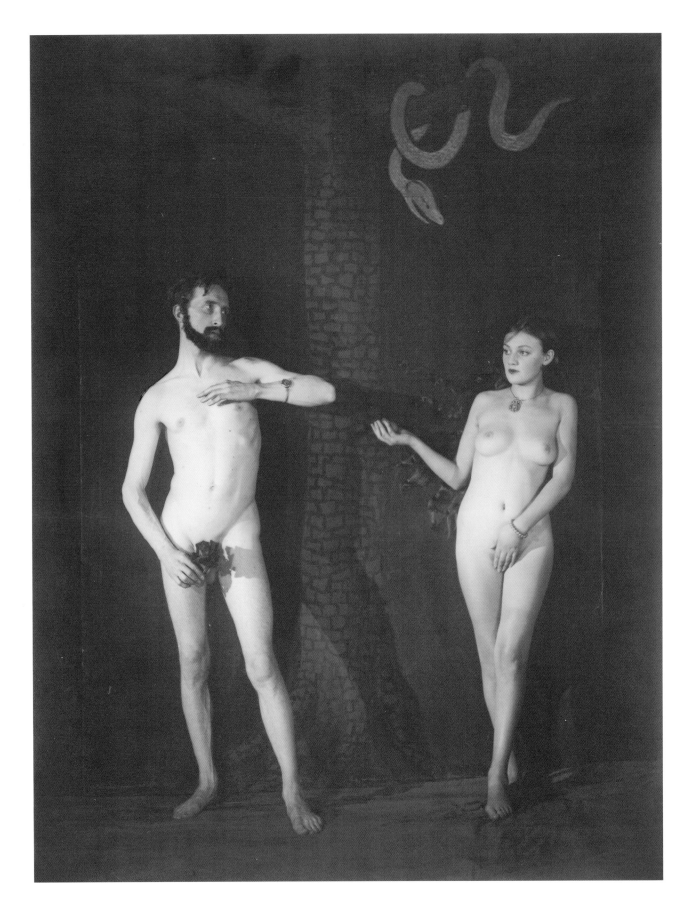

Plate 236

Man Ray (American, 1890–1976)

Ciné-Sketch: Adam and Eve (Marcel Duchamp and Bronia Perlmutter), 1924

Gelatin silver print

11⅛ x 8⁹⁄₁₆ inches (28.2 x 21.7 cm)

The Lynne and Harold Honickman Gift of the Julien Levy Collection, 2001-62-784

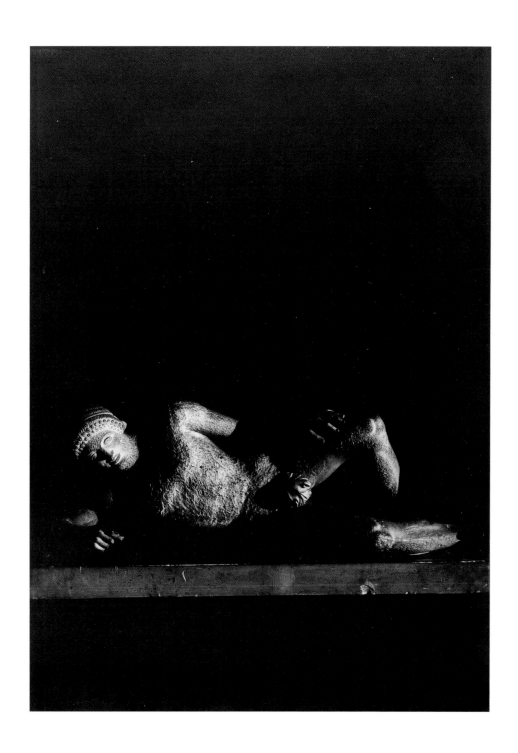

Plate 237

George Platt Lynes (American, 1907–1955)

Untitled (Sculpture), c. 1930–34

Gelatin silver print

6¹⁵⁄₁₆ x 5 inches (17.7 x 12.7 cm)

The Lynne and Harold Honickman Gift of the Julien Levy Collection, 2001-62-753

Plate 238
Manuel Álvarez Bravo (Mexican, 1902–2002)
Optic Parable (Parabola optica), 1931
Gelatin silver print
7½ x 8⅜ inches (19 x 21.3 cm)
The Lynne and Harold Honickman Gift of the Julien Levy Collection, 2001-62-35

Plate 239
Maurice Tabard (French, 1897–1984)
Untitled (Dentist's chair), c. 1930–32
Gelatin silver print
8¾ x 6½ inches (22.2 x 16.5 cm)
The Lynne and Harold Honickman Gift of the Julien Levy Collection, 2001-62-1152

Plate 240

Lee Miller (American, 1907–1977)

Untitled (Hand against sky), 1931

Gelatin silver print

9⁷⁄₁₆ x 8¹³⁄₁₆ inches (24 x 22.4 cm)

The Lynne and Harold Honickman Gift of the Julien Levy Collection, 2001-62-816

Plate 241

Manuel Álvarez Bravo (Mexican, 1902–2002)

Box of Visions (Caja de visiones), c. 1930

Gelatin silver print

7⅞₆ x 9¼ inches (18.9 x 23.5 cm)

The Lynne and Harold Honickman Gift of the Julien Levy Collection, 2001-62-33

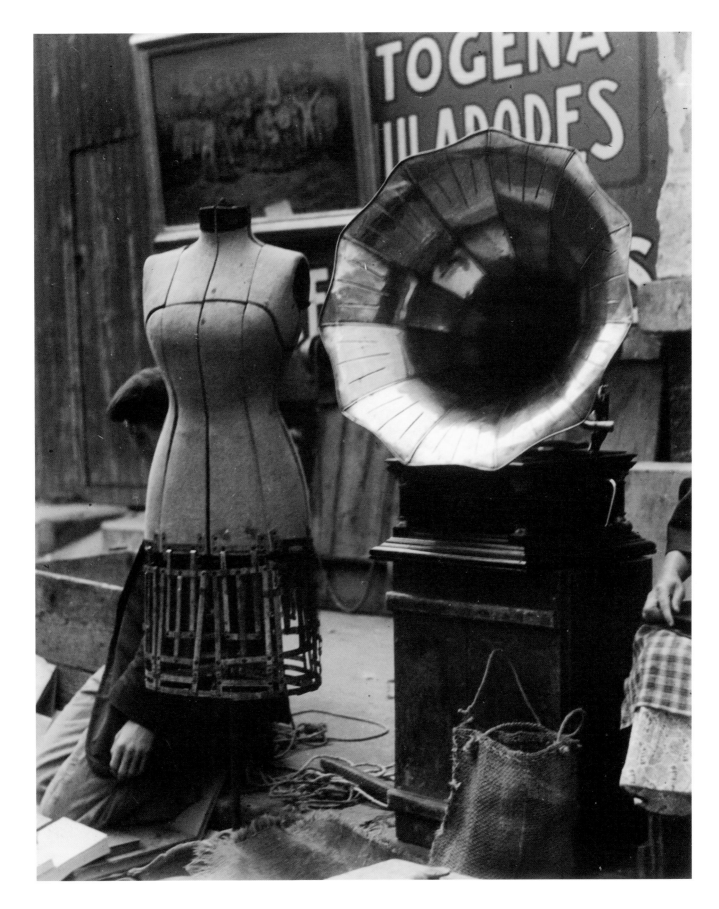

Plate 242

Manuel Álvarez Bravo (Mexican, 1902–2002)

Mannequin with Voice (Maniqui con voz), c. 1930–35

Gelatin silver print

9⁳⁄₁₆ x 7⅜ inches (23.3 x 18.7 cm)

The Lynne and Harold Honickman Gift of the Julien Levy Collection, 2001-62-34

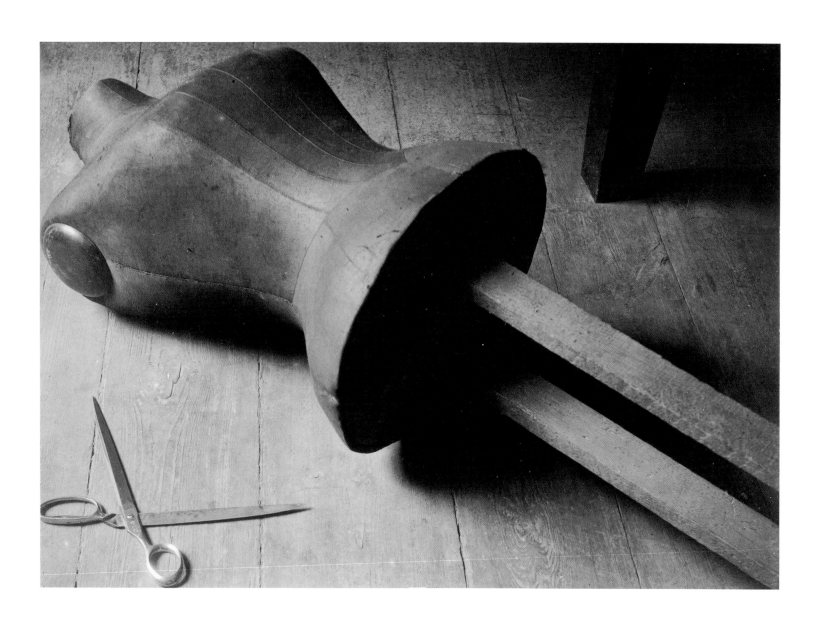

Plate 243
Alice Lex-Nerlinger (German, 1893–1975)
Tailor's Mannequin (Schneiderpuppe), c. 1930
Gelatin silver print
4¹³⁄₁₆ x 6¾ inches (12.2 x 17.1 cm)
The Lynne and Harold Honickman Gift of the Julien Levy Collection, 2001-62-668

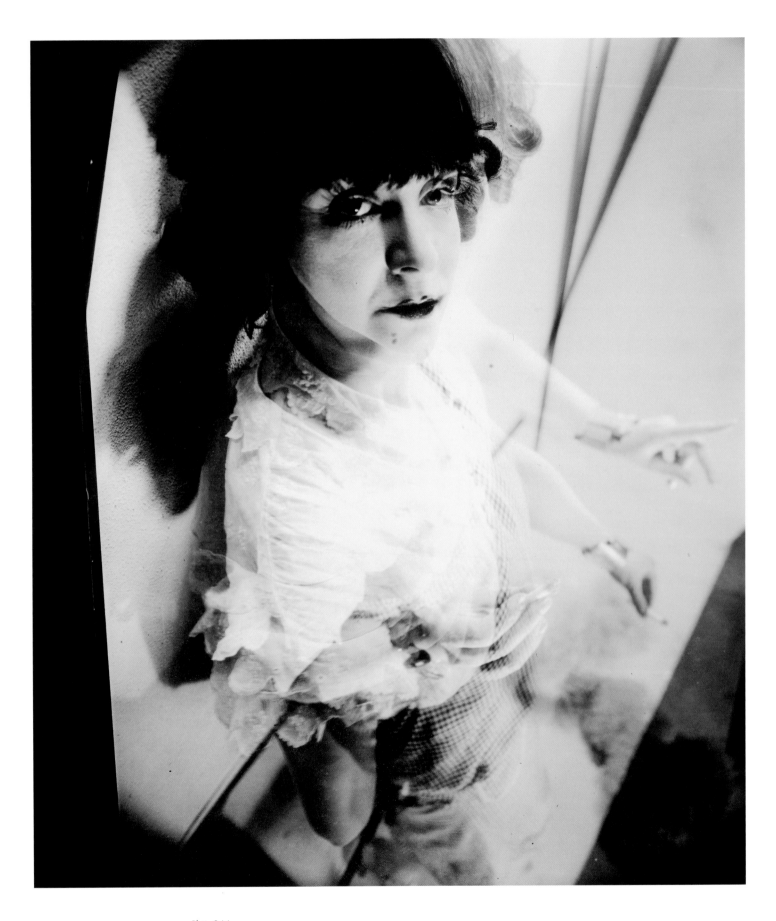

Plate 244

Roger Parry (French, 1905–1977)

Untitled (Double exposure of a woman), c. 1930

Gelatin silver print

7⅝ x 6⅝ inches (19.3 x 16.8 cm)

The Lynne and Harold Honickman Gift of the Julien Levy Collection, 2001-62-988

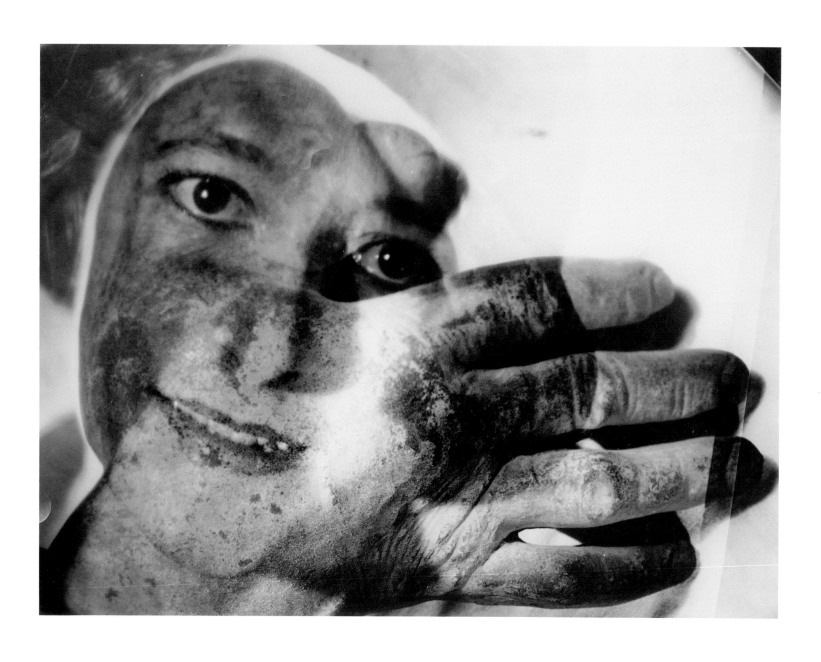

Plate 245
Roger Parry (French, 1905–1977)
Untitled (Montage with hand and face), c. 1930–31
Gelatin silver print
6¹⁵⁄₁₆ x 9³⁄₁₆ inches (17.6 x 23.6 cm)
The Lynne and Harold Honickman Gift of the Julien Levy Collection, 2001-62-990

Plate 246

Ecce Photo (French, active early twentieth century)

Untitled (Sculpture casts), c. 1930–31

Gelatin silver print

9⁹⁄₁₆ x 7 inches (23.7 x 17.8 cm)

The Lynne and Harold Honickman Gift of the Julien Levy Collection, 2001-62-840

Plate 247
George Platt Lynes (American, 1907–1955)
Untitled (Sculpture bust), c. 1930–34
Gelatin silver print
6¹⁵⁄₁₆ x 4¹⁵⁄₁₆ inches (17.7 x 12.6 cm)
The Lynne and Harold Honickman Gift of the Julien Levy Collection, 2001-62-752

Plate 248
Manuel Álvarez Bravo (Mexican, 1902–2002)
The Obstacles (Los obstáculos), 1929
Gelatin silver print
7½ x 8¹⁵⁄₁₆ inches (19.1 x 22.7 cm)
The Lynne and Harold Honickman Gift of the Julien Levy Collection, 2001-62-25

Plate 249
Manuel Álvarez Bravo (Mexican, 1902–2002)
Our Daily Bread (Pan nuestro), 1929
Gelatin silver print
7 1/16 x 9 3/8 inches (17.9 x 23.8 cm)
The Lynne and Harold Honickman Gift of the Julien Levy Collection, 2001-62-26

Plate 250
L. Ollivier (French, active late nineteenth–early twentieth century)
Untitled (Fallen horse), c. 1900
Gelatin silver print
8⁹⁄₁₆ x 11³⁄₁₆ inches (21.7 x 28.4 cm)
The Lynne and Harold Honickman Gift of the Julien Levy Collection, 2001-62-1607

Plate 251

Eli Lotar (French, 1905–1969)

Untitled (Head of a slaughtered calf), c. 1929

Gelatin silver print

8³⁄₁₆ x 6¼ inches (20.8 x 15.9 cm)

The Lynne and Harold Honickman Gift of the Julien Levy Collection, 2001-62-717

Plate 252
Lee Miller (American, 1907–1977)
Untitled (Tar), c. 1930–32
Gelatin silver print
8¹⁵⁄₁₆ x 10¼ inches (22.7 x 26.1 cm)
The Lynne and Harold Honickman Gift of the Julien Levy Collection, 2001-62-819

Plate 253
Henri Cartier-Bresson (French, 1908–2004)
Untitled (Viscera), c. 1933
Gelatin silver print
9¾ x 7¹³⁄₁₆ inches (24.7 x 19.9 cm)
The Lynne and Harold Honickman Gift of the Julien Levy Collection, 2001-62-464

Plate 254
Alice Lex-Nerlinger (German, 1893–1975)
Dead Chicken (Totes Hühnchen), c. 1930
Gelatin silver print
6¹⁄₁₆ x 7⁵⁄₁₆ inches (15.4 x 18.6 cm)
The Lynne and Harold Honickman Gift of the Julien Levy Collection, 2001-62-664

Plate 255

Imogen Cunningham (American, 1883–1976)

Growth, c. 1925–31

Gelatin silver print

10⅜ x 8¹⁵⁄₁₆ inches (26.4 x 22.7 cm)

The Lynne and Harold Honickman Gift of the Julien Levy Collection, 2001-62-485

Plate 256
Lee Miller (American, 1907–1977)
Untitled (Rocks and sand), 1931
Gelatin silver print
8¹¹⁄₁₆ x 11⁹⁄₁₆ inches (22.1 x 29.3 cm)
The Lynne and Harold Honickman Gift of the Julien Levy Collection, 2001-62-815

Plate 257
Lee Miller (American, 1907–1977)
Untitled (Stone), 1931
Gelatin silver print
8¹³⁄₁₆ x 11 inches (22.4 x 28 cm)
The Lynne and Harold Honickman Gift of the Julien Levy Collection, 2001-62-817

Plate 258

James Thrall Soby (American, 1906–1979)

Untitled (Rooftop composition), c. 1935–40

Gelatin silver print

7¾ x 7⁵⁄₁₆ inches (19.7 x 18.6 cm)

The Lynne and Harold Honickman Gift of the Julien Levy Collection, 2001-62-1112

Plate 259
Brett Weston (American, 1911–1993)
Untitled (Rock formation), 1929
Gelatin silver print
7¾ x 6⁷⁄₁₆ inches (19.7 x 16.3 cm)
The Lynne and Harold Honickman Gift of the Julien Levy Collection, 2001-62-1188

Plate 260

James Thrall Soby (American, 1906–1979)

Untitled (Leonid Berman, Italy), 1937

Gelatin silver print

7¹¹⁄₁₆ x 6⅜ inches (19.6 x 16.2 cm)

The Lynne and Harold Honickman Gift of the Julien Levy Collection, 2001-62-1107

Plate 261
Stella Simon (American, 1878–1973)
Untitled (Design for a photomural), 1932
Gelatin silver print
6¾ x 12¹¹⁄₁₆ inches (17.1 x 32.3 cm)
The Lynne and Harold Honickman Gift of the Julien Levy Collection, 2001-62-1091

Plate 262
Remie Lohse (American, 1893–1947)
Fan Dance, c. 1930–34
Gelatin silver print
5³⁄₁₆ x 7¹¹⁄₁₆ inches (13.2 x 19.5 cm)
The Lynne and Harold Honickman Gift of the Julien Levy Collection, 2001-62-706

Plate 263 (top)

Paul Nadar (French, 1856–1939)

Untitled (Woman with flowers in her hair), c. 1885–1900

Gelatin silver print

5¹¹⁄₁₆ x 4⅛ inches (14.5 x 10.5 cm)

The Lynne and Harold Honickman Gift of the Julien Levy Collection, 2001-62-973

Plate 264 (bottom)

Paul Nadar (French, 1856–1939)

Untitled (Reclining woman in costume), 1885–1905

Gelatin silver print

6⅝⁄₁₆ x 8¼ inches (16 x 21 cm)

The Lynne and Harold Honickman Gift of the Julien Levy Collection, 2001-62-950

Plate 265
Julien Levy (American, 1906–1981)
Frida Kahlo, c. 1938
Gelatin silver print
9⅞ x 6⅝ inches (25.1 x 16.8 cm)
The Lynne and Harold Honickman Gift of the Julien Levy Collection, 2001-62-645

Plate 266
Julien Levy (American, 1906–1981)
Frida Kahlo, c. 1938
Gelatin silver print
6½ x 4¼ inches (16.5 x 10.8 cm)
The Lynne and Harold Honickman Gift of the Julien Levy Collection, 2001-62-636

Plate 267 (top)

Julien Levy (American, 1906–1981)

Untitled (Dancer), c. 1935–40

Gelatin silver print

7¾ x 7⅜ inches (19.7 x 18.7 cm)

The Lynne and Harold Honickman Gift of the Julien Levy Collection, 2001-62-652

Plate 268 (bottom)

Julien Levy (American, 1906–1981)

Untitled (Dancer), c. 1935–40

Gelatin silver print

7¹⁵⁄₁₆ x 7½ inches (20.1 x 19 cm)

The Lynne and Harold Honickman Gift of the Julien Levy Collection, 2001-62-651

Plate 269
Julien Levy (American, 1906–1981)
Untitled (Adobe building), c. 1935–40
Gelatin silver print
7¹⁵⁄₁₆ x 7¹³⁄₁₆ inches (20.2 x 19.9 cm)
The Lynne and Harold Honickman Gift of the Julien Levy Collection, 2001-62-648

Plate 270
Thurman Rotan (American, 1903–1991)
Untitled (Meat), c. 1930–32
Gelatin silver print
9⅛ x 7⅜ inches (23.2 x 18.7 cm)
The Lynne and Harold Honickman Gift of the Julien Levy Collection, 2001-62-1051

Plate 271
Peter Weller (German, 1868–1940)
Untitled (Still life with fish), c. 1930
Gelatin silver print
6⁷⁄₁₆ x 8¾ inches (16.4 x 22.3 cm)
The Lynne and Harold Honickman Gift of the Julien Levy Collection, 2001-62-1171

Plate 272

Thurman Rotan (American, 1903–1991)

Untitled (Trees), c. 1932

Collage of gelatin silver prints

18¾ x 13¹¹⁄₁₆ inches (47.6 x 34.8 cm)

The Lynne and Harold Honickman Gift of the Julien Levy Collection, 2001-62-1031

Plate 273

William M. Rittase (American, 1887–1968)

The Spillway, c. 1930–32

Gelatin silver print

12¹³⁄₁₆ x 10½ inches (32.6 x 26.6 cm)

The Lynne and Harold Honickman Gift of the Julien Levy Collection, 2001-62-1023

Plate 274

Emmanuel Sougez (French, 1889–1972)

Untitled (Wheat), 1930

Gelatin silver print

15¹/₁₆ x 11⅛ inches (38.3 x 28.2 cm)

The Lynne and Harold Honickman Gift of the Julien Levy Collection, 2001-62-1116

Plate 275

Whiting-Salzman Studio (American, active early twentieth century)

Photograph design with matchbox, c. 1931

Gelatin silver print

6³⁄₁₆ x 8¹⁄₁₆ inches (15.7 x 20.5 cm)

The Lynne and Harold Honickman Gift of the Julien Levy Collection, 2001-62-1241

Plate 276

Arthur Gerlach (American, born 1898)

Still Life in Aluminum, c. 1930

Gelatin silver print

13⅞ x 9 inches (35.2 x 22.9 cm)

The Lynne and Harold Honickman Gift of the Julien Levy Collection, 2001-62-514

Plate 277
Arthur Gerlach (American, born 1898)
Still Life in Fruit, c. 1930
Gelatin silver print
14⅟₁₆ x 9⅛ inches (37 x 23.2 cm)
The Lynne and Harold Honickman Gift of the Julien Levy Collection, 2001-62-515

Plate 278

Attributed to **Whiting-Salzman Studio** (American, active early twentieth century)

Photograph design with pencil shavings, c. 1931

Gelatin silver print

4½ x 3⁹⁄₁₆ inches (11.4 x 9.1 cm)

The Lynne and Harold Honickman Gift of the Julien Levy Collection, 2001-62-1232

Plate 279 (top)

Berenice Abbott (American, 1898–1991)

Photograph design for a textile, 1931

Gelatin silver print

6⁵⁄₁₆ x 8⅞ inches (16.1 x 22.5 cm)

The Lynne and Harold Honickman Gift of the Julien Levy Collection, 2001-62-1234

Plate 280 (bottom)

Berenice Abbott (American, 1898–1991)

Photograph design for a wastebasket, 1931

Gelatin silver print

9½ x 7½ inches (24.1 x 19.1 cm)

The Lynne and Harold Honickman Gift of the Julien Levy Collection, 2001-62-1506

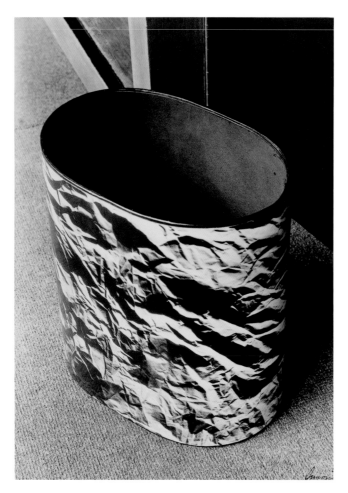

Plate 281 (top)

Stella Simon (American, 1878–1973)

Cigarette box made from a photograph design by Sherril Schell, 1931

Gelatin silver print

7⅜ x 9¹¹⁄₁₆ inches (18.7 x 24.6 cm)

The Lynne and Harold Honickman Gift of the Julien Levy Collection, 2001-62-1221

Plate 282 (bottom)

Stella Simon (American, 1878–1973)

Wastebasket made from a photograph design by Berenice Abbott, 1931

Gelatin silver print

9³⁄₁₆ x 6¹¹⁄₁₆ inches (23.3 x 17 cm)

The Lynne and Harold Honickman Gift of the Julien Levy Collection, 2001-62-1225

Plate 283

Stella Simon (American, 1878–1973)

Lampshade made from a photograph design by Berenice Abbott, 1931

Gelatin silver print

9½ x 7³⁄₁₆ inches (24.1 x 18.2 cm)

The Lynne and Harold Honickman Gift of the Julien Levy Collection, 2001-62-1209

Photography Exhibitions at the Julien Levy Gallery

This list reflects photography activities at the gallery that have been verified by exhibition announcements and gallery press releases available at the Julien Levy Archive, Connecticut, with some use of contemporaneously published articles and reviews.

1931

November 2–20[1]
American Photography Retrospective Exhibition
Anne Brigman, Frank Eugene, Paul Haviland, Gertrude Käsebier, Joseph T. Keiley, Charles Sheeler, Edward Steichen, Alfred Stieglitz, Paul Strand, Edward Weston, Clarence White, portraits and Civil War photographs by the Mathew Brady Studio, daguerreotype portraits and stereographs by unknown photographers

1931–32

December 12–January 9[2]
Photographs by Eugène Atget: Intérieurs, Statues, Voitures
and
Photographs by Nadar

1932

January 9–29
Surréalisme
Included photographs by Eugène Atget, Herbert Bayer, Jacques-André Boiffard, Max Ernst, George Lynes, Man Ray, László Moholy-Nagy, Roger Parry, Maurice Tabard, Umbo

February 1–19[3]
Walker Evans and George Lynes

February 20–March 11
Modern European Photography
Herbert Bayer, Ilse Bing, Brassaï [listed as Halesz], Ecce Photo, Walter Hege, Florence Henri, André Kertész, Helmar Lerski, Alice Lex-Nerlinger, Eli Lotar, Lee Miller, László Moholy-Nagy, Oskar Nerlinger, Roger Parry, Walter Peterhans, Man Ray, Emmanuel Sougez, Maurice Tabard, Umbo, Dr. Peter Weller

April 9–30[4]
Photographs by Man Ray

May 2–June 11
Photographs of New York by New York Photographers
Berenice Abbott, Kurt Baasch, Margaret Bourke-White, Maurice Bratter, Anton Bruehl, Walker Evans, Arthur Gerlach, Samuel Gottscho, [Herbert] Johnson, [Gene] Lester, George Lynes, [Ira] Martin, Wendell MacRae, Mortimer Offner, Thurman Rotan, Sherril Schell, Stella Simon, Ralph Steiner

September 26–October 15
Photographs by Berenice Abbott

October 15–November 5
Exhibition of Portrait Photography
Berenice Abbott, Antoine-Samuel Adam-Salomon, Bachrach, Mathew Brady, Anton Bruehl, Julia Margaret Cameron, Etienne Carjat, Frank Eugene, Arnold Genthe, David Octavius Hill [and Robert Adamson], George Hoyningen-Huene, Gertrude Käsebier, Helmar Lerski, Jay Leyda, George Lynes, Pirie MacDonald, Lee Miller, Nadar, Dorothy Norman, Man Ray, Reutlinger, Napoleon Sarony, Sherril Schell, Edward Steichen, Ralph Steiner, Alfred Stieglitz, Clarence White, and physionotrace engravings, daguerreotypes, and calotypes by unknown makers

1932–33

December 30–January 25
Lee Miller, Exhibition of Photographs

1933

January 26
The Carnival of Venice: Photographs by Max Ewing

January 28–February 18
Photographs of the American Scene by Luke Swank

February 24–March 18[5]
Kurt Baasch Photographs

September 25–October 16
Photographs by Henri Cartier-Bresson
and
Exhibition of Anti-Graphic Photography
Berenice Abbott, Walker Evans, Lee Miller, Creighton Peet, Man Ray, Dorothy Rolph, and what Levy called "'accidental' photographs, both old and new"[6]

1934

February 6–March 3[7]
Remie Lohse, Exhibition of Photographs

April 21–28
Wynn Richards, Exhibition of Photographs of Women Prominent in Fashion

October 1–13[8]
Fifty Photographs by George Platt Lynes

1935

January 5–31
Emilio Amero
Included photographs as well as work in other mediums

April 23–May 7
Documentary and Anti-Graphic Photographs by Cartier-Bresson, Walker Evans, and Álvarez Bravo

October 1–15[9]
Brett Weston Photographs

1936

May 14–29
Eugène Atget, An Epoch of Contrasts: Paris Chateaux, Chiffonneries, Petits Métiers

1937

October 6–November 1
Review Exhibition at Our New Address
Included photographs by Berenice Abbott, Eugène Atget, Henri Cartier-Bresson, Walker Evans, George Platt Lynes, Nadar, Man Ray

1939

May 16–30
Tri-State U.S.A., Photographs by Sheldon Dick

October 17–30
Full Color Abstract Photograms by Nicholas Ház

1940

November 12–December 7
Severity and Nostalgia in 1940: Abstract Sculpture by Theodore Roszak, Photographs by Clarence John Laughlin, Paintings by Enrico Prampolini
Included photographs by Eugène Atget and paintings by Herbert Bayer, Stuart Davis, and Max Ernst

December 10–26
Joseph Cornell, Exhibition of Objects: Daguerreotypes, Miniature Glass Bells, Soap Bubble Sets, Shadow Boxes, Homage to the Romantic Ballet
and
Exhibition of Photographs in Color and Portraits by David Hare

March [1943–47]

Photographs in Portfolio from the Julien Levy Collection, "through March"

1. November 2–21, 1931, according to the press release. The dates given in the exhibition announcements have been used throughout this list.

2. December 12, 1931–January 11, 1932, according to the press release.

3. January 30–February 19, 1932, according to the press release.

4. April 9–29, 1932, according to the press release.

5. February 24–March 25, 1933, according to the press release.

6. Julien Levy, press release for *Photographs by Henri Cartier-Bresson* and an *Exhibition of Anti-Graphic Photography.*

7. February 13–March 5, 1934, according to the press release.

8. October 1–15, 1934, according to the press release.

9. October 1–14, 1935, according to the press release.

Selected Bibliography

Abbott, Berenice, with text by Elizabeth McCausland. *Changing New York: Photographs by Berenice Abbott.* A publication of the Federal Art Project of the Works Progress Administration. New York: E. P. Dutton and Co., 1939.

Adams, Ansel, with Mary Street Alinder. *Ansel Adams: An Autobiography.* Boston: Little, Brown and Co., 1985.

Ades, Dawn. *Dada and Surrealism Reviewed.* Exh. cat. London: Arts Council of Great Britain, 1978.

Albrecht, Donald. *The Mythic City: Photographs of New York by Samuel H. Gottscho, 1925–1940.* Exh. cat. New York: Museum of the City of New York and Princeton Architectural Press, 2005.

Albright Art Gallery. *Modern Photography: At Home and Abroad.* Exh. cat. Buffalo, N.Y.: Albright Art Gallery, 1932.

Allen, Frederick Lewis. *Since Yesterday: The Nineteen-Thirties in America, September 3, 1929–September 3, 1939.* New York: Harper and Brothers, 1940.

Atget, Eugène, with a preface by Pierre Mac Orlan. *Atget, photographe de Paris.* New York: E. Weyhe, 1930.

Barberie, Peter. *Looking at Atget.* Philadelphia: Philadelphia Museum of Art, 2005.

Barr, Alfred H., Jr., ed. *Fantastic Art, Dada, Surrealism.* New York: Museum of Modern Art, 1936.

Barrett, Nancy C. *Ilse Bing: Three Decades of Photography.* New Orleans: New Orleans Museum of Art, 1985.

Beals, Carleton. *The Crime of Cuba.* Philadelphia: J. B. Lippincott Co., 1933.

Bois, Yve-Alain, and Rosalind E. Krauss. *Formless: A User's Guide.* Exh. cat. New York: Zone Books, 1997. Originally published as *L'Informe: Mode d'emploi* (Paris: Editions du Centre Pompidou, 1996).

Borhan, Pierre, et al. *André Kertész: His Life and Work.* Boston: Little, Brown and Co., 1994.

Borràs, Maria Lluïsa. *Arthur Cravan: Une Stratégie du scandale.* Edited by Arlette Albert-Birot. Paris: Editions Jean-Michel Place, 1996.

Bossen, Howard. *Luke Swank: Modernist Photographer.* Pittsburgh, Pa.: University of Pittsburgh Press, 2005.

Bouqueret, Christian, and Christophe Berthoud. *Roger Parry: Le Météore fabuleux.* Exh. cat. Paris: Marval in association with Mission du Patrimoine photographique, 1995.

Brancusi, Constantin. *Brancusi.* Exh. cat. New York: Brummer Gallery, 1926.

Breton, André, and Marcel Duchamp. *Surrealist Intrusion in the Enchanters' Domain.* Translated from the French by Julien Levy and Claud Tarnaud. New York: D'Arcy Galleries, 1960.

Brown, Milton W. *The Story of the Armory Show.* 2nd ed. New York: Abbeville Press, 1988.

Burke, Carolyn. *Becoming Modern: The Life of Mina Loy.* New York: Farrar, Straus and Giroux, 1996.

Buskirk, Martha, and Mignon Nixon, eds. *The Duchamp Effect.* Cambridge, Mass.: MIT Press, 1996.

Calvocoressi, Richard. *Lee Miller: Portraits from a Life*. New York: Thames and Hudson, 2002.

Caws, Mary Ann, ed. *Surrealism*. London: Phaidon Press, 2004.

Centre Georges Pompidou. *Atelier Man Ray: Berenice Abbott, Jacques-André Boiffard, Bill Brandt, Lee Miller, 1920–1935*. Exh. cat. Paris: Centre Georges Pompidou and Philippe Sers Editeur, 1982.

Chadwick, Whitney. *Women Artists and the Surrealist Movement*. 1st U.S. ed. Boston: Little, Brown and Co., 1985.

Clair, Jean. *Duchamp et la photographie: Essai d'analyse d'un primat technique sur le développement d'une oeuvre*. Paris: Chêne, 1977.

Coke, Van Deren. *Avant-Garde Photography in Germany, 1919–1939*. New York: Pantheon Books, 1982. Originally published as *Avantgarde-Photografie in Deutschland 1919–1939* (Munich: Schirmer/Mosel Verlag, 1982).

Coleby, Nicola, ed. *A Surreal Life: Edward James, 1907–1984*. Brighton and Hove: Royal Pavilion, Libraries and Museums in association with Philip Wilson Publishers, 1998.

Contemporary Arts Museum. *The Disquieting Muse, Surrealism: An Exhibition*. Exh. cat. Houston: Contemporary Arts Museum, 1958.

Copley, William. *CPLY, Reflection on a Past Life: An Exhibition of William Copley's Recent Mirror Pieces and Earlier Paintings and Drawings in Houston Collections*. Exh. cat. Houston: Institute for the Arts, Rice University, 1979.

Corn, Wanda M. *The Great American Thing: Modern Art and National Identity, 1915–1935*. Berkeley and Los Angeles: University of California Press, 1999.

Cravan, Arthur. *Œuvres: Poèmes, articles, lettres*. Edited by Jean-Pierre Begot. Paris: Editions Gérard Lebovici, 1987.

Crosby, Caresse. *The Passionate Years*. New York: Dial Press, 1953.

Dalí, Salvador. *The Secret Life of Salvador Dalí*. Translated by Haakon M. Chevalier. New York: Dial Press, 1942.

Davis, Keith F., with Nancy C. Barrett and John H. Lawrence. *Clarence John Laughlin: Visionary Photographer*. Kansas City, Mo.: Hallmark Cards, 1990.

De Salvo, Donna, with an essay by Mary Ann Caws. *Staging Surrealism: A Succession of Collections 2*. Exh. cat. Columbus: Wexner Center for the Arts, Ohio State University, 1997.

Dervaux, Isabelle, et al. *Surrealism USA*. Exh. cat. New York: National Academy Museum, 2005.

Desmarais, Charles. "Julien Levy: Surrealist Author, Dealer, and Collector." *Afterimage*, January 1977, pp. 4–7, 20.

Duve, Thierry de, ed. *The Definitively Unfinished Marcel Duchamp*. Halifax: Nova Scotia College of Art and Design; Cambridge, Mass.: MIT Press, 1991.

Enyeart, James. *Bruguière: His Photographs and His Life*. New York: Alfred A. Knopf, 1977.

Ernst, Jimmy. *A Not-So-Still Life: A Child of Europe's Pre–World War II Art World and His Remarkable Homecoming to America*. New York: St. Martin's Press/Marek, 1984.

Evans, Walker, with an essay by Jerry L. Thompson. *Walker Evans at Work: 745 Photographs Together with Documents Selected from Letters, Memoranda, Interviews, Notes*. New York: Harper and Row, 1982.

Federal Writers' Project, New York. *New York Panorama: A Comprehensive View of the Metropolis*. American Guide Series. New York: Federal Writer's Publications, 1938.

Fiedler, Jeannine, ed. *Photography at the Bauhaus.* Cambridge, Mass.: MIT Press, 1990. Originally published as *Fotografie am Bauhaus* (Berlin: Verlag Dirk Nishen, 1990).

Ford, Charles Henri, ed. *View: Parade of the Avant-Garde; an Anthology of View Magazine (1940–47).* New York: Thunder's Mouth Books, 1991.

Foresta, Merry, et al. *Perpetual Motif: The Art of Man Ray.* Exh. cat. Washington, D.C.: National Museum of American Art, Smithsonian Institution; New York: Abbeville Press, 1988.

Foster, Hal. *Compulsive Beauty.* Cambridge, Mass.: MIT Press, 1993.

Frank, Waldo, et al., eds. *America and Alfred Stieglitz: A Collective Portrait.* New York: Doubleday, Doran and Co., 1934.

Gaddis, Eugene R. *Magician of the Modern: Chick Austin and the Transformation of the Arts in America.* New York: Alfred A. Knopf, 2000.

Galassi, Peter. *Henri Cartier-Bresson: The Early Work.* Exh. cat. New York: Museum of Modern Art, 1987.

Gray, Andrea. *Ansel Adams: An American Place, 1936.* Exh. cat. Tucson: Center for Creative Photography, University of Arizona, 1982.

Griswold, William. *Pierre Matisse and His Artists.* Exh. cat. New York: Pierpont Morgan Library, 2002.

Hall, W. S. "Angusta ad Augusta." *The Saturday Review of Literature,* June 2, 1934, p. 736.

Hambourg, Maria Morris, and Christopher Phillips. *The New Vision: Photography Between the World Wars; Ford Motor Company Collection at the Metropolitan Museum of Art, New York.* Exh. cat. New York: Metropolitan Museum of Art, 1989.

Hambourg, Maria Morris, et al. *Walker Evans.* Exh. cat. New York: Metropolitan Museum of Art in association with Princeton University Press, 2000.

Hambourg, Maria Morris, Françoise Heilbrun, and Philippe Néagu. *Nadar.* Exh. cat. New York: Metropolitan Museum of Art, 1995.

Harnoncourt, Anne d', and Kynaston McShine, eds. *Marcel Duchamp.* New York: Museum of Modern Art; Philadelphia: Philadelphia Museum of Art, 1973.

Hauptman, Jodi. *Joseph Cornell: Stargazing in the Cinema.* New Haven, Conn.: Yale University Press, 1999.

Herrera, Hayden. *Frida: A Biography of Frida Kahlo.* New York: Harper and Row, 1983.

Homer, William Innes. *Alfred Stieglitz and the American Avant-Garde.* Boston: New York Graphic Society, 1977.

Joselit, David. *Infinite Regress: Marcel Duchamp, 1910–1941.* Cambridge, Mass.: MIT Press, 1998.

Josephson, Matthew. *Life Among the Surrealists: A Memoir.* New York: Holt, Rinehart and Winston, 1962.

Kammen, Michael. *The Lively Arts: Gilbert Seldes and the Transformation of Cultural Criticism in the United States.* New York and Oxford: Oxford University Press, 1996.

Keller, Judith. *Walker Evans: The Getty Museum Collection.* Malibu, Calif.: J. Paul Getty Museum, 1995.

Kellner, Bruce, ed. *Letters of Carl Van Vechten.* New Haven, Conn.: Yale University Press, 1987.

Kismaric, Susan. *Manuel Álvarez Bravo.* Exh. cat. New York: Museum of Modern Art, 1997.

Krauss, Rosalind, and Jane Livingston. *L'Amour fou: Photography and Surrealism.* Exh. cat. Washington, D.C.: Corcoran Gallery of Art; New York: Abbeville Press, 1985.

Krauss, Rosalind E. *The Originality of the Avant-Garde and Other Modernist Myths.* Cambridge, Mass.: MIT Press, 1985.

Kuenzli, Rudolf E., ed. *Dada and Surrealist Film.* Cambridge, Mass.: MIT Press, 1996.

Lavin, Maud, et al. *Montage and Modern Life, 1919–1942.* Exh. cat. Boston: Institute of Contemporary Art; Cambridge, Mass.: MIT Press, 1992.

Laxton, Susan. *Paris as Gameboard: Man Ray's Atgets.* New York: Miriam and Ira D. Wallach Art Gallery, Columbia University, 2002.

Leddick, David. *George Platt Lynes, 1907–1955.* Cologne: Taschen, 2000.

Levy, Julien. *Arshile Gorky.* New York: Harry N. Abrams, 1966.

——. *Eugene Berman.* New York: American Studio Books, 1947.

——. *Max Ernst, Arshile Gorky, from the Collection of Julien Levy.* Exh. cat. New Haven, Conn.: Yale University Art Gallery, 1964.

——. *Memoir of an Art Gallery.* New York: G. P. Putnam's Sons, 1977. Reprinted with an introduction by Ingrid Schnaffner, Boston: MFA Publications, 2003.

——. *Surrealism.* New York: Black Sun Press, 1936. Reprint, New York: Arno Press, 1968, and with a new introduction by Mark Polizzoti, New York: Da Capo Press, 1995.

List, Larry, ed. *The Imagery of Chess Revisited.* Exh. cat. New York: Isamu Noguchi Foundation and Garden Museum and George Braziller, 2005.

Livingston, Jane. *Lee Miller, Photographer.* Exh. cat. Washington, D.C.: Corcoran Gallery of Art; New York: Thames and Hudson, 1989.

Lynes, Russell. *Good Old Modern: An Intimate Portrait of the Museum of Modern Art.* New York: Atheneum, 1973.

Marquis, Alice Goldfarb. *Alfred H. Barr, Jr.: Missionary for the Modern.* Chicago: Contemporary Books, 1989.

May, Antoinette. *Passionate Pilgrim: The Extraordinary Life of Alma Reed.* New York: Paragon House, 1993.

McAndrew, John, ed. *Guide to Modern Architecture, Northeast States.* New York: Museum of Modern Art, 1940.

——, et al. *What Is Modern Architecture?* Introductory Series to the Modern Arts, no. 1. New York: Museum of Modern Art, 1942.

Menil Collection and Philadelphia Museum of Art. *Joseph Cornell / Marcel Duchamp—in Resonance.* Exh. cat. Houston: Menil Collection; Philadelphia: Philadelphia Museum of Art, 1998.

Moholy-Nagy, László. *Painting, Photography, Film.* Translated by Janet Seligman. 1st English ed. London: Lund Humphries, 1969. Originally published as *Malerei, Fotografie, Film,* Bauhausbucher, no. 8 (1925).

Mundy, Jennifer, ed. *Surrealism: Desire Unbound.* Exh. cat. London: Tate Publishing, 2001.

Musée nationale d'art moderne. *Eli Lotar.* Exh. cat. Paris: Musée nationale d'art moderne, Centre Georges Pompidou, 1993.

Museo Nacional Centro de Arte Reina Sofía, Madrid, and Musée d'art moderne et contemporain de Strasbourg. *Surrealistas en el exilio y los inicios de la escuela de Nueva York.* Exh. cat. Madrid: Ministerio de Educación y Cultura, 1999.

Museum of Modern Art. *Murals by American Painters and Photographers.* Exh. cat. New York: Museum of Modern Art, 1932.

———. *Painting and Sculpture by Living Americans: Ninth Loan Exhibition, December 2, 1930, to January 20, 1931.* Exh. cat. New York: Museum of Modern Art, 1930.

———, with an essay by Lincoln Kirstein. *Walker Evans: American Photographs.* Exh. cat. New York: Museum of Modern Art, 1938.

———, with an introduction by Beaumont Newhall. *Photography, 1839–1937.* New York: Museum of Modern Art, 1937.

Nesbit, Molly. *Their Common Sense.* London: Black Dog Publishing, 2000.

Newhall, Beaumont. *Focus: Memoirs of a Life in Photography.* Boston: Little, Brown and Co., 1993.

Newhall, Beaumont, and Leland Rice. *Herbert Bayer: Photographic Works.* Los Angeles: Arco Center for Visual Art, 1977.

Parker, Judith. "'Art to me is almost a religion': A Talk with Julien Levy." *Harvard Magazine,* vol. 82, no. 1 (September–October 1979), pp. 38–44.

Pauli, Lori. "Stella F. Simon, 1878–1973." *History of Photography,* vol. 24, no. 1 (Spring 2000), pp. 75–83.

Penrose, Antony. *Roland Penrose, The Friendly Surrealist: A Memoir.* Munich and New York: Prestel, 2001.

Phillips, Christopher, ed. *Photography in the Modern Era: European Documents and Critical Writings, 1913–1940.* Exh. cat. New York: Metropolitan Museum of Art and Aperture, 1989.

Poniatowska, Elena. *Frida Kahlo: The Camera Seduced.* London: Chatto and Windus, 1992.

Rogers, Agnes, and Frederick Lewis Allen. *Metropolis: An American City in Photographs.* New York: Harper and Brothers, 1934.

Roh, Franz, and Jan Tschichold, eds. *Photo-Eye: 76 Photos of the Period.* New York: Arno Press, 1973. Originally published as *Foto-Auge: 76 Fotos der Zeit* (Stuttgart: F. Wedekind, 1929).

Rosemont, Penelope, ed. *Surrealist Women: An International Anthology.* Austin: University of Texas Press, 1998.

Rosenheim, Jeff L., and Douglas Eklund. *Unclassified: A Walker Evans Anthology; Selections from the Walker Evans Archive.* Zurich: Scalo in association with the Metropolitan Museum of Art, 2000.

Rubin, William S. *Dada and Surrealist Art.* New York: Harry N. Abrams, 1968.

Schaffner, Ingrid. *Salvador Dalí's Dream of Venus: The Surrealist Funhouse from the 1939 World's Fair.* New York: Princeton Architectural Press, 2002.

Schaffner, Ingrid, and Colin Westerbeck. *Accommodations of Desire: Surrealist Works on Paper Collected by Julien Levy.* Pasadena, Calif.: Curatorial Assistance, 2004.

Schaffner, Ingrid, and Lisa Jacobs, eds. *Julien Levy: Portrait of an Art Gallery.* Cambridge, Mass.: MIT Press, 1998.

Seldes, Gilbert. *The Seven Lively Arts.* New York: Harper and Brothers, 1924.

———, ed. *This Is New York: The First Modern Photographic Book of New York.* New York: David Kemp, 1934.

Sire, Agnès, et al. *Documentary and Anti-Graphic: Photographs by Cartier-Bresson, Walker Evans, and Álvarez Bravo.* Exh. cat. Göttingen: Steidl, 2004.

Solomon, Deborah. *Utopia Parkway: The Life and Work of Joseph Cornell.* New York: Farrar, Straus and Giroux, 1997.

Le Surréalisme au service de la révolution: Numbers 1–6 (1930–1933). Arno Series of Contemporary Art, no. 4. New York: Arno Press, 1968.

Szarkowski, John, and Maria Morris Hambourg. *The Work of Atget.* 4 vols. New York: Museum of Modern Art, 1981–85.

Tanning, Dorothea. *Birthday.* Santa Monica, Calif.: Lapis Press, 1986.

Tashjian, Dickran. *A Boatload of Madmen: Surrealism and the American Avant-Garde, 1920–1950.* New York: Thames and Hudson, 1995.

Tejada, Roberto. "Documentary and Anti-Graphic: Three at the Julien Levy Gallery, 1935." *Afterimage,* vol. 30, nos. 3–4 (Winter 2003), pp. 15–16.

Tomkins, Calvin. *Duchamp: A Biography.* New York: Henry Holt and Co., 1996.

Travis, David. *Photographs from the Julien Levy Collection, Starting with Atget: The Art Institute of Chicago.* Exh. cat. Chicago: Art Institute of Chicago, 1976.

Ware, Katherine. *In Focus: László Moholy-Nagy; Photographs from the J. Paul Getty Museum.* Malibu, Calif.: J. Paul Getty Museum, 1995.

———. *In Focus: Man Ray; Photographs from the J. Paul Getty Museum.* Los Angeles: J. Paul Getty Museum, 1998.

Watson, Steven. *Prepare for Saints: Gertrude Stein, Virgil Thomson, and the Mainstreaming of American Modernism.* New York: Random House, 1998.

Weber, Nicholas Fox. *Patron Saints: Five Rebels Who Opened America to a New Art, 1928–1943.* New York: Alfred A. Knopf, 1992.

Weston, Brett, with an afterword by Beaumont Newhall. *Brett Weston: Voyage of the Eye.* Millerton, N.Y.: Aperture, 1975.

Williams, Jonathan, with Lafcadio Hearn and Clarence John Laughlin. *Clarence John Laughlin: The Personal Eye.* Exh. cat. Millerton, N.Y.: Aperture in association with the Philadelphia Museum of Art, 1973.

Acknowledgments

Any project of this magnitude requires the help of many individuals and institutions. In particular, we owe a great debt to Jean Farley Levy and the Julien Levy Archive. We are truly grateful to Mrs. Levy for giving her husband's photographs a home in Philadelphia. For their work toward the service of that goal we are also immensely indebted to Miles Borzilieri, Marie Difilippantonio, Eric Strom, and Beth Gates Warren. Without the vision of Lynne and Harold Honickman, whose passionate commitment to photography has aided this Museum in innumerable ways over the years, this acquisition would not have been possible. At the Museum, we thank Anne d'Harnoncourt, Alice Beamesderfer, and Innis Shoemaker for their unhesitating efforts to secure the photographs for the collection.

We join Anne d'Harnoncourt and Innis Shoemaker in acknowledging the great support given to both this book and the exhibition by The Horace W. Goldsmith Foundation and by Furthermore: a program of the J. M. Kaplan Fund; we also appreciate the additional support from an endowment for scholarly publications established at the Philadelphia Museum of Art by The Andrew W. Mellon Foundation and matched by generous donors.

Our unofficial and utterly indefatigable assistant on this project was Marie Difilippantonio, Mrs. Levy's assistant and friend, who oversees the Julien Levy Archive in Connecticut. Ever generous with her time and knowledge, Marie was able to unlock many mysteries for us and was a vital and engaged participant in our journey to uncover the photographic activities at the Julien Levy Gallery.

For loans to the exhibition, we are grateful to the Julien Levy Foundation in Connecticut and, here at the Museum, to C. Danial Elliott and Michael Taylor.

Our friends in the Photography Department at The Art Institute of Chicago, including Kate Bussard and Newell G. Smith, were generous with their assistance. We humbly and gratefully acknowledge David Travis for his groundbreaking original research on Levy, and for his collegiality during our research with Chicago's collection of Levy's photographs. At the Fogg Art Museum at Harvard University, Michelle Lamunière, Abigail G. Smith, and Mazie Harris were particularly helpful in providing information about Julien Levy and his collection of photographs. Many thanks to Eugene R. Gaddis at the Wadsworth Atheneum for his extensive research on the period and for assistance in identifying images, and to his colleague Rena Hoisington, who was helpful in clarifying many details.

Others who generously shared information or memories include Josephine Albarelli, Stuart Alexander, Jonathan Bayer, Simon Bieling, Howard Bossen, Susan Ehrens, T. Lux Feininger, Karen Haas, Emily Hage, Michael Hargraves, Lynda Roscoe Hartigan, Anne Havinga, Mark Haworth-Booth, Frank Kolodny, Dierdre Lawrence, Judith Young-Mallin, Steven Manford, Hattula Moholy-Nagy, Anne Morra, William Nabers, Antony Penrose, Charmaine Picard, Jeff Rosenheim, Ingrid Schaffner, Joel Smith, Jenna Webster, Gillian White, and Ariel Zuñiga.

Among our colleagues at the Museum, we especially thank the members of the Department of Prints, Drawings, and Photographs, particularly Innis Shoemaker, John Ittmann, Christa Carroll, Jill DeWitt, Peter Fox, Stacy Kirk, and Jane Landis.

Our warmest thanks go to Sherry Babbitt and her staff in the Museum's Publishing Department. Special recognition goes to our dedicated editor Kathleen Krattenmaker, whose tremendous

facility with the written word, familiarity with early twentieth-century art, and persistence in tracking down details helped to bring this volume to its present realization. Also integral to the success of this project were Rich Bonk, whose skill with image reproduction greatly contributed to this volume, and Jennifer L. Vanim, who helped to track down many loose threads. Book designer Katy Homans did a marvelous job of integrating images with text and was, to our surprise, no stranger to Julien Levy's photographs; in 1977 she designed the Witkin Gallery's catalogue of Levy's pictures.

Great appreciation is extended the Museum's paper conservators Nancy Ash and Scott Homolka; our colleagues in the library, especially archivist Susan Anderson and reference librarian Lilah Mittelstaedt; and the staff of the photography studio, including Andrea Simon, Amelia Walchli, and Graydon Wood and the very patient Jason Wierzbicki. Assistant registrar Nancy Baxter painstakingly numbered each of the 2,500-plus photographs in the collection to facilitate their identification. In the Development Department, thanks go to Betty Marmon and her staff, along with Linda Jacobs.

Finally, we would like to acknowledge two very dear colleagues who died last year. Dean Walker, the Henry P. McIlhenny Senior Curator of European Decorative Arts and Sculpture, and Faith Zieske, Conservator of Works of Art on Paper, were both contributors to this project and supporters of photography at the Philadelphia Museum of Art. We miss their energetic engagement with photographs and the pleasure of their friendship.

Index

Illustrations are indicated by page references in italics. To distinguish them from artworks, titles of publications are annotated with the date of publication.

Abbott, Berenice, 9, 10, 21, 23, 36, 45, 63, 65, 73–75, 76, 79, 81, 82, 86, 97, 111n29, 117n228, 149, 163, 167, *167*, 170n41, 320, 321, 322
 Atget, photographe de Paris (1930), 23, 47, 111n30
 Changing New York (1939), 74, 75, 167
 Eugène Atget, 21, *40*, 112n32
 Fabienne Lloyd, 76, *78*, 146
 James Joyce, 17, 76, 112n32
 Julien Levy, 8
 Lampshade made from a photograph design by, 153, *154*, *319*
 Photograph design for a textile, 65, 153, *317*
 Photograph design for a wastebasket, 65, 153, *317*
 portrait of André Gide, 112n32
 portrait of Jean Cocteau, 112n32
 portrait of Princess Eugène Murat, 112n32
 portrait of Sophie Victor, 112n32
 prints of Atget's negatives by, *21*, *39*, 111–12nn29, 30, 149, *152* (two images), 153
 Rockefeller Center, 68, *69*, 75
 Untitled (New York City) (two images), 68, 73, *74*, *202*
 Wastebasket made from a photograph design by, 65, *318*
Abbott, Jere, 27
Abstract-Expressionism, 103
Adams, Ansel, 31, 93, 94, 98, 113n70, 119n297, 120n315, 149
Adam-Salomon, Antoine-Samuel, 76, 321
 Untitled (Reclining figure in costume), 76, 142, *173*
Adamson, Robert, 113n93, 118n234, 137, 169n29, 321
African sculpture, 30
Agha, Mehemed F., 27, 90, 93, 119n285
Albrecht, Donald, 11
Albright Art Gallery (later Albright-Knox Art Gallery), Buffalo, 9, 76, 116n188
Allégret, Marc, 111n14
Allen, Frederick Lewis, *Metropolis: An American City in Photographs* (1934), 75
Allen, Gracie, 98, *99*
Álvarez-Bravo, Lola, 45, *281*
Álvarez Bravo, Manuel, 10, 44–45, 88, 90, 92, 115n128, 123, 136, 153, 322
 Box of Visions, 45, 90, *281*
 Laughing Mannequins, 130, 225
 Mannequin with Voice, 45, *282*
 Obstacles, The, 116n157, *288*
 Optic Parable, 44–45, 90, *278*
 Our Daily Bread, *289*

Tehuantepec (film), 44
Toltec, The, *272*
Untitled (Man against wall), 90, *90*
Untitled (Mannequin with fur stole and reflections), 45, *45*, 90
Untitled (Window with a ship model), 90, *225*
American Institute of Architects, 82, 118n254
American Museum of Natural History, New York, 101
American Photographs (1938), 48
Amero, Emilio, 91–92, 119nn284, 286, 287, 321
 Caracoles, 119n287
 Fantasía, 119n287
 S Cloud Photogram / Eyes in the Sky, frontispiece, 93
 777 (film, with Gilberto Owen), 92
 Untitled (Study with glasses and circles), 93, 119n287, *290*, *259*
 Untitled (Study with stemware), 119n287
 Untitled (Two women), 92
An American Place (gallery), New York, 9, 31, 33, 93, 112n52, 113n70, 126
Anderson, Sherwood, 83
Antheil, Georges, 46, 115n135
applied photography, 10, 65, 149, 153, 170n41, *313*, *316–19*
Architectural Digest (periodical), 109
Architectural Review (periodical), 47
Arensberg, Louise and Walter, 102
Argent Gallery, New York, 116n189
Armitage, Merle, 95
Armory Show (*International Exhibition of Modern Art*), New York (1913), 15, 111n13, 128
Art Center, New York, 9, 68, 75, 153
Art Digest (periodical), 24–25
Art Institute of Chicago, 10, 67, 108, 109, 111n29
Art News (periodical), 42, 66, 76, 83, 96
Art of This Century (gallery), New York, 101, 121n334
Art Vivant, L' (periodical), 54, 112n33
Arts et métiers graphiques (periodical), 123, 153
Askew, Constance, 29, *242*
Askew, Kirk, 28, 29, 40, 102, 120n330
Atget, Eugène, 10, 19–24, 38, *40*, 45, 73, 91, 93, 112n33, 116n157, 118n256, 120n321, 320
 Atget's Workroom, 21–22, *21*
 Boulevard de la Villette, *219*
 Grocery-Bar, Boulevard Masséna, 23, *23*, 112n36
 Hearse (lst Class), *178*
 Impasse Chartière, 24, 83, *85*
 Shop, Les Halles, *20*, 21
 Saint-Cloud, *179*
 Untitled (Copy photograph of a female nude), *152* (two images)

Versailles, 22, *177*
 possibly, Untitled (Man on a bicycle), 130, *134*
 see also Abbott, Berenice, prints of Atget's negatives by
Aurenche, Marie-Berthe, 108, 121n352
Au Sacre du Printemps (gallery), Paris, 54
Austin, A. Everett ("Chick"), 15, 27, 41, 107, 111n3, 114n112, 120n330, 162, *164*

Baasch, Kurt, 75, 82, 83, 116n188, 118nn260–62, 320, 321
 Untitled (Cellar door and cat), 68, 83, *206*
Bachrach Studios, 76, 321
Ballets Russes, 114n112, 115n136
Barr, Alfred H., Jr., 15, 27, 45, 79, 104, 111n2, 114nn111, 122, 115n136, 118n240
Barry, Iris, 47
Barrymore, John, 102
Bataille, Georges, "Critical Dictionary," 116n161
Baudelaire, Charles, 40, 120n320
Bauhaus, 58, 60, 65, 103, 116nn171, 176
Bayer, Herbert, 42, 52, 59, 115n132, 116n176, 120n321, 320, 322
 Good Night, Marie, 59, *59*
 Hands Act A–Z, 59, 116n177
Bayer, Javan Levy, 24, 112n37
Bayer, Joella Levy, 17, 22, *22*, 24, *25*, *26*, 29, 41, 65, 76, 81, 83, 102, 112n61, 116n176, 163, *247*
Bayer, Jonathan Levy, 97, 112n37
Beals, Carleton, *The Crime of Cuba* (1933), 88
Bellmer, Hans, 46
Benjamin, Walter, 94, 131
Bérard, Christian, 29
Berman, Eugene, 29, 77, 107, 115n136, 120n326, 159, 162
Berman, Leonid, 115n136, 159, 162
Bernhardt, Sarah, 40, 114n101, *138*
Berthet, Marcel, 131
Bethlehem Steel Corp., 82
Bibesco, Princess, *274*
Biddle, George, 117n201
Bing, Al, 15
Bing, Ilse, 52, 56–57, 116nn163, 164, 320
 Untitled (Child), 57, *57*
 Untitled (Birds), *267*
 Untitled (Figures in street), two images, 56–57, *228*, *231*
 Untitled (Flowers in vase), *258*
 Untitled (Harbor at Veere, Holland), 57, *230*
Biot, Jean-Baptiste, 118n234, 137, *139*, 169n29
Black Sun Press, 46
Blum, Albrecht Viktor, 115n135
Blume, Peter, 104
Bode, Allie, 113n89
 Mexican Madonna, *187*

Boiffard, Jacques-André, 42, 56, 320
Bonnaire, Mlle E., *144*
Bonwit Teller (store), New York, 57, 116n166
Bossen, Howard, 11
Bourke-White, Margaret, 72, 99, 320
Bowles, Paul, 105
Boyle, Kay, 17
Brady, Mathew B., 36, 38, 76, 137, 321
 formerly attrib., 137, *180–81*, 320
 studio of, 320
 Walt Whitman, 38, *58*
Brancusi, Constantin, 15, 17, 111n20, 121n351
 Bird in Space, 15, 16, 111n12, 126, 169n13
 Le Nouveau-né, 111n20
Brassaï (Gyula Halász), 52, 54, 56, 63, 159, 320
 Paris de nuit (1933), 54
 Woman's Torso (Scissors), 56, 116n182, *264*
Bratter, Maurice, 65, 72, 320
Braunstain, Arthur, *Mlle Rouge, Halles*, 137, 139, *140*
Brehme, Hugo, 44
Breton, André, 21, 42, 44, 101, 104, 107, 114nn119, 122, 127, 115n134, 121n345, 123, 124, 136, 168
 L'Amour fou (novel), 124
 chess set, with Nicolas Calas, 103
 Manifeste du surréalisme (1924), 114n108
 Nadja (novel), 124, 131
Breuning, Margaret, 72
Brigman, Anne, 34, 36, 93, 136, 320
 Pine Sprite, The, 36, *188*
 Sanctuary, *34*, 36
 Self-Portrait with Mask, 36, *186*
Brooklyn Daily Eagle, 9, 49, 110
Brooklyn Institute of Arts and Sciences, 119n285
Brooklyn Museum, 9, 60, 62, 75, 83, 113n75, 116n188
Brooklyn Times, 48
Broom (periodical), 63
Bruehl, Anton, 34, 72, 76, 117n218, 320, 321
Bruguière, Francis, 63
 Untitled (Cathedral montage) (two images), 63, *262, 263*
 Untitled (Cut-paper abstraction), 63, *261*
Brummer, Joseph, 24, 111n12
Brummer Gallery, New York. *See* Joseph Brummer Gallery, New York
Bucher, Jeanne, 29
Buñuel, Luis, and Salvador Dalí
 L'Âge d'or (film), 47
 Un Chien andalou (film), 46, *46*, 47, 115n137
Byars, James Lee, 107

Cage, John, 107
Calas, Nicolas, chess set, with André Breton, 103
Calder, Alexander, 22, 103, 104, 105, 111n28, 114n112
Calder, Louise, 104
Callahan, Harry, 98
Camera Club of New York, 29, 83
Camera Notes (periodical), 29
Camera Work (periodical), 29–30, 36, 113n67

Cameron, Julia Margaret, 76, 321
Campendonk, Heinrich, 16, 111n15
Campigli, Massimo, 39, 77
Cantacuzène, Princess Olga, 76, *182*
Carjat, Etienne, 76, 321
Cartier-Bresson, Henri, 10, 24, 31, 44, 46, 54, 86–90, *87*, 97, 108, 109, 110, 114n125, 116n157, 119nn273, 278, 128–30, 136, 153, 321, 322
 Funeral of the Comic Actor Gallipeaux, Paris, 88, 130, *226*
 Ivory Coast (Côte d'Ivoire), 90, 119n278
 Marseilles, 88, *235*
 "Menagerie All Day," Marseilles, 88, *88*
 Mexico, 89, *90*
 Rouen, 89–90, 119n277
 Untitled (Girl sleeping, Mexico), 90, *232*
 Untitled (Family in doorway, Mexico), 90, 119n278
 Untitled (Viscera), 56, *87*, *293*
 Untitled (Woman and child), *87*, 87
Cary, Elisabeth Luther, 9
Chagall, Marc, 16
Chaplin, Charlie, 128, 146
Charlot, Jean, 92, 93
Chekhov, Anton, 107
Chen, Si-lan. *See* Leyda, Si-lan Chen
Chirico, Giorgio de, 60, 100, 114n111
Christo, 107
Clair, René, 63
Clarence White School (of photography), 36, 91, 110
Clark, Colonel Jonas, tombstone of, *48*
Clark, Guy Gayler, 68
Coburn, Alvin Langdon, 36, 63, 113n91
 Snow in the Canyon, 36, *189*
 Wawona, Yosemite, *35*, 36
Cocteau, Jean, 42, 112n32
Colle, Pierre, 29
Condé Nast (firm), 9, 27, 79, 90
Connor, Bruce, 107
Conservatory of Music, Englewood, N.J., 116n183
Contemporáneos (periodical), 92
Coomaraswamy, Doña Luisa. *See* Llamas, Zlata
Copland, Aaron, *32*, 33
Copley, William, 107
 SMS (portfolios), 107
Copley Foundation, 106
Cornell, Joseph, 40–41, 42, 44, 79, 101–2, 113–14n96, 114nn112, 116, 122, 124, 118n241, 123, 124, 137, 162, 168n8, 322
 announcement for *Surréalisme* exhibition, 42, *42*
 Goofy Newsreels (film), 114n123
 "Imperious Jewelry of the Universe" (Lunar Baedecker): Portrait of Mina Loy, Daguerreotype-Object, 44, 162, *248*
 Monsieur Phot (film scenario), 114n123
 Portrait of Julien Levy, Daguerreotype-Object (c. 1938–39), 44, 162, *249*
 Portrait of Julien Levy, Daguerreotype-Object (1939), 44, 162, *246*
 Rose Hobart (film), 47, 114n123
Cornell, Katharine, 76
Cosmopolitan Studios, New York, 107
Courvoisier, Guthrie, 102
Covarrubias, Miguel, 81, 113n70
Cowley, Malcolm, 104
CPDE (Paris Electric Company), 63, 65

Crane, Hart, *The Bridge* (1930), 47
Cravan, Arthur (Fabian Avenarius Lloyd), 146
Crawford, Ralston, 83
Creative Art (periodical), 47, 68, 74–75, 76, 120n319
Crosby, Caresse, 46, 86, 108, 121n352
Crowinshield, Frank, 79
cummings, e. e., 81
Cunningham, Imogen, 10, 24, 93, 94, 95–96, 120n304
 Banana Plant, 96
 Growth, 96, *295*
 Hand of Gerald Warburg, Cellist, 96, *96*
 Leaf Pattern, 96
 Magnolia Blossom, 96
 Rock Shadows, 96, *193*
 Snake, 96
 Two Callas, 96, 120n305

Dada, 41, 146, 159
daguerreotypes, 36, 44, 76, 101, 114n124, 320, 321
Daily News Building. *See* Rotan, Thurman
Dalí, Gala, 27
Dalí, Salvador, 29, 57, 68, *100*, 102, 114nn111, 112, 115n134, 116n166, 121n351, 159
 Dream of Venus Pavilion, 99, *100*, 120n318
 Persistence of Memory, The, 29, 41, 42, 113n66
 and Luis Buñuel
 L'Âge d'or (film), 47
 Un Chien andalou (film), 46, *46*, 47, 115n137
Dallemagne & Lazerges, attrib.
 Portrait of a Man, 142, *143*
 Princess Olga Cantacuzène, 76, *182*
Daniel Gallery, New York, 19
Daumier, Honoré, 40
Davis, Jean McLaughlin. *See* Levy, Jean Farley
Davis, Stuart, 107, 117n201, 120n321, 322
Davis, Wyatt, 116n189
Debabov, Dmitri, 47, 115n136
Debabov, Margarita, 115n136
Debussy, Claude, 46
Delphic Studios, New York, 58, 62, 83, 92, 93, 94, 116n169
Delton, Louis-Jean, *Album hippique*, 139, 142, 169n32
 Mr. Brewer's American Trotting Horses, 139, *183*
 The Princess of Metternich's Saddle Horse, 139, *142*
de Maria, Walter, 107
Derain, André, 107
Deutsche Werkbund, 58
de Young Museum, San Francisco. *See* M. H. de Young Memorial Museum
Dial, The (periodical), 111n12
Dick, Sheldon, 97–98, 170n61, 322
Dickinson, Emily, 79
Dieulafoy, Madame Jane, 131, 136, 139, *141*
Dignimont, André, 146, 149
Disdéri, André-Adolphe-Eugène, Untitled *carte-de-visite* (Child with a drum), 137, *140*
Disney, Walt, 123, 146
Documents (periodical), 116n161, 131
Donati, Claire, 159
Donati, Enrico, 104, 159

Doré, Gustave, 40, 114n104, *175*
Dornac et Cie, *Ernest Renan*, 142, *145*
Dorsey, Tommy, 110
Dove, Arthur, 33
Downey, W. & D., *Madame Sarah Bernhardt*, 137, *138*
Draper, Muriel, 29
Dreier, Katherine S., *Marcel Duchamp, Venice*, 16
Duchamp, Marcel, 15–16, *16*, 36, 41, 63, 101, 104, 105, 107, 110, 123, 124, 126, 128, 146, 159, *159*, 168, 168n9, 169nn15, 22, *276*
 Anémic cinéma (film, with Man Ray and Allégret), 16, 111n14, 114n123
 "Compensation Portrait," 159, 170n57
 Nude Descending a Staircase, 15
 plate for a photomechanical relief print, *125*, 126
 Wanted—$2,000 Reward, 159
 Why Not Sneeze Rose Sélavy, 46, 115n130
 after, brochure for the exhibition *Man Ray: Objects of My Affection* at the Julien Levy Gallery, *125*, 126, 146, 169n15
Duisburg (balloon), 131, *133*
Dumas, Alexandre, père, *245*
Duncan, Isadora, 17
Durlacher Brothers, New York, 102
Durst, André, Untitled (Head of a woman), *258*
Duryea, Drix, 65, 149, 153, 170n41

Ecce Photo, 52, 57, 320
 Untitled (Figures, sculptures, and machine), 57, *257*
 Untitled (Nude figures and girders), 57, *252*
 Untitled (Sculpture casts), 57, *286*
Edison, Thomas, 169n15
Edwards, John Paul, 93, 94
Eisenstein, Sergei, 47, 77, 111n2, 115n136
 Battleship Potemkin (film), 77
 Bezhin Meadow (film), 77
Eliot, T. S.
 Waste Land, The (1922), 33, 113n72
Elisofon, Eliot, 72, 83, 117nn220, 221
 Untitled (Barber shop), 72, *205*
 Untitled (Hat shop window with reflections), 72, *73*
 Untitled (Junk shop), 72, *221*
 Untitled (Store window with display reflections), 72, *213*
Eloui, Nimet, *80*
Eloui Bey, Aziz, 79
Eluard, Paul, 115n134, 124
Equitable Gallery, New York, 11
Erfurth, Hugo, 60
Ernst, Jimmy, 29, 72, 113n62, 117n222
Ernst, Max, 29, 42, 101, 102, 103, 104, *104*, 105, 108, 113n62, 114nn111, 112, 115n132, 120n321, 121n352, 170n49, 320, 322
 Health Through Sports, *253*
 Une Semaine de Bonté (1934), 105
Erwin, Hobe, 25
Es kommt der neue Fotograf! (1929), 58
Etting, Emlen, 115n137
Eugene, Frank, 34, 76, 320, 321
Evans, Walker, 10, 25, 44, 45, 47–48, 54, 63, 72, 75, 79, 82, 86, 88, 89, 93, 94, 97, 109, 115n138, 136, 153, 167, 320, 321, 322

Bed and Stove, Truro, Massachusetts, 89, *89*

Berenice Abbott, 163, *167*

License Photo Studio, 89

Public Square, Havana, 88, 136, *234*

Stamped-Tin Relic, 47, *200*

Untitled (Doorway), 82, 83, *84*

Untitled (Tombstone of Colonel Jonas Clark), 48, *48*

Ewing, Max, 81–82, *81*, 118n248, 321

exhibitions

 Accommodations of Desire: Surrealist Works on Paper Collected by Julien Levy (2004–2006), 11

 American Photographs (1938), 48, 89

 Artists in Exile (1942), 103

 Atget Photographs (1930), 23, *23*, 96

 Das Lichtbild (Munich, 1930), 58, 60

 Fantastic Art, Dada, Surrealism (1936), 45, 46, 114n122

 Film und Foto (Stuttgart, 1929), 58, 60, 112n33, 123

 First National Exhibition of Photographs for Commerce, Industry, and Science (1932), 75

 First Papers of Surrealism (1942), 159, 170n57

 First Salon of Pure Photography (Oakland, Calif., 1934), 83

 42nd Annual Exhibition of Pictorial Photography (1932), 9, 62

 International Exhibition of Modern Art. See Armory Show

 International Exhibition of Photography (1932), 9, 60, 62, 83

 International Exhibition of Pictorialist Photography (1910), 31

 Looking at Atget (2005), 10

 Mexique (Paris, 1939), 44

 Modern Photography at Home and Abroad (1932), 116n188

 Murals by American Painters and Photographers (1932), 9, 83, 153

 Mythic City: Photographs of New York by Samuel H. Gottscho, 1925–1940 (2005), 11

 Newer Super-Realism, The (1931), 41, 42, 114n111, 115n137, 169n32

 Painters of Fantasy (1942), 120n330

 Photographs from the Julien Levy Collection, Starting with Atget (1976), 108

 Photographs of Art Forms in Nature by Blossfeldt (1932), 9

 Photo-patterns (1932), 68

 Portrait of an Art Gallery (1998), 11

 Premier salon indépendant de la photographie (Paris, 1928), 112n33

 Sarah Bernhardt: The Art of High Drama (2005), 114n101

 Six Portraits by Berenice Abbott (1930), 23

 Surrealism and New Romanticism: Poetry in Painting from the Collection of the Julien Levy Gallery (1965), 107

 Surrealism U.S.A. (2005), 11

 Two Hundred Portraits, Plus an Assortment of Less Formal Pictures of People (1941), 115n153

 see also Julien Levy Gallery, exhibitions at

Fargue, Léon-Paul, *Banalité* (1930), 52, 270

Farm Security Administration (FSA), 97, 167, 170nn57, 61

Feininger, T. Lux, 60

Fels, Florent, 54

film, 11, 14, 16, 19, 35, 36, 44, 46–47, *46*, 58, *58*, 59, 60, 72, 76, 77, 92, 105, *105*, 107–8, 111nn3, 14, 112n33, 113n70, 114n123, 115n37, 135, 146, 148, 170n49, *243*

Film and Photo League, New York, 167

Film Society, New York, 47, 113n73, 116n173

Fini, Léonor, *269*

Flanner, Janet, 17

Fleischer, Anna, 81, *275*

Florence Cane Art School, New York, 92

Flushing News (Long Island, New York), 93

Fogg Art Museum, Harvard University, 11, 14, 107, 108, 109, 112n40, 117n220, 121n354, 130

Forbes, Edward Waldo, 14

Ford, Charles Henri, 162

Ford Motor Plant, 67, 113n86

Frank Perls Gallery, Los Angeles, 102

French, Jared, 67

Freud, Sigmund, 124

Friede, Donald, 81

Friede, Mrs. Donald. *See* Fleischer, Anna

Fry, Varian, 15

FSA. *See* Farm Security Administration

Fuller, Buckminster, 75

G—, Lady Liliane, 139, *141*

Gabo, Naum, 115n136

Galería de Arte Moderno, Mexico City, 92

Galería Posada, Mexico City, 92

Géant, Le (balloon), 114n100

Genthe, Arnold, 76, 321

George Eastman House International Museum of Photography, Rochester, N.Y., 111n20

Georget, Léon, 131, *132*

Gerlach, Arthur, 65, 320

 Energy, 66, 117n204

 Still Life in Aluminum, *314*

 Still Life in Fruit, *315*

Gershwin, George, 33, 113n73

Giacometti, Alberto, 59, 115–16n153

Gide, André, 17, 50, 112n32

Godfrey, Kenneth, 169n23

Goethe, Johann Wolfgang von, *Faust*, proposed film of, 115n135

Goff, Lloyd, 67

Gorky, Arshile, 103, 104, 105–6, 107, 121n345

Gottscho, Samuel, 11, 36, 68, 117n212, 320

 Interior of Mill at Hayground, Long Island (First Story), 68, *197*

 Untitled (New York City skyline at dusk), 68, *214*

Graham, Martha, 33

Grant, General Ulysses S., 38

Grierson, Samuel, 25

Grinnell-Wolf, 146

 Untitled (Theater film still), 146, *243*

Gropius, Walter, 116n176, 118n230

Group f.64, 9, 83, 93–96, 119n292, 120n304

Guggenheim, Peggy, 17, 101, 102, 103, 121n334, 170n44

Hackenschmied, Alexander (Alexander Hammid), 169n15

Halász, Gyula. *See* Brassaï

Hall's Portrait Studio, Untitled (Boxing pose), 109, *122*, 146, *147* (two images)

Hamilton, Richard, 107

Hammid, Alexander. *See* Hackenschmied, Alexander

Hare, David, 97, 101, 103, 104, 120n326, 322

Harlingue, A., *Versailles Congress: Wallpapering the Bedroom . . .*, 130, *131*

Harper's Bazaar (periodical), 91, 99

Hartley, Marsden, 33

Harvard Society for Contemporary Art, 15, 46, 75, 111n6, 112n33, 52, 115n132, 169n32

Harvard University, 115n132

 see also Fogg Art Museum; Harvard Society for Contemporary Art

Haviland, Paul, 34, 320

Ház, Nicholas, 97, 98–99, 120n315, 322

 Image Management (Composition for Photographers) (1946), 98

Hege, Walter, 52, 60, 62, 116n187, 320

 Acropolis (two images), 60, *62*, *201*

Heinz Company, 82

Henne, George, 149, 170n43

Henri, Florence, 52, 116n186, 320

Hersan, M., 130, *130*

Herschel, Sir John, 170n29

Heston, Charlton, 72

Hill, David Octavius, 36, 76, 113n93, 118n234, 137, 169n29, 321

Hine, Lewis, 163

Hitchcock, Henry-Russell, 27, 75

Honickman, Lynne and Harold, 10

Hound & Horn (periodical), 15, 47

House and Garden (periodical), 149, 153, 170n42

Hoyningen-Heune, George, 76, 321

Hubbel, Renée, *80*

Hughes, Alice, 91

Hughes, Langston, 114n125

Hurwitz, Leo, 10, 170n41

 Lampshade made from a photograph design by Berenice Abbott, and cigarette box made from a photograph design by the Whiting-Salzman Studio, 149, *154*

Institute for Contemporary Art, Boston, 107

Institute of Design, Chicago, 98

Interior Architecture and Decoration (periodical), 149

International News Photos, *Muriel Streeter (Levy), Julien Levy, Max Ernst, and Dorothea Tanning*, 104

International Style, 75

Intimate Gallery, The, New York, 9, 29, 124

Isamu Noguchi Garden Museum, Long Island City, 11

Jackson, William Henry, 113n75

Jacobs, Lisa, and Ingrid Schaffner, *Portrait of an Art Gallery* (1998), 11

Jewell, Edward Alden, 42, 66, 74, 169n23

Jiménez, Augustín, 92

John Becker Galleries, New York, 47

Johnson, [Herbert], 72, 320

Johnson, Jack, 146

Johnson, Philip, 27, 75, 118n230

Joseph Brummer Gallery, New York, 15, 16, 126, 169n13

Joyce, James, 17, *17*, 76, 111n20, 112n32

Julien Levy Gallery, 24–29, *26*, 46–47, 97, *98*, 102, 106, 112n41, 52, 56, 115n137, 123, 126, 128, 136, 153, 162, 168, 168n7, 169n32, 170n60

 exhibitions at

 American Photography Retrospective Exhibition (1931), 9, 31, 33–34, *33*, 76, 113n86, 320

 Brett Weston Photographs (1935), *94*, 95, 322

 Carnival of Venice: Photographs by Max Ewing, The (1933), 81, 321

 Documentary and Anti-Graphic Photographs by Cartier-Bresson, Walker Evans, and Álvarez Bravo (1935), 11, 44, 88, 89, 119n274, 321, 322

 Emilio Amero: Paintings, Watercolors, Drawings, Prints, Photographs, Photograms (1935), 91–92, *92*, 321

 Eugène Atget, An Epoch of Contrasts: Paris Chateaux, Chiffonneries, Petits Métiers (1936), 96–97, 114n99, 322

 Exhibition of Anti-Graphic Photography (1933), 86–88, 128–29, 321

 Exhibition of Photographs in Color and Portraits by David Hare (1940), 322

 Exhibition of Portrait Photography (1932), 75–77, *76*, 321

 Fifty Photographs by George Platt Lynes (1934), 50–52, 91, 321

 Full Color Abstract Photograms by Nicholas Ház (1939), 322

 Imagery of Chess, The (1944), 11, 103–4, 111n20, 121n337

 Joseph Cornell, Exhibition of Objects: Daguerreotypes, Miniature Glass Bells, . . . (1940), 322

 Kurt Baasch Photographs (1933), 83, *83*, 321

 Lee Miller, Exhibition of Photographs (1932–33), 79, *80*, 321

 Modern European Photography (1932), 9, 52–63, *52*, 79, 97, 320

 Mural Decoration for the House of Wright Ludington (1939), 67

 Murals by Jared French (1939), 67

 Mural by Lloyd Goff (1939), 67

 Old and New "Trompe l'Oeil" (1938), 111n14

 Photographs by Berenice Abbott (1932), 73–75, 321

 Photographs by Eugène Atget: Intérieurs, Statues, Voitures (1932–33), 39–41, *39*, 320

 Photographs by Henri Cartier-Bresson (1933), 86–88, 128–29, 321

 Photographs by Man Ray (1932), 63, *63*, 79, 320

 Photographs by Nadar (1932–33), *39*, 76, 320

Photographs in Portfolio from the Julien Levy Collection (March [1943–47]), 322

Photographs of New York by New York Photographers (1932), 9, 26, 65, 68, *68*, 72, 83, 153, 320

Photographs of the American Scene by Luke Swank (1933), 82–83, *82*, 112n46, 321

Remie Lohse, Exhibition of Photographs (1934), 26, 90–91, *91*, 321

Review Exhibition at Our New Address (1937), 97, 322

Severity and Nostalgia in 1940: Abstract Sculpture by Theodore Roszak, Photographs by Clarence John Laughlin, Paintings by Enrico Prampolini (1940), 120n321, 169n35, 322

Surréalisme (1932), 9, 41–47, *42*, 49, 101, 114n99, 115nn132, 137, 169n32, 170n60, 320

Surrealist Paintings, Documents, Objects (1941), 102

Tri-State U.S.A., Photographs by Sheldon Dick (1939), 97–98, *97*, 322

Walker Evans and George Lynes (1932), 320

Wynn Richards, Exhibition of Photographs of Women Prominent in Fashion (1934), 91, 321

Kahlo, Frida, 44, 110, 123, 159, *160–61*, *162*, *163*, *304*, *305*

Käsebier, Gertrude, 33, 76, 109, 113nn78, 90, 136, 320, 321
Family, The, 184
Grandmother, The, 76, *185*

Kaulen and Schmidt (balloonists), 131, *133*

Kawara, On, 107

Keiley, Joseph T., 34, 320

Kertész, André, 10, 52, 54, 63, 116nn156, 159, 153, 320
Carousel Horses in the Tuileries, *54*, 268
Old Chimneys, Montparnasse, 54, *220*
Place Saint-André-des-Arts, Latin Quarter, 218
Siamese Cat, Paris, 54, 266
Untitled (Baby), 54, *236*
Untitled (Vagrant in street), 54, *55*, 153

Keyser, Jacques, 130, *132*

Keystone View Company, *Untitled (Press photograph of women holding ropes)*, 130, *130*

Khartoum (film), 72

Kiesler, Frederick, 104, 121n334

Kiesler, Stefi, 104
A Chess Village, 104
Is Chess a Martial Game?, 104, 121n337

Kiki de Montparnasse, 81

King, Carol Weiss, 77, *241*

Kirstein, Lincoln, 15, 27, *28*, 65, 81, 89, 102, 111n6, 112n61

Klee, Paul, 16, 107

Kolodny, Frank, 10, 108

Kolodny, Patricia, 10

Koltanowski, George, 104

Krull, Germaine, 56

Kuspit, Donald, 94

Lange, Dorothea, 94, 119n297, 167

Laughlin, Clarence John, 94, 97, 99–100, 120nn319–22, 128, 322
Eye #1: Homage to de Chirico, The, 100
Lost New Orleans (series), 120n320
Poems of Desolation (series), 120n320
Three Vistas Through One Wall, 100, *273*
Untitled (Cemetery, New Orleans), 100, *101*

Léger, Fernand, 46–47, 68, 105, 107, 121n351
Ballet mécanique (film), 11, 46, 107, 115n135

Legget Galleries, New York, 62

Lellis, Keith de, 117n217

Lempicka, Tamara de, 102

Leonardo da Vinci, 107

Lerski, Helmar, 52, 76, 320, 321
Head of a Bearded Man, 63, *239*

Lester [Gene], 72, 320

Levy, Edgar, 15, 16–17, 111n13, 113n66, 121n332, 124, 126, 169nn11, 13

Levy, Edgar, Jr., 15

Levy, Elizabeth, 15

Levy, Isabel Isaacs, 14, 15

Levy, Javan. *See* Bayer, Javan Levy

Levy, Jean Farley, 10, 11, 106, *106*, 108, 109

Levy, Jerrold Edgar, 24, 112n37

Levy, Joella. *See* Bayer, Joella Levy

Levy, Jonathan. *See* Bayer, Jonathan Levy

Levy, Julien, *8*, 14–15, 19, 21–24, *22*, 30–31, 41, 42, 44, 79, 81, *100*, 102, *104*, *104*, 109, *110*, 111n11, 123–24, 126, 128, 149, 153, 159–63, 170n49, *244*, *246*, 249
Arshile Gorky (1966), 107
chess set by, 111n20
FBI Wanted Notice: Edward Aloyisus Hannon, Wanted for the Crime of Impersonation (Marcel Duchamp), 159, *159*, 170n50
Frida Kahlo, 159, *160–61*, *162*, *163*, *304*, *305*
letter from, to Paul Sachs, 26
Memoir of an Art Gallery (1977), 10, 108, 128, 169n12
Pharmaceuticals, 107
Surrealism (1936), 46, 115nn133, 134, 123–24, 128
Surrealism Is . . . (film), 107
Untitled (Adobe building), *307*
Untitled (Child and adobe houses), 153, *156*
Untitled (Dancer), 153, *306* (two images)
Untitled (Pavel Tchelitchew), with Tchelitchew, 158, *159*
Untitled (Portraits in a window), 153, *157*
Untitled (Wall graffiti), with Roberto Matta, two images, 103, 126, *126*, *127*
Untitled (Woman and child), 153, *156*
possibly
Bonne Année, 162, *165*
Untitled (Dog's hindquarters), *156*, 159
see also Lloyd, Peter (pseudonym)

Levy, Muriel Streeter. *See* Streeter, Muriel.

Lewis, John L., 97

Lewis, Sinclair, 62

Lewisohn, Margaret, 29

Lewisohn, Sam, 29, 112n61

Lex-Nerlinger, Alice, 52, 60, 116n183, 181, 320
Dead Chicken, 56, 60, *294*
Die Näherin, 116n180
Eggs, *53*, 60
Tailor's Mannequin, 60, *283*

Leyda, Jay, 47, 77, 79, 115nn135, 136, 118n240, 321
Aaron Perlman, 77, 79, 116n182
A Bronx Morning (film), 46, 77
Carol Weiss King, 77, *241*
Julien Levy, 79, 118n240, *244*
portrait of Alfred H. Barr, Jr., 79, 118n240
portrait of Frank Rehn, 79
Sonya Schultz, *241*

Leyda, Si-lan Chen, 77

Liebling, A. J., 119n280

Lifar, Serge, 50, *50*, *51*, 114n112, 115n136

Life (magazine), 72

Lincoln, Abraham, portrait of, 38

List, Larry, 11

Little, Emma, 65

Little Galleries of the Photo-Secession, New York. *See* 291 (gallery)

Llamas, Zlata (Doña Luisa Coomaraswamy), *Alfred Stieglitz*, 29, *30*

Lloyd, Fabian Avenarius. *See* Cravan, Arthur

Lloyd, Fabienne, 76, *78*, 146

Lloyd, Peter (pseudonym), 86, 118n266, 128, 146, 169n35

Locher, 65

Lock and Whitfield, London, possibly, *J. L. Toole as Barnaby Doublechick*, *138*

Lohse, Remie, 26, 90–91, *91*, 321
Fan Dance, *91*, *302*

Lotar, Eli, 52, 54, 56, 116nn161, *162*, 320
Packing Up a Street Fair, 56, *56*, 88
Untitled (Globe advertisement), 56, *223*
Untitled (Head of a slaughtered calf), 56, 136, *291*

Loy, Mina, 17, *18*, 41, 44, 108, 111n12, 123, 146, 149, 153, 162, 170nn44, 49, *248*

Lynes, George Platt, 9, 10, 42, 47, 48–52, 57, 62, 65, 81, 91, 97, 115n148, 150, 153, 128, 146, 149, 153, 170n41, 320, 321, 322
Aaron Copland, 32, 33
Agnes Rindge, 28
American Landscape, 1933, 67, *67*, 117n205
As a Wife Has a Cow, 115n147
Constance Askew, 29, *242*
Gracie Allen, 98, *99*
Mina Loy, 18
New York Series #3, 50, *224*
New York Series #4, 115n151
New York Series #5, 115n151
New York Series #6, 115n151
New York Series #8, 49, 50
Serge Lifar, 50
Serge Lifar in "L'Après-Midi d'un Faune," 50, *51*
Serge Lifar in "La Spectre de la Rose," 50, *51*
Sleeping Beggar, Valladolid, 52
Untitled (Allen Porter?), 162–63, *166*, 170n60

Untitled (Male nude), 163, *166*
Untitled (Sculpture), 50, *277*
Untitled (Sculpture bust), 50, *287*
Vulture, 52

Maar, Dora, *Léonor Fini*, 269

MacDonald, Pirie, 76, 321

Mac Orlan, Pierre, 23, 111n30

MacRae (McRae), Wendell, 117n209, 320
Fantasy in Concrete, 68, *70*
Seed of Mars, 215
Summer, 68, *69*

Magritte, René, 159

Mailer, Norman, 109

Maintenant (periodical)

Man Ray, 9, 10, 16, 19, *19*, 21, 22, 41, 42, 46–47, 52, 56, 57, 58, 62, 63–65, *63*, 76, 79, 81, 86, 92, 97, 98, 100, 102, 103–4, 105, *105*, 107, 115n132, *125*, 126, 149, 159, 320, 321, 322
Anémic cinéma (film, with Duchamp and Allégret), 16, 111n14, 114n123
Boule de neige, 46
Ciné-Sketch: Adam and Eve (Marcel Duchamp and Bronia Perlmutter), 63, *276*
Electricité (portfolio), 63, 65, 117n193
Emak Bakia (film), 19
Étoile de mer, L' (film), 46, 114n123
Joella Levy, 17, 76, *247*
Noir et blanche, 81
portrait of Arnold Schoenberg, 76
portrait of Lee Miller, 62, 118n247
portrait of Mina Loy, *248*
portrait of Sinclair Lewis, 62
portrait of Tanja Ramm, 76
Princess Bibesco, 63, *274*
Untitled (Mannequin hand and corkscrew), 62
Untitled (Multiple-exposure nude), 42, 63, *64*
Untitled (Peony and glove), 42, 62, *260*

Manuel, Henri, 131
Madame Dieulafoy, 131, 136, 139, *141*

Manzanar Relocation Center, California, 119n297

Marin, John, 33

Marsh, Reginald, 117n201

Martin, Ira, 68, 72, 320

Martins, Maria, 159

Marx Brothers, *Animal Crackers* (film), 46

Mas, V., Untitled cabinet card (Portrait of a sailor), 137, *140*

Masson, André, 114n111

Matisse, Henri, 29, 30

Matisse, Pierre, 27, 102

Matta, Roberto, 103, 114n112, 115–16n153
Untitled (Wall graffiti), with Julien Levy, two images, 103, 126, *126*, *127*

Matulka, Jan, 117n201

McAlmon, Robert, 17

McAndrew, John, 25, 46, 112nn44, 48

McCausland, Elizabeth, 96–97

McRae, Wendell. *See* MacRae (McRae), Wendell

Mednick, Sol, 107

Melville, Herman, 79

Mérode, Cléo de, *138*

Metropolitan Museum of Art, New York, 60

Meurisse, Henri Louis, 129

At the Congress, an Unexpected Candidate . . ., 130, *130*
Bicycle-Torpedo, The, 131, *135*
Bicycle-Torpedo, Frontal View, The, 131, *155*
Prix Lemonnier, Versailles to Paris on Foot . . . , The, 130, *132*
Lady Liliane G., Women's Suffrage by Gentle Means, 139, *141*, 169n31
M. H. de Young Memorial Museum, San Francisco, 93
Michelangelo Buonarroti, 107
Michigan State University, 11
Miller, Erik, 79
Miller, Lee, 9, 10, 52, 62–63, 76–77, 79–81, *80*, 86, 110, 118n244–47, 146, 149, 320, 321
Julien and Joella Levy in front of the Julien Levy Gallery, 602 Madison Avenue, 25, *26*, 149
Man Ray, 19
Mrs. Donald Friede, cover, 81, *275*
Nimet Eloui, 79, *80*
portrait of Eugene Berman, 77
portrait of Joseph Cornell, 79, 118n241
portrait of Mary Taylor, 81, 118n246
portrait of Massimo Campigli, 77
portrait of Tanja Ramm, 81, 118n246
Renée Hubbel, 79, *80*
Untitled (Hand against sky), *280*
Untitled (Rocks and sand), 79, *296*
Untitled (Stone), 79, *297*
Untitled (Tar), 79, 118n245, *292*
view of cows in landscape, 79, 118n244
Minotaur (periodical), 44, 114n122, 120n319
Miró, Joan, 104, 114n111, 126
Modotti, Tina, 44, 94
Moholy, Lucia, 42, 59–60
László Moholy-Nagy, 42, 60, *61*
Stage set with shadow projection for *Tales of Hoffmann, The*, 60, *61*
Straw Hat (Strohhut), 60, *240*
Moholy-Nagy, László, 10, 25, 52, 58–60, *61*, 63, 92, 98, 116nn172, 173, 320
Lichtspiel Schwarz-weiss-grau (film-strips), *58*, *59*
Malerei, Fotografie, Film (1925), 123
Marseille vieux port (film), 59, 116n174
Untitled (Beach scene), 59, *254*
Untitled (Cat on a chair), 58–59, *237*
Untitled (Woman and baby, Finland), 59, *229*
MoMA. *See* Museum of Modern Art, New York
Mondrian, Piet, 54
Mongan, Agnes, 15
Montross, Newman Emerson, 113n91
Montross Gallery, New York, 36, 113n91
Morris, Thomas E., 9, 75, 113n75
Moscow State Film School, Russia, 77
Moulin, Félix-Jacques-Antoine
L'Algérie photographiée (album), 137
Boghari, Arab Horse, 137, *174*
Mumford, Lewis, 50, 86–87
murals, 91, 117n201
see also photomurals
Murals by American Painters and Photographers (exh. cat., 1932), 65, 66
Murat, Princess Eugène, 112n32
Muray, Nickolas, attrib., *Frida Kahlo with Her Head in a Brace*, 162, *163*
Murphy, Dudley, 107

Museum of Modern Art, New York (MoMA), 9, 11, 27, 33, 45, 46, 47, 48, 54, 65, 66, 67, 70, 72, 75, 76, 77, 83, 89, 93, 95, 98, 102–3, 111n6, 112nn48, 58, 113n62, 114n122, 116n176, 117nn222, 239, 118n245, 121n349, 153

Nadar (Gaspard-Félix Tournachon), 36, 39–40, *39*, *40*, 76, 114nn100, 101, 103, 136, 142, 320, 321, 322
Alexandre Dumas, Père, 245
Baron Taylor, 137, 142, *143*
George Sand, 40–41, 113–14n96, *176*
Gustave Doré, 40, 114n104, 142, *175*
Mademoiselle E. Bonnaire, 40, 142, *144*
Self-Portrait, *39*, 40
Nadar, Paul, 40
photographs printed by, 40, 142, *175–76*, *182*
plate from *Paris-Photographe*, 40, 91, 142, *144*
Untitled (Deathbed portrait), 40, 142, *227*
Untitled (Reclining woman in costume), 149, *303*
Untitled (Woman with flowers in her hair), 142, *303*
National Academy Museum, New York, 11
National Gallery of Art, Washington, D.C., 111n6
National Geographic (periodical), 72
National Museum of African Art, Washington, D.C., 117n220
Neo-Romantics, 102, 107, 159
Nerlinger, Oskar, 52, 60, 63, 116n181, 320
Doll, 60, *255*
Neuberger Museum, State University of New York-Purchase, 106
Neue Sachlichkeit (New Objectivity), 94, 95
Neumann, J. B., 29, 113n62
Newhall, Beaumont, 33, 54, 83, 93, 95, 103
Newhall, Nancy, 93, 98
New Objectivity. *See* Neue Sachlichkeit
New School for Social Research, New York, 72
New York City American (newspaper), 91
New Yorker (periodical), 82, 86–87
New York Evening Graphic, covers, 45
New York Evening Post, 72, 86
New York Herald-Tribune, 74
New York Post, 74
New York Sun, 66, 82, 91, 93
New York Times, 9, 33, 34, 42, 47–48, 49–50, 63, 66, 72, 74, 79, 93, 97, 109
Nicolas Dinky (cat), 54, *237*
Nierendorf, Karl, 29, 113n62
Noguchi, Isamu, 50, 81, 103
Norman, Dorothy, 321
Nos Contemporaines chez eux (cabinet card series), 142, *145*
Noskowiak, Sonia, 93
Nouvelle Revue française, La (publisher), 52

Offenbach, Jacques, 40
Offner, Mortimer, 72, 320
O'Keeffe, Georgia, 16, 33, 117n201, 162, 169n11
Ollivier, L., Untitled (Fallen horse), 56, 136, 137, 146, *290*
Ono, Yoko, 107
Oppenheim, Meret, 107
Orlik, Emil, 60

Orozco, José Clemente, 91
Outerbridge, Paul
New York from a Back Window, 36, *207*
Rhythmic Curves, 36, *37*
Owen, Gilberto, *777* (film, with Emilio Amero), 92

Pach, Walter, 15, 111n13
Painlevé, Jean, 56
Parry, Roger, 42, 52, 116n154, 320
Untitled (Abstraction), *271*
Untitled (Composition with feathers, rocks, shells, and burlap), *256*
Untitled (Double exposure of a woman), *284*
Untitled (from *Banalité*), 52, *270*
Untitled (Montage with hand and face), *285*
Pascin, Jules, 17
Peaches and Daddy, 169n32
Peet, Creighton, 86, 321
Pennsylvania State University, 107
Perlman, Aaron, 77, 79
Perlmutter, Bronia, 63, *276*
Perls, Hugo, 102
Perls, Klaus, 102
Peterhans, Walter, 52, 60, 116n186, 320
Philadelphia Museum of Art, 109
photogram, 42, 58, 62, 63, 65, 92–93, 98–99, 109, 116n172, 119n287, *260*
photographer unknown
Atget possibly, Untitled (Man on a bicycle), 130, *134*
Levy possibly, *Bonne Année*, 165
Lock and Whitfield possibly, *J. L. Toole as Barnaby Doublechick*, 137, *138*
Remie Lohse exhibition at the Julien Levy Gallery, 91, *91*
Untitled (Biplanes on the ground), 131, *134*
Untitled (Dead Civil War soldier in a trench), 38, 137, *181*
Untitled (Dead Civil War soldiers in a trench), 38, 137, *180*
Untitled (Female nude), 146, 149, *150* (two images)
Untitled (Hans Richter and Man Ray with the poster for *Dreams That Money Can Buy*), 105
Untitled (Julien Levy, Salvador Dalí, and a nude model with a fish—Dream of Venus Pavilion, World's Fair), 99, *100*, 120n318
Untitled (Male nude), 149, *151* (three images)
Untitled (Police photograph), 168, *168*
Untitled film still, 146, *148*
Untitled film still (Ruth Roland in *White Eagle*), 146, *148*
White Globe Onion, 137, *137*, 146
Photographie (annual publication), 123, 153, *319*
Photo League, New York, 72, 167
photomontage, 59, *59*, 109, 117n204, 162–63, *166*, 170nn48, 60
photomurals, 65–67, 83, 118n239, 170n41
Photo-Secessionists, 24, 31, 34, 36
photostats, negative, 45
physionotrace engravings, 137, *139*, 321
Picabia, Francis, *Relâche* (ballet), 63
Picasso, Pablo, 114n111
Pictorialism, 31, 36, 62, 63, 93, 98, 117n217, 118n262, 136, 168

Pierre Matisse Gallery, New York, 103, 111n28, 115n153
Pop art, 107
Porter, Allen, 25, *26*, 46, 81, 112nn48, 61, 162–63, *166*, 170n60
Porter, Eliot, 31, 98, 113n70
Porter, Katherine Ann, 50
Post, Chandler, 14
Powel, Peter and Gretchen, 86
Prampolini, Enrico, 120n320, 322
Pueblos, documentation of, 101

Quenedey, Edme, Untitled (Physionotrace portrait), 76, 137, *139*
Querschnitt, Der (periodical), 57
Quinn, John, 15

Rachmaninoff, Sergei, 79
Ramm, Tanja, 76, 81, 118n246
Rayograph, 58
Read, Helen Appleton, 9
Reed, Alma, 93, 94
Regnault, Henri Victor, *Jean-Baptiste Biot*, 118n234, 137, *139*, 169n29
Rehn, Frank, 79
Renan, Ernest, 142, *145*
Renger-Patzsch, Albert, 94, 95, 100
Die Welt ist schön (1929), 94
Reutlinger, Charles, *Cléo de Mérode*, 76, 137, *138*, 321
Révolution surréaliste, La (periodical), 21, 131
Richard Feigen Gallery, Chicago, 107
Richards, Wynn, 91, 321
Richter, Hans, 104–5, *105*, 121n342, 159
8 x 8 (film), 105
Dreams That Money Can Buy (film), 104–5, *105*
Rieti, Vittorio, 104
Rigg, Lynn, "A Day in Santa Fe" (film), 115n135
Rindge, Agnes, 15, 28, 29
Rittase, William A., 65, 117n215
Forgers, Midvale Steel, 66, *216*
Spillway, The, *311*
Steel (photomural), 66
Roché, Henri-Pierre, 15
Rockefeller Center, New York, 65, 68, *69*, 75, *217*
Rodakiewicz, Henwar, *Portrait of a Young Man* (film), 113n70
Rodin, Auguste, 30, 111n12
Roh, Franz, and Jan Tschichold, *Foto-Auge* (1929), 58, 123
Roland, Ruth, *148*
Rol, M., 129
December 23, 1912. The Arrival of Christmas Geese . . . , *233*
Heat in Paris, 35∞ in the Shade, 136, *136*
January 11, 1913. Paris: The Champion Aviator Tabuteau . . . , 129, *130*
January 13, 1913. The Six Days' Course at the Palais des Sports . . . , 131, *132*
October 23, 1913. The Balloonists Kaulen and Schmidt . . . , 130–31, *133*
Rolph, Dorothy, 86, 321
Rosenberg, Harold, 107
Roszak, Theodore, 120n320, 322
Rotan, Thurman, 36, 65, 68, 70, 75, 117nn214, 215, 216, 217, 153, 170n48, 320
Daily News Building (collage), 70, 153, *211*

Daily News Building (montage), 66, 66, 70, 117n204
Five Cats from Siam (1935), 117n217
Untitled (Construction in Manhattan), 70, *71*
Untitled (Logs and Empire State Building), 70, *210*
Untitled (Meat), 70, *308*
Untitled (Oil barrels floating at a pier), 70, *71*
Untitled (Poultry crates at Washington Market, New York City), *222*
Untitled (Trees), 70, *310*
Rouge, Mlle, 137, 139, *140*
Roussy de Sales, Raoul de, 65
Roy, Pierre, 114n111

Sachs, Paul, 14, 24
 letter to, from Julien Levy, 24, *26*
Sade, marquis de, 124
Sage, Kay, 104, 159
Sakier, George, 25
Sand, George, 40, 41, *176*
Sander, August, *Menschen des 20. Jahrhunderts* (series), 73
San Francisco Museum of Art, 93
Sarah Lawrence College, 106, 108
Sarony, Napoleon, 76, 321
Save Venice, Inc., 112n44
Schaal, Eric, 120n318
Schaffner, Ingrid, and Lisa Jacobs, *Portrait of an Art Gallery* (1998), 11
Schawinsky, Xanti, 103, 104
Schell, Sherril, 65, 68, 75, 76, 117n210, 149, 320, 321
 Buildings on West 33rd Street, *209*
 Construction of Rockefeller Center, *217*
 Construction, Radio City, 68
 photograph design by, *318*
 Reflection in Window Pane of Empire State Building, 68, *208*
 Window Reflection—French Building, 68, *203*
Schiaparelli, Elsa, 57
Schiele, Egon, 16
Schoenberg, Arnold, 76
School of American Ballet, New York, 111n6
Schultz, Sonya, *241*
Schwarz, Heinrich, 94, 119n296
Seattle Art Museum, 119n290
Seldes, Gilbert, 81, 82
 This Is New York: The First Modern Photographic Book of New York (1934), 75
 Seven Lively Arts, The (1924), 118n249
Shahn, Ben, 117n201, 167, 170n57
Shakespeare, William, 107
Shapazian, Robert, 108
Sheeler, Charles, 10, 25, 33, 34, 35, 65, 113n86, 128, 320
 Industry, 67, 113n86
 Manhatta (film, with Paul Strand), 35
 Shaker Stove, 35, *198*
 Side of White Barn, Doylestown, 35, 82, 113n86, *194*
Siegel, Arthur, 98
Simon, Louis, 35, 36, 113n89
Simon, Stella, 35–36, 65, 113nn89, 90, 149, 167, 170n41, 320
 Chinese Coat, 36, *190*

Cigarette box made from a photograph design by Sherril Schell, 65, *318*
Hände (film), 36, 115n135
Lampshade made from a photograph design by Berenice Abbott, 65, 153, *319*
Skunk Cabbage, 36, *191*
Untitled (Design for a photomural), 67, *301*
Wastebasket made from a photograph design by Berenice Abbott, 65, *318*
Sipprell, Clara, *Barns in Winter*, 36, *37*, 82
Smith, Pamela Colman, 30
Smith College Museum of Art, Northampton, Mass., 9, 116n183
Snow, Carmel, 91
Soby, Eleanor Howland, 162
Soby, James Thrall, 27, 65, 107, 162
 Untitled (A. Everett Austin and Pavel Tchelitchew, Pompeii), 162, *164*
 Untitled (Leonid Berman, Italy), 162, *300*
 Untitled (Rooftop composition), 162, *298*
Society for Contemporary Art. *See* Harvard Society for Contemporary Art
Sougez, Emmanuel, 10, 52, 57, 108, 320
 Untitled (Wheat), 57, *312*
Springfield Republican (newspaper), 35, 96–97
State University of New York-Purchase, 106, 107
Steichen, Edward, 33, 57, 65, 66, 76, 77, 118n239, 320, 321
Stein, Gertrude, 50
Steiner, Ralph, 33, 34, 36, 75, 77, 83, 108, 118n237, 162, 320, 321
 Untitled (New York City), *12*, 68
stereographs, 36, 320
Sterne, Katharine Grant, 9
Stieglitz, Alfred, 9, 16, 19, 24, 29–31, *30*, 33, 36, 62, 74, 76, 77, 83, 86, 93, 99, 100, 110, 112n52, 113nn67, 70, 83, 124, 128, 136, 162, 167, 168, 169, 168n9, 169nn11, 12, 320, 321
Stoddart, Seneca Ray, 113n75
Stradivarius Quartet, 96
Strand, Paul, 10, 25, 27, 31, 33, 34–35, 44, 83, 100, 109, 113n83, 128, 136, 149, 320
 Cobweb in Rain, Georgetown, Maine, 35, *192*
 Manhatta (film, with Charles Sheeler), 35
 portraits of Kurt Baasch, 118n261
 Redes (*The Wave*) (film), 44
 Untitled (Machine, Akeley camera shop), 35, *199*
Streeter, Muriel, 103, *104*
Sun (Sydney, Australia, newspaper), 117n204
Surrealism, 10, 11, 41–42, 79, 87, 96, 107, 114nn109, 119, 120, 116n166, 120n317, 123–24, 131, 142, 146, 159
Survage, Leopold, 114n111
Swank, Luke, 10, 11, 65, 75, 82–83, *82*, 112n46, 118nn254, 256, 321
 Catalpa Tree, *195*
 Pittsburgh #12, 82–83, *212*
 Steel Plant, 66, *67*

Untitled (Doorway and street light), 82, *84*
Untitled (Farm-door mechanism), *196*
Untitled (Tenement), 82, *204*
Untitled (Victorian house), *206*
Swift, Henry, 93

Tabard, Maurice, 10, 42, 52, 63, 116–17n190, 320
 Untitled (Dentist's chair), 52, *279*
 Untitled (Lanvin advertisement), 57, *265*
Tabuteau, Maurice (aviator), *129*, 130
Tales of Hoffmann (opera), 60, *61*
Tanguy, Yves, 104, 115–16n153, 159
Tanning, Dorothea, 103, *104*
Taylor, Baron, *143*
Taylor, Mary, 81, 118n246
Tchelitchew, Pavel, 50, 115n136, 120n322, 158, 162, 164
 Untitled (Pavel Tchelitchew), with Julien Levy, 158, *159*
Terry, Emilio, 118n229
Threepenny Opera, The (film), 47
Time (periodical), 97
Toole, J. L., *138*
Tournachon, Gaspard-Félix. *See* Nadar
Town and Country (periodical), 79, 82
Travis, David, 10, 108, 121n354
 Photographs from the Julien Levy Collection, Starting with Atget (exh. cat., 1976), 10, 108
Tschichold, Jan, and Franz Roh, *Foto-Auge* (1929), 123
291 (gallery) (Little Galleries of the Photo-Secession), New York, 9, 29, 30, 112n52

Umbehr, Otto. *See* Umbo
Umbo (Otto Umbehr), 42, 52, 59, 108, 320
 Uncanny Street I, *43*, 59, 116n178
University of Oklahoma Museum of Art, Norman, 119n290
University of Pittsburgh, 82
Unterrichtsanstalt am Kunstgewerbemuseum, Berlin, 60
U.S. Camera (periodical), 85
U.S. Engineer Department, New Orleans, 100
U.S. War Department, 38

Vandamm Studios, portrait of Katharine Cornell, 76
Van Dyke, Willard, 93
Vanity Fair (periodical), 27, 63, 79, 90
Van Vechten, Carl
 Henri Cartier-Bresson, 86, *87*
 Kirk Askew, *28*
 Lincoln Kirstein, *28*
 Max Ewing, 81, 82
Velo-Torpille (bicycle-torpedo), 131, *135*
Victor, Sophie, 112n32
Vogue (periodical), 79, 90, 97, 99
Vu (periodical), 57
VVV (periodical), 101, 114n122

Wadsworth Atheneum, Hartford, Conn., 15, 41, 45, 47, 65, 67, 111n3, 114nn111, 112, 115n147, 120n330, 169n32
Walker, John, III, 15, 111n6
Walker Galleries, New York, 101

Walther, Thomas, 118n247
Warburg, Edward M. M., 15, 27, 47, 96, 102, 111n6, 112n61
Warburg, Gerald, 96, *96*
Watkins, Franklin, 117n201
Weiner, Lawrence, 107
Weller, Peter, 52, 320
 Untitled (Male nude), *251*
 Untitled (Still life with fish), *309*
 Untitled (Woman with cigarette), *250*
Wells, H. G., *The Work, Wealth, and Happiness of Mankind* (1931), 117n215, 153
Westcott, Glenway, 50, 112n44
Weston, Brett, 94–95, 322
 Cactus, 95, *95*
 Untitled (Rock formation), 95, *299*
Weston, Edward, 23, 34, 44, 62, 93, 94, 100, 119n293, 120n300, 128, 320
Weyer, Edward M., 75
Weyhe, Erhard, 22, 23
Weyhe Gallery, New York, 9, 22, 23, 24, 27, 47, 73, 96, 111n28, 112n36, 119n290
Wheeler, Monroe, 112n44
White, Clarence, 33, 36, 76, 83, 91, 113nn78, 83, 89, 90, 170n49, 320, 321
Whiting-Salzman Studio, 149, 153, 170n41
 Photograph design for a cigarette box, 149, *154*
 Photograph design with beans, 149, 153, *155*
 Photograph design with matchbox, 65, *313*
 Photograph design with zebra skin, 149, 153, *155*
 attrib., Photograph design with pencil shavings, 65, 149, *316*
Whitman, Walt, 38, *38*
Whitney Museum of American Art, New York, 33, 106–7
Wilde, Oscar, 146
Witkin Gallery, New York, 10, 108, 114n101, 116n159, 120n305
 Photographs from the Julien Levy Collection (exh. cat., 1977), 10
Witkin, Lee, 108
Wolcott, Marion Post, 167
woodburytypes, 40, 137, *138*, *143*
Woodner, Ian, 99
Works Progress Administration (WPA), 167
World's Fair, New York (1939), 99, 120n317
World's Work (periodical), 70
WPA. *See* Works Progress Administration
Wright, Cedric, 120n315

Zayas, Marius de, 30, 31
Zigrosser, Carl, 22, 23, 24, 111–12nn26, 30